Praise for

ABORTION

"*Abortion* offers a surprising and ultimately optimistic history of how women have managed their reproductive lives for thousands of years in the face of legal and mortal danger. Expertly researched and deeply empathetic, *Abortion* centers the lives and stories of women and provides a crucial and fascinating context for understanding abortion politics today."
—Leah DeVun, author of *The Shape of Sex*

"An important book that tells the history of abortion—and its frequent repression—from antiquity to the modern day."
—Leslie J. Reagan, author of *When Abortion Was a Crime*

"In this innovative new history of abortion, Fissell eloquently, brilliantly, and poignantly relates the experiences of individual women to convey the long histories of the complexity, sadness, and determination of women's efforts to control their fertility. Their stories provide a reality check about the universality and persistence of women's needs to end pregnancy, no matter what level of repression or discipline, but it also offers an essential note of hope—waves of repression have always been followed by phases of toleration."
—Julie Hardwick, author of *Sex in an Old Regime City*

"A compelling, compulsively readable, and timely account of the very long history of abortion and abortion restrictions. Fissell's prose sparkles, and the stories of women—married and single, rich and poor, enslaved and free—leap off the pages. Fissell shows us that the need and desire to control one's reproductive life is not a modern phenomenon; women have been controlling their fertility by seeking abortions for thousands of years. Recurrent attempts to ban abortion have never been successful and have always had devastating consequences for women and families. This is essential reading for health-care providers, policy makers, and all who care about the lives and well-being of pregnant and potentially pregnant people."

—Kathleen M. Crowther, author of *Policing Pregnant Bodies*

"Vital reading. This is a clear and engaging account of the long history of abortion. Mary Fissell tells the story through vivid, engaging, and often alarming accounts of real women who tried to end their pregnancies. Abortion has always been an important aspect of women's healthcare; and, its history shows, it has largely been tolerated. The range of experiences documented by Fissell will inform and educate the wide audience this book deserves to find."

—Helen King, author of *Immaculate Forms*

"*Abortion* is the definitive history of abortion in the West. Fissell centers the experience of women as seekers and providers of abortion, demonstrating that, for all of the recent controversy about the practice, abortion has also enjoyed centuries-long periods of acceptance by the powerful. Accessible and absorbing, *Abortion* gives us hope for the future!"

—Nicholas L. Syrett, author of *The Trials of Madame Restell*

ABORTION

MARY FISSELL

ABORTION

A HISTORY

HURST & COMPANY, LONDON

First published in the United Kingdom in 2025 by
C. Hurst & Co. (Publishers) Ltd.,
New Wing, Somerset House, Strand, London, WC2R 1LA

© Mary Fissell, 2025
All rights reserved.

Published by arrangement with Seal Press, Hachette Book Group
1290 Avenue of the Americas, New York, NY 10104

Print book interior design by Amy Quinn.

The right of Mary Fissell to be identified as the author
of this publication is asserted by her in accordance
with the Copyright, Designs and Patents Act, 1988.

A Cataloguing-in-Publication data record for this book
is available from the British Library.

ISBN: 9781805262756

www.hurstpublishers.com

Printed and bound in Great Britain by Bell & Bain Ltd, Glasgow

For my students

CONTENTS

	Introduction	1
Chapter 1:	The Singer: Abortion in Antiquity	13
Chapter 2:	The Saint and the Sinner: The Middle Ages and the Rise of Christianity	39
Chapter 3:	The Maidservant and the Witch: Crackdowns in Early Modern Europe	67
Chapter 4:	The Botanist: New Plants, New Worlds	97
Chapter 5:	The Seamstress and the Midwife: Sensational Stories in Victorian Britain	125
Chapter 6:	The Schoolteacher: Anti-Abortion Campaigns in Nineteenth-Century America	149
Chapter 7:	The Housewife: Repression and Reform in Twentieth-Century America	177
	Coda	213
	Acknowledgments	*219*
	Further Reading	*223*
	Notes	*231*
	Index	*263*

INTRODUCTION

I'M STANDING IN A CHURCHYARD IN SOUTH LONDON. IT'S A cool, drizzly April day, and the wet, green grass is spangled with tiny daisies. I have come here to mourn a woman who died many years ago. Her name was Eliza Wilson.

The stone church, with its graceful proportions and classical pillars, still stands, but it has fallen on harder times. Like many London churches, it's locked during the week, and there are empty beer cans on the porch, despite signs forbidding the drinking of alcohol. In front is a slim bit of lawn, what is left of the churchyard where Wilson was buried; the graves were moved to a cemetery many decades ago. In Wilson's day, it was open country around here. Now the church is squeezed onto a narrow triangle, with busy streets on either side and a railway line behind. The scrap of land looks like a miniature village green; in front of the church stand memorials to parishioners lost in the First and Second World Wars. Eliza Wilson died long before then, in 1848, after an abortion that went wrong. She was only thirty-two.

I had encountered Eliza in a Victorian newspaper, while looking for something else. Her story is known to us because after her death, her midwife was put on trial. Every salacious detail was covered by the newspapers. But before all that, Eliza

was an ordinary young woman, working as a seamstress. She lived with her father and sisters in Norwood, a village south of London that was being swallowed up by the metropolis. Like so many others, they were migrants to the capital; they had come from the Lake District, way up north. In truth, I'm not entirely sure why I needed to come here to mourn someone I never knew. But historians bear witness, and I wanted to remember Wilson here where she lived.

This book tells the stories of Eliza Wilson, and other women like her, who sought to end pregnancies in the past. Wilson's was the first abortion I researched, and I was stunned by the depth of detail hidden in the many column inches dedicated to her case. It was striking in part because it was so ordinary. Dressmaking was one of the most common occupations for working-class women in nineteenth-century Britain. Her decision to end her pregnancy was ordinary, too. Some women, like Wilson, were unlucky; she lived in a time before antibiotics and died from an infection. Countless others survived. Their success in managing their reproductive lives makes them almost invisible in the historical record, but their decisions can echo in our imaginations. They remind us that abortion has long been an option for women, as far back in the historical record as we can see.

Much of the scholarship on the history of abortion has focused on regulation. But this book is first and foremost about women who sought to end their pregnancies, rather than the laws that restricted them. Their stories reveal how both childbearing and abortion were woven through women's lives. They remind us of the complexities that an unwanted pregnancy can provoke. They also suggest long continuities in women's experiences.

I say *women* because I'm writing about the past. Today, we recognize that many trans and nonbinary people can also

become pregnant, and so we talk about *people* who seek abortions. There have always been those who did not fit into male and female binaries, but it is not easy to map our current understandings of sex, gender, and identity onto people in centuries gone by. We can't know how these people understood themselves, as male or female, both or neither. However, because the story of abortion is plaited with the history of how societies organized and regulated male and female behavior, it matters that the people who sought abortions in the past—the people whose stories I tell in this book—were labeled as women.

This book takes the long view of abortion, moving from ancient Greece all the way into late-twentieth-century America and the world-famous *Roe v. Wade* ruling, stopping in various times and places along the way. The most important things I have learned from this long view are simple. First, women have always ended pregnancies. They had abortions because they were single, because they could not afford to have another child, because they had been raped—all kinds of reasons. Abortion has also long been a lifesaving procedure. Ancient Greek doctors knew that a woman could die when fetal tissue started putrefying inside her body after a pregnancy ceased being viable. Circumstances change, but these basic facts of women's lives endure; prohibition of abortion did not change them.

Second, while there have been periods of extreme repression, with drastic penalties visited upon women who got caught seeking to end a pregnancy, these gave way to times of quiet toleration. Neighbors, employers, and family looked the other way, ignoring any evidence that a woman might have had an abortion. Such turning away is an active choice, a decision to prioritize an individual woman's well-being over the letter of the law. It is only by taking the long view that we can see these ebbs and flows, crackdowns followed by acceptance.

Finally, these patterns of restriction and toleration are linked to larger shifts in gender relations, in the ways a society expects men and women to behave. In first-century Rome, for example, men complained that elite married women were getting abortions because they were so vain that they refused to hazard their slim figures or because they were hiding adulterous affairs. Or so the men believed. Those same cultural critics bemoaned the fact that women no longer stayed demurely at home but rode around the city in carriages as they pleased. Abortion became a sign of women's new freedoms. Similar arguments were made in antebellum America, when first-wave feminists were agitating for women's suffrage, giving lectures to women about sexual health and pleasure, and advocating for equality in marriage. People got scared about these threats to the status quo and, like the Romans many centuries earlier, imagined that women were being unfaithful to their husbands, concealing adultery by ending pregnancies. Abortion restriction has often been gender backlash.

While anti-abortion laws might encode concerns about women's social roles, what was "wrong" about abortion has varied over time. Today's anti-abortion activists focus on what they call "innocent unborn life" or "the child." But for most of the past two millennia, the fetus was not at the center of concern about abortion. In sixteenth-century Italy, outlawing abortion was supposed to combat illicit sexual relations. While relatively few abortion cases were prosecuted in colonial New England, the issue there was about single women. Town fathers worried that abortion was a sign of extramarital sexual relations, which might lead to the births of babies whom the town would have to support. In seventeenth-century Caribbean colonies, the concern was not too many children but too few. Enslavers wanted a larger labor force and imagined that women were terminating

pregnancies as a form of resistance against their enslavement. Such women were punished harshly for refusing to reproduce.

When we look for abortions in the past, often we uncover tragic stories like Eliza Wilson's. Death tends to leave records, and deaths followed by prosecutions leave even more records. But many of the women in this book ended pregnancies successfully and moved on with their lives. Beatrice J., for example, the mother of four children, lived in mid-twentieth-century Baltimore, when reliable contraception was difficult to obtain. She ended pregnancies at least twice, using over-the-counter medication and cervical probes. Elsbetha Eggenmann, a servant in seventeenth-century Germany, also performed what we now call a *self-managed abortion*, using herbal remedies. I suggest that we remember these women's experiences, even as we mourn those of women like Wilson.

Many, many women who ended pregnancies remain invisible because their abortions were unproblematic, and so their stories were never recorded. We can hardly even guess at a multiplier. A thousand? Ten thousand? Fifty thousand? Because things associated with sex were often shameful and abortions were sometimes illegal, the successful ones were rarely written down. A woman survived and moved on.

Language about abortion has also changed over time. Today, it is politically charged. Activists shelter behind the "pro-life" designation, but I prefer plain speech and call them *anti-abortion*. For centuries, the English word *abortion*, as with its cognates in several European languages, has encompassed a range of endings to a pregnancy, including what we now distinguish as miscarriage, abortion, and stillbirth.

Nor does the word *abortion* encompass the full range of the ways that women ended pregnancies in the past. Women knew that taking an herbal preparation early in pregnancy could

provoke an early abortion that was indistinguishable from a late period. Indeed, I argue that women were often intent upon restoring menstrual regularity because humoral medicine, the dominant medical theory for centuries, insisted that it was crucial to female health. It may be that what we would see as an early abortion was understood by a woman in the past as a return to her regular cycle—or it may be that she preferred not to think too much about the possibility that she might have been pregnant.

Taking the long view also reveals that attempts at abortion control have been less about the Church than readers might expect. Religious authorities in the past, especially Christian ones, have rarely spoken with a single voice. Nor has the Catholic Church been categorically opposed to all abortion at all times. The fathers of the early church had a range of opinions about the practice. Individual writers, like Augustine (354–430), even made different arguments about abortion over the course of their lives. It was only in 1869 that the Catholic Church declared that abortion at any stage of pregnancy merited excommunication, and various Protestant Churches have come to oppose abortion more recently yet. When churchmen and Supreme Court justices claim that abortion has always been unacceptable, they imply an unchanging set of moral imperatives. Such is simply not the case. Abortion has meant many different things in the past and has often been accepted, even if only tacitly.

Abortion-provoking plants feature in every chapter of the book but the last. For most of recorded time, what we call *medication abortion* was the norm, rather than procedures involving tools. Such mechanical interventions were dangerous before antiseptics and anesthesia—that is why Eliza Wilson died—and doctors and women alike usually opted for herbal remedies. Women could harvest abortifacient herbs from gardens or fields,

or buy them in a market, with no one the wiser about their ultimate purpose. Women told other women how to identify and use such plants. In 1655, for instance, a German servant and her employer were walking home through the fields, and the older woman pointed out some red pennyroyal to the younger, explaining its purpose. When the servant became pregnant, she knew what to do. But most of these conversations, like most abortions, went unrecorded.

Plants, however, can be unsafe. Some were hard to identify correctly, in part because they often had a wide range of local names. It is also difficult to assess pharmacologic potency in leaves, stems, and roots. At least some of the plants used for abortion, often over many centuries, provoke uterine contractions that can cause a pregnancy to pass or have other effects upon the female reproductive system. However, the difference between effective and fatal doses can be slim. So often in the historical record we read of a woman trying two or three abortion medicines in turn, as each failed to bring about the desired result. We also read of women who died, having taken just that bit too much of a plant or medicine. So do not try any of these plants yourself. They can be deadly.

IN MANY OF THE TIMES AND PLACES DISCUSSED IN THIS BOOK, women lived in deeply patriarchal societies, places where few people, male or female, had anything that we might recognize as rights. Advocates for reproductive justice, often women of color charting the legacies of chattel slavery in the United States, have argued that abortion is not a choice isolated from other life circumstances. What kinds of choice does a working woman have when childcare would consume most of her hourly wage? Nor is choice a helpful way to think about abortion in the past. In early

modern German towns, an unwed mother faced a brutal public flogging, the executioner whipping her out of town into the countryside, where she had nothing, no home or support. However risky—if convicted, she faced execution—abortion often looked like survival. So, too, intimate relationships have often been sites of domination. In colonial Maryland, William Mitchell pinched his lover's nose to force her to swallow a poached egg with abortion medication inside. Abortion is woven into the larger fabric of social relations, structured by the same inequalities as the rest of life. Women sought abortions because they had been raped, because they could not countenance bearing a child into a life of servitude, because they would lose their jobs. None of these circumstances can be described as moments of choice.

It is not only legal controls that limit women's abilities to manage their own reproductive lives. Abortion is often about inequality, both between the sexes and between those who command more resources and those with fewer. There are countries where abortion is technically legal, but women in some places cannot access it, because there are few if any local physicians who will end a pregnancy. In these circumstances, a woman with money and time can travel elsewhere. Her poorer sisters cannot. In the United States, inequalities are often structured by racism, past and present. Black and brown women get lower-quality maternity care than do white women, a disparity reflected in maternal death rates three times higher for women of color. Abortion is health care, and health care always carries the racial and class inequalities at work in wider society.

I WROTE THIS BOOK IN THE SHADOW OF INCREASED LIMITS ON abortion in the United States. Almost fifty years after *Roe v. Wade*, the Supreme Court struck down the right to abortion in

the summer of 2022 (the *Dobbs* ruling). Even before then, while abortion was legal nationwide, provision was already scarce in some states, where decades of pushback had closed clinic after clinic. But now we are in a different time. Abortion is regulated state by state, not federally. Some states have banned the procedure completely, and others limit it to the first few weeks of a pregnancy. Some states have criminalized traveling to another state to get an abortion, and some have created laws that make it every citizen's responsibility to report such travel. For some legal scholars, such laws are a chilling echo of the 1850 Fugitive Slave Act, in which every American was "commanded" to capture enslaved people who fled captivity. Medication abortions are similarly under threat, with pending lawsuits attacking the use and distribution of abortion pills.

Tales of women in the 1950s being blindfolded and packed into the back of a car in order to obtain an abortion now feel all too real, like something that might easily happen again in America. The internet has largely replaced the hushed conversations that conveyed knowledge from woman to woman in times past, but people are once again asking how they can end a pregnancy themselves, with no one the wiser. History doesn't repeat itself, but sometimes it seems to echo.

When I talk with American women over seventy about this book, their stories of abortions before *Roe v. Wade* follow. Some of those illegal procedures were very safe, safer than childbirth, performed in modern medical offices by physicians with high standards of medical care. One such New York City physician was known as the go-to doctor for the city's ballerinas. But other providers were dangerous, using substandard techniques or even forcing women into sex before the procedure. Another story told to me was about the college student who bled to death on the steps of her university library after an abortion.

Globally, abortion law has been changing since the turn of the twenty-first century. Sixty countries, from Ireland to Colombia, Portugal to India, have liberalized abortion laws. A handful of others, including the United States, Poland, and El Salvador, have rolled back legislation, often making it impossible for a woman in these countries to end a pregnancy. A handful of countries forbid abortion even to save a woman's life. At the time of writing in late 2024, forty percent of the world's reproductive-age women live in places with restrictive abortion laws.[1] Even in places where the law has liberalized, access still limits women's abilities to manage their reproductive lives. In Portugal, for example, doctors can refuse to perform abortions, claiming conscientious objection, making it difficult for women to find a provider. In India, a substantial proportion of maternal mortality is reportedly due to unsafe abortions performed by unregistered providers.

Living in such a deeply polarized moment means that we often leave little room for complexity. It is either/or, not but/and. The possibility that a woman might feel relief, grief, and confusion about an abortion, all at the same time, is hard to discuss. That's why we need stories of actual women who decided to end their pregnancies. While the records that document their experiences are often terse, they offer details that can prompt us to think.

There are so many silences in stories about abortions. For most of the eras I write about, literacy was a very scarce resource, and women were much less likely than men to be able to read, let alone to write. Often, we can only hear a woman's story refracted through the words of a man, and likely a hostile one at that. Records from courtrooms are essential sources for the history of abortion, from the Middle Ages onward. However, women on trial, fighting for their lives, crafted their narratives

in ways that they thought would serve them best. And male scribes may have altered their words, recording them in standard prose that bore little resemblance to what a woman might have actually said. Often, we can only ask, "What might she have felt?" instead of offering answers. But such questions can help us imagine worlds very different from our own.

It was an act of imagining that brought me to that South London churchyard to mourn Eliza Wilson. It matters what she thought and felt, however elusive those thoughts and feelings might be in the historical record. But while it is historians' duty to bear witness, it is arrogant to think that I might speak for any such woman in the past. Rather, I do my best to convey what I have pieced together of her story, creating a space where we can picture what the world might have looked like from her perspective. It is an exercise to be performed with humility, an attempt to remove myself from the picture even as I paint it.

Some of the stories in this book are sad ones. Often, we only know about an individual woman because something bad happened to her and her story got written down. Grief shapes our responses, and perhaps relief that we live today. The long view, however, is more optimistic than it may seem. Even in this time of increased repression, history suggests that such limits will not last. They never do. There have been, and will be, untold miseries caused by these restrictions. But in time, people will start looking the other way again.

This book is dedicated to my students. I have learned so very much from them, more than they will ever believe. And it is my hope that their generation will be able to do what mine was ultimately unable to: stop the long cycles of repression and toleration by creating laws protecting abortion rights, laws that will endure.

CHAPTER 1

THE SINGER

ABORTION IN ANTIQUITY

SHE WAS A SINGER, AN ENSLAVED YOUNG WOMAN HIRED OUT TO entertain men. We do not know her name, because the doctor who wrote about her in the fourth century BCE did not record it. He had been called to see her by her enslaver, a woman who was his relative. The singer knew that her value depended on not getting pregnant, because she was hired out to have sex as well as to sing. She might be out in the street if her belly began to swell. So she had listened carefully when women talked about women's things: periods, pregnancy, and such. She heard that if a woman were going to conceive, semen did not run out of her body after sex, as it usually did. She pondered this fact and kept a sharp eye out.[1]

One day, it happened. The seed did not run out. The singer told her enslaver, who called in a doctor. He came on the sixth

day after the seed had failed to run and told the singer to jump up and down very vigorously, so that her heels touched her bottom. After six or seven jumps, there was a small noise, and to her surprise, a tiny bit of something fell out of her vagina onto the floor. The doctor wrote down these details not to document abortion, which was unexceptional, but because he wanted to understand the processes of conception and pregnancy. This doctor was a follower of Hippocrates, who emphasized rational explanations for sickness. He carefully described the under-formed thing that had fallen from the singer's body, hoping that it would reveal insights about early fetal development. Like other Hippocratic doctors, he believed that paying detailed attention to bodily processes would help him discover natural explanations for health and illness.[2] His description was so detailed that modern doctors have been able to speculate about the probable length of the pregnancy.

But I'm more interested in what this story tells us about abortion in the ancient Mediterranean world. It was not shameful or stigmatizing. The author recounts these details—about his female relative and this enslaved woman, no less—without any hesitation. Other Hippocratic doctors recorded similar investigations into conception and development using aborted fetuses from sex workers. There are sixty surviving books that list Hippocrates as the author. In reality, they were written by a range of doctors, covering a wide array of medical topics. One writer commented that women frequently tried out a variety of abortifacients, suggesting that abortion was a common practice and understood to be so. While doctors worried that women might use remedies that could be harmful, their texts were not critical of women's choices to end pregnancies. Neither sex work nor ending a pregnancy were morally repugnant in ancient Greece.[3]

The singer's situation—enslavement—was a common one. The motive power of the premodern world was unfree labor. People owned by others plowed the fields, sowed the grain and harvested it, cooked food, wove the wool, did the laundry—and were abused sexually. When a territory defeated another in battle, the conquered men were usually slain and the women and children, sometimes thousands of them, were enslaved. Greek elites could hardly imagine a world without the manual labor of the enslaved. As Aristotle put it, drawing an image from the ubiquitous domestic labor of woolworking, if shuttles wove by themselves, there would be no need of slaves.[4]

In addition to domestic tasks, some enslaved people, like the singer, worked at specialist trades outside their enslavers' homes. They earned wages when they did so, generating income for their enslavers. The singer would have been much better paid than a sex worker in a brothel, most of whom were also enslaved. She may have been able to save some of her earnings, hoping to buy her freedom in the future; numbers of sex workers did so. She may have also been doing domestic work in her enslaver's home, although there were likely other enslaved women for whom these were primary responsibilities. Better-off households in fourth-century ancient Athens averaged two or three enslaved people who did manual domestic labor. Did she learn about pregnancy from other women in her household?

The singer's primary job was to entertain at parties, where all the guests were men, who lazed on couches, drinking, bantering, and enjoying music and dance. The only women present were sex workers (there were male ones also) and entertainers, who might also provide sexual services. Vase paintings sometimes show such singers wearing suggestively sheer clothing at such events. Perhaps conversations among these women tipped the singer off about signs of pregnancy. It's this kind of

talk that historians like me wish we could overhear—what was it that women knew, and how did they know it? But we must always hear it secondhand in ancient texts, because almost all the words we have were written by men.[5] What did the young woman feel when that tiny lump of flesh hit the floor, aside from surprise? Relief? Confusion? Competence? We will never know.

Whatever she felt about her situation, this young woman sized it up astutely and took action. But we cannot think about her experience in terms of rights and choice, the language of our own time. Only some men, and no women, had rights in her world. If her enslaver were an older widow, she would have had a bit more liberty than a younger or married woman. Even so, some man—brother, son, nephew—was legally in charge of her.

THE IDEAL WOMAN, THE ELITE MODEL HELD UP BY CLASSICAL Greek writers—almost all male—was the wife married to a citizen, an adult free man who had the right to vote. She would have grown up sheltered in her father's household. Sexual honor was paramount, and so privileged girls had very little freedom. Citizens' daughters were not supposed to go to the market or hear public debates, lest any potential glance or smile be misunderstood or lead to anything worse. Chastity was so important that if a father caught his unmarried daughter having sex, he was legally entitled to enslave her. Xenophon, author of a manual for running a good household, said girls should be raised seeing, hearing, and saying as little as possible. They were married off very young, around age fourteen, to husbands around thirty. At the wedding, guests were served little cakes decorated with sesame seeds, thought to promote fertility.[6]

These marriages were not romances; they were exchanges negotiated between households. A bride came with a

dowry—money and valuables—the amount of which was carefully hammered out between father and potential husband. A dowry had to be sufficient to support the wife if the couple later divorced; it would be returned to her father or brother. When the bride accompanied her husband home after the wedding, her dowry was carried with them, in a chest in their carriage. It must have been a tough adjustment for an adolescent bride, moving from the only home she had known to a different existence in her husband's family's house, likely under the supervision of her mother-in-law. Nor did marriage bring new freedoms. Married women were supposed to stay at home, with exceptions for religious festivals and family events. The primary goal for the new wife was to bear a son as quickly as possible, to continue her husband's lineage. Her status in her new home would improve considerably once she gave birth to a boy.[7]

Then as now, pregnancies in such young women could be challenging. Girls and women might be relatively undernourished; men came first when it came to food resources, so some young women's bodies may have struggled to maintain a pregnancy. Women encountered a variety of problems with fertility and childbearing. At the famous healing temple at Epidaurus, where stories of successful cures were carved into stone, fertility issues were the second-most-common ailment recorded. While most pilgrims were not literate, they heard the stories read aloud, offering testimonials to the temple's successes. Nikasiboula walked 100 miles to the temple. Her hopes were answered when she had twin boys a year later. Agamede came even farther, 225 miles from Chios, and later had five children. Women repeatedly made long journeys, giving offerings and sleeping in the temple's inner sanctum in hopes of becoming fertile.[8]

Not all children were wanted, however. Once a baby was born, the father had to make a decision: Was he going to keep

the infant or not? If the answer was no—something that may have been more likely if the infant had a visible abnormality or was a twin or a baby girl—the infant was exposed, or left to die outdoors, out of sight. A later medical writer instructed midwives to check if a newborn were "worth rearing." He specified, for example, that a baby cry vigorously when it was laid on the ground and that all body parts be perfect and in working order. We have little concrete evidence about the practice of exposure: we simply do not know how often it was done. Sources say that unwanted babies might be abandoned in places where there was a good chance they would be found, such as temples, baths, pilgrimage sites, racetracks, or even rubbish heaps. Such public places suggest hopes for the baby's survival: exposed babies could be taken into other families, enslaved, or adopted as free. Such adoptions were sometimes used as plot devices in comedies, with the exposed infant ultimately reuniting with their birth family, but we cannot assess frequency from such tales.[9]

For those infants who were kept, life was not free of dangers. Babies were ceremonially introduced to the household only on the fifth day after their birth, when relatives visited with gifts. It was not until the tenth day that they were named. Well-to-do families usually employed enslaved wet nurses to feed their babies, but many infants died from feeding troubles. Between a quarter and a third of newborns did not survive until their first birthdays, dying from diarrhea due to unclean water, malnutrition, infectious diseases, and a host of other harms. But these everyday experiences of high infant mortality did not mean ancient Greeks were indifferent to their babies or inured to loss. Funerary memorials indicate that small children could be well loved. The burial inscription for a boy nicknamed "Little Chatterbox" described him as a source of joy for his parents.[10]

Even taking infant mortality into account, elite Greek families did not have as many children as we might predict. Because a woman usually was married very young, there were decades in which she could, in theory, have had children. While a woman married to a citizen was under significant pressure to produce a son and heir, a bevy of children would make inheritance complicated. After the birth of a son, a husband might take his sexual pleasures elsewhere, or the couple might limit their fertility by employing contraceptive herbs. Married women probably also sought abortions—the very real risks of childbirth may have made early abortion seem a safer choice than exposure—but classical Greek texts are quiet about that possibility.

Many ancient Greek women were not under this kind of pressure to produce sons. They were *metics* (guest workers from another city-state), or they never married men with citizen status, which was held by only about 10 to 20 percent of the adult male population. Such women might be concubines, free or enslaved, living with a man, but not formally married to him. Working women such as textile workers and midwives might not have male partners.

The same was true for a range of women whom we would call sex workers. *Hetairai* were high-class escorts, providing social as well as sexual services to elite men. They were known for their wit and charm, often akin to long-term mistresses. Entertainers, such as singers, flute players, and dancers, might be enslaved or free, and might be sex workers as well, or not. Some women's primary work was providing sexual services to men, working in brothels. It was women like these who were likely the primary abortion clients in ancient Greece.[11] For many of them, like the singer, pregnancy—let alone motherhood—could have been devastating.

Classical sources repeatedly linked sex work and abortion. One Hippocratic writer noted that he had seen many fetuses aborted by sex workers and examined some by putting the tiny bits of flesh into glasses of water. Such women were attentive to small bodily changes and knew very early when they were pregnant. This careful monitoring of their own bodies allowed them to abort within weeks or even days of conception.[12] Abortion was woven into the fabric of sex work, understood as its obvious and necessary concomitant.

CLASSICAL WRITERS ALSO FREQUENTLY ASSOCIATED ABORTION with midwives, who provided much of women's reproductive care. Such women were skilled and respected. Even Galen, the best-known Greek doctor in ancient Rome, who was scathing about the skills of almost all of his competitors, had respect for able midwives. Given that many married women were limited to the domestic realm, "protected" against opportunities for adultery, it made sense that midwives were the practitioners of choice for women's reproductive health. It was also thought that only a woman could truly know about another woman's reproductive body. A healer needed an empathetic reading of the body she sought to help, an understanding from the inside out. Because men lacked bodily experiences of childbearing, there were kinds of knowledge about the female body they simply could not attain.[13]

Abortion was understood as an integral part of midwives' practice. Socrates's mother, Phaenarete, was a midwife, and in one of his books, Plato had the character of Socrates outline the role of the midwife. Plato had Socrates say, in a matter-of-fact way, that a midwife could provoke or alleviate the pains of childbirth, assist at difficult births, or help a pregnancy pass if

required.[14] Evidence like this about midwives is indirect. They did not leave behind any written works, because ancient Greek women were rarely taught to read and write.

While Hippocratic medical texts, written by men, include extensive discussions of women's reproductive health, some of that information was probably gathered secondhand by male writers consulting with midwives. This cooperative relationship may help to explain why the Hippocratic Oath famously forbade abortions. At modern medical school graduations when the oath is recited, this clause is often quietly omitted. Even in antiquity, other doctors were puzzled by this part of the oath because they knew abortion to be commonplace. But the oath did not forbid *all* abortions. It stated, "I will not give a woman a pessary to provoke an abortion."[15] A pessary, something like a tampon soaked in herbal or chemical solutions, was only one form of abortion and mentioned less frequently in Hippocratic texts than plant products taken by mouth. Possibly the oath was telling doctors that it should be midwives, not medical men, who manipulated women's genitals to insert pessaries. That kind of touching might be too transgressive, unless a woman's life was at risk.[16]

While oral medications and pessaries were the most common forms of provoking abortion mentioned in ancient texts, medical writers sometimes recommended vigorous movements. Five centuries after Hippocrates, a Greek physician repeated the story of the young singer, emphasizing that if a woman did not want to get pregnant, she should make sure the seed ran out. During sex, at the moment of ejaculation, the woman needed to hold her breath so that the seed would not be sucked in too far. Then she had to get up immediately, squat down, and make herself sneeze so that the seed ran out.[17] For millennia, sneezing and jumping continued to be recommended to women seeking

to end pregnancies, although these are seen as ineffective means today.

Far more common, however, were what we would call *medication abortions*, which were widely discussed in both medical and nonmedical texts. Many writers integrated discussions of contraceptives and abortifacients with emmenagogues—that is, drugs that could bring on a late period. It is not that medical men were murky thinkers, confusing many different kinds of uterine issues. Rather, from the perspective of a fertility-oriented society, in which medicine was often enlisted to help families produce a male heir, inducing the uterus to contract could have multiple purposes. Texts list many such herbs, which were typically taken by mouth or smeared on a clump of wool and inserted as a pessary into the vagina. Such drugs might clean out the womb after a birth, or end an evil discharge, or prompt the uterus to miscarry and rid itself of a nonviable fetus. The womb had to be clean and ready to house a new being. Just as a good host cleaned her home before guests arrived, sometimes the womb needed to be scoured to make it ready for a pregnancy.[18]

It was important for women's health that they menstruate regularly. Humoral theory, at the heart of medicine in the ancient Mediterranean world, explained that women were by nature wetter than men, and they had bodies with a spongier, softer texture. After all, their bodies nurtured new life, and everyone knew what happened if you planted a seed in ground that was too dry. In this model, because they were wetter and colder, women's bodies digested food less completely than did men's, leaving unhealthy residues. Bleeding every month rid the body of such dangerous leftovers. Ancient Greek women probably had less-regular cycles than women do today, because they could be undernourished and were often breastfeeding. Menstruating

less frequently might have added to concerns about regular cycles. If a woman's period were late, there could be considerable ambiguity.[19] Was she pregnant or just late? She might take an emmenagogue that was also an abortifacient and opt not to know. We could interpret her action as ending a pregnancy very early, but we cannot know how she would have understood it herself.

A first-century CE text called *On Simples* (simples were plants that could be taken individually rather than in combination) describes a stunning array of uterine remedies under the heading "Expellants." First come eighteen plants that "draw out" both the menses and the afterbirth. Next are forty-four herbs described as "more effective at drawing out." The intensity of the preparation ramps up again with twenty-four remedies that "have an intense drawing-out effect (so as actually to expel fetuses)." Even stronger are four items that "make fetuses slip out without pain." Twenty-six plants are next described as "also effective." All of these remedies are taken orally; the text then repeats the ascending structure of ever-more-potent herbal preparations used for pessaries, fumigations, and warm medicated baths.[20]

On Simples was by a doctor, for doctors. It is unlikely that women read it or that any one woman could know about or access all of the one-hundred-plus plants listed as potential abortifacients. However, the depth of the list suggests just how extensive knowledge of abortion was in the ancient Mediterranean world. Much of this knowledge had likely been passed along to male writers by women.

Some plants mentioned in this text had already been described for centuries as herbs that promoted uterine emptying or cleansing. Pennyroyal, a kind of mint, was understood as having a range of reproductive effects, including ending a

pregnancy. The Hippocratic text *Diseases of Women* had noted that it could make a uterus expel its contents, provoking the menses, or cleaning out the womb. Five hundred years later, in the first century CE, Dioscorides, author of the best-known ancient work on drugs, also noted pennyroyal's abortifacient properties. A century later, the Roman physician Celsus recommended taking pennyroyal to induce delayed menstruation. Like a number of other herbs mentioned in classical Greek texts, such as rue and savin, pennyroyal continued to be recommended as an abortifacient up into the twentieth century.[21]

Pennyroyal's abortifacient properties were known by ordinary men and women, not just doctors. The playwright Aristophanes, a contemporary of Hippocrates, mentioned the herb in his play *Peace*, first produced in Athens in 421 BCE. The character Trygaeus worries about getting his partner pregnant; Hermes quickly replies, "Not if you wash it down with a dose of pennyroyal," implying he would take the herb after intercourse.[22] Presumably all-male audiences were supposed to get the joke—a man taking an abortifacient herb to prevent his partner's pregnancy—suggesting pennyroyal was not just women's knowledge.

Pennyroyal also featured in a scene in Aristophanes's *Lysistrata*. Women are getting tired of the ongoing war among Athens, Sparta, and a number of other city-states, so Lysistrata decides to bring together women from all sides of the conflict to propose a sex strike. Men are not going to enjoy their wives, nor are they going to engender any male heirs until they put down their lances (the phallic joke is Aristophanes's).

In one scene, women from the warring states are just arriving. Lysistrata is backed up by her visibly pregnant friend Calonice, and there's banter among the women about her swelling body and their slim ones. Lampito, just arrived from

Sparta, is very fit; Spartan girls and women were well known for exercising. "What rosy cheeks, what firmness of physique," exclaims Lysistrata. Lampito brags, "I do take exercise, and I jump-kick my butt." That kind of kicking was well known as a Spartan exercise, but it was also exactly the move that the Hippocratic doctor used to induce an early abortion for the enslaved singer.[23]

Next, Calonice compares the body of the similarly thin and attractive representative from Boeotia to her lushly fertile homeland. Calonice describes the Boeotian woman's body as adorned with pennyroyal. It was slim for a reason, she implies. These sly allusions to abortifacient methods bandied around Calonice's pregnant belly underscore that a sex strike might affect men's lineages as well as their pleasures.[24] Presumably, Aristophanes thought that his audience would pick up on the references.

Like pennyroyal, pomegranate was used in reproductive medicine but was also mentioned in a variety of nonmedical texts. Pomegranate peel—the tough, bitter pith that encases the juicy nuggets of fruit—was recommended in Hippocratic texts for cleaning out the womb, including in the prolonged treatment of a woman threatened with sepsis because her fetus was no longer viable. The peel was also recommended as a contraceptive, because its astringent qualities closed the cervix so that seed could not get in. The ruby-colored arils inside the rind often worked the other way. To the ancients, the multitude of little fruits inside the pomegranate suggested a kind of abundant fertility. The myth of Persephone in the underworld, where she eats six pomegranate seeds, emphasized its link to fertility. A medical recipe involving an entire pomegranate casually compared its form to that of a pregnant woman, referring to its prominent navel. Another said to mix breast milk from a

woman who was nursing a male child with freshly squeezed pomegranate juice, a kind of fertility milkshake.[25]

References in Aristophanes and the Persephone myth suggest that the abortifacient properties of both pennyroyal and pomegranate were well known. If a woman wanted to keep her reproductive decisions to herself, she could easily do so. While some medical texts record complex medicines with multiple ingredients, many other remedies involved a single plant growing in a woman's garden or available at the market. *Diseases of Women* has pages and pages of very simple preparations. Mix an obol (about three-quarters of a gram) of the juice of the squirting cucumber plant with an equal amount of myrrh into some honey, apply to wool, and insert in the vagina. To accelerate a birth (or provoke an abortion): two obols of dittany, a common wild herb, in hot water. Such straightforward preparations enabled women to manage their fertility quietly, without husbands or fathers knowing.[26] Buying or picking herbs and preparing them fit easily into the work of cooking, and what ancient Greek household was not involved in the spinning and weaving of wool? Abortion could be part and parcel of everyday women's work.

These methods often mimicked a natural miscarriage, prompting the uterus to empty itself, so that a woman's role in ending her pregnancy might never be suspected. Indeed, some women who have medication abortions today have alluded to the way the process resembles miscarriage, describing it as "more natural." As many as 20 percent of all pregnancies end in miscarriage today, and we have no reason to think this proportion was smaller in antiquity. When fetal loss was so common, an early abortion could go unnoticed. While abortion itself was not stigmatized, in some circumstances, women may have wished to keep their reproductive decisions private.[27]

The consistency with which certain plants appear in medical texts—recommended for centuries, even millennia—suggests that they were understood as particularly efficacious. Modern science has cautiously agreed that some of these remedies may indeed affect the female reproductive system. One such study lists 565 plants with long reputations as abortifacients and suggests that fully half of them can be shown to have a stimulant effect on uterine muscle. Pennyroyal, for example, has properties that might induce a late period or abortion. Pomegranate has been shown to contain estrogens and cytotoxic (cell-killing) compounds that may have effects on the female reproductive system.[28] Other abortifacient plants commonly mentioned in classical Greece, such as rue, tansy, savin, and fennel species, have similarly been shown to have biochemical properties that might have effects on reproductive functions. Even if such herbs only worked sometimes, they would still earn a powerful reputation for efficacy, as individual failures could always be explained away.

The key issue with ancient abortifacients is toxicity. The chemical substances in these plants were strong, and they could kill a woman. *Diseases of Women* warned that abortion was more difficult than birth because "it is not possible to abort a fetus without violence," whether caused by oral medicines or pessaries.[29] Not only did these plants contain strong biochemicals, it was also impossible to gauge the strength or concentration of an active ingredient in a plant, even when a Hippocratic recipe might have listed a quantity like "an obol." None of this imprecision would have made the process safer.

There is one ancient plant known for its abortifacient properties that we cannot test in a laboratory today. Silphium is one of the first plants in history to have been described as going extinct. The plant, similar to fennel, grew in only one location,

in Cyrene, on the coast of what is now Libya. Silphium was known as a gourmet ingredient. Juice from the root was made into a resinous substance grated over food, like asafetida in Indian cooking today, or like a shaving of truffles in Italian cuisine. Silphium stalks were eaten in the wild by grazing sheep, whose meat was supposed to be made extra tasty thereby.[30]

The resin's reproductive effects were also well known. Greek texts cited silphium for its uterus-cleansing properties. Soranus, a Greek doctor who practiced in the Roman era, recommended dissolving a chickpea-size lump in water, taking it monthly to ensure regular menstruation or to provoke an early abortion. Dioscorides mixed a form of it with myrrh and pepper to bring on the menses. By the time Soranus was writing, about a hundred years later, in the second century CE, the plant was just a memory. Writers said that silphium had been so overharvested that none was left, and it would not grow in cultivation. Modern scholars point out that silphium might have been overgrazed by sheep or that the Roman Warm Period, a slight change in climate, might have inhibited the plant's growth. Perhaps silphium still grows in other parts of the world, known by another name, or maybe it hybridized with a similar plant. But if that were the case, the Greeks weren't aware of it—nor were the Romans. In the first century CE, the natural historian Pliny the Elder described one last stalk of the plant being given to the Roman emperor Nero as a rarity.[31]

BY NERO'S TIME, ROME HAD BECOME THE MEDITERRANEAN SUPERpower, outstripping Greece. Ancient Greek society had been organized around the city-state, an urban center with surrounding agricultural hinterland. Most cities were tiny, more like towns of about 1,500 inhabitants, although Athens mushroomed to 150,000 people by 350 BCE. While Greeks had

settled extensively around the Mediterranean, these various city-states were largely independent of one another. Greeks were connected by ties of language and culture much more than any kind of national identity. A man was a Corinthian, or a Spartan, or an Athenian first, and Greek as a very distant second. Macedon, a province in the north, played one city-state off another, and in 338 BCE, its ruler, Philip, united them in a federation under his military control. His son Alexander the Great battled all the way east to modern-day Pakistan before retreating when his troops had had enough. In 168 BCE, Macedon fell to Rome, and many Greeks were enslaved and brought to the capital city.

The Roman world was organized very differently from the Greek. Rome had begun inauspiciously, a small, marshy town with little to recommend it. But by the third and fourth centuries BCE, the Roman Republic was a military machine, conquering its neighboring cities, then Gaul to the north, and the entire Italian peninsula. With the 202 BCE defeat of Carthage in North Africa, Rome came to be the dominant power in the Mediterranean and just kept on expanding, adding province after province, formally becoming an empire in 27 BCE. A century later, the empire stretched from Hadrian's Wall in the north of England, south and east through Europe, all the way around the Mediterranean and farther, through what we now call the Middle East. Many of the roads the Romans built, the infrastructure of empire, survive even today.

While Rome exported many features of Roman life, from elaborate public baths to comfortable underfloor heating in villas, Romans revered Greek civilization. Much as French was the language of culture in nineteenth-century Europe, so Greek was in ancient Rome. In the capital, wealthy families often had Greek slaves as tutors for their children, who grew up speaking Greek as well as Latin. Many of the city's doctors were Greek,

and many were enslaved. The best known of all, Galen, whose theories held sway over Western medicine for centuries, was Greek by birth and wrote his many books in his native language. Because medicine itself remained largely Greek, medical thinking about abortion persisted in the transition from Greek to Roman dominance in the Mediterranean.

Even if the practice of abortion may have changed little, by the time Nero was given that famous last stalk of silphium, the meanings of abortion were shifting. In this new cultural climate, the story of silphium could be read as a morality tale. Abortion was invoked as a sign of women's dangerous sexuality, repeatedly linked to vanity and adultery. A married woman who got pregnant might abort to avoid ruining her figure, denying her husband a rightful heir. Worse, a married woman who got pregnant while her husband was away could rely on abortion to help her hide the affair. Or so Roman writers like Juvenal and Suetonius claimed. Generations of historians have taken these scandal-mongering tales of abortion as indications of actual practice, but they were often little more than salacious gossip, colored with misogyny. It is difficult to see through them to anything like women's actual experiences.[32] Instead, what we see is abortion gaining new cultural significance.

One concern was that abortion might threaten the property rights of elite men. Unlike today, neither men nor women imagined the fetus as a baby. In the evocative phrasing of one historian, it was but "a hope." For a man who wanted to continue his family line, such a hope might loom large. Cicero, the leading orator in the Roman Republic, distilled such ideas in a 69 BCE speech. He told a story about a woman in Asia Minor who was widowed while she was pregnant. A contest broke out between two potential heirs. One of them bribed the widow to abort, to ensure that he would inherit. When the plot was discovered, she

was condemned to die not because abortion was immoral but because she had wrongfully disposed of her late husband's property. As Cicero put it, "She had cheated the father of his hopes, his name of continuity, his family of its support, his house of an heir, and the Republic of a citizen-to-be."[33] Abortion was wrong, Cicero argued, because a fetus was a father's property, not for a wife or widow to discard.

Inheritance mattered a great deal in the Republic. For elite Romans, like ancient Greek citizens, the purpose of marriage was to produce legitimate children. A wife who had produced an heir, and maybe a couple of other children, was a respected member of her husband's household. If she did not bear children, she might be divorced and sent, with her dowry, back to her father's house. Sometimes women were exchanged to help men get heirs. A surprising number of pregnant women got divorced. If a woman who had already produced an heir became pregnant again, her husband might pass her along to a male friend or relative to ensure that he, too, would have an heir. Marriage, not what we would call genetics, was what made inheritance. Divorces like these were worked out between men, and no record survives to indicate what women made of them.[34] We know much less about the marriages of working women such as barmaids, hairdressers, and the cookshop attendants who served the many Romans who lacked kitchens and therefore lived on takeout.

When the republic gave way to the Roman Empire, concerns about inheritance became a matter for the state. While ancient Greek citizen families prized the continuation of the paternal line, that was generally family business. In Rome, the state increasingly legislated such matters, and abortion was construed as depriving the state of new citizens needed to administer its far-flung territories.

As Rome added province after province to its empire, it gradually extended citizenship to their inhabitants, expanding the ranks of the upper classes. Nevertheless, emperors fretted about elites not reproducing, envisioning a future lack of leaders and administrators. The emperor Augustus enacted pronatalist legislation in 18 BCE to urge elite Romans to have bigger families, penalizing those who did not have children. This initial legislation evidently did not lead to enough of a bump in the elite birth rate, because Augustus followed up with further laws in 9 CE that stiffened penalties for remaining unmarried.[35]

Abortion became a concern because Roman women had greater freedoms than had ancient Greek women, and men worried that they were using their liberty to conceal illicit affairs. Perhaps in response to such anxieties, Augustus made adultery a criminal offense. Roman women were not cloistered at home like Greek women had been. While they were not allowed to go to Greek-style athletic contests where men competed in the nude, they went to other athletic events, gladiatorial combat, theaters, public festivals, and even to the public baths, although these often had male and female sections. Roman wives attended dinner parties with their husbands. With the exception of the vestal virgins who tended Rome's sacred flame, priestesses might be married women, undertaking very public roles.

More Roman-era women seem to have been literate than in ancient Greece, too. Officers' wives stationed in the north of England wrote notes to one another, with one sending a written invitation to another for a birthday party around 100 CE. Detfri and Amica, two enslaved women who labored in a tile-and-brick factory in the middle of Italy, scratched their names into the back of a tile and then stamped it with their footprints, marking their backbreaking work for eternity.[36] Writing, of course,

did not mean freedom, but the extent of women's literacy in the Roman Empire is suggestive of women's expanded horizons.

CONCERNS ABOUT ADULTERY AND ABORTION WERE ALSO PART OF a larger politics of nostalgia. During the first and second centuries, Roman satirical writers complained about the immorality that appeared to surround them, writing narratives of moral decline. Contemporary women's wicked ways were contrasted with images of virtuous Roman matrons of the past, a past that was somehow simpler and better. Juvenal's satires used abortion as a marker for this decline. He bemoaned that, now, "hardly any woman lies in labor on a gilded bed" because wealthy women took contraceptive drugs or aborted pregnancies. On the next page, he raised the specter of illegitimacy, threatening that a Roman man might become the father of an "Ethiopian." While race and skin color did not have the same meanings that they do in our time, a baby with black skin born to an elite Roman woman often suggested an affair with one of the household's enslaved African men.[37]

Even if a woman were wholly faithful to her husband, men worried that she might be too vain to go through with a pregnancy, with all the bodily changes it entailed. The author Aulus Gellius compared women who refused to breastfeed with those who had abortions so that their beauty would not be spoiled. A century earlier, the philosopher Seneca—a contemporary of Emperor Augustus—had praised his mother, Helvia, by saying that she had never been unchaste or yet "crushed the hope of children" by aborting to preserve her figure. Other women, Seneca implied, were doing so, but not his virtuous mother.[38] We might ask just how much of his mother's intimate reproductive history Seneca was likely to have known.

These narratives of moral decline shaded into political critique. Abortion became weaponized, a way to take down a political opponent, as emperors began claiming the moral authority of sexual virtue. Augustus, for example, supposedly exiled his daughter, Julia, because she was notoriously adulterous, although he may have been responding to gossip more than any real behavior. Juvenal, Pliny the Younger (the nephew of the natural historian), and Suetonius all used abortion stories to criticize the emperor Domitian (51–96 CE), known for his reign of terror. He was offered his niece Julia in marriage but turned her down to marry Domitia. Once Julia was married to another, supposedly he seduced her, and they began an affair that continued after she was widowed. Eventually, she became pregnant, and when Domitian forced her to have an abortion, she died from it, or so the story went.[39] We will never know if Julia truly died from the effects of an abortion, but the heat with which the story was told and retold suggests the ways in which abortion had become politicized as a sign of inability to rule.

All of these stories in which abortion was used as a marker of immorality were just that—stories. They do not tell us much, if anything, about real women's experiences, although the frequency with which abortion was invoked suggests that it was common enough to be immediately understood. None of these writers had to explain what they meant by abortion, assuming readers had familiarity with the term.

Roman-era medical writers offered a nod to the empire's new pronatalist stance by noting abortion's immorality, but they also carefully described medical and surgical methods to end pregnancies. Such works suggest that women continued to abort using means similar to those employed by ancient Greeks. Soranus used a brief disclaimer about abortion that echoed new

moral concerns. He made sure to tell his readers that he never offered abortion "because of adultery or out of consideration for youthful beauty," repeating familiar tropes. But then he went on to describe both medical and surgical abortion in detail. Contraception was preferable to abortion, because it was safer, but Soranus insisted that abortion might be necessary in some cases. Some, such as teenaged girls, simply could not deliver safely because their pelvises were too small to permit them to birth a full-term infant. Given that girls married as young as fourteen, such cases were not unknown.[40]

So, too, when a fetus was no longer viable, it had to be extracted. While the ancient world had no understanding of germs, they knew that deadly putrefaction might ensue if the womb wasn't rid of its contents. If a woman did not miscarry or only lost some tissue, a doctor had to intervene. Soranus described the gruesome processes of restraining a woman and dismembering the inert fetus with bronze knives and hooks, to extract it piecemeal from the uterus in an attempt to save the woman's life. Abortion had to be part of any doctor's tool kit for circumstances such as these, whatever disclaimers they added to conform to the empire's concerns about abortion's moral meaning.[41]

Pliny the Elder used similar language about the morality of abortion. While working as an imperial administrator, he wrote his vast encyclopedia by synthesizing many fragments of written knowledge, nuggets that arrived from all corners of the empire via Roman roads. He indulged in women-blaming, saying that men had invented every weird form of sexual indulgence, even those "against nature," but women had invented abortion, implied to be a much worse practice. Pliny staked his claim to moral probity, saying, "I personally do not mention abortives."[42]

But Pliny was a pack rat for information, and he did in fact talk about "abortives." Twenty-eight such plants crept into his text. Pliny claimed that a woman would miscarry if she merely stepped over the root of a cyclamen plant, so powerful were its abortifacient properties; cyclamen had also featured in earlier Greek texts. So, too, he thought a mere sneeze after sex would end any nascent pregnancy. Pliny sometimes described abortion-producing plants at one remove, protecting him from seeming to recommend them; for example, he preceded his statement about cyclamen with the disclaimer, "It is said that . . ." Watercress's properties included a warning: "It should not be eaten by pregnant women unless the fetus be dead, since even an application of it produces abortion." Pliny put himself in the position of merely passing information along, rather than fully endorsing it.[43] While Pliny's moralizing about abortion was new, the information about plants used to end pregnancies, some attributed to women, suggest that there were strong continuities in the actual practice of abortion. Greek writers had been discussing many of these plants as abortifacients for centuries.

Given the extensive knowledge of herbal abortifacients indicated in medical texts, we have reason to think that Roman working women used abortion to manage their fertility, as had their earlier Greek counterparts. Women like the Hippocratic singer could not afford to become mothers. Even Juvenal, who penned some of the most biting comments about elite abortions, alluded to their use by working women. Just after claiming that some Roman women were having affairs with eunuchs so that they could avoid abortion or pregnancy, he noted, "And these days the greatest and least of women alike experience the same lust. The woman who treads the black pavement with her bare feet is no better than the woman

conveyed on the shoulders of tall Syrians."[44] Only the wealthiest women would have been carried in litters by "tall Syrians," but Juvenal implied that they were no better than sex workers, both relying upon abortion to manage their reproductive lives.

Except for an occasional aside such as this, we have little evidence of abortion used to regulate working women's fertility in the Roman Empire. Ambrose, an influential fourth-century Christian theologian, thought that wealthy women used abortion to regulate their fertility, but poorer women relied upon exposure of unwanted infants. Possibly he was unaware of the widespread availability of abortifacient herbs, or possibly poorer women thought abortion was risky.[45] By this time, the politics of abortion were changing again, with the advent of Christianity and its reworking of the meaning of sexual relations. Having started as a tiny Jewish splinter group, the emerging Christian faith spread to settlements all around the Mediterranean during the third century CE. Sacred texts were composed in Greek, becoming the New Testament, while the Jewish scriptures became the Christian Old Testament. Christian communities stressed individual moral behavior and the value of charity, including care for the sick.

In its early days, the Christian faith was just another set of religious practices in a polyglot world. The Roman Empire had incorporated many faiths as it had expanded, and Romans worshipped a wide array of gods. In 213 CE, the emperor Caracalla set off on a pilgrimage for his health, including visits to shrines to Apollo in modern-day Germany, Asclepius in Greece, and Serapis in Egypt. In Rome, sufferers might also seek help at temples to Minerva, Isis, and more. In 313, the struggles of the early church were lessened by the emperor Constantine's legalization of Christianity, and in 383, it became the official religion of the Roman Empire.

Some Christian writers adopted the Roman critique of abortion as a sign of moral decay, but in these early centuries, there was a welter of varying opinions about ending pregnancies. It was only well into the Middle Ages that the Church firmly established a unified position on abortion.

CHAPTER 2

THE SAINT AND THE SINNER

THE MIDDLE AGES & THE RISE OF CHRISTIANITY

It was a miracle. In the sixth century CE, a young Irishwoman had taken vows of chastity, but then a young man had come along, and she had forgotten herself. Now she found her belly swelling. A holy woman named Brigid of Kildare came to her rescue. Brigid prayed over the young woman, and the pregnancy vanished as if it had never been. The woman did penance, left her youthful indiscretion behind, and resumed the life of celibacy to which she had sworn herself. Saint Brigid, as she later became, had performed a miracle, ending a pregnancy. She is associated with a variety of miracles, although only once did she interrupt a pregnancy.[1]

Brigid was born around 450 in Kildare, about forty miles west of Dublin, the daughter of a chieftain and an enslaved woman. She grew up in a druid's household before converting

and choosing to dedicate herself to a religious life. Much of what we know about her comes from hagiographies, biographical accounts of saints' lives designed to foster worship and engage potential converts, so these must be taken with a grain of salt. Indeed, Brigid may not have been an actual historical person but rather a Christianization of a Celtic goddess with whom she shared a feast day—in early Christianity, becoming a saint was an informal, local affair, and such combinations were not uncommon. Either way, the stories told about her offer a vivid window into early medieval life and ideas about abortion.[2]

Christianity had been introduced to Ireland around the time of the fall of the Roman Empire, a few decades before Brigid's birth. Saint Patrick's introduction of the faith there is as much myth as history, but we have evidence that by the fifth century, Irish holy men and women had founded Christian monasteries incorporating aspects of the local religion. They fostered the preservation of both religious and secular knowledge. By the sixth and seventh centuries, Irish foundations were sending missionaries to Scotland and the Continent.

Brigid founded a convent in Kildare on the site of a shrine to the Celtic goddess also called Brigid. It developed into a powerful double monastery, one side for monks and one for nuns. These religious settlements were just that—settlements. They were not tightly cloistered like Continental monasteries, and included laypeople as well as those sworn to God. These institutions preserved and produced substantial amounts of writing, from hymns to hagiographies, poetry to secular stories, serving as key strongholds of spirituality. Monks preserved and copied manuscripts as best they could; such books were treasured resources. It would not be until the twelfth and thirteenth centuries, as the Church was developing institutionally, with universities, cathedrals, and church courts, that it would

consolidate its position on abortion as a part of a larger campaign to regulate sexual expression.³

FOR MEDIEVAL CHRISTIANS, ABORTION HAD TWO MEANINGS: SEX and violence. Abortion might be a sign of illicit sexual relations, an attempt at a cover-up. But the first biblical mention of abortion—the meaning that became folded into Christian belief and then into European law—was about something else. In the Hebrew Old Testament, Exodus defined abortion as a crime of violence. Fetal loss was accidental, occurring when a pregnant woman was injured, often as a bystander to some other offense. For example, if men were fighting and hit a woman so that she lost a pregnancy, they had to pay recompense: "And should men brawl and collide with a pregnant woman and her fetus comes out but there be no other mishap, he shall surely be punished according to what the woman's husband imposes upon him." This item comes immediately after a ruling about a man killing his enslaved man or woman, and before another about harm done to an enslaved person, connecting a fetus with other beings owned by men. The passage continued with the famous phrase, "And if there is a [further] mishap, you shall pay a life for a life, an eye for an eye, a tooth for a tooth"—should the pregnant woman die, the usual penalties for homicide applied."⁴ The offense was not intentionally ending a pregnancy but rather harming a man's wife and potential offspring.

The Septuagint, the Greek translation of the Old Testament adopted by Christians, added another layer to the Exodus text. It specified that if miscarriage ensued, but the fetus was not yet "formed"—that is, if it lacked something like a human shape—the offense was punishable by a fine. After formation, however, the punishment was the same as for any other form of homicide,

a life for a life. The Jewish text's original focus had been on the violence done to a woman, but now the harm was twofold, to both woman and fetus.

The concept of formation derived from Ancient Greek ideas about fetal development. Aristotle had specified that a fetus took form at forty days if male, ninety if female, reflecting the idea that males were more valuable. Before such a time, a fetus was merely "an unarticulated fleshy construction." The ancient Hippocratic text *On the Nature of the Child* offered a slightly shorter timeline, holding that males were "articulated" or "congealed" by thirty days, females by forty-two.[5] Ancient scholars also linked animation—when a fetus could move—as a key developmental milestone, but again, determining the timing of such was difficult. Exactly when either formation or animation happened in any given pregnancy was hard to pin down, not least because the sex of the fetus was unknown.

Christian thinkers worried about fetal souls. It seemed obvious to them that getting rid of an ensouled being was against God's law, but early churchmen debated about when exactly in a pregnancy that crucial moment of ensoulment might happen. In the late second century CE, the Roman hard-liner Tertullian had argued that the soul came into being at the same moment that seeds met in the womb. However, most thinkers connected ensoulment with fetal formation or animation, implying that later abortion was of a different character to earlier.[6] During the Middle Ages, this way of punctuating a pregnancy into a "before" and "after" came to be applied to abortion law and religious doctrine. The dividing line changed over time, but the concept of two halves of pregnancy continued to be significant.

Early laws about abortion also emphasized the before-and-after distinction in accidents that ended pregnancies. Such laws addressed the same concerns about violence that Exodus had

done: What happened when a pregnant woman was hurt and miscarried? Assaults in the second half of pregnancy demanded larger fines, in part because the potential harm done to a man's wife or slave was greater. For example, a mid-seventh-century Visigothic legal code detailed various issues concerning abortion and how they should be punished. By this point, the Visigoths, a Christianized people originally from lands east of the Danube, controlled much of what is today France and the Iberian Peninsula. Most of the Visigoth statutes parsed different levels of harm according to social status. Was she a free woman? Or an enslaved one? Was the offender free or enslaved? For free women, the extent of the pregnancy mattered. Later in the pregnancy, the fine was 150 solidi, a substantial sum that would have supported a small household for a number of years. Earlier in pregnancy, the fine was 100 solidi, probably because less physical harm was done to the woman. If she were enslaved, however, the extent of the pregnancy did not matter. The offender paid 20 solidi to her enslaver, a small sum compared to the fines for free women.[7]

Christianity began to connect abortion to illicit sex as well as to violence, but with much variability. In the fourth century, for example, both Basil of Caesarea, writing in what is now Turkey, and Caesarius of Arles, a bishop in the South of France, argued that in addition to assaults on pregnant women, the Bible also forbade intentional abortions. Basil thought that talking about formed and unformed was a waste of time—what really mattered was intention. He added gloomily that women usually died from abortions anyway. But if they lived, they merited ten years of penance. Caesarius, known for his preaching, was more thunderous. Six of his surviving sermons discuss abortion, which he considered tantamount to murder. He also condemned any form of contraception, because fertility was up to

God's discretion, not men's or women's. Both Basil and Caesarius were articulating hard-line positions about abortion relative to their peers, but their larger point, connecting abortion and illicit sex, was shared by many early Christians.[8]

Two early Church councils also discussed abortion in terms of illicit sex. A council that met at Elvira in Andalusia around the year 305 portrayed abortion as a cover-up for adultery, so a woman was guilty of two sins, sexual infidelity and then abortion. These Christians were adapting contemporary Roman ideas about abortion as a sign of female infidelity to their particular faith. Ominously, the council held that a wife who aborted should not get Communion on her deathbed, underlining the severity of the sin and forbidding her from reconciling with God. A few years later, a council held at Ancyra (modern-day Ankara) categorized abortion as a sin under the larger category of fornication. Such a sinner was to be excluded from the Church for a decade.[9]

Councils such as these were trying to hammer out a Christian set of virtues that would distinguish followers of the new faith from nonbelievers, whether Jewish or pagan, around them. One of the most distinctive differences between Christians and their neighbors of other faiths concerned attitudes toward marriage and sexual relationships. Christian thinkers changed the relative value of marriage versus celibacy. Marriage was now second best. In ancient Rome, marriage had been a civic obligation, at least for the upper classes, not least because the empire needed new citizens. In the Roman world, men might take women as concubines or mistresses, or engage with women in an array of types of sex work. Such sexual relationships, from prostitution to concubinage, were socially accepted. For these women, abortion seems to have been considered largely unproblematic and is rarely discussed in the historical record.[10] Virginity had special meaning

for Romans in the shape of the vestal virgins who tended the city's sacred flame, and unmarried women were expected to remain virgins. But otherwise, staying chaste had little meaning. Christian believers, on the other hand, saw marriage as the only legitimate context for sex—but even within marriage, celibacy was morally superior to sexual relations.

Saint Augustine, whose views on abortion were later to become influential in the Middle Ages, shows us how Christian values about sexual relations were formed in opposition to contemporary Roman norms. Born in 354, Augustine grew up in a comfortable home in Roman North Africa. When he reached puberty, his mother warned him about sexual relations with other men's wives, for they were their husbands' property. Sex with the enslaved women of the household, prostitutes, or concubines was different. But Christianity came to cast all sex that was not intended for procreation within marriage as innately sinful. In his later writings, Augustine carefully graded the different levels of offense. Intercourse in marriage undertaken with the specific purpose of getting children was no sin. Intercourse in marriage for pleasure was a venial, or minor, sin. Adultery or fornication was much more serious, a mortal sin. Far better than any of these, however, was to choose celibacy, "to become spiritually subject to Christ as sole husband." This image, of Christ as a husband, became widespread and later made any nun's sexual relations with a man into a dreadful form of adultery, a betrayal of her divine husband. Male chastity was also highly valued for men committed to a religious life.[11]

Augustine, however, was no stranger to sexual desire. Before taking up a life of religious devotion, he had lived with a concubine for about fifteen years and then become engaged to a ten-year-old heiress. Augustine sent his concubine away, but while he waited for his fiancée to reach the marriageable age of

twelve, he took another. So when he cited the famous injunction of Paul in Corinthians 7, "It is better to marry than to burn," he knew of what he spoke.[12] It was only upon his full conversion to Christianity in 386 that he adopted a life of celibacy, abandoning marriage plans and his second concubine.

Historians have speculated that Augustine may have had personal knowledge of abortion, contraception, or both. His long-term relationship with his first concubine, begun when he was sixteen or seventeen, was deep. They had a son together, whom Augustine helped to rear. The breakup hurt them both. Augustine wrote, "My heart, which was so attached to her, was broken and pierced, leaving a trail of blood. . . . I was wretched." His lover returned to North Africa, telling Augustine that she would never have another partner, while their son remained in Milan with his father. Everything Augustine tells us, from his plea, "Grant me chastity and celibacy, but not just yet!" to his description of his youth as "unspeakably wicked," suggests that theirs was not a chaste relationship.[13] The couple had been together for sixteen years, and yet their only child had been born early in the relationship, in 371. How had they avoided additional children?

As a part of their new ideas about the value of sexual relations, different understandings of abortion came to demarcate Christians from their non-Christian neighbors. Drawing upon Greek philosophy to distinguish between formed and unformed fetuses, Augustine argued that the unformed fetus lacked both sensation and shape; therefore, its loss could not be considered a loss of life. But abortion after formation was different: it involved the loss of a soul. He compared abortion to the pagan practice of exposure, leaving unwanted newborns to die. Augustine described parents motivated by "dark savagery" to abandon newborns, and then shifted to abortion: "At times

this lust-filled cruelty or cruel lust . . . somehow extinguishes and destroys within the womb the fetus already conceived." A married woman who aborted, he added, was no better than a prostitute and her husband an adulterer.[14]

Intentional or induced abortion was construed differently in Judaism and then Islam, the two other major Mediterranean faiths. Medical texts by medieval Jewish writers included remedies that explicitly provoked abortion. A thirteenth-century Talmudic commentary by the Spanish sage Meir Abulafia articulated the timing of ensoulment and personhood in ways that differed from the emergent Christian position. While the soul entered at the moment of conception, a fetus was not a person until birth, when it drew its first breath. Until then, the fetus was part of the mother, and as such was a lesser entity.[15] Such a view made the moral meaning of abortion different for Jews than for Christians.

After the death of the Prophet Muhammad in 632, Islam spread rapidly through the Arabian peninsula, North Africa, and Iberia, and west to Persia and beyond. The new faith shared with Christianity and Judaism laws concerning accidental violent miscarriage, with greater penalties applied to those that happened later in pregnancy. But induced abortion was largely acceptable to the end of the fourth month in Islam and contraception unproblematic. Nor was celibacy valued; Muhammad had considered it unnatural.[16]

MEDIEVAL CHRISTIANITY'S INSISTENCE THAT ABORTION WAS wrong—unlike the position of the other major Mediterranean faiths—was part of its larger emphasis on regulating sexual behaviors, first of those who took religious vows, and later of all members of the flock. Celibacy became a distinctive feature

of the new institutions of monasteries and convents. In the late 200s CE, holy men had sometimes sequestered themselves in deserts and other remote places, living as hermits and worshipping the Lord. Some decades later, men and women who had consecrated themselves to religious lives instead began to live in communities, the origins of convents and monasteries. They took vows of celibacy as a part of their devotion. Such abstinence separated holy men and women from ordinary people and connected them to the sacred; it was the superpower of those who took religious vows. Celibacy's new significance as a marker of religious life created a new kind of unwanted pregnancy: a woman who had sworn herself to a chaste life in the Church could now be seen to have violated that vow.[17]

When Brigid of Kildare helped rid the young nun of her pregnancy, she did so at a time when the Church had not yet codified its proscriptions about abortion. Christianity was not yet the dominant religion in Europe that it would become, and written texts were scarce. Nor were scholarly arguments about when a fetus became formed particularly relevant to the needs of an evangelizing church. We know about Brigid's life from seventh-century hagiographies, compiled a century after her death. Such narratives were written to describe a saint's miracles and reflected themes likely to resonate with their intended audiences of local worshippers and potential converts. The miracles attributed to Brigid were deeply rooted in the subsistence agrarian economy of Kildare. For example, she repeatedly gave away food to the needy, food that was then miraculously regenerated. Water was transformed into calorie-rich ale for leprous beggars or became milk for a sick nun. Local rulers measured their wealth in cattle, and so cattle-rustling raids were frequent occurrences. When the raiders came to Kildare, Brigid made a river rise up so that the raiders could not easily return to their territory; the cows turned around and walked back to the convent.[18]

Unlike the austere caves where holy fathers had isolated themselves in deserts, the convents and monasteries of early medieval Ireland were bustling communities of men and women who prayed and who supported themselves in ways very familiar to their neighbors. Many of the religious came from local families, so ties of kinship connected them to the area. Nor were religious men and women the only inhabitants of these communities. Servants, craftspeople, and older men and women who retired to a religious life might all take up residence there, joined by a revolving array of travelers, pilgrims, and sinners seeking prayer and advice. Sometimes powerful local rulers might visit for a few days, requesting counsel. Bigger communities even began to host markets and fairs. While these communities were religious, they resembled other local areas governed by chieftains.[19]

Such places were spiritual powerhouses, sites where those in need sought healing and succor. Their powers came from monks' and nuns' dedication to lives of prayer and the renunciation of sex and family life. In another of Brigid's miracles, a man tried to seduce a woman who was intending to commit herself to a religious life. She resisted, and he set up a sting. He threw a silver brooch into the sea and accused her of stealing it so that she would be enslaved and could not resist his sexual advances. The young woman fled to Brigid's convent. A fisherman brought the nuns an offering, a fish he had caught. When the nuns cut it open, it revealed the stolen brooch in its belly, and the woman was saved from slavery and unwanted sexual relations.[20] Here, chastity was preserved; in the miracle that ended the young woman's pregnancy, it was reinstated.

Brigid was not the only holy person to use abortion in defense of chastity. Her contemporary Ciarán, who founded a monastery twenty-five miles west of Kildare, also helped to end a holy woman's unwanted pregnancy. Bruinech, a beautiful young

woman, was living in a community of nuns when she caught the eye of Dimma, a local ruler, who promptly kidnapped her. Ciarán went to the rescue. Dimma proposed an impossible challenge to Ciarán: if Dimma were awakened by a cuckoo's song, highly unlikely in the midst of winter, Ciarán could take Bruinech back. Miraculously, a cuckoo sang at dawn, and Dimma was as good as his word. But when they returned to the monastery, Bruinech revealed that she had been raped by Dimma and was now pregnant. Ciarán made the sign of the cross over her belly, and the pregnancy was over instantly, as if it had never been. The story explains that his actions were spurred by a sense of justice. He did not want the "serpent's seed" to flourish, to have a child born of rape by a pagan.[21] Ciarán's careful justification for ending this pregnancy shows us how a man of the Church might consider some abortions acceptable, while the Church was coming to condemn others.

The early Middle Ages are so distant from us that it is hard to imagine the meanings of chastity and childbearing in a world so different. For example, across the Irish Sea from Brigid and Ciarán, infant deaths had been marked not by burial with the rest of the community's dead but by interment at the edges of house walls, along roadways, and at the margins of fields. Initially, archaeologists inferred that such deaths were so common that the disposal of infant bodies was a matter of little consequence. As many as half of all babies born did not survive until their fifth birthdays. But take a closer look and we see that these infants were buried with care. Later burials, for example, did not overlap earlier ones but merited their own spaces, indicating that local memory had mapped these tiny interments. In the absence of written records, it is difficult to interpret such practices. Possibly these graves functioned as a form of community, weaving remembrance of these lost babies into the social fabric.

A woman from this kind of settlement who entered a convent would live in a profoundly different space from her family, one in which the numinous presence of buried babies was wholly absent.[22]

Abortions performed by holy men and women in the chaste spaces of convents were different from those that laywomen might have experienced. Hagiographies emphasize that miracle abortions were quick and painless, as if the pregnancy had never happened. The chapter title for this miracle in Brigid's hagiography is "Of the Pregnant Woman Blessed and Spared of the Birth-Pangs," emphasizing the lack of pain. Irish women who had aborted using herbs would recognize that such holy erasures of pregnancy were very different from their own experiences. Their prolonged cramping, contractions, and bleeding echoed the pains of childbirth, the mark of Eve's original sin. The painlessness of miracle abortions signaled that these holy women were different, preserved from the usual bodily experiences of women.[23]

Tales such as these would have been heard by many people who were not literate. A saint's life might be read aloud on her or his saint's day, with listeners able to reflect on the meanings and deeper themes of the various wonders performed.[24] Miracles took the hardships of everyday life and proposed extraordinary solutions to them, solutions couched in a familiar idiom. For women, these stories of miraculous abortions might have had different kinds of significance over their life cycles, first as they were virgins themselves, and later after they had experienced the pains of childbirth. In any case, the commonsense nature of these tales suggests that ending a pregnancy was also within ordinary experience.

Such miraculous erasures of pregnancy were exceedingly rare, and as the Church developed institutionally, it increasingly

cast abortion as a sin. We can see how priests may have dealt with abortion in their own parishes by looking at confessors' manuals. These guidebooks helped clergy allocate appropriate penances when they heard confessions. These were not as prescriptive as they might sound; priests were enjoined to think about the actual circumstances of the individual sinner, not merely apply a standard penance. For example, while abortion was a sin, confessors recognized that an abortion due to dire poverty had a different moral tenor from one intended to hide an illicit sexual relationship. In the three or four centuries after Brigid's life, a woman who confessed to ending a pregnancy might be forbidden Communion for a number of years or ordered to fast on bread and water for a year or more, depending on her circumstances.[25]

In these manuals, abortion was wrong because it implied illicit sex, and accounts of it were usually limited to a woman committed to a holy and celibate life, like the one whom Brigid of Kildare protected. A sixth-century Irish manual, contemporary with Brigid's life, discussed abortion in the section on clerical sins, not the sins of ordinary folk. Such a sinner was usually described as a woman who made an herbal preparation to end a pregnancy, sometimes early, sometimes later in gestation. If a holy woman sworn to celibacy went on to bear an illegitimate child, she would be required to perform six years of penance. But then she could go to the altar, "restore her crown and put on the white robe and be declared a virgin." Forgiveness was possible, and she could return to her status as a celibate nun.[26]

SOME ANCIENT MEDICAL KNOWLEDGE ABOUT ABORTION WAS transmitted to medieval Europe, transformed in ways analogous to other aspects of Greek and Roman culture: it was simplified,

repurposed, and reused. In the centuries after the fall of Rome, monks and nuns copied and preserved texts and provided medical care, both to their communities and to travelers in need of charity. These healers wanted a medicine for use and tended to strip out theoretical discussions of how the body worked, focusing instead on prognosis and remedies—the *how to* of medicine, not the *why*. Because monks and nuns provided charitable care to a range of sufferers, their medical texts contained details about abortion that we might not expect to find in manuscripts copied and recopied in celibate monasteries and convents. Those same writers also updated ancient texts, adding their own contemporary knowledge to that of antiquity.[27]

For example, a work likely compiled in Ravenna in the sixth or seventh century drew upon ancient medical knowledge to describe three hundred medicinal substances, including ones that explicitly ended pregnancies, "expelling" or "ejecting" a fetus. The book emphasized how familiar these plants were: "Pennyroyal is a plant known to everyone." "Savin is known to everyone." "Elecampane is a plant known to everyone, for it grows in gardens." Knowledge of abortifacient plants, the text implied, was widespread. Similarly, the tenth-century *Old English Herbarium* listed abortifacient plants familiar from antiquity, such as pennyroyal and dittany. The text conveyed its information plainly in phrases, such as "Quickly it will purge the dead fetus without danger," suggesting that the manuscript writer recognized the extreme urgency of such a situation.[28]

Similarly, medieval medical texts in Arabic discussed herbal remedies both old and new that prompted abortion. These books were produced in a sophisticated medical community that ranged from the highlands of modern Iran across North Africa and up into what is today Spain and Portugal. Because significant Greek medical texts were translated into Arabic,

the Islamicate world enjoyed a much richer classical heritage than the Latinate West, whose monks did not read Greek. When the tenth-century Baghdad physician al-Razi described 106 abortifacient herbs, for example, he was able to draw upon Greek authors such as Dioscorides, but other herbs he discussed were more recent innovations. It was not until the Renaissance that European scholars learned Greek and had access to a wider array of ancient medical texts.[29]

Looking at these medieval medical books from Ravenna, England, and Baghdad, we see the long echo of antiquity in each. But these medieval texts also reveal innovation and adaptation. The Ravenna book recommended spignel, a plant with white flowers, as an abortifacient, not mentioned in most classical sources as such. The plant was, however, common in medieval monastic medicine. The *Old English Herbarium* listed a few abortifacients not known in ancient sources, like fleabane, and some, like Saint-John's-wort, that were similar but not identical to those mentioned in classical works. Al-Razi drew upon experiences of abortion in his own medical practice, noting that thirty-two of his abortifacient remedies were his own inventions.[30]

These three medical works were written by men. One of the few women who wrote about medicine in the Middle Ages was the twelfth-century nun Hildegard of Bingen, who lived in the Rhineland area of what is now Germany. Like Brigid of Kildare, Hildegard spent part of her life in a double convent that housed men and women, which may have given her access to a better library and more medical works than most nuns enjoyed. In her medical writings, Hildegard discussed abortifacient plants in the same straightforward manner that male writers did. Some herbs, like goatsbeard and hazelwort, were indicated to be a risk for a pregnant woman because they could prompt an abortion

that might endanger her life. Others, such as German chamomile and bearberries, brought on obstructed menses.[31]

Like other medieval writers, Hildegard combined knowledge from antiquity with her own experience. Her discussion of tansy, for example, added considerable new detail, including a recipe for a fumigation of tansy, mullein, and feverfew. Her book specifies how to heat tiles to create steam and where to place the herbs so that their properties will be taken up by the steam and thence into the woman's body. It goes on to advise the woman to cook bearberries, yarrow, dittany, and rue in wine and drink it every day.[32] Most of these plants had been known as abortifacients in antiquity, but ancient sources did not usually combine them in this kind of menstrual cocktail, nor did they usually provide step-by-step instruction on how to make a fumigation with them.

Such written texts incorporated local knowledge while transmitting older wisdom. Hildegard used local vernacular names for plants and made observations about how they grew that seem to have come from her experience as a healer in her convent. For other ancient abortifacient herbs, like savin and pennyroyal, she made no mention of any effects on women's reproductive bodies. It seems unlikely that she was censoring herself, given the other abortifacient knowledge she presented. Transmission of knowledge could be spotty. Possibly Hildegarde was unaware of these therapeutic effects because they were not mentioned in the manuscripts to which she had access.

BY THE TIME THAT HILDEGARD WAS WRITING, THE CHRISTIAN Church had evolved from a loosely strung collection of largely autonomous religious settlements into Europe's biggest bureaucracy, and it was beginning to flex its institutional muscle. As

the European population rose, cities developed, and society and the economy grew more complex, in tandem with the Church. In the eleventh century, universities began to take shape, in part because the Church needed well-trained lawyers and administrators. Such universities focused on law, medicine, and theology, so scholarship in these subjects flourished. Such learned men were only ever a small proportion of the array of medieval healers, including midwives, enchanters, and herbwomen. These local healers' knowledge likely made its way into some of the scholarly texts, but because they did not write books themselves, we know less about the specifics of their practices.[33]

As a part of its new assertion of authority, the Church began claiming greater powers over the members of its flock, especially when it came to their sexual lives. While the celibacy of monks and nuns had long been important, now church leaders put a greater emphasis upon the sexual activities of parish priests, who were forbidden to marry. Church leaders frowned on the common practice of priests taking concubines, women who combined the functions of sexual partner and domestic help.[34]

More generally, the Church revamped ideas about marriage, which came to be understood as a sacrament, not just a contract between two families. When married couples had babies, they were urged to baptize them promptly, creating new anxieties about the fates of stillborn children and those who died unbaptized. The unbaptized were not allowed to be interred in church graveyards, so in some places, parents came to bury them under the eaves of a church. Rainwater rolling off the church roof seemed to provide some form of sanctified ground, some comfort in their loss. In keeping with its new focus on the morality of its lay members, in 1215, the Church also specified that all Christians should go to confession in private at least once a year.[35]

As a body of church, or canon, law developed, the Church instituted a system of courts that policed moral offenses, sins rather than crimes. For example, in October 1412, officials in the southwest English county of Dorset prosecuted a range of such misdeeds. William Doke, a local clergyman, was accused of having had sex with Marion Powke. Doke had a history: he had been in court for a similar cause a few years earlier. But Marion was also a repeat offender, confessing to a sexual relationship with Robert Bouton in the same court session. Richard Lombe and Edith Smyth were cited for fornication. They were engaged, and the wedding banns—the announcement from the pulpit a few weeks before the ceremony—had been called. But then they changed their minds and refused to wed, despite having possibly engaged in sexual intimacy. Richard tried to weasel out of marriage by claiming he had also had sex with Edith's mother, raising the specter of incest. John Macy, meanwhile, had been having sex with his servant, Maud, and the court forced them to marry.[36] Clearly, people in these Dorset villages knew who had been sleeping with whom and reported at least some affairs to church authorities, who followed up with prosecutions. Very few cases involved abortion, suggesting it did not bother people much.

The Church also used the confessional to police the sexual activities of its flock, with confessors' manuals becoming more detailed. When priests asked about abortion practices, their questions may have served as inadvertent sources of knowledge. The tenth-century writer Regino of Prüm, for example, wrote sample questions for confessors that described how abortions could be provoked with poisonous herbs and dangerous potions. Another confession manual noted that there were women who specialized in providing abortifacients. A woman who heard such questions—which, in theory, would now have

happened in private at least once a year—might have put two and two together and started asking older women about remedies for unwanted pregnancy. In the early eleventh century, Bishop Burchard of Worms instructed his confessors to ask, "Have you done what some women are accustomed to do?" implying that abortion was women's knowledge and customary practice.[37] The frequency with which confessors' manuals talked about abortion suggest it was an ordinary practice, or at least a widely understood one, in Christian Europe.

As the Church continued to focus on sexual behavior, it reworked its position on abortion. The Benedictine monk Gratian wrote one of the first compilations of canon law around 1140, creating what became a foundational reference. He equated some kinds of abortion with homicide. A fetus was not always the same as a person, however. Like earlier thinkers, Gratian assumed that personhood happened at formation, when a fetus assumed a recognizable human shape and, more important, a soul. In practice, determining if a fetus were formed or not was difficult. Women rarely knew exactly when they had conceived and thus when the countdown to formation might have started. No one had ever seen a soul, nor was anyone likely to be able to perceive the ineffable moment when a fetus became ensouled.[38]

So the Church adopted a proxy for ensoulment, declaring that it happened at quickening, when a woman first felt a fetus move within her. Quickening happened much later than formation, somewhere between the sixteenth and twentieth weeks of pregnancy. Crucially, this determination depended upon a woman's own testimony. Only she could feel the first faint flutter of fetal movement. Abortion after quickening was equivalent to homicide. Abortion before quickening might be a sin, but of much lesser magnitude.[39] For women, this meant that the

window for early abortion now extended into the fourth month of pregnancy, affording them time to marshal resources, such as information from other women, or herbal remedies, without arousing concern.

Actual prosecutions for abortion, however, remained rare. Most people, it seems, just looked the other way and avoided asking questions about how women managed their reproductive lives. When abortion went to criminal court, it was often about violence rather than sex. A foundational English thirteenth-century legal work *De Legibus et Consuetudinibus Angliæ* (usually known as *Bracton* after its compiler, Henry Bracton) classified abortion as homicide. However, *Bracton* defined the crime of abortion narrowly, much as Exodus had done—hitting a pregnant woman or compelling her to take a dangerous poison. The blame was laid upon the man who ended the pregnancy, and liability was defined according to the age of the fetus.[40]

Bracton's concern here was violence; abortion was part of a discussion about the definition of homicide more broadly. He went on to consider other types of murder. What if someone threw a stone at a bird and instead hit a person and killed them? Was that homicide? No, said *Bracton*, that was an accident. However, had the stone-thrower been on a busy roadside, where hitting a person might be likely, some form of legal liability could be incurred. While *Bracton*'s pronouncement on abortion has often been cited as legal precedent for criminalization, it focused on accidental miscarriage caused by violence, after quickening, or the harms of poisoning, rather than intentional abortion.[41]

Nor was *Bracton* the only legal opinion about abortion. Two other contemporary English legal compilations declared that abortion was not a crime at all. As one explained, no one could judge if an apparent pregnancy might truly produce a baby until

it was born.⁴² In practice, abortion appeared only very rarely in English courtrooms, usually in the context of a fetal loss provoked by assault. What women did to provoke menstruation or to put a stop to an early pregnancy was of little interest to England's criminal courts.

For example, in December 1273, Richard Taillhehaste broke into Robert le Gras's home in London, intending burglary. He found Robert's wife, Isabel, and her friend Isabel de Benteley and beat them. Both were pregnant, and both subsequently miscarried, losing male fetuses. Since someone determined the sex of the fetuses—perhaps the women themselves—likely these were fetal losses later in pregnancy. Richard found himself in a criminal court on felony charges, although we do not know the outcome of the case. Husbands, too, might be accused of such violence. In 1405, John Warham was tried in a church court in Dorset. He was alleged to have beaten his wife so severely that she miscarried and then died.⁴³ Such cases were unusual, but indicate that earlier medieval ideas about violence, assault, and fetal loss persisted.

Many of the cases involving abortion were prosecuted in church courts, not criminal ones, and hinged not on violence but on sexual behaviors. Penalties involved public penance or, for serious infractions, excommunication, rather than the payment of fines or physical punishment, as was the case in criminal courts. Those few cases for which evidence survives offer glimpses into individual women's experiences and provide hints about how the Church's new policing of sexual behaviors played out on the ground. Such cases began to allude to quickening as the key factor in determining whether or not fetal loss should be prosecuted.

For example, in 1417, Margaret Knobull was tried in the bishop of Lincoln's court in the English Midlands. Knobull's

testimony, described as "tearful," told that she had had an affair with John Holedon, become pregnant, and aborted. The court record was clear: her actions did not constitute homicide, because the fetus was unformed, so a soul had not yet been infused in it. Knobull was assigned penance. How Knobull had been found out and the case been brought to court, we cannot know. But because the abortion had occurred before quickening, her punishment was relatively mild.[44]

VERY FEW ABORTION CASES APPEAR IN FRENCH COURT RECORDS. It seems that abortion only came to the attention of authorities rarely, suggesting quiet neighborhood toleration of the practice most of the time. However, a handful of abortion cases were recorded in much greater detail than those in England, illuminating the circumstances in which a few women sought to end their pregnancies. The French legal system was based in Roman law, and it categorized these cases, in which abortion was late and the fetus fully formed, as something akin to manslaughter or infanticide.[45]

In a case from the South of France, Huga, a young widow in the small town of Manosque, was the talk of the neighborhood in spring 1298. She was pregnant, but as a widow, she should not have been. Manosque was a town of about four thousand people, the size of some American high schools, and gossip spread quickly. One local woman, Beatrix Gaufrid, said that the pregnancy was obvious from Huga's appearance; another, Andrea Pelegrini, thought so, too. Months later, some said Huga had died in childbirth, the infant undelivered. Then rumors started that it had been a botched abortion, that Huga had died because she took a potion prepared by Isaac, a Jewish physician. Christians in Manosque saw Jewish doctors frequently, as

they comprised a third of all doctors in town, but anti-Semitism may have been a factor in the case coming to trial.[46]

Matters came to a head in November. The chief priest in the town, one Master Bertrand, along with Brother Arnaud, a friar, had Isaac arrested and thrown in jail in chains. Joseph, another local Jewish man, interceded on his behalf, asking that Isaac be spared, as he was in poor health, but in vain.

Bertrand and Arnaud had been feeding the rumor mill; when the case came to trial, Guilhem of Rocencus said that he had only learned about the pregnancy from the churchmen. He testified that he had seen Isaac enter the inn where Huga had been staying. Other men, like Guilhem Pelegrini, had heard the story from their wives, although some women clammed up or claimed ignorance. Alacia Garrella and Elisabet, a nursemaid, possibly enslaved, testified that they had heard nothing.[47]

Isaac mounted a strong defense. He said that Huga had given birth to a live infant, which her mother, Cristina, had smuggled out of town to Lurs, fourteen miles away. Huga's mother thought that Lurs was far enough that the baby could be nursed quietly there, and the family's reputation mended back in Manosque. Isaac had met Cristina on the road to Lurs, and when he heard the weak cry of the infant, he had asked her what was happening. So much for the idea that the story could be kept quiet! Beatrix Gaufrid confirmed the Lurs story in her testimony as well, suggesting rumors had been spreading.[48]

The court evidently did not believe the story about taking the baby to Lurs. Isaac was convicted and fined a whopping fifty livres, approximately the cost of feeding a knight's entire household for a year.[49] The churchmen seem to have pushed through the prosecution because in their view such behavior would have set a bad example and needed very public correction. Abortion, however, was not their only or even chief concern. Rather, it

seems to have been the attempt to cover up illicit sex, combined with administering a dangerous, even deadly, medicine, that concerned the priest and the friar. The churchmen were worried that the usual mechanisms of control—gossip, rumor, and shaming—might not be working as they should. It was the sexual behaviors of their flock, not the moral status of the fetus, that prompted them to prosecute. Like her daughter, Cristina was widowed, and maybe the priests also wanted to exercise some male governance over this female-headed household.

Another French case offers insight into how male as well as female family members might be involved in abortion. In 1466, in the Languedoc region of the South of France, a family drama unfolded when Katherine Armant found she was pregnant. She was unmarried, and her fiancé was traveling far away. Katherine turned to her future sister-in-law, Jehanne Collette. Jehanne confided in her husband, André, and they beat Katherine on her back, over her kidneys, attempting to provoke abortion, to no avail. Jehanne then consulted a physician, Guillem Masson, telling him that Katherine had a grave uterine ailment. When the remedy prescribed by Masson did not work, Jehanne had her husband consult the apothecary Pierre Delala. André told the apothecary that Katherine was suffering from constipation, and he prescribed medicine and warm herbal wraps. Once again, the treatments failed to work.[50]

Next, the Collettes consulted a barber-surgeon, Etienne de Linas, claiming that the patient's private parts needed purging. Linas let blood from Katherine's foot, arm, and uterine area. Bloodletting from the saphenous vein in the foot had long been considered abortifacient. In theory, the bloodletting pulled the fetus down and out of the body. Linas was the only one of the three medical practitioners to see Katherine in person, since bloodletting could not be provided through an intermediary.

When he saw the patient, maybe he figured out what the real problem was. But bloodletting failed, too. By now, Katherine and the Collettes must have been desperate. They told Linas to provide an abortion, and he prescribed medicines. We do not know if they succeeded, but it is likely, given the prosecution that followed. The Collette family's attempt to conceal the pregnancy and protect the family from shame failed. The case was brought to court, so must have sparked local gossip. André and Jehanne were convicted, but received a pardon in 1468.[51]

The Collette case shows us two women and a man working together to try to end a pregnancy. More often, this may have been women's work. As in the various subterfuges tried by the Collette family—Katherine had a uterine malady, she was constipated—practitioners and patients might tackle the problem indirectly, not acknowledging the real issue. One such practitioner, Alyson Taneure, provided well-regarded medical care to women in Beaune, in central France, for almost two decades up to 1425. That year, Perrenet le Moyne asked her to see his ailing wife, who was complaining of pains in the chest, kidney, and groin. When Taneure examined her, she asked the patient if she might be pregnant. "Not that she knew" was the guarded answer. Taneure proceeded with a treatment she had used before. She inserted a pessary with an herbal preparation into the vagina and the next day made a hot bath with herbs, including fennel, a classic abortifacient. She placed three or four small wax candles on her patient's belly, lit them, and then snuffed them out with a small pot of earth. Four days later, the patient expelled a small fetus-like object, claiming that she had had no idea that she was pregnant, as she had experienced no signs of life. Taneure's request for a royal pardon stated that, despite her many years of experience, she, too, had had no idea that her patient was pregnant.[52]

Records such as these, from the fourteenth or fifteenth centuries, are often too thin to allow us to see into the complexities of gender relations in abortion cases. In the Collette family, it is clear that both men and women knew what was going on, although they conspired to keep the news of infidelity from Katherine's fiancé. It is harder to tell in the Moyne family. Did Perrenet know his wife's symptoms were due to pregnancy? Did she?

Often, abortion was imagined as something women did, as when Bishop Burchard had instructed his confessors to ask, "Have you done what some women are accustomed to do?"[53] But a story recorded by a fifteenth-century Cistercian monk in Byland Abbey, on the Yorkshire moors, gives us a rare glimpse of how men might have imagined the gender politics of abortion, especially in their absences from home. The monk's dozen or so stories are full of local detail, set in specific nearby villages, suggesting that they had been told to him, not merely copied from another manuscript.

It was an eerie tale. Richard Roundtree, who lived in Cleveland, thirty miles north of the abbey, left his pregnant wife to go on pilgrimage. He was going all the way to Santiago de Compostela, in northern Spain, a journey of many months. He traveled with a band of pilgrims. As they camped out on roadsides, they took shifts staying awake and standing guard. While Richard watched one night, he saw a ghostly parade of people on horseback, accompanied by phantom cattle and other animals. That was strange enough, but then he saw something that looked like a small creature, rolling along, apparently wrapped in a sock. He spoke to it, asking it to explain itself. It replied that he should not have done so, "For you are my father and I am your son, miscarried without baptism and buried without a name."[54]

Richard took off his shirt and dressed the small figure in it. Then he performed an impromptu baptism and gave the tiny ghostly figure a name. His actions echoed those of a good midwife, swaddling a baby in fabric and doing an emergency baptism if its life were at risk. At this, the tiny figure leaped with excitement and began to walk, while before it could only roll. After the ghost went on its way, Richard carried the sock with him as a sign of the baptism.[55] He must have recognized it. Socks were hand-knit, and likely, his wife had made it.

Eventually, Richard Roundtree made it back home. In celebration of his successful pilgrimage, he held a feast for his neighbors. He asked his wife for his socks, and she could find but one. To her amazement, Richard produced the other. The tale relates that her midwives then confessed to the fetus's death and burial in the sock. Richard went on to divorce his wife.[56]

Is this a story about abortion? Possibly. Who knows what hardships Richard's wife faced while he was away all those months? Miscarriages and stillbirths were all too common, and it is hard to see how such would have merited a divorce. The story suggests a reservoir of men's fears about how women might conspire about pregnancies, births, and abortions. In the centuries that followed, such fears would lead to more frequent and intensive prosecutions.

CHAPTER 3

THE MAIDSERVANT AND THE WITCH

CRACKDOWNS IN EARLY MODERN EUROPE

ADELHEID HAD BEEN PROVIDING ABORTIONS TO RESPECTABLE women in Sélestat, south of Strasbourg, in France, for years. In 1409, the town fathers decided they had had enough of her herbal concoctions and roots. She was told to remove herself across the Rhine and not to come back for three years unless she got special permission. Only a few details about her survive in town records.[1]

We know she was originally from Stuttgart, about 125 miles northwest of Sélestat. We know her nickname was "the limper," suggesting some kind of disability. But there is so much we cannot know. Did she have a wider medical practice? Where had she learned her trade? What happened to her after she left town? Banishment was a stern punishment. As the crow flies, it was about ten miles to the Rhine, but it was many more to

a bridge or a ferry that would carry her to the other side, extra challenging for a woman with a disability.²

In centuries to come, women like Adelheid would face much stricter penalties than this. One was Anna Harding. In 1618, in the German town of Eichstätt, Harding was interrogated repeatedly about her life and abortion practice, sometimes under torture. Harding told the court about the reproductive services she provided for local women. She had been born in Swabia, farther east, and moved to Eichstätt around 1600, although she may have also lived there previously. At the time of her trial, she was sixty-four and had been widowed for many years. Women consulted her about their periods: Was the flow too heavy? Did it fail to return? She could, in effect, turn the tap off or on with her herbal preparations. She told the court the names of the herbs she used: alamander, muselblue, and galgans. These names cannot (yet) be mapped fully onto plant names we know today. The first may refer to alexander, a wildflower that looks like Queen Ann's lace, known as an abortifacient since antiquity. "Galgans" probably refers to the East Asian spice galangal, used as an abortifacient in other German communities. "Muselblue" remains a mystery.³

Some of Harding's patients were unmarried women. When Maria Mayr got pregnant, Harding provided the herbs that caused an abortion, hiding Maria's shame so that she was able to marry blamelessly a few years later. Harding treated the daughters of Father Johann Reichard's cook, the daughter of a bricklayer from Obereichstätt, and many others for stopped menses. She also cared for married women, including Eva, the wife of the butcher Biebel Lenz, helping her restart stopped menses. When Eva had tired of her husband's sexual attentions, Harding gave her herbs that would make him impotent. But the healer refused to help a gravedigger's wife, implying

that the woman might have been trying to hide an adulterous affair.[4]

During the time between Adelheid's exile across the Rhine and Harding's interrogation in Eichstätt, the meanings and legal status of abortion had changed profoundly in Europe. Abortion was now a capital crime in some places; women could be—and were—executed for either providing or getting an abortion. One of the triggers for these new abortion laws was the sixteenth-century Protestant Reformation, which profoundly altered gender relations, stressing the sanctity of marriage and penalizing extramarital sex. In newly Protestant places, clergy were now allowed—even encouraged—to marry. The Catholic hierarchy responded to the rupture of European Christianity with a period of intense self-scrutiny and recommitment to the faith that historians call the *Catholic Reformation*.

Across confessional divides, religious leaders sought to reform the sexual behaviors of their flocks. New laws against abortion were a part of such campaigns, because abortion was imagined as a sign of illicit sexual relations. Such laws were usually intended to regulate the sexual behaviors of unmarried women. Everyone knew that infants were fragile creatures, and no one would inquire if a married woman miscarried or lost a newborn. Single women, desperate to hide pregnancy, were the usual focus of prosecution. But older women were tried for providing abortions, too. Sometimes a mother was executed for helping her daughter end a pregnancy.[5]

While cities and states began to punish abortion much more strictly in the sixteenth century, knowledge about how to provoke an abortion remained widespread, often communicated from one woman to another. In Constance in 1597, Anna Dischler took savin from a garden grown by a painter's wife and then bought wild ginger at a shop in town. Because such

abortifacient herbs were often also general-purpose purges, her request might not have prompted an apothecary to ask any awkward questions.⁶

Or let's eavesdrop on a 1665 conversation between a maidservant and her mistress as they walked home from the fields in the German territory of Swabia, where Anna Harding had been born. The mistress noticed some red pennyroyal and instructed her servant that this was a good medicine for women whose periods did not come as expected. She remembered back to the terrible time during the Thirty Years' War, two decades earlier, when a local woman had used the herb to abort after being impregnated by a soldier. As it happened, the mistress's son was pressuring the maidservant into sex. Perhaps with this piece of local history, the mistress was also offering covert instruction about how to deal with an unwanted pregnancy much closer to home. If this were the case, the message was received: the servant later took the same red pennyroyal when she found herself pregnant. But her employer's attempts at discretion failed; the servant ended up in court.⁷

WHILE MOST KNOWLEDGE OF ABORTION-PRODUCING PLANTS WAS probably conveyed orally, woman to woman, as the mistress instructed her servant, the advent of the printing press in the middle of the fifteenth century had created new ways to learn about such plants. Renaissance botanists looked back to the ancients but also came to realize that they were not living in Dioscorides's Greece. They cataloged local plants and added them to their books. Despite increased controls on abortion, printed works were not shy about the matter. William Turner, for example, author of the first herbal printed in English, baldly told his readers about dozens and dozens of plants

that restarted the menses, hastened births, or brought away fetuses.⁸

Books like Turner's were heavy tomes, written for other scholars. As literacy spread, smaller, cheaper books and pamphlets were produced for ordinary men and women. A century after Turner, books were being written specifically for women readers; as many as half of all London women could read. Leonard Sowerby's *The Ladies Dispensatory* (1651) listed 121 different herbs that would bring on the menses and another 45 that would provoke abortion. Many had been known since antiquity. Indeed, Sowerby probably alluded to a classical source when he used a measurement of "half an obol"—a weight used in classical antiquity, but not employed in early modern England. Most of his instructions, however, were phrased in very basic language, easy for a novice reader: "Cedar berries drunk with pepper," "Juyce of Onions applyed on the secret parts," and so forth. Even cheaper than Sowerby's small book was Sarah Jinner's 1659 almanac, which offered readers a total of eighteen different remedies to provoke menses or evacuate a dead fetus. Some were available commercially at an apothecary shop, while others could be made at home.⁹

SINCE KNOWLEDGE OF ABORTIFACIENT HERBS WAS COMMON, AND they could be found in fields, markets, and shops, Church and state authorities faced an uphill battle when they tried to crack down on their use. But in law after law, prosecution after prosecution, early modern men tried to limit women's ability to manage their own reproductive lives. Such repression of abortion was especially fierce in Italian- and German-speaking regions of Europe.

In the sixteenth century, neither Germany nor Italy was yet a nation-state. Both were patchworks of principalities, duchies,

free cities, and a host of other small-scale polities. Details of their laws on abortion varied from place to place. But many were significantly shaped by larger shifts in gender relations prompted by new Protestant teachings about the purpose and value of sexuality—or by the Catholic backlash to those teachings. Martin Luther, architect of the Protestant faith that bears his name, thought priestly celibacy was unnatural: it alienated pastors from their flocks. His reforms included marriage for clergy as well as a new valuation of sexual relations within marriage.

Luther had been ordained as a Catholic priest in 1507. A few years later, he began to criticize what he saw as the decadence of the Church. By 1521, the criticisms had become so acute that the pope excommunicated him, and Luther began to build a new faith. Fiercely critical of religious celibacy, in 1523, he liberated nuns from a convent, supposedly by smuggling them out in herring barrels, and then went on to marry one of them, Katharina von Bora. His writings praised the virtues of married life.[10]

The new faith inverted the old Catholic values: now marriage was superior to celibacy, so celibate orders of monks and nuns were abolished. However, sexual intercourse was restricted much more strictly to married life, and it was the law of princes, not popes, who would oversee this new order, in a faith that rejected ecclesiastical hierarchy. City fathers in Lutheran cities and towns closed the brothels that they had previously accepted as safety valves for male sexual appetites. In Augsburg in 1537, the city government created the new office of Discipline Lords, a morality police who investigated and prosecuted sexual irregularity, including adultery, fornication, and prostitution. Having turned their backs on Catholicism, newly Protestant territories could no longer avail themselves of church courts,

public penances, and the like. So they wrested control of morals from Church to state. That control reached into the household, cementing a patriarchal model of the relationship between man and wife, and fostering a sentimental image of motherhood, now women's sanctified calling.[11]

Tracing the legislative history of abortion across a Europe composed of many different cities and states is challenging, given the number of separate polities peppering the continent. But two edicts stand out, both for their severity and the breadth of their reach. In 1532, the Holy Roman emperor Charles V instituted a new criminal code, called the Carolina after his name in Latin, which included draconian punishments for abortion. The empire was, as the saying has it, neither Roman nor particularly holy. Charles, a Catholic, ruled a congeries of smaller German principalities and cities, including Nuremberg, Hamburg, Stuttgart, and Augsburg. Some were Protestant, while others remained Catholic, a situation that led to a series of military conflicts fought over religious allegiances. Relative peace was only achieved in 1555 with the decision that a territory followed the faith of its local ruler, such as a duke or prince.

Both Protestant and Catholic leaders increasingly sought to regulate morality, especially sexual behaviors, wanting to make their realms into highly visible models of sanctity. To that end, the Carolina moved moral offenses from the realm of the Church to that of the state, bolstering secular authority. Now a range of offenses, including witchcraft and men having sex with men, were made crimes that the state could prosecute. Women convicted of abortion or infanticide were to be executed in vicious and spectacular ways, such as drowning after being attacked with red-hot pincers. Men who helped women abort were to be beheaded. The Carolina echoed medieval distinctions between quick and not-quick fetuses by specifying that

execution was reserved for the abortion of a "living" fetus, but it did not illuminate what was meant by "living." Early abortions were also criminalized, with exile a typical punishment.[12]

German-speaking territories had already been attempting to regulate women's sexual and reproductive lives since before the Reformation, as we saw in the case of Adelheid at the beginning of this chapter. In the late fifteenth century, cities like Strasbourg, Munich, Augsburg, and Frankfurt had begun to license and pay midwives, ensuring that very poor mothers did not have to find a midwife's fee to get help with childbirth. From one perspective, this had been a public health initiative, ensuring that midwives were competent, and increasing the number of women who had access to the specialized care they provided. But licensed midwives were also supposed to police their clients. In Nuremberg, midwives had to report any illegitimate births, whether stillborn or living, and interrogate the mother about paternity. In Freiburg im Breisgau, midwives also had to report any abortions or attempts at abortion that they saw or suspected.[13] While such policing had intensified municipal control over women, it was less punitive than the violence later mandated by the Carolina.

TO THE SOUTH, ACROSS THE ALPS, THE CATHOLIC CHURCH responded to the Reformation by renewing attempts to educate peasants in the true faith, urging them to abandon their superstitious ways. In 1588, Pope Sixtus V issued a papal bull that paralleled the Carolina in intensifying the prosecution of abortion. Unlike the Carolina, of course, this new ruling was religious, not secular. Sixtus declared that anyone who got an abortion, provided one, or merely assisted would be summarily excommunicated. Now no distinctions were made according to

the stage of the pregnancy: any abortion at any stage was murder. Sixtus encouraged local churches to turn such women over to secular authorities so that they could be prosecuted for homicide. Should a woman want to overturn her excommunication, she had to come to Rome. Unlike other sins, only the pope, not a bishop or a confessor, could undo this excommunication. Imagine a woman in a small Italian village. Likely she had sought an abortion because of the shame that unwed motherhood would bring upon her and her family. Now there could be no keeping the matter secret. Not only could she no longer attend Mass, but she would have to travel a great distance to Rome to plead her case, and she risked criminal prosecution that could result in her execution.[14]

Pope Sixtus's bull quickly proved too strict. A mere three years later, his successor, Pope Gregory XIV, overturned it, returning Catholic law to its prior state. The distinction between early and later abortion was restored, with stricter penalties assigned to the latter. And a woman seeking absolution no longer had to travel all the way to Rome. Now she could appeal to a local bishop for help in lifting a sentence of excommunication. While women were turned over to secular authorities charged with abortion, in practice, the death penalty was only pursued in a tiny handful of cases. A woman had to confess to the abortion in order to be condemned, and courts often fell back on gender stereotyping to mitigate responsibility. Everyone knew women were the weaker sex, prone to emotional storms and unable to rely upon rational thought to guide them. The Italians even had a name for it: "fragilitas sexus" was the legal term for female frailty that underwrote the practice of giving a woman a generous benefit of doubt in court.[15]

And Italian abortion cases came to court relatively rarely, only when local habits of looking the other way and not asking

questions had somehow broken down. In the spring of 1613, Superio de Magistris, a well-to-do man from Sezze, a small town south of Rome, tried to cover up his incestuous relationship with his niece Maria de Vecchis, who was pregnant. He bought the purgative herb calamint from a local healer, and aristolochia, or birthwort, from the local apothecary; both had long been recommended as abortifacients.[16]

He also tried to get the town surgeon and a local barber to let blood from Maria's foot, another time-honored method of abortion. The barber and the surgeon both refused because Superio lacked a physician's prescription. Such regulation, designed to curb abortion practices, was relatively recent. However, when Maria was later examined by a surgeon, he noted a scar on her foot over what was known as "the vein of the mother" (*mother* in this case meant "womb"); someone had provided bloodletting.[17]

Next, Superio turned to a Dominican friar, Fra Maccabeo, and commissioned him to buy both fresh savin and colocynth from an herb seller in the Piazza Navona market, forty miles away in Rome. The friar was known locally as a skilled herbal healer and an exorcist. He later explained to a judge that colocynth had not worked because it was relatively mild and only provoked abortion in the early months of pregnancy. The friar, it seems, knew a great deal about abortifacient plants. However, the combination of purging herbs finally worked; Maria aborted two fetuses that she judged to be about seven months.[18]

Usually such cases did not come to court because everyone understood the importance of preserving a family's honor. In this instance, "even the chickens know," as the locals said. Superio was a powerful and wealthy man, but his sin of seducing his virgin niece was made worse by the stain of incest. The community was in silent accord that Maria was a victim in need of their support. She was considered unmarriageable because of

disability; she was visually impaired and had a chronic respiratory ailment. Because her father was dead, she lacked paternal protection, although she lived with an older brother and their mother. If convicted, Maria could be executed, burned at the stake. No one wanted that to happen.

Nor did any local want to get on the wrong side of the powerful Superio. The case only arrived in court after Angelo Cima, a prosecutor linked to the papal court, refused a bribe from Superio. In the end, the judge construed the case as a fight between two men, Superio and Angelo, and ordered them to make peace. On pain of a substantial fine, they had to pledge not to offend each other. No punishment was handed down to Maria. The goal was the restoration of local peace, not the kind of display of a community's moral righteousness common to abortion trials elsewhere.[19]

SOME EUROPEAN STATES ATTEMPTED TO TIGHTEN CONTROL OVER women's sexual behaviors by making more aspects of reproduction a matter of state supervision. In Catholic France, for example, Henri II created a 1557 law declaring that any unmarried woman concealing a birth would face murder charges if the baby died. Henri also criminalized infant substitution—swapping a living baby for one who had died, in order to manipulate inheritance. In 1624, Protestant England enacted an infanticide law similar to the French one. It inverted the principle "innocent until proven guilty," typically the keystone of English law: unwed mothers were presumed guilty of murder if they had hidden their pregnancy and delivered a stillborn infant, or one who died shortly thereafter. Similar legislation followed in Scotland. Over time, British women developed the "baby clothes defense." In the courtroom, they produced infant-size garments

to demonstrate that they had not concealed their pregnancies, or at least had prepared for the birth by making clothes for an expected child, as a proper mother should.[20] Such laws about concealment hardened the divide between married women, who were entitled to enjoy sexual relations, and their unmarried sisters, who were not.

Not every man or woman could fit into this new model of a holy household. Fewer men and women could afford to marry. A series of Europe-wide crises over the sixteenth century, from repeated warfare to the Little Ice Age—a climate shift that made for years of bad harvests—led to hard times and scarce resources. The gulf between the haves and the have-nots deepened, especially in German-speaking lands. Guilds, which exercised monopolies over trades like shoemaking, printing, and metalwork, tightened their regulations. Now they excluded women and made membership for men more difficult to attain, limiting access to skills and well-paid work. Many young people were shut out of the marriage market, unable to earn a sufficient living to acquire basic household goods, or to subsist without a wife's wages when she fell pregnant. Men and women migrated for work, and desperate men enlisted in the armies that fought in recurring wars. Women might find themselves relegated to domestic service, powerless and poorly paid. In England, such service was largely a life cycle phase for both young men and women, enabling them to save wages toward setting up a marital household. But in German towns, it was becoming a life strategy for women who did not have husbands and were unlikely to find them.[21]

Even the few women who were paid well enough to enable them to live on their own, or with another woman, began to find themselves boxed in by urban governments. German cities came to insist that single women live in male-headed households. In 1665, for example, Strasbourg city council forbade

single women from living on their own, because it resulted in "shame, immodesty, wantonness and immorality." Single women were increasingly seen as a problem group whose sexual behaviors needed to be monitored closely. City fathers were worried both about the morality of the cities they governed and about potential illegitimate children without fathers to support them, a potential drain on city resources.[22]

While unmarried women in German-speaking lands often faced a life of backbreaking domestic servitude, in Italian cities and towns, they might be incarcerated. Many families who wished to conserve their financial resources provided a dowry for only one daughter. Remaining daughters had to become nuns, whether they had a genuine religious calling or not. Convents also became holding tanks for a variety of women who had not taken religious vows: women whose marriages had broken down, victims of rapes that families had been unable to hush up, even daughters whom families simply considered too difficult to manage. A range of other prisonlike institutions developed, designed to confine working women and enforce chastity. Homes for reformed prostitutes expanded to hold pretty women whom local authorities merely considered at risk for sex work. Other refuges housed poor widows and orphan girls.[23]

One of the ironies of these various places of incarceration was that the inmates became prey to sexual assaults by male servants or even visiting clerics. In 1561, Giovanni Pietro Lion was executed for his many violations as confessor to the Convertite, a home for reformed prostitutes in Venice. He had egregiously abused his position, seducing and raping inmates. When some of them got pregnant, he provided medicines to make them abort. The scale and magnitude of his crimes eventually caught up with him, but there were many other instances where authorities looked the other way.[24]

While German and Italian authorities responded with different strategies, both constituted single women, and single women's sexuality, as a pressing problem, a problem that grew as access to marriage became more limited. Over the course of the sixteenth century, both religious and secular leaders devised an array of institutions and legal structures designed to control these women and their sexual behaviors. But sexual relations were never actually limited to married life, whatever authorities like the Discipline Lords in Augsburg might have dictated.

Older forms of courtship lingered. As many as 20 percent of all brides went to the altar pregnant in the sixteenth century. Some women did not make it to the altar, abandoned by their men, who found it easy to slip away in times of turmoil. At some point in her youth, Anna Harding had been engaged to a cobbler's apprentice and went to bed with him. He skipped town before the wedding. She was lucky, avoiding (or ending?) any ensuing pregnancy. Women such as she were in a terrible double bind; sex with one's fiancé sealed the deal, as it were—but not completely. Still, only a small percentage of births were illegitimate, suggesting that women in these situations were, like Harding, able to evade pregnancy more often than not.[25]

Anna Laistler was less fortunate than Harding. In 1665, she was engaged to a baker's apprentice, who deserted her. She moved from her rural village to Stuttgart, a city of nine thousand people, hoping to conceal her growing belly. She consulted an herb seller at an inn, complaining about stagnant blood, possibly a euphemism for stopped menses. The little basket of herbs she bought did not work, so she saw a Dr. Müller. He touched her belly, noting that it was hard, suggesting a growth rather than pregnancy. He sent her off with seventeen pills. She was scared to take all seventeen, but a reduced dose did not have the desired effect. She wrote home to her mother, noting that she

also kept experiencing nausea and vomiting. Her mother had a good idea of what the trouble was and sent her daughter a powder from a barber in nearby Sulz. Nothing worked, and Laistler eventually gave birth to an infant who died. She found herself in court on a charge of infanticide.[26] Her story was repeated all over Europe: engaged, pregnant, abandoned, and desperate.

Not all extramarital sex was something a woman had wanted; our notions of consent map very poorly onto sexual relations in early modern Europe, where economic or political male power shaded into coercion and rape in a thousand ways. Even women who could afford to marry might be pressured into sexual relations by the men courting them. In 1681, a barber helped his stepdaughter abort after she had been raped by a young man who resented the barber's refusal to take him on as an apprentice. The practice of quartering soldiers in ordinary German people's homes created unsafe situations for young women. These women were then vilified as "soldiers' whores" if they became pregnant and gave birth. Female domestic servants could find themselves in impossible situations, prey to sexual exploitation and abuse by masters and their sons. If a servant got pregnant, she risked denial and abuse from the mistress and might be thrown out on the street. She would face shaming punishments, such as standing in the pillory, and then banishment. Both mother and child would be stigmatized for life.[27] Taking an abortifacient herb, however unpleasant and risky, could look like the better choice.

While some women were pressured into sexual relations, others took up sex work in order to make ends meet. Anna Harding had enjoyed what sounds like a fairly comfortable married life when she was young, in the Swabian town of Markt Jettingen. She had at least one child with her husband, Jobst Harding, who was sufficiently well off that he sent his son to

apprentice with a Nuremberg merchant in Venice, a step toward a potentially lucrative career. It is not clear if this child was also Anna's son, or a stepson from an earlier marriage; in any case, he disappeared from the record once he went to Italy.[28]

Sometime in the late 1580s, Jobst died after six months of illness. Anna was around forty, and the long illness must have wiped out the family's resources. In dire poverty, she turned to sex work in order to survive; her first client was a clergyman. When she moved to Eichstätt, a bigger town of about four thousand people, she found a few male clients who paid her for sex. Since she may have lived in the town previously, these might have been longer-term relationships. In court, her interrogators went out of their way to avoid putting the identities of those men "with whom she had to do here in Eichstätt" on the record. Their names were "not incorporated in this transcript."[29]

Such discretion suggests that Harding's sexual partners were leading citizens. She knew the bodily secrets of both men and women in Eichstätt. Anna Harding did not fit the stereotype of a wanton single woman who engaged in illicit sex. She had married, become a mother, cared for her husband, and turned to sex work because, despite all her efforts, she was left destitute.

Stories such as Harding's or Laistler's might imply that women who had sex outside of marriage—those most likely to seek abortion—were victims. While some of them had been raped or had taken up sex work to avoid starvation, I do not want to depict women as solely the prey of aggressive men. Women shaped their destinies as best they could, within the constraints of poverty and patriarchal households. Elsbetha Eggenmann was a sexually active woman who does not sound much like a victim. She was twenty-seven, working in Constance, near the Swiss border, as a domestic servant. She had sex ten times in the spring of 1688, with different men. She had tried to be careful, insisting that they

practice withdrawal so as to avoid pregnancy. In court testimony, she portrayed herself as in charge; having had sex with multiple partners meant she could not claim the usual "abandoned after promises of marriage" excuse. And she specified the terms of those sexual encounters: the men had to pull out. Perhaps she was engaging in sex work on the side; we will never know.[30]

But then Elsbetha's belly swelled up like a sponge and contracted again. What was going on? She sent her urine off to be inspected, and the resulting diagnosis was dropsy, a collection of fluid in the belly. Reading urines was a common method of diagnosing pregnancy, although medicine's elite were coming to scorn the practice. The practitioner's wife also examined the urine and told Elsbetha to buy medicines from the pharmacy that she herself had used successfully against "a growth." Those medicines did not help, so Elsbetha saw a woman who prescribed herbs. By now, her master and mistress were deeply suspicious, and a different doctor read her urine and suggested three more medicines. After taking these, Elsbetha miscarried.[31]

Women like Anna Laistler, Elsbetha Eggenmann, or Maria de Vecchis found themselves in court, fighting for their lives. In the Middle Ages, abortion might have been the focus of prosecution because it pointed to a violation of a nun's chastity. Such women had taken vows that cut them off from a woman's normal life. Excommunication, not execution, might have been their fate. Or they might have done penance for a number of years and then returned to their customary life as a nun. In the sixteenth century, abortion became a greater focus of prosecution for laywomen as well. Now abortion signified the grave threat that single women's sexuality posed to civic and religious order during the upheavals of the Reformation.

In German cities and towns, women who were married testified repeatedly about the sexual sins of those who were not.

Such women were stressing the difference between their virtuous marital sexual relationships and illegitimate ones indulged in by others. Had they not married, they, too, might be laboring in someone else's home and trying to avoid pregnancy. In Catholic Italy, the potential shame of illicit sex was focused more on the family than it was in German cities and towns. Often family and court collaborated to conceal any wrongdoing. Families denied, waffled, and prevaricated when testifying in court. Nothing had really happened, they said, it was all misunderstood. And Italian courts, committed to maintaining the peace and preserving a family's honor, often accepted such tales.[32]

Abortion threatened civic order because city fathers saw it as a sign of illicit sexual relations. Babies without fathers were supported by local poor relief. In tough times, mayors and aldermen worried about what seemed to them to be a sea of hardship, with beggars and cheats everywhere. It seemed obvious to the ruling classes that fatherless children would grow up to augment the numbers of such disreputable folk. Nor were city fathers able to assess population numbers accurately, which probably amplified their worries. Those committed to intense religious reform, often Protestants, also wanted their towns to demonstrate moral worth, both to God and to their fellow citizens. An unmarried woman who got pregnant revealed that their governance was shaky, that sexual desires were not controlled by their strict marriage regimes. Abortion similarly served as an indicator of local immorality, an indication that not everyone was abiding by new moral codes.[33]

But Anna Harding was not in court because she provided abortions or because she had sexual relations with various men in town. She was interrogated on charges of witchcraft.

Witches became associated with abortion in a late-medieval book, the *Malleus Maleficarum*, or the *Hammer of Witches*. First published in 1486 by two Dominican friars, the tome offered new ideas about witchcraft by putting sex at the heart of it. In the late Middle Ages, witches had often been men. They used their supernatural powers to do evil, to gain advantage for themselves or their clients. But then European witchcraft changed gender: it became largely female, connected to the belief that women were the lustier of the two sexes. According to the *Malleus*, witches made sexual pacts with demons instead of exchanging marriage vows with husbands. Demon sex wasn't even all that enjoyable; supposedly their penises were ice-cold, but female desires knew few limits. Women's sexual relations were like two sides of a coin: younger women were having sex outside of wedlock, while older women were seduced by Satan's agents. Abortion linked the two, because older women either already knew about abortifacients or were instructed about them by demons, and younger women were desperate for such knowledge.[34]

The *Malleus* seems to have combined aspects of everyday practices with fantasies about what women were doing when men were not around. For example, the book acknowledged repeatedly that there were natural ways to prevent conception and to cause miscarriage, using plants and other means, just as Anna Harding did in Eichstätt. But then the text veered into tales about women's supernatural powers. A woman in Reichshoffen could cause miscarriage just by placing her hands on a pregnant woman's belly. A young man lost his penis—as he put it, it went all smooth down there—when he broke up with a young woman. It came back when he strangled her, almost killing her.[35]

At times, the Dominican authors of the *Malleus* seem to have misunderstood things they had heard. For example, they repeat

what appears to have been a common anticlerical joke as if it were true. A sorceress, they tell us, collected men's penises, keeping them in a bird's nest, deep in the woods. When a man bargained with her and went to reclaim his penis, he reached for the biggest one. The enchanter told him not to take that one because it belonged to the local priest. Stories often circulated about the sexual appetites of priests, whatever their vows of celibacy. For example, villagers in Bavaria liked their local priest to keep a concubine so that he did not prey on local girls.[36] In the heavy hands of the Dominican friars, even dirty jokes were transmuted into signs of witchcraft.

In the same way, the two friars observed many aspects of pregnancy and childbirth, but often misunderstood or misinterpreted them. Women did control fertility using local plants. Both new mother and infant were exceptionally vulnerable during the few weeks after birth. Men did abandon girlfriends and they did respond with violence when challenged. Impotence happened, and domestic animals stopped bearing young. The authors of the *Malleus* provided long-winded explanations for how demons and the devil caused such misfortunes, replete with learned references to the Bible and the works of Church fathers. They also created a judicial apparatus to investigate, interrogate, convict, and execute witches. Their book provided a how-to manual for investigating outbreaks of witchcraft used by Catholics and then Protestants alike.

From our perspective, what the authors of the *Malleus* really provided was a template for creating a witch craze. Prosecutors used detailed lists of leading questions designed to elicit information that would match the *Malleus*'s description of witchcraft. They regularly tortured suspects, and not surprisingly, if you torture people enough, they may tell you what you want to hear. Such testimony mixed aspects of women's own lived

experiences with details prompted and shaped by the forms of the questions.

It wasn't just religious authorities who began to link abortion and witchcraft. Some doctors concurred. In his midwifery guide, sixteenth-century surgeon Jacob Rueff described a maidservant finding herself pregnant. Rueff was part of a new wave of male writers seeking to improve the practice of female midwives, who continued to attend almost every birth. He imagined the maidservant consulting "some old Witch," complaining of pains in the thighs and abdomen. The older woman knew full well what the problem was and prescribed a series of medicines from an apothecary as well as herbs that could be collected in the country. As a cover, the maid told her mistress and master that she had gripings in her belly, and eventually succeeded in aborting. She then shared the older woman's advice with other young women.[37] While Rueff's book was a medical guide to pregnancy, this story functioned like a folktale. It suggests that many, male and female, could imagine an older witchlike woman prescribing abortion medicines, much as Anna Harding was accused of doing.

Rueff also discussed sexual relations with demons. Such an idea may seem bizarre or laughable to us. But Rueff took it seriously and spent pages worrying about whether sex with demons might ever produce offspring. His book concluded that God would not permit demons to impregnate women, but a demon might make a woman *think* she was pregnant by puffing up her womb with wind and causing her grievous pains that might be mistaken for labor. This kind of confusion—was she pregnant or not?—was part of early modern women's everyday experience. There were no surefire pregnancy tests, and cessation of the menses did not automatically suggest pregnancy. The womb was subject to all kinds of swellings and discharges, just

as Elsbetha Eggenmann had experienced. We might interpret some of these symptoms as early miscarriage, but women often did not.[38]

Works such as the *Malleus* and Rueff's book offered new stories about female witches and the dangers they posed to their communities. However, decades of scholarship have not offered us any simple explanations for the outbreaks of witchcraft prosecutions in the sixteenth and seventeenth centuries. However, they seem to have been prompted by social upheaval—warfare and Reformation—combined with profound misogyny. These panics tended to descend suddenly on a town or group of villages. Sometimes a poor older woman's curses, tolerated for decades, would provoke an outburst of accusation. Then the authorities stepped in and started interrogating people in ways that began to shape the narrative. Interrogators knew what they were looking for and, under torture, pushed to get the answers they sought. Neighbor testified against neighbor, old grudges were rehashed, old stories were mixed with newer fantasies, all recorded by scribes in a courtroom or torture chamber. A rash of executions followed. Scholars estimate that as many as one hundred thousand people, mostly women, met their deaths in such early modern paroxysms of terror.[39]

Witchcraft panics did not happen all over Europe, nor were they associated specifically with abortion everywhere. German-speaking lands, and the adjoining territory of Lorraine in France, saw especially harsh outbreaks. England, Scotland, and the American colonies experienced convulsive panics in which accusations snowballed to include dozens and dozens of women, but Italy and the rest of France rarely saw such outbreaks. Nor was this a Catholic/Protestant distinction, as the list of countries on each side might suggest. Both Catholic and Protestant places experienced witch trials. And as we have seen,

key pre-Reformation texts such as the *Malleus* were later used by Protestants and Catholics alike.

In these repeated terrors, witchcraft narratives became rooted in the daily lives of women. The raw materials of witchcraft accusations came from the everyday experiences of women's lives, the cycles of pregnancy, breastfeeding, and childcare that characterized daily routines. The material facts of women's lives became the fantasies of witchcraft precisely because they were the stuff from which so many stories could be told—and because so many cultural anxieties centered on the fragile processes of childbearing and infant care.[40]

While single women's sexuality was the visible target of moral reform, the much more profound worries that haunted every household were about fertility. Why was the cow not giving milk anymore? Would the crops fail next year? Would the babies thrive to become the workers that the household needed? Would the children grow up to inherit the farm? Or would husband and wife grind on, year in, year out, ultimately with nothing to show for it all?[41]

In predominantly agrarian societies, connections between farming and pregnancy ran deep. Reproductive processes were imagined in terms of agriculture. Both men and women produced "seeds," which met in the womb. Seeds grew into plants that bloomed, and menstruation was often referred to as "flowers" in everyday speech. A midwifery manual explained that the earth embraced and nourished seeds, just as the mother's womb did a fetus. In cases of infertility, the book recommended planting two seeds, each in its own pot, and watering them with urine, one from the man, the other the woman. The pot that did not sprout indicated which of the couple was infertile. Sometimes the penis was directly compared to the plow, cultivating the womb like a field. Other comparisons linked pregnancy to

trees in an orchard, whose seeds became flowers and then fruit. As one midwife put it, "A good Tree will bring forth good Fruit." Conversely, in some communities, sexual rituals were practiced to ensure a good harvest.[42] A community depended utterly on the fertility of its fields and farm animals, and the fertility of its women. All were mysterious, and anyone who seemed to have power over them might become a focus for fear and anxiety.

Wondrous though the processes of conception and pregnancy were, they were also risky, liable to fail for reasons no one could diagnose. Again and again, testimony in witchcraft cases included litanies of pregnancies gone wrong, women in childbed suddenly taken ill, and babies dying. Often these were coupled with tales of cows no longer giving milk, or chickens no longer laying, or farm animals unexpectedly lamed or dying. A 1582 witchcraft outbreak in St. Osyth, on the Essex coast in England, detailed the harms witches caused babies and children. Ursley Kempe was furious when she was refused the job of nurse to Grace Thurlowe's newborn. Three months later, the baby fell out of its cradle and died. After another woman, Annis Leatherdell, refused Kempe some scouring sand for cleaning kitchen pots, her baby got sick and then got worse after Leatherdell confronted Kempe. William Byet's cows became strangely ill after he had conflicts with Kempe. Once interrogations started, other stories emerged. A family fired Cisley Selles as a wet nurse, and their four-year-old son dropped dead playing in the yard. Mrs. Glasscock bewitched and hurt two other children. Elizabeth Bennett injured three women and a child.[43] All these harms to mothers, children, and livestock in St. Osyth were attributed to witchcraft.

In German villages and towns, women who worked as lying-in maids, hired to care for mother and baby for a month after a birth, were exceptionally vulnerable to accusation. In

1669 in Augsburg, sixty-seven-year-old Anna Ebeler was nursing a new mother who died delirious after eating soup the maid had prepared. Ebeler was charged with witchcraft, and other women soon came forward with their own tales. One baby had become terribly thin. A second had been unable to nurse from its mother, only from other women, before it died in great pain. Yet another infant had broken out in strange swellings and blisters. A fourth case involved a baby whose skin dried out so much that it peeled off like a tiny shirt, and its mother's periods stopped suddenly and strangely. Ebeler had been the lying-in maid for each. She was convicted and executed as a witch two months after these accusations were voiced.[44]

A similar sequence had unfolded in Lorraine in 1609, when Jennon Petit was accused of causing nine miscarriages as well as the deaths of sixteen babies and five mothers in childbed. Women dredged up all kinds of losses from their memories and made sense of them by linking them to Petit's witchcraft.[45] Given rates of miscarriage and infant mortality, any community could probably have done the same.

Many older women—and those accused of witchcraft were often older women—had knowledge of abortifacient herbs and may well have used them in their youth. Maybe they had also recommended them to younger women. But the connections between witchcraft and abortion ran deeper than that. Even today, reproductive processes can be mysterious. As many as one-third of all infertility cases cannot be assigned a definite cause. Nor can medicine yet explain why childbirth starts when it does. Five hundred years ago, so much reproductive misery seemed inexplicable, potentially the result of malevolent forces. There was a continuum between witches who could provide abortions and those who might hurt children, because both pregnancy and infancy were risky times whose harms could

rarely be predicted. The supernatural seemed as good an explanation for these misfortunes as any other.⁴⁶

AND SO IT WAS IN EICHSTÄTT. IN 1612, THE REGION'S NEW PRINCE-bishop, Christoph von Westerstetten, pursued an aggressive policy to ensure that his territory remained Catholic. Some neighboring areas had become Protestant, and he was worried. A ruler both temporal and spiritual, Westerstetten welcomed the Jesuit order, known for educational and missionary work, to Eichstätt, and joined the Catholic League, an alliance of territories defending themselves against the tide of Lutheranism. He cracked down on local practices now deemed superstitious or irreligious, from extramarital sexual relations to wild parties on Fastnacht, on the eve of Lent. The Jesuits, meanwhile, instituted new forms of devotion, such as penitential processions in town and blessings of the fields to protect them from hail.⁴⁷

In 1617, a team of witch commissioners started investigating in Eichstätt. While there had been a flurry of witchcraft trials in the region in the 1590s, now the commissioners fomented a full-blown panic that ultimately resulted in the execution of 175 women and a small number of men. These numbers are startlingly high. This was a small and sparsely populated area that had already lost as much as half its population from poor harvests due to prolonged bad weather.⁴⁸

Despite such hard times, the trials seem not to have evoked the stories of neighborly resentments often seen in other witch trials, nor were those accused the most marginal in their community. Witnesses refused to corroborate stories produced under torture, and friends and neighbors even brought food to those in jail, risking being associated with witchcraft themselves. After Anna Harding was accused in 1618, she was visited

by at least two of her clients, Barbara Rabel and Eva Susanna Moringer, and by a friend, the vicar's cook Anna Maria, who also did sex work. It's possible that they wanted to make sure Harding did not implicate them, but maybe they brought comfort as well.[49]

The witchcraft commissioners used a list of eighty-four questions to interrogate suspects, twenty-two of which concerned the accused's personal life and moral status. When had she met her husband? Had they had sex together before marriage? How many children did she have, and were they living or dead? With whom did she "keep company"? The questions planted the idea of demonic sex, asking when—not if—the accused had had a relationship with a demon, whether she desired him, and how often they had sex. Further questions modeled a gathering of witches at night, with detailed inquiry into the food served, the topics of conversation, the dancing, and even how the accused managed to slip out of the house with no one noticing.[50]

As in so many other instances, the interrogators often got the answers they wanted, confirming the basic narrative of demonic sex laid out by the *Malleus*. Harding initially resisted their implications. Although three babies of the many she treated had died, they had been given regular herbal medicines, not some magical ointments. She had given the butcher's wife herbs to make the butcher impotent, but again, this was no magic. About a month after her arrest in January 1618, Harding told the commissioners firmly that she "was certainly no such person and the lord commissioners would not want to wash their hands in her blood." She was tortured in the town square, and cried out, "Jesus, Mary, help, I am no witch."[51]

After torture, Anna began to confess, offering a tale about a demon who came to her in the form of a nobleman from

Freihalden. This encounter may have been about the time that she started sex work; Freihalden is near Markt Jettingen, and it is easy to see how she might have imaginatively transmuted sex with a well-to-do client into a narrative about a relationship with a demon.[52] Yet even under torture, she continued to deny that her healing practices were witchcraft.

In June 1618, Anna Harding was convicted and burned at the stake. She had worked as a healer for decades.[53] She and other women like her had their ordinary medical practices transformed into evidence of magic by misogynist fantasies of male interrogators and a larger cultural shift that sought to control female sexuality in the interests of Church and state. Abortion became associated with witchcraft because it was a routine part of women's lives and healing practices. Those associations had power in a society that increasingly sought to restrict female sexuality and punish women who violated new norms about marital sex.

Anna Harding had the grave misfortune to be at the wrong place at the wrong time, to be swept up in a witchcraft panic. Like us, she was living in a moment when abortion was increasingly restricted, part of a larger pattern of gender backlash. Her life was shaped by many of the same forces as those of her clients: poverty, misogyny, migration. Both she and the women who sought her services were vilified when the witchfinders started torturing people. Her story shows us how larger forces shaped the landscape of reproductive restriction, from religious reformation to warfare, but it also shows us that despite severe penalties, abortion remained commonplace. Women were caught in the crossfire in so many ways in Anna Harding's world. Abortion was sometimes an obvious solution to their woes, even when it carried the risk of execution. In the centuries that followed, the rich European knowledge of

abortion-producing plants that Harding and others drew upon would travel farther afield, as Europeans began exploring the world across the Atlantic. Enslaved women from Africa, Indigenous Americans, and settler Europeans created new traditions of healing, often in circumstances they had not chosen.

CHAPTER 4

THE BOTANIST

NEW PLANTS, NEW WORLDS

Around 1700, two women met in Surinam, then a Dutch colony on the Caribbean coast of South America. Both were far from home. One woman had been captured in West Africa, enslaved, and transported to the Americas. We do not know her name, because the other woman, Maria Sybilla Merian, chose not to record it. Merian was a noted botanical illustrator who had come from Amsterdam to collect and paint insects and plants of the Americas. Once she returned home, she published a gloriously illustrated folio volume of what she had seen in Surinam. Gathering information for her book, Merian had asked the enslaved woman about the peacock flower, a dramatic plant with yellow-and-red blooms. The woman told Merian that the peacock flower's seeds had powerful effects on women's childbearing. She was echoed by local Carib and

Arawak women, also enslaved by the Dutch. These women told Merian that in their communities, both African and Indigenous American women were using the seeds to abort, so that their children would not be born into slavery.[1]

Merian does not tell us what she thought about this information. She was probably more interested in the pale green caterpillars that frequented the plant than this item of reproductive knowledge; she was fascinated by metamorphosis, the process by which a caterpillar becomes a butterfly or moth. The fifty-two-year-old Merian had already broken barriers by carving out a career as a solo female artist after leaving her husband. When she undertook her voyage to Surinam, she opted to bring her adult daughter with her, rather than a male protector.[2]

Merian settled in the small Dutch community of Paramaribo, alongside a few hundred European colonists. They were greatly outnumbered by enslaved people who grew cotton, coffee, and cocoa, harvested sugarcane, and performed domestic labor. Like their neighbors, Merian and her daughter were almost entirely dependent on the labor of the enslaved. Plant-hunting in the jungles was hard work, and sometimes Merian had her enslaved workers chop a path for her through the dense undergrowth of thistles and vines. An enslaved woman, probably Arawak or Carib, grew plants in Merian's garden, cooked her meals, did her laundry, and performed a host of other household chores. Merian referred to her as "my Indian." When Merian and her daughter sailed back to the Netherlands in June 1701, they brought this woman with them. We do not know what she made of Europe or what became of her there.[3]

Merian, the enslaved African woman, as well as "her Indian," would all have had knowledge of abortion, but this kind of women's information tended to be local. Their exchange of

information was a product of early modern European expansion, when people traveled long distances all over the globe, often propelled by enslavement and oppression. The Portuguese sailed down the coast of Africa, around the Cape of Good Hope, and on to India. The Spanish sailed in the other direction, across the Atlantic, and the Portuguese went that way as well, between them colonizing much of the Americas. These voyages brought crops across vast distances—think of the introduction of tomatoes and corn to Europe, or rice to the American South, or cassava to Africa.

Disease as well as knowledge crossed the Atlantic. Indigenous Americans, who lacked immunity to many of the diseases Europeans brought with them, suffered huge death rates; as many as 90 percent died. Both Spanish and Portuguese occupiers enslaved local populations and began importing enslaved Africans to replace them as they fell prey to disease and overwork. In the early seventeenth century, the Dutch set up colonies in Guyana, Surinam, and then in North America. By the end of the century, they would lose most of this territory to the upstart English, who colonized Caribbean islands and the east coast of North America, alongside settlements by the French, Germans, Swedes, and other European powers.

Knowledge traveled with people as they crossed oceans, sometimes not of their own volition. Take, for example, the experiences of Maaij Claesje, a seventeenth-century midwife. Born in Angola in 1646, she was enslaved by the Portuguese at age twelve. She was on a ship bound for Brazil and the sugar plantations, or possibly the silver mines, both very hard physical labor with high mortality rates. Then the Dutch captured the ship while it was still just off the African coast. They took many of the enslaved people, including Claesje, to a new colony, called Cape Town, in South Africa.[4]

There, Claesje worked as a midwife, and in 1671, she had a daughter of her own, named Sara, from a relationship with a Dutchman, Leendert Jansz van Gijselen. She must have been a good midwife, because in February 1689, when the Dutch official Pieter van Helsdingen was transferred to Batavia in the East Indies, he arranged for Claesje to accompany his pregnant wife on the long journey from Cape Town. In return, the midwife was supposed to be emancipated. With Claesje at her side, Geertruyd van Chastelein gave birth on board the ship. It is unclear whether the Dutch kept their part of the bargain, for when Claesje died at the age of eighty-six, she was living in the so-called Slave Lodge back in Cape Town.[5]

We can only speculate about the kinds of reproductive knowledge that Claesje might have encountered over her long life, from Bantu-speaking peoples in West Africa, Khoi and San peoples in South Africa, and Indonesian peoples in Batavia, as well as Dutch and Portuguese enslavers. As we lack any records of what she thought or knew, we can only make inferences based upon sparse Dutch records focused on slavery.

WOMEN IN THE CARIBBEAN HAD LONG BEEN FAMILIAR WITH A range of plants that would end a pregnancy. The sixteenth-century priest Bartolomé de Las Casas recorded early European encounters with Caribbean peoples. His writings describe the miseries experienced by the Indigenous Americans enslaved by the Spanish. The women were so desperate, Las Casas wrote, that they used "poisonous herbs" to abort pregnancies. When the English doctor Hans Sloane came to Jamaica in 1687, he recorded a number of local plants used for abortion. The "penguins plant," for example, provoked the menses, dewormed children, and caused abortion. Sloane added that sex workers used it frequently.

In Barbados, planters used a thorny shrub called the "flower fence" to hedge their fields. Sloane noted that it caused abortion, just like savin did back in Europe. In Surinam, John Gabriel Stedman described a local abortifacient as the "seven-boom" tree. *Seven-boom* is Dutch for "savin."[6]

On the North American mainland, too, Indigenous American peoples used local plants to end pregnancies. When European travelers arrived, they described abortion practices among the various peoples of the eastern woodlands and beyond. In 1632, Nicholas Denys noted that Wabanaki women in Acadia would abort if they found themselves pregnant while nursing a baby, in order to preserve their milk for the nursling. In the cold forests of the north, many women of the Algonquian-speaking nations might breastfeed a baby for two or three years, trying to ensure its survival. The Baron de Lahontan, a French explorer, traveled extensively in what is now Wisconsin and Minnesota in the late 1680s and, like Las Casas, brought an ethnographic eye to his discussions of Indigenous American peoples. He considered Algonquin nations to be admirably restrained in their sexual behaviors, better than many Europeans. He noted that an unmarried mother would never find a husband, so single women took herbal potions to end any pregnancies. Pregnant married women whose husbands died or were killed did the same.[7]

Farther south, John Lawson described the practices of the Tuscarora, Occoneechee, and Catawba peoples in what is now South Carolina. Women whom he called "trading girls" sold their sexual services to European traders. They aborted any ensuing pregnancies. Lawson added that a young woman who gave birth as a result of one of these unions was considered foolish or irresponsible. When these women tired of sex work, they married and started families, without any stigma. Virginian Thomas Jefferson reported that Indigenous American women

aborted any pregnancies when they accompanied their husbands on hunting expeditions or war parties, knowing that they could not sustain a pregnancy while traveling with the group.[8] Some of these European writers, like Lahontan and Lawson, admired Indigenous Americans, while others were much more critical, but their reports about abortion are similar, suggesting that the practice was known in eastern North America.

AS AFRICANS, INDIGENOUS AMERICANS, AND EUROPEANS BUILT new societies in the Americas, knowledge of abortion-producing plants intersected and started to overlap, creating hybrid knowledge and practices. For Europeans and Africans, the Americas provided an abundant array of new abortifacient plants, both those native to that hemisphere and those imported from tropical regions of Africa and Southeast Asia. Such exchanges were shaped by the contexts of conquest, genocide, and enslavement.

Often, the only textual records we have of such exchanges were written by Europeans, and like most people in strange places, they assimilated new things to old ones. Familiar with abortifacient herbs from back home, they slotted new plants and practices into well-known categories. When Europeans in North America learned about Indigenous American uses of abortifacient plants, they often described them using the offensive term *squaw*. Abortifacients and menstrual regulators included squawbush (guelder rose); squaw mint (American false pennyroyal); squawroot (black cohosh); squaw vine (partridgeberry); and squaw-weed (Philadelphia fleabane). Squaw mint was understood as a form of pennyroyal while squaw vine was similar to madder, both longstanding Eurasian abortifacients.[9]

One of the most widely discussed American healing plants was Seneca snakeroot, named by the English after the Seneca

people, an Indigenous nation settled in upstate New York. It was reputed to be an antidote to the bite of a rattlesnake. As in Europe, colonizers often reasoned that a plant that made the body rid itself of one thing might well rid it of others, so purges might be abortifacients as well. Snakeroot was both. Women took it when a period was late. Both men and women took it to purge their digestive systems. Snakeroot did not grow in cultivation, so it had to be harvested in the woods, but it was abundant in mid-Atlantic colonies, and collected commercially. By the 1790s, over two tons of snakeroot were being exported annually from Philadelphia to England.[10]

We also know about a few instances where Indigenous Americans took up European abortifacient plants. In South Carolina, Cherokee women used spotted cowbane and hemlock, or wild parsley, as contraceptives and abortifacients. These plants had long been used in German-speaking lands back in Europe and were now used by German immigrant settlements in America. One such community adjoined the Cherokee nation. These plants were not recorded as being in use by other Indigenous peoples, making it likely that the Cherokee learned of their abortifacient properties from their German neighbors.[11]

By the eighteenth century, a few Indigenous Americans lived as healers amid Euro-American communities, fostering new forms of exchange. In Rhode Island, a Narragansett healer known as "Indian Hannah" testified in a 1730 infanticide case. The accused woman, Sarah Pharaoh, had consulted her, asking for herbal remedies that would provoke uterine contractions. Hannah assured the court that she had been reluctant to provide the plant, because she thought Pharaoh was pregnant. She explained that her people often used this root to accelerate labor if a birth progressed too slowly. However, it should not be given earlier in pregnancy, as it would kill the fetus. We cannot know

what kinds of Indigenous knowledge Hannah might have been drawing upon in her testimony or what she was careful not to say in court. She knew that she had to be circumspect lest she, too, be prosecuted for some offense defined by the colonizers.[12]

A century later, Peter Smith's 1813 medical manual *The Indian Doctor's Dispensatory* captured some of the cross-cultural hybridization that had come to characterize abortion in the Americas. Smith claimed that his father had been an "Indian doctor." It is not clear what he meant by this, as there is no evidence that he was literally Indigenous American. Perhaps the term meant that he practiced using native plants, with knowledge thought to be derived from Indigenous Americans. His choice of title indicates that he thought this kind of medicine would be appealing to readers. Smith drew on multiple sources of medical knowledge. A Dr. Reeder was cited as the origin for a remedy for "female weakness" (an emmenagogue—that is, a drug that promoted menstruation) that contained the familiar European abortifacient plants dittany, aloes, and hellebore—but also Seneca snakeroot. A plant he called "square-stalk root" was credited to Indigenous American women. Smith described it as the "best women's root I know." He recommended imported tincture of cantharides to remove "obstructions," another euphemism for delayed periods. It was made from Spanish fly, a beetle native to Eurasia.[13] By the time Smith wrote his book, knowledge about abortion deriving from interactions among Africans, Europeans, and Indigenous Americans had become simply American.

IN THE SEVENTEENTH CENTURY, PLANTATION OWNERS IN THE Americas imported enslaved Africans in ever-growing numbers: thirty thousand a year by the 1690s. Caribbean plantations

focused on high-value export crops: sugar, coffee, and cocoa. In the Chesapeake and the American South, it was more basic commodities: cotton, indigo, and rice. Enslaved Africans brought their own knowledge of abortifacients with them. Back in West Africa, local plants such as cotton, manioc, yam, papaya, mango, lime, and frangipani had been used to end pregnancies, and some of those plants were imported to the Americas. Enslaved Africans in the Caribbean also identified and employed local plants that were botanically related to ones they had known back home, assimilating new herbs with those already familiar.[14]

In the seventeenth-century Caribbean, conditions were so brutal and mortality rates so high that plantation owners regularly budgeted for the purchase of additional Africans. In North America, enslaved people labored in a variety of contexts— those with a specialist skill, such as barrel-making or shipbuilding, might be hired out to earn income for the enslaver, while others labored on plantations, often of a smaller scale than those in the Caribbean.

Medical men in the seventeenth- and eighteenth-century Caribbean often interpreted abortion as Black women's resistance, similar to what Maria Sybilla Merian was told by enslaved informants in Surinam. Women did not want to bear children into perpetual servitude and so ended pregnancies. Other medical men just disparaged their female patients, assuming that they were up to no good. Hans Sloane, for example, was disdainful about some of his female patients in Jamaica, black and white, enslaved and free. He claimed that women saw him with pretended ailments so that they could get strong medications that would prompt abortion. He was confident, however, that he could see through such stratagems, and he either offered them harmless pills or assured them that they would recover without

any medicine.[15] Who knows how many women went without needed medical care because Sloane assumed they were lying?

When enslaved women avoided pregnancy or failed to carry to term, or when their infants were stillborn or died, doctors accused enslaved women of ill intent. Edward Long, a deeply racist recorder of life in eighteenth-century Jamaica, wrote that enslaved women used plants like bitterwood, known in local dialect as quassi, to end pregnancies. Medical man John Williamson claimed that enslaved women sought abortions because of some "ill disposition" toward their enslavers.[16] These men did not consider that the extremely hard physical labor these women performed, as well as malnutrition, might contribute to high rates of miscarriage. From our perspective, the widespread sexual abuse of enslaved women by white men might also explain a great deal of "ill disposition," but such went unremarked by writers like Williamson.

Evaluating evidence about enslaved women's use of abortion is challenging, because we almost never have their own words; their stories are refracted by doctors, overseers, and enslavers whose concerns were very different from the women's. Doctors who wrote about enslaved people were treating them as patients but obeying the directives of the enslaver paying the bills. They worried about malingering: Were enslaved people really ill or just trying to avoid work? How much physical punishment could a person endure before losing value? So doctors' words need to be read carefully.

By the later eighteenth century, the abolition movement was growing in Britain, and enslavers began to worry that the trade in Africans might come to an end. No longer would they simply be able to replace worn-out laborers with new ones purchased on the auction block. Now overseers and plantation owners began to be concerned with enslaved women as mothers. They

started considering the women they enslaved as generators of human capital. Such women were subject to increased surveillance, and abortion was punished more harshly. These women carried a double burden, laboring in the fields, and bearing the next generation of enslaved workers.[17]

British advocates for abolition pointed to the low fertility rates of enslaved women as evidence of their maltreatment. They testified in Parliament about the physical abuses of slavery, including ill treatment of pregnant women. In Jamaica, the Reverend Henry Beame noted that enslaved women's harsh treatment might end pregnancies. After describing how such women promptly obtained herbs and powders to abort if they were deserted by their husbands or quarreled with them, he also acknowledged that overwork, "particularly carrying heavy loads of provisions to the Sunday market," prompted miscarriages. He claimed that he had learned these details from enslaved people, as "the white medical man and overseers know little except from surmise." We can easily imagine that enslaved women were not forthcoming to overseers about such reproductive matters.[18]

The British Parliament abolished the slave trade in 1807, and the new United States followed suit the following year. No longer were ships going to cross the ocean from West Africa to the Caribbean or the Southern US—but abolition did not mean that enslaved peoples were emancipated, just that Africans were not newly enslaved and sold in British colonies or the US. It was not until 1834 that Britain outlawed the ownership of another person, and it was 1863, in the midst of the Civil War, when Abraham Lincoln emancipated American enslaved peoples.

With abolition, enslavers' concerns about maternity only intensified. They interrogated women about reproductive matters and handed out punishment to those whose behavior they

considered negligent or worse. Overseers faulted enslaved midwives for poor birthing practices, although often it was they who had selected such midwives. Others criticized women's care of their babies, suggesting that they were killing infants through neglect or careless practices.[19]

For enslaved women, motherhood was always already enmeshed in the coercive relations of slavery. In such a context, abortion can be understood as a form of resistance, refusing to add to an enslaver's capital by having a child, or judging that never being born would be preferable to a lifetime of enslavement. Our understanding of enslaved women and abortion must juggle two ideas in tension: enslaved women, especially in the Caribbean, were treated so poorly that it was difficult for them to bear and raise children—and such women knew and used abortion as both a personal and political act. But enslaved women also valued motherhood and mourned their losses when children died.[20]

THE EXPERIENCES OF CATALINA, AN ENSLAVED JAMAICAN woman, help illuminate how various factors influenced enslaved women's reproductive lives. Catalina lived and worked on the Wemyss Estate, a sugar plantation on the north side of the island, east of Montego Bay, along with about 250 other enslaved people. Producing sugar was known to be a brutal form of labor. Enslaved people in Massachusetts, for example, would be threatened with sale to Jamaica if they misbehaved. And the Wemyss Estate had money troubles; it was heavily mortgaged and, being inland, paid more to ship its sugar than did coastal plantations.[21]

In May 1824, Catalina was thought to have procured an abortion. She was thirty-five years old and described as

"Creole"—that is, she had been born into slavery, rather than transported from Africa. She had been married to William Polson for two years. Catalina told the overseer that she was pregnant and requested a transfer to a lighter work gang. In the spring, she and others would have been engaged in the exhausting labor of hoeing and harvesting sugarcane and transporting it to the mills where it was crushed to extract sap. She had previously quarreled with another woman in her gang, and the overseer suspected that the quarrel was the real reason for the request. He brought in a midwife, who examined Catalina and assured him that she was indeed pregnant. It was likely early in the pregnancy, as she had given birth the previous October to a baby who had died only recently. The overseer recorded that other enslaved people had ridiculed Catalina for engineering a lighter workload, and in response, she had told the midwife that she was going to abort, using a plant the overseer called "country Ebo."[22]

The attorney for the plantation, called in to interrogate Catalina, told a slightly different story. According to the lawyer, Catalina had taken vervain and contrayerva, both well-known abortifacient plants, because of a disagreement with her husband. After the lawyer and the overseer decided that Catalina had indeed ended a pregnancy, she was imprisoned for a month in what the overseer called "the Dungeon," allowed only bread and water as punishment.[23]

We will never know what really happened. Did Catalina end her pregnancy because of strife with her husband? Or quarrels with fellow workers? Or some other reason? Or did she miscarry? Did grief followed grief, as her infant had recently died? Whatever the case, her story, told by an overseer and a lawyer, treats abortion as part of the everyday reality of plantation life. Catalina's reproductive cycles were the subject of scrutiny

because enslavers were pressuring women to have children. In Catalina's case, the financial strain of a mortgaged plantation and uncertain sugar prices ramped up that pressure. We can speculate that enslaved women had been ending pregnancies all along, using both African and local knowledge, but enslavers' new focus on fertility makes such abortions more visible in the historical record.

IN THE AMERICAN SOUTH, PLANTATION OWNERS ALSO WORRIED about enslaved women as mothers. American plantations were more varied in scale and scope than the large sugar estates in Jamaica and other Caribbean islands. But enslavers and overseers worried about enslaved women's fertility in ways similar to their island counterparts. Over time in the South, women of European and African heritages appear to have exchanged information about abortifacient plants. By the mid-nineteenth century, both Black and white American women were employing cotton root, tansy, rue, and camphor to end pregnancies. Cotton root had long been used to provoke abortion in Africa, but tansy and rue were not native to West Africa. Rather, they had been used by European women for millennia. Camphor came from a tree native to China and would have been obtained commercially. While knowledge of cotton root had come with enslaved peoples from West Africa and then spread to white women, the uses of tansy, rue, and camphor had gone the other way.[24]

In a poignant historical irony, cotton root—the same plant that made enslavers' fortunes—was often the abortifacient and/or contraceptive of choice for enslaved women in the American South. In the daytime, women performed the backbreaking labor of cultivating and harvesting cotton, while by night, some

chewed the root of the same plant to try to control their own reproductive lives.

By the mid-nineteenth century, white Southern doctors were becoming aware of the practice. A Mississippi physician encountered a plantation where enslaved women seemed to miscarry very frequently. Hardly any children were born. Supposedly, an older enslaved woman revealed the secret: cotton root. A series of physicians then began to test the remedy on white women. In 1852, for example, a Tennessee physician treated an unmarried eighteen-year-old white woman for stopped menses. He reported happily that the remedy, new to practitioners like himself, was successful. Had the young woman been pregnant? Or merely late? The circumspect medical report does not acknowledge the former possibility. By 1860, cotton root bark was sold as an abortifacient as far north as Boston. A decade later, extract of cotton root was widely available, bought by women off the shelf, or used by local druggists to compound their own custom emmenagogues.[25] Knowledge that had its origins in Africa had been appropriated by white physicians, becoming part of their own expertise.

We have very few pieces of evidence about abortion from enslaved women themselves, rather than plantation enslavers or the doctors they hired. In the 1930s, the Works Progress Administration (WPA) hired writers to interview elderly Black people who had been born in slavery. A handful of these individuals told interviewers about abortion practices. By the 1930s, many decades had passed since they had been enslaved, so we must allow for the fact that memories can fade and change over time, but this is the closest we can get to hearing the voices of enslaved people on the question of abortion.

Mary Gaffney was born in Selville, Mississippi, in 1846, but was brought to Texas in 1860. Both she and her mother were

taken away from their partners in Mississippi and forced to marry men chosen by their Texas enslaver. In her WPA interview many decades later, Gaffney said bluntly that she hated her new husband and refused to let him touch her. He told his enslaver, Gaffney was whipped, and their sexual relationship commenced. But Gaffney refused to have children that would enrich her enslaver—as she put it, "I never did have any slaves to grow"—and her enslaver was puzzled. As Gaffney explained to the WPA interviewer, she chewed cotton root all the time, but was careful that her enslaver did not see her. Perhaps she became reconciled with her husband, Paul, because after Emancipation, she stayed with him, and they had five children together.[26]

Lu Lee, enslaved in Texas, recalled women "unfixing" themselves with indigo, which they grew in their garden to use for "bluing" the laundry. They harvested other medicinal plants from nearby uncultivated land. Enslaved women also used turpentine and calomel to "unfix" themselves, but these products would have been purchased rather than harvested. Lee thought the turpentine manufacturers had changed the way they made their product. Where once ten to twelve drops produced abortion, the same amount of the new formulation failed to do so, and women stopped using it. After Emancipation, two marriages, and three children, Lee trained informally to be a midwife—or a "granny," as she put it—and delivered many a baby.[27]

Dave Byrd, formerly enslaved in Texas, also spoke about the use of cotton root by enslaved women. They sneaked out at night to dig the roots, he told a WPA interviewer, and then planted them under their quarters in secret. Evidently, the roots were only effective after the plant flowered—but, as Byrd recalled, one flower was all that was needed. This detail

indicates that enslaved women were mobilizing botanical knowledge that doctors may not have known, as they did not mention this specification in journal articles of the period. Byrd opined that if slavery had lasted much longer, it would have died out because so many women were using cotton root. William Coleman, another elderly man who had been enslaved in Tennessee, recalled that women were very severely punished if they were caught chewing cotton root—but they kept on doing it. He marveled that any babies were born on plantations, so common was the practice. Byrd was only thirteen in 1865, and Coleman a year younger, so probably they heard about the use of cotton root after Emancipation, but it is striking that both men, formerly enslaved in different states, had such similar memories.[28] Sometimes abortion-producing plants are thought of as knowledge shared woman to woman, but these two men's memories suggest that cotton root's properties were well known to both sexes.

ENSLAVED WOMEN LIKE CATALINA AND MARY GAFFNEY WERE punished by their enslavers for trying to regulate their reproductive lives. But white women in colonial America rarely came under scrutiny or discipline from the authorities for the same kind of attempts. While abortion was prosecuted in a few instances, there were no statues criminalizing it in British law, which governed the colonies until 1776. After independence, the new United States did not enact legislation that outlawed abortion until a few individual states began to do so in the 1820s. When abortion was prosecuted in early American courtrooms, it was almost never the principal charge. Usually, men and women had to have done something else that troubled their neighbors, and abortion was just a part of larger concerns. Or

sometimes the topic of abortion arose incidentally in the course of testimony about something else. These fragmentary mentions offer historians glimpses of abortion practices otherwise unrecorded.[29]

A handful of Maryland cases from the 1650s offer rich detail about abortion practices, although the matter was often tangential to a court's primary concern. Take the tangled story of Susanna Warren and William Mitchell, for example. They became involved in London in 1649, when Warren was a nineteen- or twenty-year-old widow whose husband had recently died. William was forty-five, much older than Susanna, and he assured her that he would marry her when he could. This offer might not have seemed like an empty promise, because Mitchell's wife had medical problems, fainting away for two or three hours at a time. In late winter or early spring 1650, Mitchell and Warren prepared to embark for America together, with Mitchell's wife sailing on the same ship. William Mitchell was a rogue; he borrowed money from his lover to pay for his passage and then tried to pass Warren off as his indentured servant.[30]

When they got to St. Mary's City, a small settlement on the Chesapeake, Warren feared she was pregnant. It may have been Mitchell, already a father, who first suspected. One morning, he commanded Warren's servant to poach an egg and bring him his pillbox. The pills smelled so nasty that the servant refused to touch them. Mitchell stuck a pill into the poached egg and forced Warren to take it. He pinched her nose until she opened her mouth for air and then slid the egg down her throat. The effects were drastic. The pill caused terrible griping pains and lots of diarrhea. Warren thought she was going to die, but Mitchell scoffed at her. After two or three days of pain, Mitchell assured her that the medicine had "frighted it away," meaning

she was no longer pregnant. Unfortunately, he was wrong. Soon Mitchell was on another ship, headed back across the Atlantic to the Netherlands, where he had business interests, leaving Warren alone and pregnant in a new land. She had to petition a Maryland court for financial support from Mitchell's estates. Mitchell was an important man, friends with Lord Baltimore, the colony's proprietor, and Susanna and William had not been discreet about the relationship. The court quickly granted her financial help.[31]

Warren's infant was born dead or died not long after birth. When Mitchell returned to Maryland, Warren not unreasonably expected him to marry her. His wife had died under suspicious circumstances on the initial voyage from London. But Mitchell had started another relationship, with a woman named Joan Toast, and spurned Warren. It seems to have been this new relationship that prompted the local community to pull together an array of offenses and take both Mitchell and Warren to court in 1652. Although the testimony enables us to see the details of the attempted abortion, that episode was not the court's primary concern. Instead, it was blatant irreligion and promiscuous sex that posed problems.[32]

Mitchell had said some grossly blasphemous things, and his lovers had started to follow his example. Maryland had been founded on the principle of religious toleration for Catholics, who were a persecuted minority in England, but toleration went only so far. In court, for example, a number of people cast their memories back to a night in London two years earlier. Mitchell had sarcastically referred to Jesus and the Holy Spirit as merely "a man and a pigeon" who had deceived everyone for centuries. Nor did Mitchell ever attend church services. When the indictment was drawn up, the first offenses were all about religion: "He hath not only professed himself to be an Atheist, but hath

also endeavored to draw others to believe there is noe God."[33] It was bad enough that he voiced such opinions, but worse when others began to echo them.

Mitchell had tried to corrupt Warren and Toast with his godless ways, the court heard. When she was very ill, probably during the attempted abortion, Warren called on God for help, and Mitchell scoffed, asking her if she had actually seen this god of hers. Had he helped her? For a halfpenny, Mitchell would answer for all of her sins, past and present. When the midwife Mary Clocker suggested to Warren that she might be pregnant, Warren sarcastically replied that if she were pregnant, it was by the Holy Spirit. After having been abandoned and betrayed by Mitchell, Warren said that, damn her soul, but she would have revenge upon that damned Captain Mitchell. The men who heard her say this were deeply shocked. **Damn** was a much stronger word than it is now, connoting hellfire. Even Mitchell's newest conquest, Joan Toast, uttered some cynical remarks about religion, saying that there was no hell but a bad conscience, no heaven but a good one.[34]

In court, Susanna Warren pled guilty to fornication—it would have been difficult to do anything else—and to blasphemy and begged the court's forgiveness. She was sentenced to be whipped thirty-nine lashes, but it appears that many in St. Mary's City saw her as the victim, and in practice, the number was greatly reduced. More important, the court affirmed that Warren was not Mitchell's indentured servant, stating clearly that she was free. Mitchell had to pay her legal costs.[35] We do not know what she did next. She was still in Maryland a year later, but after that, she disappears from the record.

Mitchell was more difficult for the court, because he had such a powerful protector in Lord Baltimore. In the end, they fined him five thousand pounds of tobacco, the local currency.

The governor lowered that to three thousand pounds and paid two thousand of that sum himself, on Mitchell's behalf. On the ground in St. Mary's City, authorities were much more critical. The court ordered that Mitchell and Joan Toast be separated until they were properly married, and the judge muttered that there had been "much Jugling and baseness to the whole business." Mitchell seems to have settled down with Toast, occasionally popping up in legal records in the disputes about debt that constituted most of the court's work.[36]

Sometimes mention of abortion in a courtroom might not arouse any legal interest at all. After about a decade in Maryland, Elizabeth Robins and her husband, Robert, had a falling-out in 1657. They went to court, seeking to end the marriage. Robert accused Elizabeth of adultery, with a witness testifying that she had lain with a Captain Hunniford on his boat when it was docked on the Wicomico River. Elizabeth was pregnant, and a group of worthy married women was deputed to examine her. They reported that she was ill, "in a very Sad Condition." She told the women that she had twice taken the well-known abortifacient herb savin, claiming it was for worms—but no one was fooled. Evidently, the medicine did not work, for Elizabeth went on to give birth to a baby, an infant whom she was unwilling to swear was her husband's.[37] Elizabeth had done the same thing that Susanna Warren had done—attempted an abortion—but she was not prosecuted, although the court had evidence it could have pursued.

Communities in New England were more censorious about sex outside of marriage than those in Maryland or Virginia. But—as with the stories we've heard from colonies farther down the East Coast—abortion still appeared in court only rarely, and often among other offenses. In 1668, Ruth Briggs was tried for infanticide in New Haven, Connecticut. Briggs, like William

Mitchell in Maryland, had annoyed her community with various transgressions: she was rumored to have engaged in sex work and was already an unwed mother, a charge on the community's resources. In court, her neighbor Mary Russell testified that she had recognized the smell of savin on Briggs's breath months earlier, suggesting that Briggs had tried to abort.[38] It is striking that savin was so ordinary a medicine that a New England court found it wholly plausible that Russell could recognize its smell. Women in colonial America regulated their fertility using plants, and everyone knew about it. Whether in New England or farther south, abortion was simply not understood as the kind of misdeed that was worth prosecuting unless it were part of a larger array of bad behavior.

AS WE SAW WITH ENSLAVED COMMUNITIES IN THE AMERICAN South, men as well as women had knowledge about abortion. William Mitchell had told Susanna Warren that had they been back in England, he knew an old woman in Chichester who could have helped her "and noe body Should know it ffurther." But it was Mitchell himself who procured the abortifacient he forced down Warren's throat. A century later, the Virginia planter Landon Carter leaped into action when his pregnant daughter-in-law, Winifred, had trouble in 1774. Carter didn't like her much; in his diary, he sniped at her, often referring to her sarcastically as "Madam." On an October morning, "Madam" did not come down to breakfast, and Carter discovered that she was in labor, a midwife attending her. Two months earlier, Winifred had stopped feeling any fetal movements, and the infant was stillborn. Trouble arose when the pains stopped before she delivered the afterbirth. Carter hastened to send for the doctor, but he did not arrive. After a couple of hours, Carter

took matters into his own hands and gave Winifred a couple of doses of an unspecified medicine, fearing her life was at risk. Ten minutes later, all was well. The pains had returned, and the afterbirth came away.[39]

Once Carter was reassured that Winifred was well, he went back to carping, claiming that Winifred had not taken good care of herself while pregnant, always jolting around in carriages. Indeed, he said this was the third pregnancy she had lost due to such behavior. But he had helped her in her hour of need. A few days later, "Madam" acted as if nothing had really been the matter, but Carter claimed to know better, saying that all that rotten material inside her body had been highly dangerous. Carter was not medically trained, but he knew just which drug might make the uterus contract and rid itself of its contents—in this case, the placenta, but the same drug might end a pregnancy under different circumstances. He wrote of his intervention as if it everyone knew about such medicines.[40]

In the Franklin household in Philadelphia, Ben and his wife, Deborah, both knew about abortifacient plants. In 1748, Benjamin Franklin reprinted a well-known English textbook about basic arithmetic, George Fisher's *The Instructor*, and included a medical pamphlet by John Tennent at the back of the book to adapt the work for American tastes. Tennent's *Every Man His Own Doctor* was one of the first medical self-help books written and published in North America. Tennent was an avid campaigner for the virtues of Seneca snakeroot, which Deborah sold at the post office she ran with her husband. Tennent emphasized snakeroot's use for pleurisy, a chest ailment, rather than abortion. He recommended other plants for ending a pregnancy. His pamphlet confidently told women that if their periods did not return as expected, they should take the iris known as highland flag, followed by the classic abortifacient

herb pennyroyal. Tennent practically winked at the reader, adding that young women should avoid this problem by not longing for "pretty Fellows or any other Trash." Franklin's arithmetic book, with its medical guide, circulated widely in the American colonies, going into at least twenty eighteenth-century editions, including one in German. In 1771, two Black men escaped from enslavement in Maryland. They took with them a gun, bullets and gunpowder, and a copy of Franklin's book.[41]

Franklin produced the German edition of his math book to appeal to the seventy thousand or so German-speaking immigrants who settled in Pennsylvania. Some came to escape religious persecution, while others simply sought better opportunities than their war-torn homelands afforded. German communities in the colony did not need to rely upon Franklin's book; they had their own sources of information about abortifacient drugs. Franklin's contemporary Christoph Sauer sold medicines and produced an annual almanac in German for his Pennsylvania Dutch clientele. Like other almanacs of its day, it offered a mix of practical information, such as phases of the moon, a ready-reckoner for interest rates, and lists of local courts and fairs. Sauer also used the work to promote his drug business. He listed ninety-seven plants or substances that might provoke a late menstrual period, many of them abortifacients known for centuries, such as pennyroyal, mugwort, rue, and savin. In the new colony, some of the older German linkages between witchcraft and abortion may have faded, or perhaps only some readers recognized the potential to provoke abortion implicit in this list. Both savin and its American counterpart red cedar grew wild in Pennsylvania, as did a number of the other plants Sauer recommended. He also listed exotic substances, such as cinnamon, myrrh, cardamon, and coffee, that could be purchased locally. Galangal, originating in Southeast Asia, was

noted as unusual, but obtainable. Aristolochia, called *osterlucey* in German dialect, did not grow in Pennsylvania, but Sauer stocked it in his shop, adding that he hoped it would soon be grown locally.[42]

PENNSYLVANIA IS THE SITE FOR ONE MORE STORY ABOUT ABORTION in colonial America: against all odds, one woman's own account survives that describes how she ended a pregnancy. In Philadelphia, a friend of Deborah Franklin's named Elizabeth Coates Paschall made a living as a healer and a shopkeeper after she was widowed. In the 1750s, she kept a notebook of medical recipes that she collected as part of her practice. In those pages, she also recorded an abortion that had saved her life a few decades earlier.[43]

Paschall was no stranger to obstetrical issues. She endured repeated miscarriages during her married life, in addition to nine live births. Paschall was about three months pregnant when things started to go awry: she was gripped with terrible violent pains. She reasoned that her body was attempting to rid itself of the fetus, but it could not be delivered.[44]

In great pain, she (or her husband) called in a new kind of practitioner: a man-midwife, as well as a female midwife. The male doctor agreed with Elizabeth's self-diagnosis but offered no remedy. The female midwife tried to provoke the uterus to empty itself, to no avail. Next, the family called in an elderly woman known for her healing powers. The older woman prescribed a "glyster" containing chamomile, long known as an abortifacient. Usually, a glyster was an enema, but this medication may have been administered vaginally. It seems to have worked. The terrible pains ceased, Paschall lay still for about an hour, and then the fetus was delivered with little trouble.

Paschall noted down the lifesaving recipe in case it might be needed again.[45]

Paschall interrupted a pregnancy that she sensed threatened her health, with the full support of her husband and an array of health care providers. In colonial America, ending a pregnancy was not unusual. Because of the mixing of African, Indigenous American, and European knowledge of herbal medicines, American women may have had a wider array of abortifacient medicines available to them than those in Europe. But the meanings of abortion differed depending upon the status of the woman involved, just as they had in Europe, where single women were prosecuted for abortion and married ones largely ignored. For Elizabeth Coates Paschall, a free, white, married woman, ending a pregnancy was largely unproblematic. Enslaved women faced a very different reality. Catalina was immured in a so-called dungeon for a month, with only bread and water, on the mere suspicion that she had ended a pregnancy. Mary Gaffney and other enslaved women made sure to chew cotton root only when their enslavers would not see them, secretly cultivating seedlings under their quarters for their own use.

Enslaved women's experiences of abortion, and its repression, cast long shadows. The traumas of slavery echoed down generations, with women telling stories about both the pleasures and perils of motherhood and the terrible double burdens placed upon enslaved women, burdens of producing and reproducing. Those legacies have helped to shape today's critiques against framing abortion as "choice," made in an abstract world in which all women have both freedom and resources to make unfettered decisions about whether or not to become mothers.

Across the Atlantic, women in Britain began to be at greater risk of unwanted pregnancy in the nineteenth century, just as new legislation criminalized abortion as never before. An array

of social changes, not least the possibility of easy immigration to the Americas, enabled men to disappear when their lovers became pregnant, much as men in turbulent Reformation Germany had done, escaping to other towns or enlisting in the military.

CHAPTER 5

THE SEAMSTRESS AND THE MIDWIFE

SENSATIONAL STORIES IN VICTORIAN BRITAIN

ELIZA WILSON STARTED SEEING RICHARD ORPIN IN THE SUMMER of 1848. She was thirty-two, unmarried, living with her father in Norwood, a suburb south of London. Her sisters and brother lived with them, or very nearby. Like so many of their neighbors, the Wilsons were not Londoners born and bred. They had come to the capital from Keswick, up in the Lake District. Eliza was a dressmaker, and her sisters were also in the needle trades. Most women were taught to sew when they were girls, so dressmaking was a very common form of work, and also very underpaid. The sewing machine had not yet been invented, so every stitch in Victorian dresses—which could contain twenty-five yards of fabric—was handsewn. Richard Orpin was two years older than Eliza. He lived in Rose Cottage in Norwood, with his wife, Jane, to whom he had been

married for a decade. He was working as a carpenter, she as a laundress. Two younger women lived with them. These three women were running a laundry business. Anyone who could afford it sent their washing out—it was hot, strenuous work, bending over tubs of scalding water.[1]

Eliza and Richard snatched time together as they could. Once they were seen at 1:30 in the morning, kissing in the dark in a quiet corner of the village. At thirty-two, Eliza was a spinster; on average, London women married at twenty-four. Perhaps she was happy to be with Orpin, even if he was married, settling for an affair. Their sexual relationship must have been furtive. Eliza and Richard may have met first at his house, when Eliza had needed Jane's services for her dressmaking. But Richard could not bring her home as his lover, and she could not bring him home either, or at least not entertain him in her bedroom. Not long after they became intimate, Eliza feared that she was pregnant. Richard told her not to fret, that they would cope. A few days later, he took her to see a midwife in Walworth, five miles away, a village that had been swallowed up by the expanding city.[2]

UNWED PREGNANCY HAD LONG BEEN RELATIVELY COMMON IN Britain, not least because sexual relations were a normal part of courtship. If a woman got pregnant, there was substantial local pressure on the couple to get married. In smaller communities, everyone knew who had been seeing whom, and local officials as well as family members made it clear to the man where his responsibilities lay. If he refused, he was liable for child support payments and medical care for his lover's childbirth and convalescence. In those cases where a woman was unwilling to admit who the father was, and the community was unsure, the local

midwife was on the case. She interrogated the mother during labor, because it was thought that a woman dare not lie when she was at risk of losing her life.[3]

However, the forced-marriage solution to illegitimacy did not always work. Women were not always able to marry the father of their child, particularly when they worked as domestic servants, as many did. In Victorian Britain, servants were not just for the rich. Even artisans and shopkeepers usually had a young woman or two living with them to do the domestic work. In the country, agriculture depended upon the work of many young male and female laborers. Agricultural households could be hotbeds of adolescent sexuality, as it was not uncommon for three, four, or more unrelated teens to be living under one roof, usually in close quarters.[4] Again and again, masters took advantage of their female servants, and when such a young woman became pregnant, she knew she would be cast out of the house by her mistress without a second thought.

By the latter half of the eighteenth century, the system of premarital sex followed by hasty weddings had broken down, especially in London. The metropolis was a magnet for young men and women seeking better wages and some urban excitement. In London, there was little community pressure on a young man to marry his pregnant lover. The city was huge: a million people by 1800, tripling by 1860. A man could melt into the shadows without any difficulty. Some did marry, but many women were left in the lurch. Historians estimate that by the early nineteenth century, over half of all first births in London had been conceived out of wedlock, some unmarried, some rushed to the altar. By 1850, the rate of illegitimacy in London was higher than it had ever been. It would not reach the same levels again until the 1960s.[5] So Eliza Wilson's plight was not unusual.

Londoners knew that young women were at risk of unwed motherhood and had begun to build a fragile and imperfect safety net for them. The Foundling Hospital, built in 1739, offered women the chance to leave a baby whom they could not keep. An infant would be wet-nursed and then cared for, trained in a useful trade. Unlike similar institutions on the Continent, it was not anonymous. In France and Italy, Catholic-run foundling hospitals worked like the "firehouse laws" of the United States today. A woman could leave a baby safely and anonymously, no questions asked. Many included a "tour," or a horizontal wheel that pivoted from outside the building to inside, like a giant lazy Susan. A woman placed a baby on the wheel, rang a bell, and fled. The hospital staff, hearing the bell, rotated the wheel into the building and retrieved the baby.[6]

The London Foundling Hospital, dependent upon donations, did not want to look as if it were supporting irregular sexual liaisons, so made its intake process much more difficult than those of similar Catholic institutions on the continent. By the early nineteenth century, women needed to prove that they had been in a committed relationship, headed toward marriage, before the hospital would consider taking a baby. Letters of recommendation and investigations were part of the process.[7] Eliza Wilson had no chance here.

In the late eighteenth century, a poorer woman might be able to deliver her baby in a new institution, the lying-in hospital. These women became so-called teaching material as these hospitals instructed both male doctors and female midwives. Only two of the five London lying-in hospitals would admit a single woman, again afraid of appearing to foster extramarital sexual relations. For those two, women usually needed to demonstrate that their pregnancy had resulted from a premarital relationship gone wrong.[8] Eliza Wilson did not fit this model, nor could she

risk dismissal from her employment as a seamstress when her condition became known.

Women became doubly disadvantaged in the 1830s and '40s. First, it became ever easier for men to disappear. The advent of train travel in the 1830s and regular transatlantic ship service from the 1820s, followed by steamships in the 1840s, meant that there were multiple ways for unwilling fathers to get away. In 1840, a ticket in steerage from Liverpool to New York City might cost a month's wages for a factory worker or three months' for a manual laborer. If a man didn't have the funds, some companies would take no money down in return for a period of indentured labor upon arrival. Ships left Liverpool weekly. By the end of the decade, steamship travel had made transatlantic trips even faster and cheaper.[9]

Probably more significant than improvements in transportation, however, were changes in the local welfare system brought about by the 1834 New Poor Law. Before then, poor pregnant women could count on help from local authorities, as they were the ones who pressured reluctant fathers into marriage or extracted child-support payments and money for the midwife. The system was far from perfect. Women were only entitled to support in the parish in which they were legally settled, and employment contracts were often written to ensure a woman could not gain settlement where she was working. In practice, poor women often only had a settlement in the parish where they had been born, often far from where they were living and working as adults.

But the New Poor Law made things much worse. The law was intended to discourage anyone from asking for relief. No longer would those in need remain in their homes. Instead, to get help, they had to be incarcerated in workhouses, which the laboring classes quickly understood as prisons for poverty.

Under the so-called Bastardy Clause, men were freed from any paternal responsibility whatsoever. They were not chased for child support or made to marry, but their pregnant partners were locked up in workhouses. Some women resisted the workhouse at all costs. In Newcastle in 1843, Margaret Wheatley, a twenty-two-year-old single woman, refused medical help from Poor Law authorities although she lacked money for a midwife. She died in childbirth.[10] Shame and imprisonment were strong deterrents.

WHEN ELIZA WILSON GOT PREGNANT, INFORMATION ABOUT BIRTH control was becoming increasingly available to Englishwomen. In 1823, the radical tailor Francis Place distributed anonymous handbills in London and the Midlands that described both withdrawal and women's use of a sponge soaked in vinegar, inserted into the vagina before intercourse, potentially without the knowledge of a partner. In 1826, Richard Carlile, another political radical, produced *Every Women's Book*, priced at one shilling and sixpence, subsequently available in a threepenny abridgment—about the cheapest price imaginable—in which he advocated for birth control (detailing the use of withdrawal, sponges, and condoms) and for sexual pleasure for both women and men. Condoms had a bad reputation in England because they had been introduced as a venereal disease preventive, and they were expensive, handcrafted from animal intestines. But the other two methods were cheap and safe.[11]

Working-class English couples were not persuaded about these new contraceptive methods. For many, large families were desirable, and birth control was tainted by its association with political radicalism and with sex work. So, too, working-class women were already practicing family limitation by means of

abortion, taking what Francis Place called "poisons," or dangerous abortifacient drugs. By the mid-nineteenth century, however, the middle classes began to adopt what were delicately called "preventive means" to space out the arrival of babies, resulting in smaller families. The French had already begun limiting family size; after the Revolution, they saw falling birth rates. Indeed, Richard Carlile may have learned about the use of the sponge from a Frenchman. He wrote to a friend that many a Frenchwoman habitually wore a ribbon inside her petticoats with a sponge tied onto it: "The women there do not hesitate to make it a common practice; though a first hearing of the matter dreadfully shocked our English women."[12] As ever, the English saw the French as more sexually sophisticated than themselves.

While this advent of contraceptive methods might have promised some women release from unwanted childbearing, none of it would have been much use to Eliza Wilson. Soaking a sponge in vinegar and inserting it into her vagina required a measure of privacy that hurried sex out-of-doors with her lover simply could not afford. In any case, she may not have known much about the mechanics of sex and reproduction. Her mother was long dead, and all her sisters were unmarried, so they were unlikely to be sources of information. Orpin was Wilson's first sexual relationship.

Richard Orpin was more knowing. Once Eliza feared she was pregnant, he had a solution to the problem. On September 4, a Monday, he took her to see a midwife named Spencer Lindfield. Lindfield was not home, so they went around the corner to Mary Dryden, an herbalist who worked with Lindfield. Dryden sold them a bottle of medicine and some pills for four shillings, about twenty-five dollars in today's value. The medicine contained savin, the herb known for millennia to provoke miscarriage. Lindfield also had a supply of the plant at her house

among a hundred other medicinal herbs. Plant-based remedies such as these were well known, and herbal practitioners were commonplace.[13]

It is intriguing that it was Orpin who knew about a local abortion provider. Possibly he had been in this situation before, with another lover, or with his wife—abortion was a common method of family size limitation among the working classes, and as far as we can tell, the Orpins had no children. In any case, faced with an unwanted pregnancy, Orpin knew where to turn.

While Eliza Wilson seems to have been unaware of the practice, medication abortion was widely available in Victorian Britain. Newspapers included advertisements for abortifacient medicines, touted in coded language. Many were made from herbs that had been used for centuries. In London, surgeon Henry Scott marketed and sold his "female obstruction pills." "Obstruction" referred to blocked menses: it was the commonest code word for abortifacient drugs. Aside from such patent remedies, there were means available from any druggist's or chemist's shop. By the early nineteenth century, arsenic was sold as a rat poison and began to be used as an abortifacient, often with deadly results.[14]

The feminist Mary Wollstonecraft casually referred to medication abortion in her 1798 novel *Maria: or, The Wrongs of Woman*. The character Jemima recalled that, aged sixteen, she was working as a servant when she was raped by her employer. When she found herself pregnant, he worried that his wife would find out and bought an abortifacient drug. Jemima did not take it immediately. Then one night, her drunken employer raped her again and was caught by his wife, who beat Jemima and turned her out in the street, saying that she had been "born a strumpet." Destitute and homeless, Jemima took the abortifacient drug and successfully ended the pregnancy.[15] Of the many twists and turns of

the plot, this one was minor and seems to have echoed many an unfortunate servant's experience.

We will never how many abortions were performed in early nineteenth-century Britain, but medical men were beginning to be concerned by what they saw as very high numbers. In 1825, one physician claimed that two-thirds of unmarried women who found themselves pregnant tried to abort, often using cantharides (better known as Spanish fly), Epsom salts, or Glauber's salts. The latter two were commonly available purgatives. In the same year that Eliza Wilson saw Lindfield, a physician at the Manchester and Salford Lying-In Hospital described abortion as a "diabolical act," claiming that it was "perpetrated to a great extent."[16] In the new lying-in hospitals, medical men were encountering working-class female patients, women who would have rarely accessed such medical care previously. The doctors' eyes were opened to lives very different from their own.

ELIZA WILSON TOOK THE MEDICINES MRS. DRYDEN PROVIDED, but they did not work as she hoped. Clearly, she was very worried, as she took the two-hour walk back to Dryden a mere two days later. Dryden took her to see Lindfield, and Wilson confided in her that the sexual relationship with Orpin was very new. At one point, Lindfield evidently told her that it was too early for even the most skilled midwife to determine pregnancy.[17] As in earlier times, pregnancy was notoriously difficult to confirm in the early months. Wilson may have been particularly sensitive to small bodily changes, or maybe her worries were also about the nature of the relationship itself.

Lindfield was an herbalist but also a highly trained midwife. Her business card described her as "Mrs. Lindfield, Midwife, Dentist, and Practical Herbalist, &c" and contained a long list of herbs

and herbal medicines, as well as the phrase "retirement for ailing females."[18] These words told readers that Lindfield was running a maternity home where a woman could give birth in secret. Neighbors noted that cabs frequently stopped in front of her house, and well-dressed women, some of them visibly pregnant, stepped into her home. Such an institution could enable a woman to conceal her pregnancy from family, friends, and neighbors.

"Concealment" had carried special weight in English law about childbirth. Back in 1624, Parliament had passed a unique law: an unmarried woman who gave birth secretly was presumed guilty of murder if the baby died. The legal system was predicated upon the well-known principle that an accused person was innocent until proven guilty. In British law, single women who had given birth were the only people judged guilty unless they could prove their innocence, and such proof was almost impossible when a woman had wanted to keep her condition secret.[19] By 1848, this law had been superseded, but it cast long shadows. If money could be found, it was much safer in every way for a single woman to give birth in a clinic like Lindfield's than to try to do so secretly in her lodgings.

Lindfield was running what we would call a *reproductive services clinic*, and hers was not the only one in Britain in this era. She provided prenatal care, delivered babies in mothers' own homes or in her clinic, diagnosed and treated clients with herbal remedies, provided both medication and procedural abortions, and even did some dentistry. As yet, historians know little about these kinds of institutions. Lindfield never advertised, as far as I can determine, but word of mouth seems to have brought her plenty of clients.

Women in other cities might also be able to find clinics like Lindfield's. A Mrs. Laidlaw ran a very similar practice in Newcastle and then in Edinburgh. In 1803, she told readers in no

uncertain terms that she was the answer to unwanted pregnancy, saying in italics that she offered a service "particularly to receive lying-in Women who wish Concealment." By using the term *concealment*, Laidlaw may have been alluding to the older law on infanticide. Laidlaw reassured women that they could have it both ways: deliver in secret, but not be at risk of accusations of infanticide if the baby did not survive. Her clinic offered a full range of services: milk, night nurses, and even the promise "to relieve the Parents altogether" for a "Sum of Money." Laidlaw moved to Edinburgh sometime around 1815, but she continued to advertise in the Newcastle newspapers for decades. Edinburgh was two days' travel by stagecoach from Newcastle, so not an option for a poor woman, but Laidlaw's continued advertising suggests persistent demand for her services. She claimed to have been in practice for forty-two years.[20]

Spencer Lindfield, whose practice resembled Laidlaw's, had experienced some of the same wrenching social changes in relations between men and women that many of her clients had done. She was born Spencer Mills in the central London parish of St. Giles Cripplegate in 1789, making her fifty-nine when Eliza Wilson sought her services. When she was twenty, she married Thomas Taylor in a parish just a short walk from where she had been baptized. At some point in the 1810s, Taylor went to sea and did not return. Spencer Taylor, as she was then known, thought he was dead. She wed William Lindfield—it's not clear whether this was a common-law marriage or a church wedding—and took his name. In August 1819, she had a huge shock: her brother James showed up at her mother's house with Thomas Taylor. By coincidence, they had returned on the same ship and went to the Mills home, not least to find Spencer.[21]

On the very same day, Spencer renounced William Lindfield and went back to living with Thomas Taylor as her husband.

But Taylor disappeared almost as soon as he reappeared. Like so many other men, he could escape to sea or to the colonies easily. By 1821, Spencer was back with William Lindfield. She gave birth to their daughter, Caroline, in February 1822. Her choice of name might have referred to Queen Caroline, who was a heroine for many in the working classes. The queen had been accused of adultery by George IV, but many saw the king as a hypocrite, as his relationships with his mistresses and the numbers of his illegitimate children were very widely known. Riots and protests demonstrating for Caroline convulsed London during her trial in 1820.[22] Caroline, therefore, was a name with resonance when Spencer gave it to her daughter eighteenth months later.

Around the time of her daughter's birth, Spencer and William were living in Walworth, where he was working as a gardener. She embarked on midwifery training, taking a course in midwifery and the diseases of women and children. It was taught by Henry Gore Clough, who had himself been trained by William Hunter, the leading man-midwife in eighteenth-century London. Clough was a member of the Royal College of Surgeons and offered instruction both at his office in Berners Street and at the Marylebone Lying-In Hospital. Clough's program offered lectures on theory and anatomy as well as practical instruction on delivering babies in the lying-in hospital. Lindfield was, in other words, a very highly trained midwife. At this time, most of her fellow midwives would not have had this kind of education, learning their craft instead from an older midwife.[23] Lindfield's training mattered to her. For decades, she carefully preserved the certificate she had earned from Clough.

Spencer's husband William died or disappeared at some point in the next few years, and by 1826, she was running a midwifery clinic on her own. Lindfield's business seems to have been well known to the local authorities, as they paid for

a number of births at her clinic. Martha Burrows, an unmarried pregnant woman, delivered her baby boy at Lindfield's establishment in April 1826. Her fees were paid by the local Poor Law. Local authorities probably tried to recover costs from the father, William Davis, a coachman in nearby Lambeth. The month after Burrows's son, William, was born, another woman, Mary Page, gave birth at Lindfield's. The father, Charles Page, was just listed as "abroad," much as might have once been said about Thomas Taylor, Lindfield's first husband.[24]

Local rumor must have reached Spencer Lindfield that autumn, for she went to see Martha Burrows's baby in October and was shocked by what she found. Little William was starving. Local authorities investigated, and in the end, Spencer Lindfield adopted William and brought him up as her son. Later, she told him that his birth mother had wanted to drown him in the Surrey Canal, a local waterway that he must have walked past frequently.[25] When he grew up, he became an herbalist like his adoptive mother.

Spencer Lindfield had been appointed as the local poor-law midwife—an indication of the respect she had garnered locally—sometime before Eliza Wilson sought her out, although we don't know exactly when. After the advent of the New Poor Law in 1834, her duties probably included attending to women who gave birth in the local workhouse. But respectable married women were also her clients, as was a local charity supporting poor mothers. One of her clients, a Mrs. Elizabeth Baker, described how Lindfield "acquitted herself with skill and judgement" when she attended the birth of Baker's baby.[26]

So when Eliza Wilson went to see Spencer Lindfield, she saw one of the most highly skilled midwives in the area, a

woman with decades of experience, recognized by the local authorities as highly competent. Tragically, however, all that training and experience could not save Wilson. Lindfield performed an abortion using instruments, and Wilson rapidly became very ill.[27] It is hard to be sure what procedure Lindfield did, but it seems likely to have been a so-called catheter abortion, in which a catheter or tube was introduced into the cervix, irritating the womb and subsequently provoking a miscarriage. It may have been a safer procedure than a dilation and curettage (D&C), which involved scraping the wall of the uterus. Before the advent of antiseptic surgery, and then antibiotics, both were hazardous.

Initially, Eliza Wilson did not want her family to know the likely reason for her illness. On Thursday, September 14, her brother took a note from her to Lindfield, saying, "Pray do not let them into the secret just yet." Eliza added that her family was angry that she had not been willing to see a doctor, even though at this point, she feared she might not recover. Lindfield sent some basic medicines, likely intended to reduce fever, but Wilson was getting worse. On the next day, her father called in a surgeon, John Chapman, who suspected that he was seeing the results of an abortion. Chapman, as it happened, was also the local police surgeon, and he began to activate the machinery of the law. He had Spencer Lindfield, her son William, Mary Dryden, and Richard Orpin taken into custody, fearing that Wilson was going to die.[28]

Six days later, a local magistrate and a minister came to Wilson's bedside to hear her testimony. Everyone present, including Eliza, knew that she was likely to die. Such in articulo mortis statements were, if properly witnessed, legal testimony in court and were used in cases where it was feared a person would not survive to testify. Two days later, Eliza Wilson did die, likely

from what we would call a *septic abortion*. It was a miserable way to die. She was fevered, retching, and in pain.[29]

Before the advent of germ theory later in the century, such infections were poorly understood. The same kind of infection could happen after childbirth, when it was called *puerperal fever*. It was a major factor in maternal mortality, accounting for half of women's deaths within six weeks of giving birth. And mothers continued to die. In 1876, the pioneering demographer William Farr, usually a numbers man rather than a poet, mourned what he famously called "a deep, dark and continuous stream of mortality" when totaling up over one hundred thousand deaths of women in childbed over three decades. The maternal mortality rate stayed at a stubborn five deaths per thousand live births from Eliza Wilson's day all the way into the late 1930s, when the advent of sulfa drugs made both childbirth and abortion much safer. We will never truly know how many similar deaths resulted from abortions, as these were sometimes only suspected, listed as miscarriages or even less specific causes of death.[30]

AFTER WILSON DIED, THE LINDFIELDS, DRYDEN, AND ORPIN WERE charged with murder. The various magistrates' hearings and the inquest were reported extensively in the press, undoubtedly adding to the Wilson family's grief. Although the charge was murder, the case was shaped by recent changes in legislation. In the nineteenth century, British law about abortion shifted considerably. Legal scholars disagree about the status of abortion in common law before that time, but there were no specific statues on the books, and prosecutions were vanishingly rare.[31]

Abortion was first specified as a statutory crime in 1803, as part of a curious piece of legislation known as Lord Ellenborough's Act. Originally titled the Malicious Stabbing or Shooting

Bill, the law specified penalties for an array of crimes, mostly assaults and violent acts of protest in Ireland. We do not know why Ellenborough added abortion to the bill, except that some of the other provisions also served to define felonies where the law had previously been unclear. The bill made it a crime to use poison to attempt to murder one of His Majesty's subjects or to procure a miscarriage. After quickening—that is, the moment when a woman first felt a fetus move within her—the penalty was execution. Before quickening, a convicted provider faced transportation—that is, exile—to Australia. Another clause tried to tighten up the peculiar 1624 law on concealment and infanticide, although by this time, convictions were rare—those who violated the law faced execution, and juries had no appetite for sending a woman to her death for the loss of a newborn, often under ambiguous circumstances.[32]

While Ellenborough's legislation was probably intended to codify the law, legal scholars see it as a bit of a mishmash. It created ten new felonies, all capital crimes, punishable by death. There were odd inconsistencies in the act. While using medication to procure an abortion after quickening was prohibited, it neglected to say anything about instrumental, or procedural, abortion after quickening. Both modes of abortion were, however, forbidden before quickening. In 1828, subsequent legislation tried to address some of the problems with the act—for example, by prohibiting procedural as well as medication abortions after quickening. In 1837, post-quickening abortion ceased to be a hanging offense, instead punished by transportation or three years' imprisonment.[33] There had been few convictions, and maybe lawmakers reasoned that reducing the penalty might actually give the law more teeth in practice.

Even as the law enshrined a distinction before and after quickening, doctors were becoming increasingly dismissive of

it. Quickening, after all, put power in the hands of a woman. Only she could say for certain if she had quickened and therefore was definitely pregnant, not simply experiencing a menstrual delay. When medical men began to be able to detect a fetal heartbeat, they were able to downgrade quickening as a moment of significance. René Laennec invented the stethoscope in 1816. A few years later, his close friend Jacques Alexandre Le Jumeau, the Vicomte de Kergaradec, used the instrument to hear a fetal heartbeat.[34] Today, sounds observable with a stethoscope during pregnancy are still known by their French names in medicine—terms like *placental souffle* and *bruit* harken back to Le Jumeau's work.

An Irish doctor, Evory Kennedy, who had spent time observing in Parisian hospitals, championed the use of the stethoscope in pregnancy. He argued that the new technology enabled both the earlier detection of pregnancy and the assessment of fetal health. Kennedy worked at the Rotunda, Dublin's renowned maternity hospital. The Rotunda, like the Marylebone Lying-In Hospital, where Spencer Lindfield trained, was a generator of new obstetric knowledge. Doctors and midwives helped hundreds and hundreds of pregnant women give birth and were able to see patterns that had eluded those whose work was on a smaller domestic scale.[35]

Kennedy also saw the stethoscope as a tool for doctors in the courtroom. Legal tradition held that execution was postponed when a pregnant woman was convicted of a felony. Often the sentence was ultimately changed to transportation or otherwise mitigated. The practice was widely known as "pleading the belly." A so-called jury of matrons, a group of married women presumed to be familiar with pregnancy, was assembled to examine the woman and determine if she were truly pregnant. Kennedy was scathing about such juries, calling them

"absurd and ludicrous." By the early nineteenth century, case law specified that a woman had to have quickened in order to plead the belly. The timing of quickening coincided with the ability to hear a fetal heartbeat using a stethoscope, roughly at the midpoint of a pregnancy. But quickening was determined by a woman and a heartbeat by a doctor. Kennedy believed that a professional medical man's diagnostic skills, heightened by the use of the stethoscope, should be all that mattered, not the words of women. Juries and judges, however, continued to pay attention to women's testimony.[36]

SPENCER LINDFIELD WAS PROSECUTED IN THE MIDST OF THIS struggle over legal authority about pregnancy: Was it women or doctors? At hearings and her trial, surgeons testified, but so did local women. Many people in the neighborhood knew that Lindfield's clinic provided abortions as well as a range of midwifery services, but opinions about her work seem to have varied. One neighbor testified that she and others found it suspicious that so many pregnant women arrived at the clinic, but no one ever seemed to leave with a baby. Cross-examined, she had to admit that she couldn't be sure that they left empty-handed, as she was not watching the house at all times. She also testified to Lindfield's skills as a midwife, adding that she believed the midwife also worked for a local charity that supported poor mothers, a clear marker of respectability for Lindfield and her practice.[37]

One local policeman, Superintendent Robinson, seems to have been especially keen to move the case toward prosecution. Robinson described the police searches of Lindfield's and Dryden's homes the day after Wilson died and noted regretfully that "nothing of a suspicious character had been found." Then

Robinson pivoted. He told the court that he had made an extract from the police station's "Occurrence Book" and then read it into evidence. It was a list of six infant bodies that had been found in the neighborhood over the past year. Next, a police surgeon described the herbs and the midwifery instruments found at the clinic, noting that they were all standard tools of the trade. Robinson could not resist adding that "in unskillful or improper hands a very dangerous and fatal use might be made of them," which might be said of any craftsman's tools, from a carpenter to a shoemaker. Lindfield, however, was very highly trained. The magistrate Norton "observed that this was all highly suspicious" and refused bail to any of the prisoners.[38]

Robinson continued to try to link Lindfield to a different crime: that of infanticide. Robinson had testified in an earlier hearing that he could not get any local sextons to talk to him, but by now, he had persuaded Harry Wheeler, the parish gravedigger, to testify. Wheeler said that he knew Mrs. Dryden well, because she often brought the bodies of stillborn infants for burial in his churchyard, with certificates from Mrs. Lindfield. Robinson was implying that these were not truly stillborns but murder victims.[39]

In raising the issue of infanticide, the police superintendent was playing upon a much larger cultural concern about infant life that was emerging at just this moment. As women began to work in factories, they were no longer able to combine childcare and textile work as they had in the past, when they had spun or knitted at home. So-called baby farms filled the gap. These baby farms often provided inadequate, neglectful childcare, and newspapers relished scandals about them. Papers also told melodramatic stories about evil wet nurses, as well as infants abandoned in all kinds of unlikely places, from railway left-luggage offices to riverbanks. One infant was discovered on

a butcher's block. That baby was alive and well, but many others were found dead.⁴⁰

Newspapers were full of stories about imperiled infant life partly because such tales alluded to illicit sexual relations. They invited readers to imagine how such children had been conceived, without having to be explicit. The reporting on the Lindfield case was similarly framed as breathless melodrama. Articles had titles such as "The Late Extraordinary Disclosures," "Extraordinary Affair at Walworth," and "The Mysterious Abortion Case at Walworth." One began, "The subjoined reports from the Lambeth Police Office resemble more strongly a chapter of iniquities out of Eugene Sue than the deliberate record of what has been passing in a quiet suburb of London."⁴¹ Eugène Sue pioneered the sensational novel, serialized in French newspapers—the best known was titled simply *The Mysteries of Paris*. Sue promised to show readers the dark and seamy side of city life, a city that readers thought they knew. His style was taken up by English writers as well, such as G. W. M. Reynolds; these tropes about the evils that lurked just outside of the gaslight in Victorian cities continue to shape our imaginations about the period.

Stories like Lindfield's were also part of a larger Victorian fascination with crime. Newspapers reported on magistrates' hearings in surprising detail, describing murders, violent robberies, poisonings, and arson. At a hearing on October 19, Spencer Lindfield finally caught a break. The magistrate decided that there was insufficient evidence to try her son, William Lindfield, and he was set free. Spencer dropped to her knees in the courtroom and prayed in thanksgiving for several minutes. Newspapers had suggested that William Lindfield might have been developmentally delayed or had health issues. One bluntly described him as "looking like an idiot."⁴² However impaired

he may or may not have been, William played a crucial role in his mother's defense. Once released, he found a solicitor for her, a Mr. Games. Such services became essential as Spencer Lindfield, Mary Dryden, and Richard Orpin were all formally committed to trial.

In the magistrates' hearings and at the Old Bailey, London's famed criminal court, the defendants told accounts that diverged from Eliza Wilson's dying declaration. In an early hearing, Richard Orpin admitted to having been on intimate terms with Wilson, but claimed that she had asked him for money to purchase an abortifacient. He said that he had "told her he would have nothing to do with it" and had not seen her thereafter. When he was arrested at his home, Orpin declared again that he had had nothing to do with the abortion. However, he was undermined by his wife, who said, "I don't know if he is guilty, but I have charged him with it." Jane Orpin, of course, had known Wilson professionally, since the dressmaker had used the washerwoman's services. Richard tried to shift the blame, replying, "You shouldn't have had her coming to the house," but his wife had none of it. Jane snapped back that if Wilson "had not taken any stuff there would have been nothing the matter." Richard defended himself again, saying that if Wilson had chosen to poison herself, it was not his fault.[43] Orpin's arrest must have been a strain on the household emotionally and financially. He was out of work for over a month while in custody, at risk of execution or a long jail term if convicted, his reputation shattered, the whole affair told and retold in the newspapers.

Spencer Lindfield was evasive in court, too, and her various evasions provide clues about the techniques she used in her abortion practice. It appears that it was Mary Dryden who gave Wilson a preparation of savin, although undoubtedly Lindfield could

have provided it as well. But only Lindfield did the procedural abortions. In early hearings, she claimed that she had not performed the abortion, just catheterized Wilson so that she could urinate, as the savin provided by Dryden had caused a problem. Lindfield also sparred with the police surgeon about the appropriate shapes for catheters, revealing her detailed anatomical knowledge. For example, she asked the police surgeon Edward Ray if it were possible, given the curvature of the female pelvis, to introduce the straight silver catheter found in her possession into the cervix and uterus. Ray agreed that it would be difficult, but possible "by the management of the hand"—that is, with skilled technique. Lindfield's larger point was made, that the tool was not an automatic indication of guilt, as it had legitimate uses, while her anatomical training with Clough was also on display.[44]

At the inquest, a juror asked if abortion could take place "with impunity" if a surgeon performed the operation. Police surgeon John Chapman indignantly replied that even in the hands of the most skilled surgeon, abortion was highly dangerous. If the woman survived, her "constitution remains ever after debilitated." The evidence of clinics such as Mrs. Lindfield's and Mrs. Laidlaw's suggests otherwise. If they had experienced high rates of mortality, they would not have stayed in business for decades. While the risk of infection was very real, it was far from inevitable. At the postmortem, Chapman and Edward Ray found that Wilson had been six or seven weeks pregnant and had miscarried or aborted. Working-class people often deeply objected to bodies being opened after death. I only hope Eliza Wilson died without realizing that this would be her body's fate. Even Spencer Lindfield, with all her anatomical training, had a horror of postmortems. She had constructed a legal document, witnessed by two women, specifying that when she eventually died, she did not want an autopsy.[45]

At the Old Bailey, Lindfield was defended by Mr. Ballantine, a barrister, as English law specified this higher grade of advocate for a felony trial. He made sure that her certificate from her training with Henry Gore Clough was read into evidence, and he cross-examined the police surgeons. In particular, he asked about what we would call a spontaneous abortion, or a miscarriage: "It constantly arises from natural causes, does it not?" Contrary to usual medical opinion, Edward Ray said that miscarriage was not common, but then he had to admit that "all the appearances I found might have arisen from natural causes if there was severe inflammation."[46] In other words, it was possible that Wilson's death was due to natural causes, not the result of complications from an abortion.

Next, Ballantine introduced testimony from a series of local women. All the record says is, "Several females deposed to Lindfield's good character, and to her skill as a midwife." After these women's evidence, Lindfield was swiftly acquitted, and the charges against Dryden and Orpin were dropped. It is a stunning result. The medical profession, represented by the two police surgeons Chapman and Ray, and the police, especially Superintendent Robinson, had pushed hard to convict. But it seems that the jury—all men—was not persuaded. The police force was a relatively new institution, founded only two decades earlier, and the medical profession did not yet have the authority it would gain later in the century. In this moment, the words of women who had been treated by Lindfield, and who swore to both her skill and her moral probity, held more weight than those of the male surgeons and policemen. It is a moment reminiscent of those juries of matrons so loathed by the medical profession, or of the process by which midwives got licensed in earlier centuries. Those licenses were issued by bishops after a group of a midwife's clients testified to both her skill and her

moral worth.[47] The women who spoke for Lindfield respected her training and decades of experience delivering babies, but they must have also known that she provided abortions. Perhaps they appreciated the circumstances that made that service so very necessary.

Lindfield walked free, but her career was largely over. Three years later, the census recorded her son, William, as the head of household. She was listed as "midwife, but past practice." She still worked a bit as an herbalist, but her health may have been failing, and she died in 1857. Richard Orpin resumed an earlier career as a coachman and lived into old age, dying in a workhouse infirmary in 1895. I cannot trace his wife, Jane Orpin, after 1851, when she was recorded by the census, living with Richard.[48]

Eliza Wilson's father, brother, and sisters buried her quietly in the parish churchyard on September 26, 1848.[49]

Wilson's story was typical of the many women who got caught twice, once in getting pregnant, and next in having the misfortune to suffer from an infection post-abortion before the development of antibiotics in the twentieth century. The 1803 abortion law added to her suffering, by making her testify on her deathbed. In the decades before the Civil War, American women were also beginning to feel the weight of new anti-abortion legislation.

CHAPTER 6

THE SCHOOLTEACHER

ANTI-ABORTION CAMPAIGNS IN NINETEENTH-CENTURY AMERICA

Lizzie Vought married Frank Ward in May 1862, just before he went off to fight in the Civil War. She did not see him again until a year later, when he was wounded and came home to western Pennsylvania, up near the New York border. After spending a few months recuperating, Frank was called back and resumed military service as a part of the so-called Invalid Corps, men who were no longer well enough to serve at the front. He became a clerk at an army hospital in Alexandria, Virginia, housed in a former seminary. Happily for the couple, he was able to wangle a position for Lizzie, supervising the Black laundresses. In the evenings, Lizzie and Frank played checkers or cards, and Lizzie learned French. They bolted together the two single beds they had been allocated to make a double. Given

low wages and wartime inflation, it could be a hand-to-mouth existence. Frank proudly recorded in his diary that he had bought a frying pan for $10 (almost £200 in today's value) and was renting it out to four other families for fifteen cents each per week. He had already recouped $7 of the purchase price when he recorded this detail. Lizzie and Frank sold their rations, and Lizzie took in washing. Amid all the death and dying in the hospital, they scraped together a surprisingly happy life.[1]

Lizzie got pregnant early in 1864, but the hospital was no place to rear an infant. Without telling her husband, she got some medicine from Martha Gee, took it, and aborted with little fuss. Gee was the wife of another Invalid Corps soldier at the hospital. Her husband, Orin, had been injured in a mule train accident, bringing supplies to frontline troops on a dark night. Like the Wards, Martha and Orin Gee had grown up in large farming families, in their case in rural Michigan, halfway between Ann Arbor and Toledo, Ohio. Orin had enlisted in the Union army in June 1861, a year before Frank did. Like the Wards, the Gees were newly married.[2]

We don't know how Martha Gee acquired the abortion pills she gave to Lizzie. Frank only found out when Lizzie contracted a dangerous sore throat a few days later, and she told the doctor about ending the pregnancy, in case it was related to her current ailment. All three were much more concerned about the sore throat than the abortion. The doctor made an incision to release an accumulation of pus in her throat, and Lizzie soon recovered. Frank was untroubled by Lizzie's decision to end the pregnancy and by the fact he had not been consulted. Nor was the physician bothered. Such lack of concern reflected the way most Americans thought about abortion at the time.[3] Over the course of Lizzie and Frank's life together, however, the politics of abortion in the United States would change dramatically.

WHILE BRITAIN HAD CRIMINALIZED ABORTION IN 1803, IN THE United States, such legislation happened later, state by state rather than nationally. As we have seen, Britain's 1803 anti-abortion law was an ill-considered bit of legislation that proposed such a severe penalty—execution—that it did not lead to many convictions. British newspaper stories about abortion were crime stories, or part of a larger dialogue about infant welfare. Doctors remained largely silent about the practice. In the United States, however, doctors spearheaded anti-abortion legislation state by state, asserting their own professional status by claiming a moral high ground.

American anti-abortion legislation was not just the result of medical activism. Much as in our own time, abortion was mobilized as a symbol in larger culture wars. For conservative men, abortion was a sign that women were making their own destinies, no longer subservient to patriarchal husbands. For abolitionists, enslaved women's alleged recourse to abortion demonstrated the profound injustices of the system of chattel slavery that lay at the heart of America's economy. For some American physicians, abortion symbolized the disarray of the medical profession itself. It also indicated a growing gap between their patients' understandings of reproduction and their own. Such patients did not defer to their physicians' expertise, instead shopping around until they found a doctor who met their needs. While these culture wars raged on, pregnant women still sought to control their reproductive lives, and they turned to abortion again and again.

In the antebellum period (the first half of the 1800s, before the Civil War), opponents of abortion faced an uphill battle. Newspapers indicate that many women could easily find pills or practitioners to end a pregnancy, if they did not rely upon

older herbal traditions. In Boston in the 1840s, for example, the city that would become the epicenter of the first American anti-abortion campaign, the *Boston Daily Times* published weekly ads for medications that promised to end a pregnancy. Such medicines were usually billed as emmenagogues, designed to return a woman's menstrual cycle to regularity, or as one ad delicately put it, "assisting nature in performing its office." Often, the advertisements warned that these drugs could not be used in pregnancy, as they would provoke miscarriage, implicitly marketing them as abortifacients.[4]

Abortion providers also advertised copiously; almost all we know about them comes from such self-promotion. Dr. Melvin Peters ran a lock hospital—a treatment center for sexually transmitted diseases—and addressed all female reproductive complaints. His advertisements warned that his French Renovating Pills were not to be taken during pregnancy, as miscarriage might ensue. Men like Peters were competing with a variety of female practitioners. Madame Vincent's advertisements emphasized that men could not consult her, even on behalf of their female friends. Many newspaper stories about abortions gone wrong featured men who had forced their lovers to take abortifacient medicines, so possibly safety as well as modesty underlay Vincent's women-only policy. Male providers were quick to recognize the appeal of a female provider. As Boston's Dr. Harrington explained, "if they feel any delicacy about consulting him," he had a woman on his staff to whom a patient could speak. Ten years later, he took Madame Drunette into partnership. She had been in solo practice for at least a decade.[5]

Many of these Boston practitioners clustered on Endicott Street, right in the middle of town, a five-minute walk from the Old North Church, but others could be found all over the city. Women living in rural areas and small towns could consult

with abortion providers and obtain abortifacient pills by mail. Boston practitioners advertised in Pittsfield, in western Massachusetts, as well as Albany, New York, and Providence, Rhode Island. Wright's Indian Pills, for example, were sold in towns all over the East Coast.[6] The greatest barrier to access was often money, not geography. Boxes of pills sold for $3 or $5, roughly between £75 and £135 today.

While Boston and New York City had especially dense concentrations of abortion providers, newspapers all over the country advertised pills. Go south to Nashville, and you could get Dr. Clarke's Pills; Dr. Marchisi's Catholicon; the Philotoken, or Female's Friend; and an Extract of Sarsaparilla, all of which were billed as restoring the menses. A Dr. Bond sold Spanish Female Monthly Pills, which offered "immediate removal of obstructions."[7] A literate woman no longer had to rely on word of mouth for abortion information: newspapers offered plenty. However, a newspaper advertisement would have been little help to the thousands of enslaved women in Tennessee, unable to read or respond to it. The meanings of abortion were different here than in Massachusetts, as plantation owners feared that enslaved women were aborting as a form of resistance. For free women, money and literacy remained the usual barriers to care.

Advertisements like these often had to be decoded. They were titled with words like "Female," "Renovating," and "Regulating." Medications were called "Lunar," playing upon the age-old link between phases of the moon and the female reproductive system. The most common tip-off was any allusion to "French," as in French Renovating Pills; female abortion providers often titled themselves "Madame" rather than "Mrs." Contemporary observers thought that many women had no difficulty whatsoever in deciphering the true meanings behind these words. An

1858 medical journal exclaimed, "What female could mistake the intention of this advertisement!" and complained about the "unparalleled success of these nefarious compounds."[8] Many physicians resented these mail-order drugs as competition in a crowded medical marketplace.

Such advertising was not cheap; abortion was big business. The most basic advertisement in a Boston newspaper cost $40 annually (about £1,200 today), but most abortion ads would have cost many times that, as they were more elaborate, and sometimes the same provider placed more than one advertisement per issue. Historians estimate that by the 1870s, New York abortion provider Madame Restell spent over $60,000 annually on advertising, a staggering £1.1 million in today's value.[9]

In addition to an array of advertising, newspapers also began to publish stories about abortion trials, offering narratives to readers that might also convey practical information. In Britain, such stories reflected a surge in reporting on all kinds of violent crimes. In America, abortion stories began to be a genre in and of themselves in the 1840s. A spate of tales about ministers who seduced innocent young women and then gave them dangerous abortifacient pills filled antebellum newspapers. One of the most prominent stories focused on the 1833 trial of the Methodist reverend Ephraim Avery, which sparked a flood of newsprint and was spun off into a book. Avery was on trial for the murder of Sarah Cornell, a thirty-year-old worker in a textile factory in Fall River, Massachusetts. She had been a member of Avery's congregation in Lowell, another textile town, but had been expelled for what was described as lewd behavior. She later met Avery at a Methodist tent meeting and begged him to destroy the letter in which she had confessed her sins. Supposedly, he agreed, in return for her having sex with him. Some

months later, she was found dead in a barn, having left a note blaming Avery if anything happened to her.[10]

Cornell had been consulting a Dr. Wilbur for months before she died, and his testimony gives us a glimpse of what the story might have looked like from her perspective. Cornell first sought Dr. Wilbur's advice about six weeks after that fateful tent meeting with Avery, fearing she was pregnant. Wilbur assured her that no one could know if they were pregnant that early. He described the situation as "taking a cold," using a women's vernacular term for a missed period, and prescribed some medicine. Over time, Cornell's fears about pregnancy deepened. Reverend Avery also knew about Cornell's worries and recommended oil of tansy, a well-known abortifacient. But Wilbur told her that tansy oil was too dangerous. Over the course of their consultations, the story of Avery's sexual abuse emerged, and as the pregnancy became apparent, Wilbur began to advise her to negotiate a financial settlement with the minister. After her death, Wilbur assisted at the postmortem; Cornell's body showed signs of violence and even an amateur attempt at a surgical abortion. Avery was ultimately acquitted of murder, but his reputation lay in shreds, and he decamped to Ohio.[11]

A string of stories about ministers who seduced maidens followed—juicy blends of hypocrisy and titillation. Towanda, the same small Pennsylvania town where Lizzie and Frank Ward would court and get married two decades later, was the site of another minister's abuse. Emma Woodburn was led into a sexual relationship with Rev. Lefever, the married minister of the church where her father served as an elder. When she became pregnant, the minister forced her to take abortifacient medicines, and a late abortion ensued. When Lefever went on trial, the couple's love letters were read aloud in court. The trope of the minister-turned-abortion-provider became so familiar, a

Boston newspaper used the title "Another Reverend Profligate" the following month.[12] As in Victorian Britain, newspapers used abortion to talk about illicit sex, under the guise of moral critique.

Newspapers might thrive on scandal, but the flood of advertisements for pills and practitioners suggest there was also a great deal of quiet toleration for abortion in the antebellum era. Popular medical books also continued to provide readers with advice, both about treating suppressed menses and about abortion. Dr. A. M. Mauriceau, the nom-de-plume of Madame Restell's husband, Charles Lohman, authored *The Married Woman's Private Medical Companion* in 1847. Right on the title page in big letters, it promised readers information about how to prevent pregnancy, as well as how to induce or prevent miscarriage. A purchaser of a copy in Philadelphia noted the book's cost on the flyleaf (fifty cents, about fifteen dollars today) and commented "cheap at that." The book served as an advertisement for Madame Restell's services, including pills by mail.[13]

When Frank Ward was courting Lizzie, he was reading a book by Frederick Hollick, author of a string of sex advice books. Hollick provided clear descriptions of sexual anatomy and argued for women's sexual pleasure. He was a strong advocate for contraception, but argued against abortion because he thought there were no safe methods. Frank was initially bashful about sharing the book with Lizzie. Once, when they were out walking, he left the book with her while he went off to cut kindling. When he returned, she told him that she liked the book and that she was as ignorant of such matters as he. She postponed borrowing the book until she had found a safe place to conceal it at home. By this point in their relationship, they were physically intimate, although they had not yet had intercourse.

Frank sometimes spent the night with her and rhapsodized in his diary about lying in her arms all night. But he was clear about some boundaries. He fretted about rumors that Lizzie's sister Sarah had borne a baby out of wedlock.[14]

Books like Hollick's were written by a range of medical practitioners and often included methods to end a pregnancy. While today medicine is a very highly regulated profession, such was not the case in antebellum America. A wide range of alternative forms of medicine flourished. Thomsonian or botanic medicine, for example, relied upon American healing plants. Homeopathic doctors promised remedies gentler than the harsh medicines prescribed by more orthodox physicians. Water-cure practitioners also promised gentler healing, offering a variety of spa treatments. So-called eclectic medical schools trained students in a variety of methods. The flowering of all these kinds of medicine made it difficult for the relatively small number of physicians trained at elite medical schools like Harvard and the University of Pennsylvania to claim authority and build practices. It was doctors like these who would eventually begin campaigning against abortion.[15]

Advice books from these different kinds of healers spoke with a surprisingly consistent voice about abortion. Most recommended the same herbal remedies. The eclectic Buell Eastman suggested: catnip, pennyroyal, maidenhair, motherwort, and pleurisy root. Thomsonian Thomas Hersey gave instruction on making a tansy syrup that included pennyroyal and madder, creating a three-way combination of age-old abortifacients. Homeopath Edwin Hale mentioned rue, savin, and tansy, as well as a host of other such well-known plants.[16] Their rationales might differ, but abortion medications in these alternative medical works were familiar.

The sheer weight of print—advice books, newspaper accounts of trials, vast numbers of advertisements—suggests that literate Americans regularly encountered the topic of abortion. By the time of the Civil War in the 1860s, something resembling a shared national understanding of the practice was emerging. At the same time, however, there were also profound differences between the South and North. In states where enslaved peoples labored, the meanings of abortion were different from those in which slavery was outlawed. In slave states, abortion was a property crime, depriving an enslaver of potential chattel.

When Edwin Fay was off fighting for the Confederacy, for example, he remained preoccupied with the reproductive lives of the women he enslaved on his Louisiana farm. He wrote to his wife regularly, instructing her on running the farm in his absence. In an 1863 letter, Fay was angry that Cynthia, an enslaved woman, was not getting pregnant, writing bluntly that "I bought her to breed." When the war would end, he predicted, "negroes will bear fabulous prices." In this same letter, he wondered if Cynthia had been using contraception or aborting, referring obliquely to "that other thing you regard as sinful." It sounds as if he were alluding to a conversation between him and his wife about contraception or abortion. Six months later, he heard from Rich, his young, enslaved body servant, that when Cynthia had been ill, it was because she had taken an abortifacient. We do not know how Rich knew this detail. In his next letter home, Fay threatened that he would sell Cynthia if she did not have children. Later letters imply that Cynthia continued to avoid carrying any pregnancy to term. Two years later, Fay was still inquiring about her lack of children.[17]

EARLY CAMPAIGNERS AGAINST ABORTION WERE WORRIED ABOUT the morals of upper-class white women, however, not the enslaved. Before the Civil War, some physicians, mostly those trained at elite medical schools, began to dissent from the widespread toleration for early abortion. They redefined their understanding of pregnancy, dismissing quickening as a crucial point during gestation, instead emphasizing a gradual steady arc of development. Since antiquity, quickening had divided pregnancy into two halves, and a pregnancy was only considered truly established in the latter half. The emerging science of embryology challenged this model. European medical researchers investigated the processes by which conception led to the production of a new being, using new techniques of microscopy. Now they described pregnancy as a continuum, with no particular threshold at quickening.[18]

American doctors, particularly those teaching at elite Northeast medical schools, began to argue that quickening was irrelevant, and therefore, abortion was wrong at every stage. Hugh Hodge, a professor at the University of Pennsylvania, was one of the first doctors to argue that life began at conception. In an introductory lecture given to medical students in 1839, he proclaimed that even when it was invisible to the naked eye, an embryo had an independent existence. It was merely housed in a woman's body. Hodge and others like him de-emphasized women's role in pregnancy by declaring the ontological independence of the embryo and then fetus.[19] This intellectual position could be difficult in practice, in effect prioritizing the care of a fetus or embryo over that of a female patient.

In 1839, Hodge was espousing a minority opinion. The University of Pennsylvania did not even publish his lecture until 1854. By that time, a few doctors had begun to argue publicly against abortion, largely in the pages of medical journals. Over

the course of the 1850s, these doctors rebranded abortion as "feticide" as they emphasized the continuous development of a fetus, unmarked by quickening, or they referred to "criminal abortion" to distinguish between induced abortion and miscarriage. For example, a Nashville medical journal reported about a Buffalo physician's investigation of a fetus miscarried at six weeks that had briefly showed movement. The writer immediately explained that the legal distinction between abortion before and after quickening was rendered problematic by such evidence. A woman might not first feel a fetus move until months after it was capable of motion, and this writer felt that fetal movement itself should take priority over a woman's experience of it. The Nashville editor added a comment: "This is truly surprising." His editorializing suggests that doctors, as well as their patients, might be startled by the new model of continuous fetal development.[20]

Doctors who opposed abortion on the basis of this model saw a gulf open up between themselves and their patients, who continued to consider abortion largely unproblematic in the early months. It was at the bedside that physicians struggled most with new ideas about the irrelevance of quickening, especially when respectable married women requested abortions. At a local medical society meeting, a Springfield, Ohio, doctor assumed that everyone in the room was regularly asked to provide abortions, receiving requests from married and single women alike. Having to refuse was damaging to any physician's practice.[21]

In the 1850s, Walter Channing, professor of obstetrics at Harvard, described bedside conflicts about abortion between family physicians and married women in articles in the *Boston Medical and Surgical Journal*. An 1859 piece tells the story of a well-to-do married woman with a ten-month-old baby

not yet weaned. The woman had found herself pregnant again and troubled with vomiting. Channing treated the vomiting successfully, but his patient sought to end the pregnancy. She knew that her milk would stop because of the new pregnancy and did not want to compromise the health of her unweaned baby. Channing described women in her situation as demonstrating "self-indulgence in most disgusting forms," a curious interpretation of her commitment to nourish her baby. He refused. Some days later, her husband's coach raced up to Channing's door late in the evening. She had taken some pills, her husband said, begging the doctor to come. The doctor found her in the throes of an abortion, which he described as accompanied by "atrocious pain." Days of illness followed, although she continued to nurse her baby successfully. Channing told an array of other stories where a successful abortion resulted in lingering ill health.[22]

Physicians like Channing complained in the pages of medical journals that their patients continued to understand pregnancy as punctuated into two distinct halves by quickening. That model made abortion before quickening largely unproblematic. While in England, some of the doctors' concerns about this issue were driven by their needs to testify in court, in the American context, it was the bedside that mattered most. Dr. J. N. Graham, who practiced in southern Indiana, just across the river from Louisville, published regularly in a Nashville medical journal. He was an advocate for the new use of chloroform in childbirth, and he adopted medicine's new stance on abortion. In an 1857 article, he argued that there was no point at which abortion could be acceptable, asking, "Who shall say at what *precise* point *mind* and *matter* become connected?" Like other anti-abortion writers, he depicted himself as a voice in the wilderness, claiming that many other physicians provided early

abortions on demand. It took "character and self-possession" to say no to such patients.[23] Like most other anti-abortion doctors, he avoided the topic of therapeutic abortions, designed to save the life of the mother.

Ironically, some physicians were beginning to decry *all* abortion at the same time that a number of technologies to induce it were being refined. The homeopathic physician Edwin Hale listed a wide array of methods in his 1860 text, arguing that the need for therapeutic abortion was growing and that every physician should know how to induce it. He described a range of procedures: inserting a metal rod, called a *uterine sound*, into the cervix, using a syringe to introduce water or air in the uterus, and puncturing the amniotic sac with a tiny blade inserted via catheter. Few of these procedures were do-it-yourself methods, as most required skill and training. Eight years later, he omitted this section in a new edition of his work, claiming that it had been "prostituted to bad purposes by immoral physicians." He regretted the omission, because he considered abortion a lifesaving procedure. Indeed, he claimed that if done properly, it was very safe, with a mortality rate no more than one per thousand—safer than carrying a pregnancy to term.[24]

When Hale was writing, the anti-abortion physician Horatio Robinson Storer was beginning to lobby state legislatures. Storer did more to criminalize abortion than any other American in the nineteenth century. He had been born into a Boston medical elite. His father was a professor at Harvard's medical school, and Storer trained there and in Europe. In 1855, he returned to Boston and set up practice focused on obstetrics and gynecology. The specialty was new. Medical schools had usually offered just a single course on the diseases of women and children. Most babies were delivered by midwives, or,

in complicated cases, by family doctors. Storer had studied in Edinburgh with James Young Simpson, one of the inventors of obstetrical anesthesia in the late 1840s. While physicians argued about its merits, women were unambiguous: they wanted anesthesia. Physicians came to adopt it and to deliver more babies themselves.

We do not know what inspired Storer to focus on abortion as he struggled to build his new Boston practice. Early in 1857, he wrote letters to influential physicians all over the country, asking them about abortion legislation in their state or territory; he handpicked those who had already voiced concern about the practice. Next, he proposed a resolution to his local medical society to inquire if stricter abortion legislation was needed in Massachusetts. The response was lukewarm at best. Here was a brand-new practitioner suggesting that the society make pronouncements about an issue that was already threatening to alienate physicians from their patients. The *Boston Medical and Surgical Journal* was blunt: "The affair was too hastily got up, and ought not to pass in its present form." The *Journal* had published a few brief anti-abortion editorials over the past decade, condemning physicians and nonmedical abortion providers alike. But Storer's campaign seemed rash to many established Boston doctors.[25]

Storer was not dissuaded and brought his campaign to the annual meeting of the American Medical Association (AMA) that summer. Today, the AMA is often considered central to the identity of American medicine, but such was not the case in 1857. It was a fledgling organization trying to promote what it saw as orthodoxy amid a sea of the various kinds of medical practice that flourished in antebellum America. Storer's anti-abortion stance resonated with university-trained physicians' desires to see themselves and their medicine as superior

to an unregulated array of water cures, botanical medicine, and homeopathy. It provided them with a moral high ground, defining them as protectors of the sanctity of family life. Storer proposed that the AMA form a committee to investigate anti-abortion legislation and packed it with men like Hugh Hodge, who were already allies.[26]

Over the next several months, Storer drafted a report and circulated it to committee members for comment. The report was submitted to the AMA meeting in Louisville in 1859. It laid out three problems with the state of abortion practice in the United States. The first was that patients continued to emphasize quickening in their definitions of the rights and wrongs of abortion. Most Americans, it seemed, just did not consider abortion before quickening to be much of a problem. Second, and probably worse, was that many physicians agreed with their patients and readily provided abortions before quickening. As Storer experienced in Boston, many medical men simply did not see the issue in the way he did. The third problem was the wording of existing anti-abortion statutes, which often focused on the harm done to women by dangerous medicines or procedures, not on the ending of pregnancy itself. A couple of committee members had wanted to address a fourth matter of concern: the evils of medication abortion. Storer did not want to take on drug companies or the newspapers that relied upon their extensive advertising income, and so omitted discussion of the substantial array of pills and potions marketed nationwide.[27]

In response to Storer's campaign, Pennsylvania and Connecticut promptly passed legislation redefining the crime of abortion in accord with Storer's tenets. Connecticut already had an anti-abortion statute on the books, but it held that abortion before quickening was at most a misdemeanor. Now, abortion

became a crime at any stage unless needed to preserve the life of a woman. It was a felony for a woman to even seek an abortion or for her to allow anyone to provide an abortion for her. The law thus quietly acknowledged the fact that some women were pressured into abortion by men, as in all the "profligate reverend" stories. But even a woman pressured into an abortion was now open to prosecution.[28]

However, in the early 1860s, Americans had much else to worry about. The Civil War, the bloodiest in American history, erupted in April 1861. While the campaign against abortion notched some victories in Western territories, which were less affected by the war—Nevada, Montana, and Arizona each passed similar anti-abortion laws in the first half of the decade—the campaign to legislate abortion largely went on hold. However, it recovered momentum quickly. In the decade after the war, fifteen additional states or territories passed new anti-abortion legislation, some of which lasted unrevised into the 1950s. Missouri law, for example, distinguished between quick and non-quick pregnancies until 1956. Many Southern states were slower to adopt new legislation. The Carolinas and Tennessee only instituted anti-abortion laws in the early 1880s.[29] Most of these laws included a clause allowing for therapeutic abortion—to save the life of a woman. One, or sometimes two, physicians had to agree that such an abortion was medically necessary for it to be allowed under the law. Such exemptions provided doctors with the discretion to offer some patients abortions while taking refuge in the law to deny others. By the late nineteenth century, Storer had largely attained his goal. Every state, and most territories, had laws against abortion on the books. He retired from medical practice in 1872 due to poor health.

Viewed narrowly, Storer's campaign represented a power struggle within medicine, ultimately resolved in favor of the

medical elite. However, doctors did not yet have the kinds of social authority they would later enjoy. Lawmakers were not interested in shoring up orthodox medicine's claims to authority. Rather, state legislatures passed anti-abortion laws because abortion came to signify larger social trends that worried both doctors and legislators. At the heart of their concerns were changing gender relations and fears about who was having babies—and who wasn't.

THE MOST OBVIOUS PRESSURE POINT FOR MANY DOCTORS WAS THE rise of the female physician. The 1830s and '40s had seen the beginnings of what we now call *first-wave feminism*, which included new kinds of health activism for women. For example, the Ladies Physiological Society, founded by a group of Boston women in 1837, used a model that we would now call *peer education*, hiring women to give lectures about health and sexuality. Female modesty, they argued, demanded that such events be women-only spaces. As Mary Gove explained in 1838, these were delicate matters that women simply could not hear from a man. Gove went on to build a career as a lecturer and architect of water-cure medicine. Her advice for women included exercising, cold showers, dietary restraint, and abandoning tight-laced corsets.[30]

Many women who embarked on healing careers did so from personal experience of the failings of medicine. Gove had suffered four miscarriages during her first marriage, as well as domestic abuse. Harriot Hunt, another lecturer, became a healer after watching her sister suffer under the care of doctors for three years until she sought help from Lucretia Mott, a Boston alternative healer. Hunt went on to become the first American woman to graduate from medical school, albeit an "eclectic"

one. Elizabeth Blackwell, the first woman to graduate from a mainstream American medical school, was similarly motivated by the ill health of her sister. By 1860, there were as many as twenty women doctors practicing in Boston.[31]

When women sought training in medicine, they were often rebuffed. Elizabeth Blackwell was only admitted to Geneva Medical College because the faculty were too spineless to reject her outright. Instead, they asked their students to put her admission to a vote. Students thought it would be a lark to have a female classmate and voted yes. The faculty guessed wrong about that outcome, but quickly banned any other female students. Harriot Hunt, practicing in Boston for many years, tried twice to sit in on lectures at Harvard Medical School. On her second attempt, she and three Black male students were permitted by the faculty to attend, but the other students erupted. They claimed that no woman of delicacy would want to attend the lectures, and they refused to associate with the Black students, two of whom had been sponsored by a missionary society to minister in Liberia. None were able to complete the semester. By 1850, there was an alternative for women. The Women's Medical College of Pennsylvania began training women doctors, including a handful of Black women, and promptly offered an honorary degree to Harriot Hunt. Many other Black students had to wait until 1868 to access mainstream medical education, when Howard University's medical school opened.[32]

The white male doctors who agitated for the criminalization of abortion were, by and large, highly critical of women doctors. They usually framed their critique by reiterating women's traditional roles. Storer, for example, wrote, "I am no advocate for unwomanly women; I would not transplant them, from their proper and God-given sphere, to the pulpit, the forum, or the cares of state," let alone to medicine. Women were portrayed as

prisoners of their imperfect physiology, irrational beings ruled by reproductive functions, unfit for any career as challenging as medicine. Some argued that women's influence over an unborn child was profound, and thus women needed to stay home quietly and be better mothers. Others argued the opposite, emphasizing the new embryology's model of continuous development to suggest that women's bodies were merely containers for the developing fetus. In either case, somehow women were unfit for medicine.[33]

What worried doctors and legislators was not just the specter of female physicians. They were part of something bigger: first-wave feminism's challenge to traditional gender roles. A California doctor, Henry Gibbons, connected the dots in 1878, describing how abortion was related to feminist politics. "Reform," he said, was a "watchword for mischief." Gibbons looked back fifty years for the origin of such mischief and found it in the New Harmony settlement, a community run by Frances Wright and Robert Owen in Indiana. Back in the 1820s, Fanny Wright was a pioneer on the lecture circuit, the first female to speak publicly to American women on the subject of physiology. Before New Harmony, she had started a short-lived commune in Tennessee designed to lead to the abolition of slavery and the reform of marriage. In her lectures, she criticized both traditional gender relations in marriage and the institution of slavery, linking two forms of oppression.[34]

Wright and Owen were relatively short-lived on the lecture circuit, but their critiques of marriage and their arguments for contraception took root in what was sometimes called the *free love movement*. Some free lovers, like Mary Gove, sought to abolish marriage altogether. Others argued that husbands had to control their sexual urges and let their wives decide when the couple would have sex. Contraception, imperfect though early

methods might be, offered women the chance to choose when and how many children they would bear, and lecturers like Gove spread the word as widely as they could. Some first-wave feminists who were not associated with the free love movement, like Harriot Hunt and Elizabeth Blackwell, turned their backs on marriage as well, pursuing careers as single women.[35]

Women were agitating for the right to vote, a campaign that gathered force after the germinal 1848 meeting at Seneca Falls. Women also spearheaded the temperance movement, arguing that too many men drank away their wages, depriving their families of support. The dress reform movement, which criticized women's heavy restrictive corseted attire, was another focus for activism. While Amelia Bloomer and the garment that bore her name were often the subjects of satire, city after city passed legislation banning such garments. Columbus, Ohio, led the charge in 1848, followed by Chicago, Wilmington, Newark, Kansas City, Houston, Toledo, Memphis, San Francisco, Saint Louis, and a host of others. The complex web of antebellum interconnections among feminism, abolition, suffrage, women's health activism, temperance, dress reform, and other movements that questioned the status quo is reminiscent of similar links during the 1960s. Civil rights, women's liberation, sexual politics, lesbian and gay rights, miniskirts, the anti-war movement—to conservatives these were all expressions of the same profound threat to the world they knew.[36]

As they built their life together, Lizzie and Frank Ward's choices exemplified some of these changes in gender relations. After the war, Ward, like many other veterans, scrambled around Washington until he found a government position. The Wards slowly became middle class, buying a house, acquiring

a piano, and settling into a bourgeois life very different from the hardscrabble agricultural rhythms of their childhoods. Both had previously worked as schoolteachers, and they continued to strive to obtain higher education. Frank proudly noted that Lizzie had done better than he in exams for a teaching certificate. They corresponded in French to improve their language skills, and she started studying Latin, very much a male preserve.[37]

Some months after the 1863 abortion, Frank Ward had gone to see a "Dr. M" about contraception. It was only after Frank found government work that he and Lizzie considered starting a family. In June 1865, Lizzie gave birth to a son. While she convalesced from the birth, Frank took up a stereotypically female role, doing the housework: "I am mistress of the house . . . cooking, washing dishes, and sweeping." Their baby, Roy, died before his first birthday, and the Wards seem to have decided not to have another child. In 1868, they had a pregnancy scare and were overjoyed when Lizzie finally got her period. The couple spent evenings at home reading the *Aeneid* in Latin or attending college courses. They were active in the suffrage and temperance movements in Washington. Sadly, Lizzie suffered repeated bouts of the malaria she had contracted during the war, and died in 1872, aged only thirty.[38]

Martha Gee, who had given Lizzie the abortifacient pills back in 1864, followed a different path with her husband, Orin. They returned to rural Michigan and a more traditional way of life. Although still partially disabled from his war wounds, Orin worked as a farmer and brickmason. The Gees had six children in short succession, just as their parents had done. Like Lizzie Ward, Martha also died young. In 1881, she passed away, likely from the effects of diphtheria, aged thirty-nine.[39] It was the women like Lizzie Ward, forging a new way of life, who worried the doctors and legislators who

restricted abortion; they preferred the old ways exemplified by Orin and Martha Gee.

IT WAS NOT JUST NEW KINDS OF GENDER RELATIONS THAT WORried anti-abortion activists. Both the Wards came from long-established families. Frank Ward's ancestors were leaders in the early years of the Massachusetts Bay Colony; Lizzie's forebears, originally from the Netherlands, had also been in America for generations.[40] The anti-abortion movement was steeped in nativism, the racist belief that the wrong kinds of Americans were thriving. The 1840s and '50s had seen waves of immigration to the United States, especially from famine-struck Ireland. Conservatives panicked, arguing that the nation would soon be overrun by people who were not descended from the original WASP settlers of New England. After the Civil War and Emancipation, such anxieties often included racist worries about Black families having "too many" children. The idea that couples like the Wards were taking advantage of new methods of contraception—and abortion—to limit the size of their families, or in the case of the Wards, to avoid parenthood altogether—was deeply concerning to these nativists.

Horatio Storer was unambiguous about what he saw as a threat. He asked rhetorically if the American West "would be filled by our own children or by those of aliens?" "Our own" was racist code, a dog whistle for the kinds of old New England families from which Storer was descended. While in the 1830s and '40s, abortion was often portrayed as the resort of innocent single women, led astray by their male lovers, now it was a married woman's practice.[41] For as far back as we can see, abortion has been used by married women for family limitation, often

going unremarked because it was associated with legitimate marital sex. Now medical men thundered about self-indulgent married women, much as nostalgic satirists had done in ancient Rome. Some writers could even excuse single women who aborted. One such said, "We can forgive the poor, deluded girl,—seduced, betrayed, abandoned," but then went on to criticize married women for refusing their natural destiny. That natural destiny had been questioned for decades by first-wave feminism and, implicitly, by the advent of contraception, which this writer also condemned.[42]

The actions of these self-indulgent married women, the argument ran, would lead to an America populated by the "wrong" people. A Vermont physician wrote that surely every doctor must have noticed that French, German, and Irish immigrants had much larger families than those native-born. Another physician threatened that "the ignorant, the low lived and the alien" would take over the country, because the more intelligent and refined couples practiced abortion to limit the sizes of their families. Some doctors heightened the racist implications of these nativist claims by comparing abortion to infanticide practiced by "savages." One described a Brooklyn minister who noted that his female parishioners frequently donated money to missions in India, their hearts moved by the spectacle of Indian mothers abandoning babies to the River Ganges. His Brooklyn flock, the minister said, were often guilty of the same, because they sought abortions—but he would never say so from the pulpit.[43]

The clergy were notably quiet during the mid-century anti-abortion campaign, much to some doctors' disgust. The Catholic bishop of Boston, John Bernard Fitzpatrick, was a rare exception, endorsing Storer's campaign. Occasionally, Mormon leaders mentioned the issue, but they were mobilizing critiques of abortion in response to attacks on polygamy. Only in

1869, when Pope Pius IX changed the Catholic Church's position on abortion, did American clergy speak up, and even then, their comments were sparse. The pope did away with the pre/post-quickening distinction that the Church had largely relied upon since the Middle Ages, saying that life began at conception. Now all abortions, at any stage, were punishable by excommunication, a sentence that could only be overturned by a bishop, not a mere confessor. In effect, the Church moved back to the 1588 papal ruling by Sixtus V, a decision that had been quickly rescinded by the next pope because it was too draconian. Yet the change went unremarked in much of the United States. While Archbishop Martin Spalding of Baltimore spoke out publicly against abortion in 1869, most Catholic newspapers and journals remained silent. This omission may reflect the religious press's general tendency to avoid mentioning anything related to sex in what they promoted as family newspapers. Another factor for the press silence may be the Church's condemnation of even those abortions necessary to save a woman's life. While some theologians had previously suggested that in obstetric emergencies, a mother's life could be saved over that of her unborn child, now the choice was supposed to always be the child, even if mothers died as a result.[44] Such a choice may have been more than most Catholics wanted to consider.

THE FIRST FEDERAL LEGISLATIVE BLOW TO ABORTION RIGHTS CAME in 1873. An activist named Anthony Comstock, who had been campaigning in New York City against an array of what were known as "racy" publications—erotic novels and sex guides—pulled off a legislative coup. Late one Sunday night, in circumstances that remain murky, Congress passed an act banning the use of the postal service to send anything "indecent." Mailing

almost any informational material or products related to sex, including contraceptives or abortifacients, was now illegal. Comstock became the special agent of the post office to enforce this law.[45]

The Comstock Act drastically reshaped the marketing of contraceptives. No longer would they be sent through the mail all over the country, nor would they be a sideline for the publishers of racy books. A few medical works for a popular audience, such as those by Frederick Hollick, continued to offer contraceptive advice, but many other authors deleted or altered those sections of their books. One even published an edition criticizing censorship by pointedly leaving a series of pages blank, pages where contraception had formerly been discussed. While contraceptives were still for sale in larger cities, shop owners feared arrest, and distributors became less reliable.[46]

Comstock repeatedly portrayed indecent literature as morally dangerous because it led to worse offenses. For example, he used sensational prose to depict the unhappy fate of a Long Island girl who went missing; her father found her dead in an apartment in the city, killed by an abortionist. Comstock never explained how obscene literature had led to this sad outcome. For him, it seemed obvious that indecent reading material was a slippery slope to illicit sexual activity and worse. Indeed, Comstock may have made the story up. In 1878, Comstock targeted Madame Restell, the famed New York City abortion provider. He employed his usual entrapment strategy, pretending first to want to buy abortifacient pills and then returning for a stronger remedy. Some days later, he brought the police and had her arrested. Bail was set high, about £23,000 in today's value. In court, Restell immediately pulled the cash from her handbag. Later that week, she took her own life rather than face another potential jail sentence.[47]

By the late 1870s, abortion had been successfully outlawed in almost all of the United States. Storer's campaign, and then Comstock's, had succeeded. And yet abortion did not go away. Drug companies kept on selling menstrual regulation medications that were thinly veiled abortifacients. In Horatio Storer's Boston, the drug company Goodwin and Co. offered seven brands of "female pills" as well as a range of products like "Lyons Periodical Drops" and "The Samaritan's Gift for Females." In 1885 Chicago, Fuller and Fuller Drug Company sold "Dr. Caton's Tansy Regulator," "Chichester's Pennyroyal Pills," and "Cook's Cottonroot Compound." If a woman recognized the names of these well-known abortifacients, she would know just what she was buying.[48]

And while some physicians began to refuse to provide abortions, others continued to do so, as did some midwives. As long as a physician thought that an abortion was necessary to preserve the life of a woman, he could perform it. We will never know how many physicians interpreted such laws generously. By the turn of the century, however, the specialty of obstetrics was becoming more highly developed, and obstetricians began to fight midwives, using abortion as a weapon. They argued that midwives, many of them immigrants, were dirty and superstitious, both immoral and dangerous. In cities like Chicago, with substantial immigrant populations, doctors took testimony from women dying from infections after abortion, prompting the prosecutions of the midwives who provided them, much as Spencer Lindfield had been tried decades earlier in London. They also put the squeeze on their colleagues who quietly condoned or performed abortions, threatening to prosecute physicians who did not report abortions or even suspected abortions, in the process destroying patient–doctor confidentiality—a core medical value.[49]

The anti-abortion movement spearheaded by Storer created a bargain between the medical profession and the law. By outlawing abortion, the state, in effect, took some of the tough bedside decisions out of the physician's hands by forbidding abortion. At least in theory, a physician could refuse his patient an abortion by pointing to the law, while at the same time reserving the right to perform an abortion if he thought it necessary. Such a move stepped right into the space of the healer-patient relationship, before the profession had the strength to regulate itself. In the same decades, the Comstock Act stepped even more boldly into American bedrooms, declaring that contraceptive information and equipment were largely illegal. Nineteenth-century laws forbidding abortion and then contraception would cast long shadows, well into the next century.

CHAPTER 7

THE HOUSEWIFE

REPRESSION AND REFORM IN TWENTIETH-CENTURY AMERICA

BEATRICE J. HAD NEVER INTENDED TO BECOME AN ABORTION provider. She was twenty-three, living in Baltimore with her husband Walter, who was a paperhanger, like Beatrice's father. She had grown up a block west of the local racetrack and married Walter when she was only sixteen or seventeen. By 1940, the couple had two daughters, ages four and six. They lived on a typical terraced street, where Beatrice kept house for the family and two lodgers. Maybe another child just seemed like too many mouths to feed. Beatrice learned how to perform an abortion on herself from a woman she called "an Italian girl"—Baltimore was a port city with many European immigrants—and ended the pregnancy without incident.[1]

A decade later, Beatrice and Walter's family had grown. They now had two sons in addition to their teenaged daughters. Her widowed mother was living with them as well, all crowded into the first floor of the house. By that time, the marriage was also beginning to fray. In 1949, Beatrice got pregnant again and went to a pharmacy to get the abortion supplies that she had remembered from her earlier experience.[2]

At the drugstore, Beatrice bought what she called a "bluejay" and some "footballs." A bluejay was a bougie, a stiff rubber tube often used as a urinary catheter. The pharmacy sold them for two dollars apiece, about twenty-three dollars today. The footballs, at two dollars a dozen, were brown pills containing ergot, which induced uterine contractions. She was open with the pharmacist, Samuel Markin, about her intentions. They both knew exactly what these items were for. Markin was concerned that she performed the abortion safely, so he gave her instructions on sterilizing the bougie, douching with dilute Lysol, and removing the tube if she started to bleed too heavily. Once again, she was successful in ending a pregnancy, an outcome she described as "coming along all right." Beatrice wasn't alone in performing what is today known as a *self-managed abortion*. This particular method of inducing abortion using a rubber tube was so well known that it served as a plot device in Richard Yates's 1961 novel *Revolutionary Road*. A husband finds a new neatly wrapped rubber syringe in the household linen closet and immediately understands its intended purpose.[3]

In the summer of 1951, Beatrice went to live with another man, also named Walter, and she and her husband planned to divorce. After she had left the marital home, the pharmacist came to her for help: "Bee, I got a lot of girls coming to me and asking me for stuff." He asked if she had ever done an abortion for anyone else. She told him she had not, and he asked if she

might try to take care of the women he would send her way. He decided that the fee was to be seventy-five dollars.[4]

Beatrice wasn't very skilled as an abortion provider. She had trouble getting the bougie inserted into the cervix properly, but usually the ergot pills provoked a miscarriage anyway. After seeing her first client, she asked the pharmacist if he wanted any part of the seventy-five-dollar fee. He declined, but suggested she could do him a favor sometime. The favor came due a month later, when the pharmacist sent his wife to Beatrice. They paid her twenty-five dollars for the procedure. Then Beatrice performed an abortion for a close friend. Possibly, she was getting uneasy, because she mislaid a card with another two women's phone numbers on it, given to her by Markin. There had been a surge in arrests and prosecutions for abortion in Baltimore, as in cities all over the country, so both the pharmacist and Beatrice were trying to be cautious. Markin created a multistep process to protect them. He would get a woman's phone number from her male partner, which he then gave to Beatrice, who would call the woman to arrange the abortion. Occasionally, she also referred women to a Dr. Monninger, a few short blocks from where she had lived previously with her husband. It is not clear how she decided which cases to refer and which she might treat herself.[5]

Some months later, they got caught. An undercover policeman sang Markin a sob story about how his girl's husband was in Korea, so she just could not have a baby. The pharmacist told Beatrice to charge the couple plenty—evidently, the policeman had looked as though he could afford it—but they balked at the price, so she lowered it to $150. On October 18, 1951, a policewoman named Ethel D. came to Beatrice's apartment to spring the trap. Ethel was likely on the kitchen table, ready to undergo the procedure, when other police officers rushed in and made the

arrest. Beatrice and Markin were charged with attempted abortion. That night, Beatrice made a detailed statement to the police, so we know much more about her than about other providers, including the local vernacular for abortion equipment. Such firsthand statements are rare in the archives, and we do not know why this typescript survives.[6]

By coincidence, Alan Guttmacher, an obstetrics and gynecology (OB-GYN) doctor at Johns Hopkins Hospital in Baltimore, imagined a scene very like the one that had taken place in Samuel Markin's pharmacy. In the 1950s, Guttmacher, who would later become the head of Planned Parenthood nationwide, criticized abortion practices. Only later in his career would he become an advocate. He could not have known about the details of Beatrice's case, but he recounted something very like her story. He imagined a woman going to a pharmacist, saying, "Doc, I ain't seen nothing for five weeks." The pharmacist sells her some ergot pills, legitimately available as "menstrual regulators." Five days later, she returns, saying, "Those pills were no good." The pharmacist replies, "Well, you are hard to bring round," and sells her a bougie, directing her to a neighbor for instruction on its use.[7] The scale of this kind of neighbor-to-neighbor abortion provision is unknowable, but the overlap between Guttmacher's hypothetical tale and Beatrice's real experience suggests it was common.

When Beatrice and Markin's case went to trial, the pair got lucky. The case was heard by a progressive-minded judge, Herman Moser. Moser listened to Beatrice's attorney, who pointed out that the policewoman was not actually pregnant. Usually, abortion stings involved arresting up to a dozen women, some of whom were recovering from abortions, and coercing them into testifying against their abortion provider. In this case, however, the only "patient" was Ethel D. Moser threw the case out; if the

policewoman were not pregnant, whatever procedure Beatrice was beginning to perform could not have been an attempted abortion.[8] Beatrice went on to marry her second Walter and live with him for decades.

TODAY, WE OFTEN REMEMBER ABORTION BEFORE DECRIMINALIZATION with images of so-called back-alley abortions, dangerous and predatory, or with coat hangers symbolizing the tragic consequences of self-induced procedures. But abortions in the middle of the twentieth century were more complicated than those stereotypes. After facing crackdowns at the turn of the century, abortion had receded from public view. No longer were newspapers filled with tragic stories of abortions gone wrong. In the US, the campaign against midwives who provided abortion services waned by the early 1920s, as physicians came to dominate the provision of reproductive care. Only in the South did midwives continue to birth babies in any numbers, usually Black women working in their own communities. Here, physicians knew that many women would be unable to pay their fees and so left obstetric practice to midwives.[9]

Physicians performed legal abortions for a variety of indications, and the rest, so-called criminal abortions, went largely unremarked. In the 1920s and '30s, abortion providers were rarely prosecuted, whether physicians or not, and the former were at risk only if a woman died. We will never know the extent of abortion provision in these years or how many physicians were willing to perform abortions for what were called "social" reasons, such as poverty or lack of a wedding ring. Big cities usually had a couple of physicians who specialized in abortion, and they practiced in modern offices with up-to-date equipment. With the advent of antibiotic sulfa drugs in the late

1930s and penicillin in the mid-1940s, as well as the availability of blood transfusions, abortion became safer than it had ever been before. Such doctors were careful, making sure that their patients could reach them by phone if any complications ensued. They did not want their patients ending up in an emergency room where questions might be asked. By the late 1950s, it was estimated that over a million abortions were performed in the United States every year, but as with every clandestine activity, numbers are impossible to determine with accuracy.[10]

Finding a physician who did abortions was not easy, however. It required knowing someone who understood such things, tapping into information networks that remain largely invisible to historians. We cannot know how many American women like Beatrice J. instead chose self-managed abortions to direct their reproductive lives, for reasons of cost or access. The gap between what the law said and what women actually did remained substantial all the way up to *Roe v. Wade*.

One historian has described women's "unarticulated, alternative, popular morality" supporting abortion. The law might say it was forbidden, but people's actions suggest that they saw it differently. Cora Winslow's story was typical of many. She was working as a secretary in Seattle, giving jazz dance lessons on the side, when she became engaged in 1929. After the stock market crash, she and her fiancé lost their jobs, and the wedding was postponed. Cora's fiancé went to California to get work and disappeared from her life. Five years later, she got engaged again, got pregnant, and had an abortion because the couple could not yet afford to wed. After they married, she had a second abortion because her husband had just been laid off at the sawmill where he worked, and they were living uneasily with his brother's family. As Cora later told a historian, "Doctors understood how hard things were," and performed abortions

for their patients in need. The couple went on to have their first child in 1938. It was only after 1945 that they finally moved into a home of their own. In the mid-1950s, Cora's daughter got pregnant and wanted an abortion. When their doctor refused, Cora was shocked at the change in medical practice. Her daughter had a hasty wedding.[11]

Hard times during the Depression meant that many understood that a planned marriage might fall through or that a married woman might be unable to feed another child. But in the 1940s and '50s, a wave of moral panic swept across the country. Abortion began to be prosecuted much more aggressively, often drawing upon laws almost a century old. Such prosecutions reduced the number of options for women seeking abortion, making it less safe.[12] In some measure, that moral panic helped to bring about the dangers of the "back-alley abortions" we recall today.

Abortion was a primary method of reproductive control because contraception was outlawed in many states, based on Comstock legislation from the 1870s, which had often been followed by similar state-level laws. Not until the Supreme Court's landmark 1965 ruling in *Griswold v. Connecticut* was access to birth control made legal in all states—and the ruling only covered married women. Even in states where birth control might be legal, it remained inaccessible to many. A number of birth control clinics had been founded in the 1920s and '30s, but they were relatively uncommon.[13]

Birth control clinics were understandably concerned about the potential for a public relations crisis if they appeared to be endorsing sex outside of marriage, and so turned away single women. These women—along with the many married women who did not live near a birth control clinic or could not afford to patronize one—had to rely on condoms, if their partner were

willing, or a variety of over-the-counter products that claimed, often with little justification, to have spermicidal properties. If such products failed, unwed mothers faced a huge stigma. The better-off might be hidden away in a home for unwed mothers, where they waited out the pregnancy and gave birth to a baby who would be adopted, sometimes without the mother even seeing the baby. Such institutions could be punitive, soul-destroying places.[14]

Abortion providers sometimes took up their work in response to the desperation felt by women who were pregnant and unmarried. Ed Keemer, a Black Detroit physician, recounted how a nineteen-year-old young woman saw his wife (also a physician) to seek an abortion. She had lost her virginity to a smooth-talking young man who assured her that douching with dilute Lysol after sex would keep her from getting pregnant. Such douches were widely used, but this time, it did not work, and the man skipped town. Keemer's wife consulted with her husband, and Keemer decided that they could not violate the code of medical ethics, which forbade abortion unless medically necessary. The next morning, the young woman's body was pulled from the river, a suicide. Keemer's refusal haunted him, especially as his wife had had an abortion while in medical school. He went to Washington, DC, and spent a week learning abortion technique, later developing his own process, which he used to provide thousands of abortions in Detroit.[15]

Like Keemer, numbers of the abortion providers in the 1930s and '40s were licensed physicians. In Baltimore, two such doctors dominated abortion practice between the world wars. George Loutrell Timanus graduated from medical school in Baltimore in 1915 and interned in the city's ear, nose, and throat hospital. He also worked as the medical advisor for the city's

Playground Athletic League, a charity that sponsored sports activities and offered some health care for poorer children. There he saw the strain that another baby could cause for a working family. So, too, teachers quietly sought his help for girls who would be thrown out of school if their pregnancies were not ended. It is not clear what prompted his entry into abortion practice, but in 1928, he sailed to Europe to learn about techniques in Paris, Vienna, Berlin, and London. He found them cruder than expected, so he went on to develop his own surgical instruments for the procedure. By the 1940s, his practice focused on abortion, and he was well known in the city for his technique. Indeed, he taught the D&C procedure, used for a number of uterine complaints as well as for abortion, to Johns Hopkins OB-GYN doctors in training, on a day known to them as "Dr. Tim Day."[16]

Albert E. MacCrowe was the other major physician abortion provider in Baltimore. He was a little older than Timanus and had an abortion practice in the city from the 1920s, if not earlier. The two physicians seem to have practiced in harmony; Timanus claimed that combined they did 90 percent of the city's abortions. In 1948, Timanus shared data from MacCrowe's and his own practice with Christopher Tietze, a physician-demographer researching illegal abortion. The data suggest that their practices were remarkably safe. MacCrowe was estimated to have performed 40,000 abortions over a fifty-year career and supposedly lost only two patients. By the late 1930s and into the '40s, he was performing 1,000 abortions a year. Timanus claimed to have performed 5,210 abortions over two decades and also only lost two patients. Timanus only performed first-trimester abortions, which had the fewest complications, turning away women who were further along in a pregnancy. He retired in 1946 but returned to practice two weekends a month in 1948 because

he owed back taxes from real estate investments. In an attempt to limit his caseload, he pushed up his prices, from $200 to $400—but if the referring physician requested, he charged less. Despite doubling his price, Timanus had a busy practice.[17]

The demographer Tietze analyzed records from a few months of both doctors' practices. During that time, 363 women sought abortions. They were young and not so young, married, single, divorced, and widowed. The youngest was thirteen, and the oldest forty-seven. About half the women were married. Like Beatrice J., three-quarters of these married women already had children and sought to limit the size of their families. The widowed and divorced women also had all borne children, so they may have sought to limit family size. However, like the single women in Tietze's sample, they may also have sought an abortion because of the stigma of out-of-wedlock pregnancy.[18]

Other cities had their skilled physician providers as well. Dr. Nathan Rappaport worked in New York City and Washington, DC. Several East Coast university physicians referred students to him. He claimed to have performed twenty-five thousand abortions over his career. In Detroit, Ed Keemer supposedly performed fifty thousand abortions over four decades, thirty thousand of them before 1973, when *Roe v. Wade* legalized abortion. Like Timanus and MacCrowe, Keemer was well known in his community as an abortion provider. In his autobiography, he told an extraordinary tale about being asked to provide an abortion for the teenage daughter of the Catholic chief of police. The girl's mother asked if the procedure could be done in such a way that her daughter did not even understand what it was. Keemer stepped up, gently explaining to the young woman that her menses were blocked and the treatment would unblock them.[19]

A small town might also have a highly competent physician who provided abortions. After graduating from the University of Pennsylvania's medical school, Dr. Robert Douglas Spencer practiced in Ashland, a coal town in rural Pennsylvania. He was beloved for his care for miners' health, having gone down mine shafts to treat injured miners. Spencer was a leading citizen—one of his best friends was the chief of police—and most of his practice was general medicine. But he had also become widely known in the region as a skilled and trustworthy abortion provider. Over a forty-year career, he thought he'd provided abortions for about half of the families in the county, and many, many more who came to Ashland for his services. Half the town's population was Catholic, and the Church forbade abortion at any stage. So occasionally the Knights of Columbus would stake out his clinic, but mostly people looked the other way. It was obvious to everyone why a steady stream of younger women came to stay in the coal town's only motel. In 1957, Spencer went on trial for involuntary manslaughter and abortion after a woman died from a bad reaction to anesthesia, but the jury quickly found him not guilty. It was the only abortion-related death in his fifty-year practice, which included many thousands of abortions.[20] Likely, there were other such small-town abortion providers, whom historians do not know about. Such physicians treated abortion much like the other medical conditions they saw, and their communities largely accepted them.

A range of other medical professionals also provided abortion services in the first half of the twentieth century. Midwives, of course, had long been associated with the practice, both because they were specialists in female reproductive health care and because the emerging OB-GYN specialty aggressively painted them as dangerous and ignorant in order to promote themselves as the only appropriate birth attendants. Back in

1909, a physician's survey of midwives in Baltimore alleged that as many as a third of them were linked to abortion, but no evidence was provided about how this information was gathered. By the mid-1950s, only seven midwives were working in the city, with a largely Black clientele. Health care was often segregated, both formally and informally. In the Deep South, Black midwives were also still the norm. If some of these midwives' clients had moved to Baltimore from farther south, they probably sought a familiar type of provider when they got pregnant.[21]

Other kinds of medical professionals also provided abortions. Alan Forte was a Black naturopath and abortion provider who practiced for decades in North Carolina and then in Baltimore. Ruth Barnett, another naturopath, practiced as an abortion provider for five decades in Portland, Oregon, where two other abortion providers worked in the same office building. Barnett estimated that she had done as many as forty thousand abortions and never lost a patient.[22]

Nurses also provided abortion care. One East Coast physician, for example, saw a young patient who naively asked him for a checkup after she had had an abortion. He examined her, saw that the abortion had been performed very neatly, and asked her about who did it. He then drove out to the countryside to talk to the nurses who provided abortions in a clean and tidy home. He liked what he saw and quietly referred selected patients to them. This physician came from an old monied family in Philadelphia, and his private patients included women from similar backgrounds. He claimed that every doctor needed a good abortion provider to whom he could refer a patient when a physician colleague, for example, had a daughter who needed to end a pregnancy. He did not, however, provide abortion referrals to the poorer patients he saw on hospital wards.[23]

EVENTS IN CALIFORNIA IN THE MID-1930S SPARKED A CHANGE IN the way US police forces and district attorneys dealt with abortion. A syndicate of physicians, the Pacific Coast Abortion Ring (PCAR), started providing abortions on a large scale in the early 1930s. Supposedly, the syndicate was patterned on Prohibition-era bootlegging organizations, changing offices frequently and dividing work among different groups without knowledge of one another. It had been founded by Reginald Rankin, not a medical practitioner himself, who hired a host of well-trained physicians. The syndicate handled the logistical work, paying off police (and at least one member of the California Board of Medical Examiners), and shifting location often to avoid detection. Rankin also hired "steerers," people who would send patients to the syndicate. One druggist earned $300 a month—a fortune during the Depression—discreetly urging physicians, pharmacists, and medical supply companies to spread the word about PCAR's business. Rankin pulled strings and had two competing abortionists arrested; in revenge, they tipped off the district attorney about PCAR. After being raided in 1936, members of the syndicate served time in San Quentin.[24]

The prosecution of PCAR was a harbinger of things to come. In the 1940s, district attorneys and police departments all over the country started aggressively targeting abortion providers, often using laws that had been on the books for many decades. Police officers spent thousands of hours on stakeouts, noting down license plates, illegally tapping phones, creating stings, staging raids, interrogating witnesses, and preparing prosecutions.[25]

The dislocations of World War II sped up dating (itself a relatively new phenomenon) and sexual intimacies. Numbers of weddings grew by 7 percent each year from 1940 to

'42, and then fell, as couples tied the knot before men went off to war. At the same time, women began bending gender norms—think of Rosie the Riveter, for example, a fictional character who embodied women working in factories and shipyards, building the tools of war. The fraction of women working outside the home increased 60 percent between 1940 and 1945, most of them married. They filled jobs left vacant by men—and often earned male wages. Even Black women were able to break out of poorly paid domestic work and move into manufacturing jobs. After the war, as is so often the case, the nation tried to return to some imagined version of normal life, including clearly delineated gender roles. Marriage rates skyrocketed, increasing almost 30 percent in 1946, and women were encouraged to stay home. Ideologies of family life seemed to offer reassurance that the war was over and, into the 1950s, buffered against the new terrors of the Cold War and the threat of nuclear warfare.[26]

Increasingly, abortion providers were described in language reminiscent of organized crime. Terms like *abortion ring* and *racket* so often used in 1940s and '50s newspapers conveyed a flavor of the underworld, as did alleged payoffs. Once America entered the McCarthy era, when Communists were imagined as hiding everywhere, ready to destroy the American way of life, such images of organized crime shaded over into the hidden menace of Communism itself. When Nikita Khrushchev liberalized USSR abortion law in 1955, it was widely reported in American newspapers, cementing the link between Communism and abortion.[27]

In the 1920s and '30s, some nonmedically trained abortion providers had offered safe care, but now they, too, were arrested or stopped working. Back in the 1910s, Inez Burns had become an abortion provider after working as a manicurist in a hotel

in San Francisco. One of her best manicure clients was a physician who did abortions. He took her on as his assistant, and then she started practicing on her own. For thirty-five years, she provided safe abortion care. She was raided in 1936, but none of her clients were willing to talk. It was only in 1944, when Pat Brown became district attorney on a platform to clean up the city, that Burns fell afoul of the law. A notebook revealed that her clinic had made half a million dollars that year. The first two trials ended in hung juries, with conviction only happening the third time. Later in life, Brown acknowledged that Burns had been providing a valued service, but he had been a young politician seeking to make a name for himself.[28]

In the late 1940s, the Baltimore Police Department set up an Abortion Squad, with at least two policewomen on the team. They met with suspects, booked appointments for abortions, and paid for them with marked bills, as Ethel D. would do with Beatrice J. in 1951. Single women's hotel rooms in Baltimore were routinely and illegally tapped—the police thought they knew why such women were in town. Providers began to use code words to evade such taps; one told prospective clients to use the words *rose pattern*, as if looking for china. More alarming, as in the Beatrice J. case, these policewomen underwent the beginning of the first stage of an abortion procedure. It is not clear from trial records at what exact point the medical procedure was stopped and arrests began, but a policewoman must have been up on the examining table. The indictments are for "attempted abortion," and they mention the use of a uterine sound, a rod used to dilate the cervix. The same two women, Ethel D. and Mary H., reappeared in trial after trial.[29] How did they understand their work? By 1951, many of the abortion providers they raided were moonlighting—one was a schoolteacher, another a cocktail waitress—and poorly trained.

Abortion was more dangerous under such circumstances. Perhaps these policewomen saw themselves as saving women from the risk of death. Or maybe it was all in a day's work, however personally invasive it must have been.

The police went after physician providers whom they had previously ignored, staking out and arresting George Timanus in the summer of 1950. He went on trial, and, unusually, a transcript survives, in which we learn about how women and doctors tried to maneuver in the new environment of repression. Timanus, for example, required a referral letter from another physician—but clients developed their own work-arounds. One seventeen-year-old woman had eloped with the son of a State Department official. When the man's parents found out about the wedding a few months later, they pressured the couple into obtaining an annulment. After it was granted, the bride found herself pregnant. Her former father-in-law arranged the abortion with Timanus, providing a fraudulent letter from a Washington, DC, physician who was actually serving overseas in the navy at the time. Another young woman supposedly swiped a piece of a doctor's stationery off his desk to manufacture her own letter of referral.[30]

Some providers used strategies to avoid prosecution that could put their patients at risk, as well as fostering opportunities for exploitation. It was routine to tell a woman to meet an intermediary at a coffee shop or hotel lobby. She would be blindfolded for a car ride designed to conceal the location of the actual procedure, which might take place in a motel or hotel. Or physicians might use their offices on the weekends, as Timanus did, or early in the morning, as did Robert Spencer. In almost all cases, the first thing a woman had to do was pay for the procedure in cash. The price might be inflated at the last minute. Some providers demanded sex from their patients, and

women, desperate to end a pregnancy, complied. Other providers appeared to be drunk. When abortion was a black-market procedure, it was difficult to gauge a provider's medical credentials or skill.[31]

The Timanus trial also sheds light on the role of nurses in abortion provision. Anne Adams, Timanus's nurse, made an impassioned plea for the right to an abortion when she was on trial. Adams was among the elite of nursing, a thirty-four-year-old graduate of the Johns Hopkins Nursing School at a time when many nurses were trained on the job, on the wards in a hospital. After graduating in 1939, she had started working as a private-duty nurse, employed by better-off families to nurse sick people in their homes. Some years after she began practice, a friend contacted her asking if she knew of a doctor in Baltimore who was sympathetic to the plight of unmarried pregnant women. Supposedly, she was asking for a friend whom Adams did not know. Adams had already heard about Timanus, possibly via her Hopkins connections. But the pregnant woman discovered that Timanus was not working anymore and killed herself in despair. As Adams explained in court, "She had no way of getting married, or taking care of an unwanted child. The social stigma attached to it upset her; she had no family to turn to, and she found the only answer was to do away with herself." In 1949, Adams had been nursing the wife of one of Timanus's friends, and she discovered that he was working again. The connection was made, and his two-weekends-a-month schedule made it possible for Adams to add her work for Timanus to her private-duty practice.[32]

When Timanus hired her, he read the Maryland state law to Adams and told her that what he did was legal. At this point, Maryland was still under an 1868 statute that banned abortion except when physicians determined that it was needed "for the

safety of the mother." The language of "safety" was capacious, so it is just possible both Adams and Timanus thought that what they were doing was legal. The law granted substantial discretion to a physician's judgment, and Timanus required a letter from a referring physician. At the trial, the prosecutor made the unusual move of asking Adams if she had any guilt on her conscience for her work. Her attorney objected, but Adams spoke up, "I have no feeling of guilt. I feel Dr. Timanus is doing a great social need." Timanus had a list of referrals from over three hundred physicians but did not invoke their names during the trial, believing that his professional standing would insulate him from conviction. He was deeply shocked to find otherwise.[33]

Anne Adams may have known personally about the strain that an unwanted pregnancy could cause. On the stand, she implied that she had herself had an abortion. When describing how D&Cs were performed at Johns Hopkins Hospital, with only four hours of bedrest afterward, Adams added dryly, "I happen to have had that experience myself." Timanus was a better practitioner, she implied, as his patients had longer to recover in bed. Clearly, the lawyers understood her allusion, for the next day, the prosecutor asked her directly if she had ever been treated by MacCrowe or Timanus, implying an abortion. She said no, and then her attorney objected, asking that the question and answer be stricken from the record. The judge refused, citing the statement she had made the day before. Anne Adams's eloquence about the plight of single women did not cut any ice with the judge or jury: she was convicted and fined $1,000.[34]

After physicians like Timanus were arrested, a host of other Baltimore providers began to fill the gap. Some were skilled, but others were not. Mary Asthure and Leo MacKenzie were arrested and tried in 1952. He had organized the abortions and

she had performed them. It is not clear from the trial record how the pair had entered the abortion business. She was a divorced mother of two, working as a cocktail waitress at a nightclub, when they became romantically involved. Court documents portray MacKenzie as a grifter, unable to hold down a job or support his family. He had been committed to a reform school while a boy. His wife was in a tuberculosis sanitarium (where MacKenzie had stopped paying the bills), while his two sons were being brought up by grandparents. His employment history was sketchy: he had failed to hold down a job at Bethlehem Steel and had then worked as an assistant manager at a pool hall, as a dishwasher, and a sandwich maker at a restaurant. Although the procedure took place at the Mount Royal Hotel, one of the women in the case told the court that she thought that Mary Asthure was a doctor.[35] It was not unknown for providers to use hotels for abortions, and supposedly hotel bellboys, like taxi drivers, were valuable sources of information about where to find abortion providers.

Herman Moser, the same judge who dismissed Beatrice J.'s case, threw the book at MacKenzie, sentencing him to six years in prison.[36] Maybe Moser recognized how repeated convictions of physicians had fostered the entry of undertrained abortion providers like these. There was a world of difference between the highly skilled physician George Timanus and Leo MacKenzie, who had struggled to hold down any job. So, too, with trials such as these, claims that abortion was associated with criminals and con men became something of a self-fulfilling prophecy.

THE POLICE RAIDS OF THE 1940S AND EARLY '50S ALSO MAKE VISIble the way race and abortion intersected in Baltimore. In a city where everything was segregated—swimming pools,

public transportation, theaters, hospital wards—abortion was the exception. Black providers saw white patients and vice versa. MacCrowe and Timanus were the two leading white physician providers; there were two leading Black physicians as well, Luther Fultz and Barnett M. Rhetta Sr. Both were graduates of Howard University and had been in practice for decades by the time the crackdowns started. They must have known each other, as each had been associated with the Provident Hospital, Baltimore's Black hospital. Their practices seem to have differed, however. Fultz was either unlucky or an inept practitioner. When he went on trial in 1940 with his wife, a trained nurse who assisted in the practice, he was accused of causing the deaths of two women. He was convicted and sentenced to four years in prison, but the state deliberately held on to thirteen additional indictments related to other abortions should they wish to try him again in the future.[37]

Barnett Rhetta, the other leading Black provider, had a long and distinguished career as a civic leader. He served as chairman of the Baltimore Interracial Commission in the 1920s, and in 1928, he was almost appointed to the city's school board, backed by the all-powerful Roman Catholic archbishop Michael Joseph Curley. It would have been an unprecedented role for a Black man; the first Black person was not appointed to the school board until 1944. Rhetta campaigned for almost two decades to be admitted to the Johns Hopkins School of Public Health, but was consistently refused, the school citing segregation laws. Only with the demands of World War II would the school finally admit Black students, but by then, it was too late for Rhetta. At the 1955 abortion trial, he pleaded guilty, and Judge Herman Moser sentenced him to ten years in prison, suspended. Moser specifically noted Rhetta's civic leadership, including his role in helping Black people get Health

Department jobs, as well as his age (seventy-one) and ill health, as reasons why he would not be incarcerated.[38]

Rhetta's career as an abortion provider represented a profound shift in his opinion. Back in 1915, seven years out of medical school, he had published an article critiquing abortion, titled "A Plea for the Unborn." Like other Black thinkers of the time, he drew a connection between abortion and eugenics, the discipline that purported to be able to improve the human race through selective breeding. In Jim Crow America, such thinking was everywhere. It fueled anti-immigration efforts and sterilization campaigns directed at the supposedly "unfit." Rhetta's article argued that "eugenics is our greatest enemy." In theory, improving mankind might be admirable, but Rhetta was blunt about what it meant for Black people: "For you and me, as practiced today, it means death." Abortionists were criminals and the laws against them should be strengthened. Equally evil were sterilizations, whether as eugenic or contraceptive measures.[39]

Rhetta's critique of eugenics and its links to abortion was typical for Black physicians at the time. We don't know what made Rhetta change his mind later in his career. He may have started doing abortion work after Luther Fultz went to jail in 1940. Or maybe he had had a change of heart when faced with a tragic case, much as Ed Keemer had done in Detroit, or Anne Adams closer to home.[40]

Baltimore's Black press covered Fultz's and Rhetta's trials in detail. These men were community leaders, models of uplift, and they provided much-needed health care services to Black West Baltimore. It must have been painful to see them prosecuted. The local Black newspaper, the *Afro-American*, chided Fultz. The paper argued that more such convictions were needed so that young Black men and women would be forced to marry, instead of resorting to abortion. Perhaps the paper

was making an appeal to a politics of respectability, although the client named in the Fultz case had been a married white woman. Racial politics meant that Black abortion providers would often be more vulnerable in courtrooms when their clients were white. The editorial suggested that Fultz must wish he had found the strength to resist the pleas of young men and women, and their parents, when they begged him to violate the law. It empathized with him for a moment, recognizing the pressure such patients put on doctors, but came down firmly on the side of the law.[41]

Rhetta was treated somewhat more sympathetically. An opinion piece by a Black woman journalist criticized the way the police raided his office, leaving fifteen patients unseen in the waiting room. Rhetta was elderly and in poor health, but he was not allowed to call a lawyer and arrange bail until it was too late, and he had to spend the night in jail. The op-ed reminded readers that when the mayor's (white) son had been arrested on rape charges, he was able to post bail and leave jail immediately. The journalist closed by highlighting the value of Rhetta's medical service to her community; she had known him for twenty-five years.[42]

WHEN STAKEOUTS, RAIDS, AND ABORTION PROSECUTIONS BECAME the norm in the 1940s, American hospitals began to worry about their own abortion practices. OB-GYN departments had controlled hospital abortions for decades, but they had done so intermittently, even haphazardly. In the late 1920s, back when Alan Guttmacher was an OB-GYN trainee at Johns Hopkins, a social worker brought a fourteen-year-old girl to the hospital seeking an abortion. She had been raped by her father, who had subsequently been indicted and convicted. Guttmacher

spoke to the head of his department, asking for permission to provide abortion care. His chairman took a strict interpretation of the law's specification about a woman's safety, saying the girl's life was not truly at risk. He offered Guttmacher the option of getting a letter from the local district attorney promising that no prosecution would follow. The DA assured Guttmacher that he would not prosecute. However, he would not put it in writing, because he did not want to go on the record telling anyone to violate the law. Six or seven months later, Guttmacher delivered the girl's baby.[43]

In Britain, the relationship among doctors, abortion, and the law had evolved differently. While abortion remained illegal, more leeway was granted to physicians to make individual decisions about which abortions were needful. A 1938 court case reaffirmed physicians' rights to make such decisions. Aleck Bourne, a London-based obstetric surgeon, saw a fourteen-year-old girl who had been gang-raped by soldiers and was now pregnant. He performed the abortion and wanted to make it a test case. In court, the girl, said to be of a "decent family," was compared to a victim of shell shock, a powerful claim in a Britain that remembered the horrors of World War I all too well. The judge was keen to acquit in a case where a doctor had humanely ended a pregnancy that threatened to make a girl "a physical or mental wreck."[44] While the decision underlined that it was only the medical profession who could perform abortions legally, it did offer British doctors a degree of professional autonomy that their US colleagues lacked. The ruling didn't provoke a surge of hospital abortions in the UK, where illegal procedures wouldn't decrease until British abortion law was liberalized in 1967. But George Timanus knew about the Bourne case, and it is possible that he hoped his own trial might result in a similar endorsement of doctors' rights to make abortion decisions.

In this environment, hospitals began insisting that abortions needed to be approved by a "therapeutic abortion committee" made up of a group of OB-GYNs. Only a handful of medical conditions, such as late-stage kidney disease, some heart conditions, poorly managed diabetes, and severe tuberculosis, were considered dire enough to merit abortion. The new committee system limited abortions both formally and informally. One physician recalled conversations in hospital hallways where a doctor might be discouraged from even bothering to bring a case to the committee. Another noted that a woman had to be truly desperate to undergo the detailed and expensive process, paying for multiple medical consultations to establish the severity of her disease.[45]

At the same time, women were under greater scrutiny because reproductive care continued to migrate into hospitals. By 1935, half of all US births already took place in hospitals. Therapeutic abortion committees replaced individual bedside decisions reached by a woman and her doctor, fostering the belief that only a tiny handful of indications for abortion were worthy while the rest were trivial.[46]

BY THE EARLY 1960S, THE THERAPEUTIC COMMITTEE SYSTEM WAS under strain. Doctors began to realize that abortion might be an important resource in the case of grave birth defects, but the committee system was slow to adapt. A crisis caused by the new drug thalidomide and an outbreak of rubella coincided in the early 1960s and raised concern about birth defects. In 1953, European physicians had started prescribing thalidomide, a new drug, often to ease nausea and vomiting in pregnancy. Dr. Frances Kelsey at the US Food and Drug Administration, however, deemed that the drug's safety had not been adequately

demonstrated and fought hard to block its approval. She was right. Thalidomide could damage a developing fetus, causing arms and legs to be deformed into flipper-like structures. Because of Kelsey's insight and determination, Americans were largely spared Europe's tragedy of thousands of children born with this drug-caused deformity. Two thousand pregnancies were affected in the UK alone.[47]

But in Phoenix, Arizona, Mrs. Sheri Finkbine, a mother of four, accidentally took what she thought were sleeping pills that her husband had brought home from Europe. It was thalidomide, and she was expecting. In July 1962, two months pregnant, she made the difficult decision to abort, having been told by her doctor that there was a 50 percent chance her baby would be born with the deformity. The therapeutic abortion committee at Mrs. Finkbine's local hospital approved the abortion because of the accidental thalidomide ingestion. As a mother, who ran a local TV show for nursery-school children and wanted another child, she was the kind of woman whom therapeutic abortion committees saw as blameless and deserving.[48]

But then a chance conversation with a friend led to the local newspaper carrying an anonymized story about her case, intending it to be a warning to other women about the dangers of the European drug. Published two days before her scheduled procedure, the story caught the attention of local Roman Catholic and fundamentalist clergymen as well as the local district attorney, who happened to be a Catholic father of nine. In the 1940s, the Catholic Church had reaffirmed its stance that even therapeutic abortions were wrong: all involved would automatically be excommunicated. The wire services picked up on the story from the Arizona newspapers, and a nationwide news storm erupted. The hospital immediately did an about-face, postponing the abortion. Mrs. Finkbine's doctor tried to obtain a court

order to make the hospital perform the procedure. The court filing revealed Mrs. Finkbine's identity to the press. The Finkbines flew to Sweden, where, after a standard review process involving tests and interviews with gynecologists, psychiatrists, a social worker, and a radiologist, she was granted approval for the abortion early in her fourth month of pregnancy. The aborted fetus showed clear signs of the thalidomide-related deformity. This episode foreshadowed the kinds of intense religious pressures that came to structure—and continue to structure—the American debate on abortion. It also highlights the inequities in abortion access that characterized America in the early 1960s; the Finkbines could fly to Sweden for an abortion, but that was a luxury few other Americans could afford.[49]

A 1963 rubella outbreak amplified American concerns about birth defects. Only a tiny handful of Americans had ever seen, let alone taken, thalidomide, but rubella was a virus, and viruses travel. By the mid-'50s, physicians had come to recognize that somewhere between a third to a half of children born to mothers exposed to rubella during pregnancy had a host of serious birth defects, including heart problems, deafness, and intellectual disabilities. In 1963, the new chairman of the Johns Hopkins OB-GYN department, Allan Barnes, published a paper in *JAMA* arguing that abortions were merited in cases of threatened serious fetal defect. Like women who had inadvertently taken thalidomide, women who had contracted rubella while pregnant began to be considered deserving of abortions. Change, however, was slow. Therapeutic abortion committees sometimes created challenging requirements, such as insisting on proof that a doctor had correctly diagnosed the rubella rash and confirmed it with difficult and time-consuming testing. In New York City, the number of therapeutic abortions nearly doubled in 1964, due to the rubella outbreak, but even this figure could not begin to

address the scale of the problem, especially since most were performed for paying patients, not charity ones.[50]

Over the course of the 1960s, air travel became more common, and increasing numbers of American women flew overseas to get abortions. On the East Coast, Puerto Rico became a preferred option, to the point where the phrase *San Juan weekend* was slang for an abortion. No passport was needed, and San Juan clinics were said to be staffed by highly trained Cuban doctors who had fled the 1959 revolution. While abortion was illegal in Puerto Rico, the police had long looked the other way. By the mid-1960s, Tokyo was also becoming an abortion destination, because it was a routine procedure in Japan. Japanese doctors who had trained in the United States could be recommended by American OB-GYNs who knew them personally from their time together on the wards. One American doctor recalled getting an advertisement from a Japanese provider describing how an American patient would be met at the airport by an English-speaking driver. Other well-to-do American women traveled to Switzerland, West Germany, Sweden, and even Poland, despite the Cold War. Women in Eastern Bloc countries, such as Poland, Hungary, and Czechoslovakia, routinely relied upon abortion, especially since reliable contraceptives could be difficult to obtain. Since abortion was legal, it was performed by trained providers in medical facilities, albeit with scant attention to the patient's comfort.[51]

On the West Coast, women at all economic levels went to Mexico for abortions, despite its being illegal there. After the key agents in the PCAR abortion syndicate were released from prison, some of them relocated over the border to Tijuana, and the city became widely known as the place to go for an abortion. A mere 20 miles from San Diego and under 140 miles from Los Angeles, Tijuana was relatively easy for many women

in Southern California to access. As women flooded over the border—like San Juan, Tijuana was a weekend trip—unskilled practitioners entered the market, with dire results. Doctors who trained at Los Angeles County General Hospital described Monday morning lineups of women who had taken their Friday paychecks and gone across the border for abortions, women who were now experiencing infections or hemorrhages. The residents worked all Monday and through the night into Tuesday doing D&Cs to try to repair the damage. But women could not always be saved. About a third of the hospital's maternal deaths were due to badly performed abortions.[52]

In the late 1950s and early '60s, medical and legal professionals also began to reconsider abortion prohibitions as they faced these kinds of death tolls. In Baltimore, an appalling eight out of ten maternal deaths were due to abortion complications in 1956. The following year, the city's Health Department specifically noted that an increase in maternal deaths was due to postpartum and postabortion infections. In New York City, over 40 percent of pregnancy-related deaths were due to abortion complications by the late 1950s, up 15 percent in a single decade. Black women fared even worse; 50 percent of such deaths were due to abortion.[53]

By the early 1960s, the arbitrariness of the therapeutic abortion system was also weighing on many physicians. Increasingly, psychiatric reasons for therapeutic abortion were accepted by committees, creating a loophole for women who knew the right psychiatrist. In the 1940s, a psychiatric case had been very difficult to claim—in some instances, a woman had to have been receiving inpatient psychiatric care at the same hospital where she sought an abortion. But in the late '50s and early '60s, women who could afford sympathetic psychiatrists were increasingly able to access abortions on mental health grounds.

Poorer women and women of color, however, were largely unable to access this pathway to safe and legal abortion. In the early '60s, only 7 percent of New York City hospital abortions were for women of color. Shut out from the therapeutic abortion option, women of color were obtaining abortions from unsafe practitioners. They had almost three times the number of deaths due to abortion than did white women, despite being a smaller proportion of the city's population.[54]

PHYSICIANS WERE ALSO RESPONDING TO A CHANGING CULTURE. The moral panic about abortion had waned. In 1967, for example, Rhetta's son, Barnett Rhetta Jr., also a physician, was accused of providing abortions for two blond "coeds." He fled to Bermuda to avoid prosecution. Three years later, the *Afro-American* took an almost celebratory tone, with the headline DR. BARNETT RHETTA ALIVE, WELL, AND STILL FABULOUS.[55] By this time, the crackdown of the '40s and '50s was truly over. While abortion remained illegal in many states, others—including Maryland—were beginning to liberalize their laws.

In 1962, the American Law Institute (ALI) published a model abortion law that would expand and codify the remit for therapeutic abortions. Abortion would be legal if the pregnancy resulted from rape or incest, if its continuance would harm a woman's physical or mental health, or if a child would be born with a serious abnormality. All of these circumstances would be determined by physicians, not by the women themselves, but the law would offer those in the medical profession much greater leeway to provide abortions. It would not do away with the institution of the therapeutic abortion committee, or with its inequities, but had the potential to increase access to safe and legal abortion for a broader array of reasons than before.[56]

Physicians like Alan Guttmacher hoped that making it easier for women to get abortions at hospitals would make them less likely to seek out substandard abortion providers—and, ultimately, less likely to die. When he moved to head the OB-GYN department at Mount Sinai Hospital in New York City in 1952, Guttmacher had quickly instituted a therapeutic abortion committee, worried by the hospital's reputation as an easy place to end a pregnancy. Sinai's abortion rates dropped rapidly. However, Guttmacher soon began to see the impact of restrictive policies, with wards full of women suffering the effects of poorly done abortions, and his position on abortion evolved to become more liberal. In 1960, he published an article in the mainstream magazine *Reader's Digest* arguing for liberalization of abortion law. He told the story of the abortion he had not been allowed to perform as a trainee, decades before, but complained that a colleague's wife had gotten a therapeutic abortion on the grounds of "severe malnutrition." She was merely underweight and had not wanted to continue the pregnancy for her own reasons.[57]

The ALI model law, accelerated by the rubella crisis, led to a wave of abortion reform in the mid- to late 1960s, with eleven states passing new legislation by 1970. With its substantial Catholic population, Maryland was not an obvious state to be at the forefront of liberalizing abortion law. However, Planned Parenthood of Maryland, joined by Johns Hopkins physicians, had been building alliances with local clergy. In the early 1950s, the group had reached out to Protestant and Jewish clergy in the city to garner support for contraception, forming the Clergymen's Advisory Board. By the 1960s, two rabbis and an Episcopalian minister routinely gave lectures on family planning, sponsored by the organization. Although careful to keep the fact out of the public eye, from 1958, Planned Parenthood began running satellite clinics based in sympathetic Baltimore churches. These

connections among clergy, family-planning advocacy groups, and Hopkins physicians were instrumental in fostering new abortion legislation in the state.[58]

The ALI laws gave more women access to abortion, but because they entrenched therapeutic abortion committees, they perpetuated the inequalities inherent in that system. A woman seeking to end a pregnancy had to see multiple physicians, obtain letters from them, and pay for a hospital stay. Women of color and those lacking financial resources were less likely than their better-off sisters to be able to access hospital-based health care of all kinds. It was not until 1973 that Baltimore's Health Department noted that there had finally been no deaths resulting from poorly performed abortions that year.[59]

It soon became clear to physicians that the new laws, while an improvement, weren't going to solve the crisis in abortion care. In 1967, a California physician, Dr. Leon Belous, was convicted for referring Cheryl Bryant to a physician in Chula Vista for an abortion. Belous was widely respected by his colleagues, becoming chief of OB-GYN at Cedars of Lebanon Hospital in Los Angeles. He tried to dissuade Bryant from abortion, but was worried that she would go to Tijuana, risking her life with an undertrained practitioner. He had already lost patients that way, describing "something dying a little inside me too" in a 1962 letter to a newspaper. Such experiences had made him a vocal critic of abortion laws. Belous knew the Chula Vista doctor to be a competent practitioner and had referred patients to him previously. Both knew that Bryant had no chance of getting through a therapeutic abortion committee at a hospital. In the trial, he invoked the "harm to a woman's physical health" clause of the new state law. Two years later, Belous won the case on appeal, not least because the language of the ALI-based law was judged too vague, protecting neither women nor physicians. The

California Supreme Court declared that the state's abortion law was unconstitutional. In effect, this stunning decision legalized physicians to provide abortions as they saw fit. It was also the first time that a court addressed a patient's constitutional right to abortion, on grounds of privacy, an important model for *Roe v. Wade*.[60]

As a handful of states began to liberalize, clergy took an unprecedented role in providing counseling about access. In New York City, the Reverend Howard Moody was asked by a woman for help in finding an abortion. He resourcefully found a provider, but the woman was turned away because she did not know the correct code word to be admitted to the apartment where the abortions were done. Moody was taken aback and early in 1967 convened a number of clergy to hear women tell of their experiences. The women shared the terrors of being blindfolded, of having procedures done without anesthesia, of not knowing whether their provider would be competent. After seeking legal advice, a group of rabbis and Protestant ministers started a clergy consultation service. Although New York broadened the remit for therapeutic abortions in 1965, it only decriminalized abortion in 1970, so theirs was a bold move. They began to refer women for abortions overseas or to providers outside New York in an attempt to avoid prosecution. By 1969, they were helping ten thousand women a year, mostly by phone.[61]

Grassroots feminist organizing created the next wave of change, especially as it became clear that the ALI model laws did not yield sufficient improvement. Access was still limited, and illegal abortions, such as that of Dr. Belous's patient, continued apace. In the early 1960s, Patricia Maginnis, a California activist, argued that women should be able to make a decision to end a pregnancy without jumping through the hoops posed by therapeutic

abortion committees. Her organization, the Society for Humane Abortion (SHA), changed the terms of the argument, offering a radical alternative to the ALI liberalization model. The power to decide would now be in the hands of women themselves. Maginnis's organization offered consults about getting abortions in foreign countries, such as Mexico, Japan, and Sweden. By 1969, the SHA had supposedly helped twelve thousand women obtain overseas abortions.[62]

But many women could not afford such costs. In 1965, Heather Booth, a Chicago college student, was asked for advice about where to get a safe abortion, and from those conversations, a local underground referral service began, known as the Jane Collective. Women were told to ask for "Jane" when they phoned, just as a 1950s Baltimore provider had used the code words *rose pattern* to circumvent wiretaps. But unlike some of these earlier providers, the Jane Collective prided itself on safety and access, providing counseling and referrals and refusing to make a profit from women's desperation. The group became truly radical when some of its members began to do D&C procedures themselves after their most trusted provider decided to retire. Both the Janes and the SHA had their early origins in the flowering of second-wave feminism in the mid-1960s. They developed powerful feminist critiques of the power granted to the largely male medical profession by the therapeutic abortion committee system. By the early 1970s, Jane offered clients the chance to use speculums and mirrors to do their own pelvic exams and began to provide them with copies of the feminist health guide *Our Bodies, Ourselves*.[63]

By that time, the Janes were seeing a shift in the kinds of women they treated. Those who could afford to fly to New York for a legal abortion did so. The Chicago women served by the Janes became the working women for whom such a trip was

unaffordable. After 1973, women no longer had to cross state lines to find legal abortions. The *Roe v. Wade* Supreme Court decision legalized abortion nationwide. This sea change resulted from the work of a new generation of lawyers committed to civil rights and feminist causes. In 1969, a group of feminist lawyers in Austin, Texas, met Norma McCorvey, a twenty-two-year-old woman who wanted to end a pregnancy. McCorvey became "Jane Roe," the test case that went all the way to the Supreme Court, although not in time to help McCorvey.[64]

The *Roe v. Wade* decision was grounded in the 1965 *Griswold v. Connecticut* decision that had invoked a right to privacy as the reason that wives and husbands should be able to make decisions about contraception. The decision to end a pregnancy, *Roe v. Wade* declared, was included in a woman's right to privacy. The state stepped back from its century-old bargain with the profession of medicine, a bargain that had taken clinical decision-making from a doctor's hands and put it in legal codes. The Supreme Court specified that a physician was able to determine, "without regulation by the State," what was best for his or her patient. In a companion decision, *Doe v. Bolton*, the court declared that the therapeutic abortion committee system was unconstitutional because it restricted both women's access and physicians' freedom to make medical decisions.[65]

In the UK excluding Northern Ireland, abortion was legalized by the Abortion Act of 1967, on the condition that two physicians attest to evidence of severe fetal anomaly or risk to the woman's life; it's also legal up to 24 weeks' gestation, if two physicians certify that continuing the pregnancy would harm the woman or her existing children. This notion of "harm" is interpreted liberally, such that abortion is effectively decriminalized and accessible through the National Health Service for the first

24 weeks of pregnancy. Any abortion outside of these conditions remains a crime, as specified in the 1861 Offences Against the Person Act.

Northern Ireland took a different path: abortion remained illegal there until 2019. It is now available unconditionally up to 12 weeks' gestation, and between 12 and 24 weeks with conditions similar to the rest of the UK. The Republic of Ireland decriminalized abortion in 2018, prompted in part by protests after a woman died from a septic miscarriage in 2012, having been refused the abortion which would have saved her life. But the recent rollback of rights in America reminds British and Irish women that what has been won can also be lost.

BEATRICE J., WHO WENT FROM ENDING HER OWN PREGNANCIES TO providing abortions for a few friends and clients, lived through a watershed in American abortion history. She had had her first two children late in the Depression, a time when anyone could recognize how hard it might be for a working family to raise another child. Her first abortion, self-administered, took place in 1941, right at the beginning of the new wave of repression. By the time she found herself making a statement in a police station in October 1951, most of Baltimore's safest abortion providers had been prosecuted, and a range of increasingly unsafe ones were filling the gap in the market. After her close shave with the law, she married her second husband and lived until she was seventy-three.

Beatrice, who died in 1990, saw both the advent of *Roe v. Wade* and the beginning of the anti-abortion movement that ultimately undid it. Her story captures so much of women's abortion experiences in twentieth-century America: the quiet toleration of the interwar period, followed by the crackdowns of the '40s and '50s, only to have that moment of moral panic

dissolve in the '60s, followed by landmark legislation that legalized abortion for American women. Today, too, many in the Western world look to the United States as a bellwether of abortion access and rights—but with anxiety, rather than hope. In this new cycle of repression, the everyday courage of past women like Beatrice is an inspiration.

CODA

As I researched Beatrice J.'s story for the last chapter, I recognized that her city was not so different from the Baltimore I inhabit. Unknowingly, I passed the sites of her home, and Dr. Timanus's office, every day when driving my son to school. But unlike Beatrice, I came of age sexually in a brief golden moment, after *Roe v. Wade* and before AIDS. I was greener than grass, as naive as the day is long, and it is probably only good luck that I avoided an unintended pregnancy. But as a white, middle-class, American woman reaching maturity after 1973, I could have accessed abortion safely and legally, a very rare privilege when viewed at the scale of this book. Access to such abortion care has often been scarce, and in my country, it is becoming more so as I write.

As many stories in this book indicate, prohibition rarely succeeds in actually stamping out abortion. After the 2022 US Supreme Court decision, states began limiting or banning abortion, but the number of legal abortions in the United States has increased, not decreased since.[1] Abortion does not go away just because it is forbidden.

Globally, abortion is a volatile issue in many places at present, but there is not any uniform direction of movement. Deeply Catholic nations like Ireland, Colombia, and Mexico have

liberalized abortion laws in the past decade, while others, such as El Salvador, imprison women who have miscarried merely on suspicion that they induced abortion. Liberalized laws, of course, are not the same as access, and so there are many regions that lack physicians willing to perform abortions, creating de facto restriction.

The long view shows us that women across many times and places have sought to manage their reproductive lives. Women in ancient Greece jumped up and down or took herbs to end pregnancies. Medieval European women used those same plants, as well as new ones native to their locales. Enslaved Black women in the American South chewed cotton root to manage their fertility, drawing upon African knowledge and practice. From our vantage point, many of the methods women have employed to end pregnancies might seem inept, inadequate, or out-and-out dangerous. But such judgments from today obscure the central point: women have always striven to control their fertility.

So often, patriarchal leaders have pushed back. Whether it was Cicero, declaiming that a pregnant woman was obliged to bear a child after her husband died because it represented his "hope," or early modern German authorities insisting that unwed pregnant women, abandoned on the eve of marriage, bear children who would be branded bastards for all their lives, the message was the same: women's bodies were not wholly their own. Often, times of repression were times of gender upheaval. Woman were struggling for new forms of autonomy, whether that was elite women riding around in coaches in ancient Rome, or antebellum American women arguing that they should be able to vote. Some responded by trying to limit women's abilities to manage their own reproductive lives.

The long view shows that abortion has always been with us. Even in times of restriction, there have been extensive periods

of toleration. Everyone knew that women needed to manage their own bodies, and many looked the other way when they saw evidence of such management. For every woman who posed awkward questions about her servant's swelling belly, there was another who pointed out an abortifacient plant in the fields on a walk home. This isn't to say that the history of abortion is a vast continuum of women helping women, some kind of happy female fellowship. For most of the past two thousand years, societies were deeply patriarchal, and women had to navigate within oppressive systems of governance supported by both women and men. But in the interstices of communities, some women offered plants and advice to others, and both men and women ignored gossip, pretended not to notice, and failed to ask questions. Abortion was often illegal, and might have been unsafe, but it was de facto permitted. Such toleration suggests that while prohibition ruins lives in the short term, it has often failed over the long run.

Looking at abortion over many centuries reveals that its meanings have shifted over time. For most of history, what was "wrong" about abortion did not center on the fetus. So abortion among elite Roman women was wrong because it assumed rights over someone else's (the father's) property. When enslaved women in the early modern Caribbean ended pregnancies, enslavers were angry because they thought they owned that right, as they owned any offspring of an enslaved woman. At other times, abortion was not the primary concern; it pointed to a greater wrong, that of irregular sexual relations. Thus sixteenth-century German women who had the misfortune to fall pregnant were punished as much for the pregnancy as for ending it. In the 1950s, abortion in the United States was linked to racketeering and Communism, hidden vices that threatened the American way of life.

The way people understood pregnancy itself was different from in our own time, when pregnancy often starts very early, with lines appearing on an at-home pregnancy test. In the premodern world, this was a much slower realization; in some ways, it scarcely was a pregnancy until quickening, when a woman felt something move within her. Splitting a pregnancy into two halves meant that early abortion was barely abortion at all; it was ridding the body of some superfluous material that might have become a pregnancy—or not.

One of my readers told me that this book was "an ode to self-managed abortions." It wasn't exactly what I had set out to write, but I could see her point. The long view shows us that while ancient doctors had detailed knowledge about abortion, physicians were not the primary providers of abortion care until very recently. Now, that pendulum is beginning to swing the other way again. Mifepristone and misoprostol, developed in the 1980s and used for medication abortion today, have long historical roots. For millennia, women have taken drugs in their own homes, quietly managing their fertility. Much has changed—mifepristone and misoprostol are carefully titrated pharmaceuticals, not plants picked in the wild or bought from a market stall. Modern drugs are safer than similar remedies used in the past. But the determination to control one's own destiny is very familiar. So, too, are the strategies and subterfuges women may employ to access such medications, shipping them across state lines, or asking a provider for a remedy with a cover story about some nonreproductive need.

This book argues that times of repression are dangerous. Women lose their lives, especially tragic today, when antisepsis and antibiotics make abortion an exceptionally safe process. To be clear, not all abortions that took place during such times of repression were dangerous. Providers have offered competent

care to thousands of women without legal access to abortion in the age of modern medicine; and in earlier times, too, though the risk was greater, many women survived successful abortions carried out by knowledgeable and responsible providers, including in times of prohibition. But when abortion is illegal and actively prosecuted, women will seek care from whomever they can find, even a cocktail waitress who does procedures in a hotel. Abortions that happen in the shadows can be dangerous because women cannot access the information they need to identify safe providers. And if a woman in medical crisis cannot access abortion in a hospital, where a procedure could be performed very safely, she may lose her life.

Some of the stories in this book are tragic. But in writing them, I also found cause for optimism. Periods of acute repression have not lasted. Like wildfires, moral panics burn out, and times of toleration usually follow. People go back to looking the other way, acting on an unspoken understanding that these things happen, that sometimes a woman cannot bear a child, or that women know best. Ultimately, I hope that we can move beyond this long series of ebbs and flows of restriction and tolerance by enshrining rights to abortion in national law, wherever such laws are lacking.. Women have long been determined to shape their own reproductive lives, and that determination won't go away.

ACKNOWLEDGMENTS

IT IS A PLEASURE TO THANK THE MANY COLLEAGUES AND FRIENDS who have been so generous with comments, references, and suggestions. Writing often seems a solitary pursuit, but in truth, we rely on so many others. First are my thanks to the librarians at Johns Hopkins. While working on this book, I'd take at least another dozen or so books out of the library every week, not to mention accessing mountains of digital sources. Heather Furnas, Zee Hinz, and Michael Seminara answered countless queries with great good humor, for which I owe my deepest gratitude. Thanks also to the interlibrary loan team who found obscure books I never imagined I'd be able to borrow. Sheridon Ward and Leigh Alon provided much-needed research support—thanks to both.

Rebecca Flemming and Lauren Kassell, noted historians of reproduction themselves, organized workshops at the University of Exeter and the European University Institute, where I could try out big chunks of the book—warmest thanks to both of them and to all who participated. Their comments, questions, and suggestions have been so valuable. At Hopkins, I had the privilege of co-organizing a workshop on the history of abortion

with Elizabeth O'Brien, from whom I learned so much, for which I give my thanks.

The book covers a long time span, and I am very thankful to colleagues who read chapters for me, contributing their particular knowledge of time and place. My appreciation for their contributions runs much deeper than mere mention of their names might suggest. Many thanks to: Kathleen Brown, Emily Janine Clark, Kathleen M. Crowther, Jonathan Durrant, Laura Gowing, Katie Hemphill, Peter Jones, Brooke Lansing Mai, Carole McCann, Graham Mooney, Zubin Mistry, Thera Naiman, Lea Olsan, Shane Prada, Sarah Pearsall, Charles Rosenberg, Johanna Schoen, Gabrielle Spiegel, Jennifer Stager, Carolyn Sufrin, Nicholas Syrett, Laurence Totelin, and Anna Weerasinghe. Lauren Kassell and William Fissell went the distance, reading the entire manuscript, for which I'm so grateful.

The idea for this book crystallized in a conversation with my agent, Amanda Annis. Thank you so much, Amanda, for your belief in the project and all of your graceful support in helping me achieve it. Special thanks to Neil Theise for introducing us, and for encouragement on the way. I have learned much from my editors at Basic: Janice Audet, Emily Taber, and especially Emma Berry, who combined just the right mix of queries, cuts, and supportive comments in the margins. Annie Chatham has been a stalwart as production editor, and careful copy edits by Sara Robb at ScriptAcuity Studio saved me various infelicities. At Hurst, Lara Weisweiller-Wu has been a sensitive, steadying, and supportive editorial presence. Thanks to all!

This past year, I served as department chair, and my warmest thanks go to Maggie Cogswell for supreme administrative assistance. She buffered me in ways that allowed me to both write and lead; thanks so much, Maggie.

Friends and family have put up with me being so deeply in the writing process that sometimes I was only half there, the other half of my mind chasing after some thought or edit. Huge thanks to my son, Sam, to my brother and sisters, and to Team Baltimore, including Anne Lester, Sarah Pearsall, Thora Sherbakov, and Jen Stager, for all of their support and kindness. Last but far from least are my students, past and present, who have asked tough questions, made me rethink my assumptions, and reminded me why history matters.

FURTHER READING

IF YOU WANT TO READ FURTHER IN THE HISTORY OF ABORTION, A rich scholarship awaits. While most work is about the recent past, there are excellent books on the premodern world as well. *Reproduction: Antiquity to the Present Day*, ed. Nick Hopwood, Rebecca Flemming, and Lauren Kassell (Cambridge, England: Cambridge University Press, 2018), provides shorter overview articles on a wide range of topics in the history of reproduction. Kathleen M. Crowther's *Policing Pregnant Bodies: From Ancient Greece to Post-Roe America* (Baltimore: Johns Hopkins Press, 2023) takes a long view of topics such as the fetal heartbeat, essential for understanding abortion.

CHAPTER 1

Konstantinos Kapparis, *Abortion in the Ancient World* (London: Duckworth, 2002), offers a detailed and readable survey of the history of abortion in ancient Greece and Rome. Ancient Greek and Roman texts are accessible to modern readers in the Loeb Library editions published by Harvard University Press. They offer facing-page translations, with the original classical language on one side and English in the other. The digital edition allows for keyword searching, but printed texts may be more

accessible. The Hippocratic text *The Diseases of Women* has abundant remedies for various reproductive system woes and offers an entry point in such literature. On women and medicine in the ancient world, see Helen King, *Hippocrates Woman: Reading the Female Body in Ancient Greece* (London; New York: Routledge, 1998); Laurence M. V. Totelin, *Hippocratic Recipes: Oral and Written Transmission of Pharmacological Knowledge in Fifth- and Fourth-Century Greece* (Leiden, Netherlands; Boston: Brill, 2009); and Rebecca Flemming, *Medicine and the Making of Roman Women: Gender, Nature, and Authority from Celsus to Galen* (Oxford, England: Clarendon Press, 2000).

CHAPTER 2

Two books about abortion in the Middle Ages are foundational: Zubin Mistry, *Abortion in the Early Middle Ages, c. 500–900* (Woodbridge, England: York Medieval Press, 2015), and Wolfgang P. Müller, *The Criminalization of Abortion in the West: Its Origins in Medieval Law* (Ithaca, NY: Cornell University Press, 2017). Mistry focuses on the early Middle Ages, and Müller on the complexities of legal thinking. M. J. Elsakkers's dissertation is available online, bundled with her published articles, and it is a trove of information: M. J. Elsakkers, "Reading Between the Lines: Old Germanic and Early Christian Views on Abortion," PhD dissertation, University of Amsterdam, 2010, https://hdl.handle.net/11245/1.327030. Roland Betancourt, "Abortion and Contraception in the Middle Ages: Both Were More Common Than You Think," *Scientific American*, December 11, 2020, offers a quick corrective for those who think such were unknown. Sarah M. Butler, "Abortion by Assault: Violence Against Pregnant Women in Thirteenth- and Fourteenth-Century England," *Journal of Women's History* 14, no. 4 (Winter 2005): 9–31, is a useful introduction to the topic of violence and abortion.

On women and medicine more generally, see Monica Green, *Making Women's Medicine Masculine: The Rise of Male Authority in Pre-Modern Gynaecology* (Oxford, England: Oxford University Press, 2008), and Victoria Sweet, *Rooted in the Earth, Rooted in the Sky: Hildegard of Bingen and Premodern Medicine* (New York: Routledge, 2006). While John Riddle's books have come under criticism for oversimplifying, they are thought-provoking and point readers to a wide range of sources: John M. Riddle, *Contraception and Abortion from the Ancient World to the Renaissance* (Cambridge, MA: Harvard University Press, 1992), and his similar *Eve's Herbs: a History of Contraception and Abortion in the West* (Cambridge, MA: Harvard University Press, 1997).

CHAPTER 3

John Christopoulos's book analyzes abortion in Renaissance Italy in terms of law, medicine, and religion, offering a comprehensive picture—or as comprehensive as any can be, given that Italy was not united but composed of multiple political entities: John Christopoulos, *Abortion in Early Modern Italy* (Cambridge, MA: Harvard University Press, 2021). On German-speaking lands, see Margaret Brannan Lewis, *Infanticide and Abortion in Early Modern Germany* (London: Routledge, 2016).

We lack similarly comprehensive books about other countries. For the larger context, see Barbara Duden, *The Woman Beneath the Skin* (Cambridge, MA: Harvard University Press, 1991), about an eighteenth-century German doctor's female patients, and Lyndal Roper, *The Holy Household: Women and Morals, in Reformation Augsburg* (Oxford, England: Clarendon, 1989), on the moral policing of women. For England, see Laura Gowing, *Common Bodies: Women, Touch, and Power in Seventeenth-Century England* (New Haven, CT: Yale

University Press, 2003), and my own *Vernacular Bodies: The Politics of Reproduction in Early Modern England* (Oxford, England: Oxford University Press, 2004). Julie Hardwick, *Sex in an Old Regime City: Young People, Production, and Reproduction in France, 1660–1789* (New York: Oxford University Press, 2020), is a rich account of young people's sex lives in a French city.

The literature on witchcraft is vast; for a start, see Jonathan B. Durrant, *Witchcraft, Gender, and Society in Early Modern Germany* (Leiden, Netherlands; Boston: Brill, 2007); Lyndal Roper, *Witch Craze: Terror and Fantasy in Baroque Germany* (New Haven, CT: Yale University Press, 2004); Thomas Robisheaux, *The Last Witch of Langenburg: Murder in a German Village* (New York: W. W. Norton, 2009).

CHAPTER 4

See Susan E. Klepp, *Revolutionary Conceptions: Women, Fertility, and Family Limitation in America, 1760–1820* (Chapel Hill: University of North Carolina Press, 2009), for a rich account of the way some colonial women came to control their fertility. On midwifery, see Laurel Thatcher Ulrich, *A Midwife's Tale: The Life of Martha Ballard, Based on Her Diary, 1785–1812* (New York: Alfred A. Knopf, 1990). On sexual relations in the colonies, Richard Godbeer, *Sexual Revolution in Early America* (Baltimore: Johns Hopkins University Press, 2002), and Clare A. Lyons, *Sex Among the Rabble: An Intimate History of Gender & Power in the Age of Revolution, Philadelphia, 1730–1830* (Chapel Hill: University of North Carolina Press, 2006), provide helpful entry points.

The literature on enslaved women and reproduction is very rich. Two early articles are foundational: Barbara Bush-Slimani, "Hard Labour: Women, Childbirth and Resistance in British

Caribbean Slave Societies," *History Workshop Journal* 36 (1993): 83–99, and Liese M. Perrin, "Resisting Reproduction: Reconsidering Slave Contraception in the Old South," *Journal of American Studies* 35 (2001): 255–74. Crucial recent scholarship includes Jennifer L. Morgan, *Laboring Women: Reproduction and Gender in New World Slavery* (Philadelphia: University of Pennsylvania Press, 2011); Sasha Turner, *Contested Bodies: Pregnancy, Childrearing, and Slavery in Jamaica* (Philadelphia: University of Pennsylvania Press, 2017); Katherine Paugh, *The Politics of Reproduction: Race, Medicine, and Fertility in the Age of Abolition* (Oxford, England: Oxford University Press, 2017); Deirdre Cooper Owens, *Medical Bondage: Race, Gender, and the Origins of American Gynecology* (Athens: University of Georgia Press, 2017).

For a biographical treatment of Maria Sybilla Merian, see Natalie Zemon Davis, *Women on the Margins: Three Seventeenth-Century Lives* (Cambridge, MA: Harvard University Press, 1995).

CHAPTER 5

There are a number of foundational works on sex and contraception in Victorian Britain: Hera Cook, *The Long Sexual Revolution: English Women, Sex, and Contraception, 1800–1975* (Oxford, England: Oxford University Press, 2004), 42–43; Angus McLaren, *Birth Control in Nineteenth-Century England* (New York: Holmes & Meier, 1978). Angus McLaren, *Reproductive Rituals: The Perception of Fertility in England from the Sixteenth to the Nineteenth Century* (London: Methuen, 1984), is a rich overview of sex and reproduction in England.

On working-class women, see Anna Clark, *The Struggle for the Breeches: Gender and the Making of the British Working Class* (Berkeley: University of California Press, 1995); for a

later period, Ellen Ross, *Love and Toil: Motherhood in Outcast London, 1870–1918* (New York: Oxford University Press, 1993). Françoise Barret-Ducrocq, *Love in the Time of Victoria: Sexuality, Class, and Gender in Nineteenth-Century London* (London: Verso, 1991), is a moving exploration of the plight of unwed mothers.

CHAPTER 6

James C. Mohr, *Abortion in America: The Origins and Evolution of National Policy, 1800–1900* (New York: Oxford University Press, 1978), remains a very helpful overview that integrates medicine and the law. Janet Farrell Brodie, *Contraception and Abortion in Nineteenth-Century America* (Ithaca, NY: Cornell University Press, 1994), and Andrea Tone, *Devices and Desires: A History of Contraceptives in America* (New York: Hill and Wang, 2001), provide rich accounts, as does Marie Jenkins Schwartz, *Birthing a Slave: Motherhood and Medicine in the Antebellum South* (Cambridge, MA: Harvard University Press, 2006).

Madame Restell is the subject of two recent biographies: Nicholas Syrett, *The Trials of Madame Restell* (New York: New Press, 2023), and the more impressionistic Jennifer Wright, *Madame Restell: The Life, Death, and Resurrection of Old New York's Most Fabulous, Fearless, and Infamous Abortionist* (New York: Hachette Books, 2023).

On Comstock-era repression and the sexual cultures of antebellum America, Helen Lefkowitz Horowitz, *Rereading Sex: Battles over Sexual Knowledge and Suppression in Nineteenth-Century America* (New York: Alfred A. Knopf: 2002), remains invaluable, not least in correcting older assumptions about Victorians and sexual repression.

CHAPTER 7

The history of abortion in the last century has been the subject of extensive scholarship. Start with Leslie J. Reagan, *When Abortion Was a Crime: Women, Medicine, and Law in the United States, 1867–1973* (Berkeley: University of California Press, 1997), which is a foundational work with rich detail. Kristin Luker, *Abortion and the Politics of Motherhood* (Berkeley: University of California Press, 1984), covers before and after *Roe*. It includes details from personal interviews, as does Carole E. Joffe, *Doctors of Conscience: The Struggle to Provide Abortion Before and After Roe v. Wade* (Boston: Beacon Press, 1995), which provide invaluable evidence of practices when abortion was illegal. See also Patricia G. Miller, *The Worst of Times* (New York: HarperCollins, 1993), for moving testimonies of abortion before *Roe*.

The literature on eugenics is sizable; see Johanna Schoen, *Choice and Coercion: Birth Control, Sterilization, and Abortion in Public Health and Welfare* (Chapel Hill: University of North Carolina Press, 2005), and Molly Ladd-Taylor, *Fixing the Poor: Eugenic Sterilization and Child Welfare in the Twentieth Century* (Baltimore: Johns Hopkins University Press, 2017), for entry points relevant to abortion.

David Garrow, *Liberty and Sexuality: The Right to Privacy and the Making of Roe v. Wade* (New York: Macmillan, 1994), and Joshua Prager, *The Family Roe: An American Story* (New York: W. W. Norton, 2021), offer ways into the 1973 legislation. More generally, see Rickie Solinger, *Abortion Wars: A Half Century of Struggle, 1950–2000* (Berkeley: University of California Press, 1998). For the period after 1973, Johanna Schoen, *Abortion After Roe* (Chapel Hill, North Carolina: University of North Carolina Press, 2015), is invaluable.

For a handful of histories in other national contexts, see Cornelie Usborne, *Cultures of Abortion in Weimar Germany* (New York: Berghahn Books, 2007); Barbara L. Brookes, *Abortion in England, 1900–1967* (London; New York: Croom Helm, 1988); William R. LaFleur, *Liquid Life: Abortion and Buddhism in Japan* (Princeton, NJ: Princeton University Press 1992); Mie Nakachi, *Replacing the Dead: The Politics of Reproduction in the Postwar Soviet Union* (New York: Oxford University Press, 2021).

NOTES

Introduction

1. "The World's Abortion Laws," Center for Reproductive Rights, accessed October 14, 2024, https://reproductiverights.org/maps/worlds-abortion-laws/.

Chapter 1: The Singer: Abortion in Antiquity

1. Hippocrates, *Generation. Nature of the Child. Diseases 4. Nature of Women and Barrenness*, ed. and trans. Paul Potter, Loeb Classical Library 520 (Cambridge, MA: Harvard University Press, 2012), 35–37; Helen King, "Self-Help, Self-Knowledge: In Search of the Patient in Hippocratic Gynaecology," in *Women in Antiquity: New Assessments*, ed. Richard Hawley and Barbara Levick (London; New York: Routledge, 1995), 141–42.

2. Hippocrates, *Generation*, 35–37.

3. Hippocrates, *Places in Man. Glands. Fleshes. Prorrhetic 1–2. Physician. Use of Liquids. Ulcers. Haemorrhoids and Fistulas*, ed. and trans. Paul Potter, Loeb Classical Library 482 (Cambridge, MA: Harvard University Press, 1995), 157, 157–59; Hippocrates, *Diseases of Women 1–2*, ed. and trans. Paul Potter, Loeb Classical Library 538 (Cambridge, MA: Harvard University Press, 2018), 141–47.

4. Aristotle, *Politics*, trans. H. Rackham, Loeb Classical Library 264 (Cambridge, MA: Harvard University Press, 1932), 17.

5. Lesley Dean-Jones, "Autopsia, Historia, and What Women Knew: The Authority of Women in Hippocratic Gynecology," in *Knowledge and the Scholarly Medical Traditions*, ed. Donald Bates (Cambridge, England: Cambridge University Press, 1995), 41–59; Laurence M. V. Totelin, *Hippocratic Recipes: Oral and Written Transmission of Pharmacological Knowledge in Fifth- and Fourth-Century Greece* (Leiden, Netherlands; Boston: Brill, 2009), 111–13.

6. Xenophon, *Memorabilia. Oeconomicus. Symposium. Apology*, trans. E. C. Marchant and O. J. Todd, rev. Jeffrey Henderson, Loeb Classical Library 168 (Cambridge, MA: Harvard University Press, 2013), 441; Robert Garland, *Daily Life in Ancient Greece* (Westport, CT: Greenwood, 2009), 97.

7. Nancy Demand, *Birth, Death, and Motherhood in Classical Greece* (Baltimore: Johns Hopkins University Press, 1994); Mark Golden, *Children and Childhood in Classical Athens* (Baltimore: Johns Hopkins University Press, 1990). For an argument that women may not have been so secluded, David Cohen, *Law, Sexuality, and Society: The Enforcement of Morals in Classical Athens* (Cambridge, England: Cambridge University Press, 1991), 150–55.

8. Lynn R. LiDonnici, ed. and trans., *The Epidaurian Miracle Inscriptions: Text, Translation, and Commentary* (Atlanta, GA: Scholars Press, 1985), 113, 115; Jean-Nicolas Corvisier, *Santé et Societé en Grèce Ancienne* (Paris: Economica, 1985), 121.

9. Soranus, *Gynecology*, trans. Owsei Temkin (Baltimore: Johns Hopkins University Press, 1956), 79–80; Judith Evans Grubb, "Infant Exposure and Infanticide," in *The Oxford Handbook of Childhood and Education in the Classical World*, ed. Judith Evans Grubbs and Tim Parkin (Oxford, England: Oxford University Press, 2013), 83–107; Debby Sneed, "Disability and Infanticide in Ancient Greece," *Hesperia* 90, no. 4 (2021): 747–72.

10. Golden, *Children and Childhood*, 83; Garland, *Daily Life*, 95.

11. Demand, *Birth, Death*, 29–30; Sarah B. Pomeroy, *Goddesses, Whores, Wives, and Slaves: Women in Classical Antiquity* (New York: Schocken Books, 1975), 41–42, 71–73; Rebecca Futo Kennedy, *Immigrant Women in Athens: Gender, Ethnicity, and Citizenship in the Classical City* (London: Taylor & Francis, 2014), 127; Rebecca Futo Kennedy, "Citizen Elite Women and the Origins of the Hetaira in Athens," *Helios* 42 (2015): 61–79; Edward E. Cohen, "Free and Unfree Sexual Work: An Economic Analysis of Athenian Prostitution," in *Prostitutes and Courtesans in the Ancient World*, ed. Christopher A. Faraone and Laura McClure (Madison: University of Wisconsin Press, 2006), 95–124.

12. Konstantinos Kapparis, *Prostitution in the Ancient Greek World* (Berlin; Boston: Walter de Gruyter GmbH, 2018); Cohen, "Free and Unfree Sexual Work"; Hippocrates, *Places in Man*, 157, 157–59. On women knowing very early that they were pregnant, Helen King, "Making a Man: Becoming Human in Early Greek Medicine," in *The Human Embryo: Aristotle and the Arabic and European Traditions*, ed. G. R. Dunstan (Exeter, England: University of Exeter Press, 1990), 10–19.

13. Galen, *On Prognosis*, ed. and trans. Vivian Nutton (Berlin: Akademie Verlag, 1979), *Corpus Medicorum Graecorum*, vol. V, pt. 8, no. 1, 113; Dean-Jones, "Autopsia, Historia."

14. Plato, *Theaetetus. Sophist*, trans. Harold North Fowler, Loeb Classical Library 123 (Cambridge, MA: Harvard University Press, 1921), 33.

15. Soranus, *Gynecology*, 63; Konstantinos Kapparis, *Abortion in the Ancient World* (London: Duckworth, 2002), 72; Elizabeth M. Craik, *The "Hippocratic" Corpus: Content and Context* (Abingdon, England; New York: Routledge, 2015), 145.

16. The Hippocratic text *Diseases of Women* portrays women's self-administration of abortive pessaries as commonplace but potentially dangerous. Hippocrates, *Diseases of Women 1–2*, and the discussion in Laurence Totelin, "Do No Harm: Phanostrate's Midwifery Practice," *Technai* 11 (2020): 129–44, see esp. 138; Charles Lichtenthaeler, *Der Eid des Hippokrates: Ursprung und Bedeutung* (Köln, Germany: Deutscher Arzte-Verlag, 1984), as cited in Kapparis, *Abortion*, 73; Craik, *"Hippocratic" Corpus*, 148.

17. Soranus, *Gynecology*, 63–64.

18. Hippocrates, *Diseases of Women 1–2*, 180–201, 215–27; Hippocrates, *Generation*, 231–33; Totelin, *Hippocratic Recipes*, 214–19; Rebecca Flemming, *Medicine and the Making of Roman Women: Gender, Nature, and Authority from Celsus to Galen* (Oxford, England: Clarendon Press, 2000), 163.

19. Helen King, *Hippocrates Woman: Reading the Female Body in Ancient Greece* (London; New York: Routledge, 1998); Suzanne Bell and Mary E. Fissell, "A Little Bit Pregnant? Productive Ambiguity and Fertility Research," *Population and Development Review* 47, no. 2 (June 2021): 1–22.

20. *On Simples, Attributed to Dioscorides*, intro., trans., con., John C. Fitch, *Studies in Ancient Medicine*, vol. 57 (Leiden, Netherlands; Boston: Brill, 2022), 119–22.

21. Hippocrates, *Diseases of Women 1–2*, expulsion: 187, provoke menses: 163, cleansing: 341, 373; Pedanius Dioscorides of Anazarbus, *De Materia Medica*, trans. Lily Y. Beck, 3rd rev. ed. (Hildesheim, Germany: Olms-Weidmann, 2017), pennyroyal: 51, savin: 58–59; Celsus, *On Medicine*, vol. I, books 1–4, trans. W. G. Spencer, Loeb Classical Library 292 (Cambridge, MA: Harvard University Press, 1935), 449; Hippocrates, *Generation*, rue: 333.

22. Aristophanes, *Clouds. Wasps. Peace*, ed. and trans. Jeffrey Henderson, Loeb Classical Library 488 (Cambridge, MA: Harvard University Press, 1998), 517; Laurence M. V. Totelin, "Sex and Vegetables in the Hippocratic Gynaecological Treatises," *Studies in History and Philosophy of Biological and Biomedical Sciences* 38 (2007): 531–40, esp. 536.

23. Aristophanes, *Birds. Lysistrata. Women at the Thesmophoria*, ed. and trans. Jeffrey Henderson, Loeb Classical Library 179 (Cambridge, MA: Harvard University Press, 2000), 279. Iain M. Lonie makes the connection to the Hippocratic text: *The Hippocratic Treatises, "On Generation," "On the Nature of the Child," "Diseases IV": A Commentary* (Berlin; New York: De Gruyter, 1981), 165.

24. Aristophanes, *Birds*, 277, 279. The allusion to pennyroyal has been interpreted in multiple ways; Totelin sees it as an allusion to pubic hair while Potter agrees, translating βληχώ as "bush." The word specifically means pennyroyal, and given Aristophanes's allusion in *Peace*, I read it more specifically. In Hippocratic works, it is often given in Ionian dialect as γληχώ.

25. Hippocrates, *Diseases of Women 1–2*, 135, 201, to prevent sepsis: 135; Hippocrates, *Generation*, 239–41, as an ingredient in cleansing douches: 251, a fumigation: 257; Soranus, *Gynecology*, 64–65. Note, however, that Soranus then says, "These things not only prevent conception, but also destroy any existing" (65–66). See pomegranate peel used in a remedy against uterine flux, 167. Hippocrates, *Diseases of Women 1–2*, 173, 175, 361–63.

26. Hippocrates, *Diseases of Women 1–2*, 185; 179. For privacy: Kapparis, *Abortion*, 21, 22–23.

27. M. M. Lafaurie, D. Grossman, E. Troncoso, et al., "Women's Perspectives on Medical Abortion in Mexico, Colombia, Ecuador and Peru: A Qualitative Study," *Reproductive Health Matters* 13 (2005): 75–83, quote on 78. Thanks to Suzanne Bell for this reference. Medline Plus, "Miscarriage," accessed August 7, 2023, https://medlineplus.gov/ency/article/001488.htm.

28. Wolfgang Jöchle, "Menses-Inducing Drugs: Their Role in Antique, Medieval, and Renaissance Gynecology and Birth Control," *Contraception* 4 (1974): 425–39. See also Sarah E. Nelson, "Persephone's Seeds: Abortifacients and Contraceptives in Ancient Greek Medicine and Their Recent Scientific Appraisal," *Pharmacy in History* 51, no. 2 (2009): 57–69; John M. Riddle, *Contraception and Abortion from the Ancient World to the Renaissance* (Cambridge, MA: Harvard University Press, 1992); Kapparis, *Abortion*, 15–16; Totelin, *Hippocratic Recipes*, 220–24. Critique: Bruce Frier, "Natural Fertility and Family Limitation in Roman Marriage," *Classical Philology* 89 (1994): 318–33; Etienne van de Walle and Elisha P. Renne, eds., *Regulating Menstruation: Beliefs, Practices, Interpretations* (Chicago: University of Chicago Press, 2001), 3–21. Norman R. Farnsworth et al., "Potential Value of Plants as Sources of New Antifertility Agents I," *Journal of Pharmaceutical Sciences* 64 (April 1975): 535–98, pennyroyal: 583; Norman R. Farnsworth et al., "Potential Value of Plants as Sources of New Antifertility Agents II," *Journal of Pharmaceutical Sciences* 64 (May 1975): 717–54, 736, pomegranate: 740.

29. Hippocrates. *Diseases of Women 1–2*, 159.

30. Lisa Briggs and Jens Jakobsson, "Searching for Silphium: An Updated Review," *Heritage* 5, no. 2 (2022): 936–55; Pliny, *Natural History*, vol. V, books 17–19, trans. H. Rackham, Loeb Classical Library 371 (Cambridge, MA: Harvard University Press, 1950), 445.

31. Soranus, *Gynecology*, 65; Hippocrates, *Generation*, 383; Hippocrates, *Coan Prenotions. Anatomical and Minor Clinical Writings*, ed. and trans. Paul Potter, Loeb Classical Library 509 (Cambridge, MA: Harvard University Press, 2010), 335; Dioscorides, *De Materia Medica*, 218; *On Simples*, 120. Briggs and Jakobsson, "Searching for Silphium," 945–46, 947–49; Nelson, "Persephone's Seeds," 61–62; Jöchle, "Menses-Inducing Drugs," 425–39, provides an extensive list of species tested. Pliny, *Natural History*, vol. V, 445.

32. Suzanne Dixon, *Reading Roman Women: Sources, Genres and Real Life* (London: Duckworth, 2001), 59–65.

33. Enzo Nardi, *Procurato Aborto nel Mondo Greco Romano* (Milan: A. Giuffrè, 1971), 354. Cicero, *Pro Lege Manilia. Pro Caecina. Pro Cluentio. Pro Rabirio Perduellionis Reo*, trans. H. Grose Hodge, Loeb Classical Library 198 (Cambridge, MA: Harvard University Press, 1927), 255.

34. Florence Dupont, *Daily Life in Ancient Rome*, trans. Christopher Woodall (Oxford, England: Blackwell, 1993), 103–21; Kristina Milnor, *Gender, Domesticity, and the Age of Augustus: Inventing Private Life* (Oxford, England: Oxford University Press, 2005).

35. Jane F. Gardner, *Women in Roman Law & Society* (Bloomington: Indiana University Press, 1991); Amy Richlin, *Arguments with Silence: Writing the History of Roman Women* (Ann Arbor: University of Michigan Press, 2014), esp. 36–61; Milnor, *Gender*, 140–85; Susan Treggiari, *Roman Marriage: Justi Coniuges from the Time of Cicero to the Time of Ulpian* (Oxford, England: Oxford University Press, 1991), 278–79; David Cohen, "The Augustan Law on Adultery: The Social and Cultural Context," in *The Family in Italy from Antiquity to the Present*, ed. David I. Kertzer and Richard P. Saller (New Haven, CT: Yale University Press, 1991), 109–26.

36. Gardner, *Women in Roman Law & Society*; Dixon, *Reading Roman Women*, 56–65; Sara Elise Phang, *Daily Life of Women in Ancient Rome* (Santa Barbara, CA: Greenwood, 2022), 171–212; Richlin, *Arguments with Silence*, 1–2.

37. Dixon, *Reading Roman Women*, 56–65. *Juvenal and Persius*, ed. and trans. Susanna Morton Braund, Loeb Classical Library 91 (Cambridge, MA: Harvard University Press, 2004), 289, 291. However, it was widely thought that a baby might not resemble its father if the mother had imagined or desired another. Frank M. Snowden Jr., *Blacks in Antiquity: Ethiopians in the Greco-Roman Experience* (Cambridge, MA: Belknap Press, 1970).

38. Gellius, *Attic Nights*, vol. II, books 6–13, trans. J. C. Rolfe, Loeb Classical Library 200 (Cambridge, MA: Harvard University Press, 1927), 355. This text is a Latinized version of the Greek author Favorinus (85–155 CE). Seneca, *Moral Essays, Volume II: De Consolatione ad Marciam. De Vita Beata. De Otio. De Tranquillitate Animi. De Brevitate Vitae. De Consolatione ad Polybium. De Consolatione ad Helviam*, trans. John W. Basore, Loeb Classical Library 254 (Cambridge, MA: Harvard University Press, 1932), 473. Dixon, *Reading Roman Women*, 57.

39. Seneca, *Moral Essays, Volume III: De Beneficiis*, trans. John W. Basore, Loeb Classical Library 310 (Cambridge, MA: Harvard University Press, 1935), 431; Elaine Fantham, *Julia Augusti: The Emperor's Daughter* (London: Routledge, 2006). *Juvenal and Persius*, 13. See also Suetonius, *Lives of the Caesars, Volume II: Claudius. Nero. Galba, Otho, and Vitellius. Vespasian. Titus, Domitian. Lives of Illustrious Men: Grammarians and Rhetoricians. Poets (Terence. Virgil. Horace. Tibullus. Persius. Lucan). Lives of Pliny*

the Elder and Passienus Crispus, trans. J. C. Rolfe, Loeb Classical Library 38 (Cambridge, MA: Harvard University Press, 1914), 167; Pliny the Younger, *Letters*, vol. I, books 1–7, trans. Betty Radice, Loeb Classical Library 55 (Cambridge, MA: Harvard University Press, 1969), 271.

40. Soranus, *Gynecology*, 189–96.

41. Soranus, *Gynecology*, 189–96; Kapparis, *Abortion*, 24, 19.

42. Trevor Murphy, *Pliny the Elder's Natural History* (Oxford, England: Oxford University Press, 2004), 3; Pliny, *Natural History*, vol. III, books 8–11, trans. H. Rackham, Loeb Classical Library 353 (Cambridge, MA: Harvard University Press, 1940), 401; Pliny, *Natural History*, vol. VII, books 24–27, trans W. H. S. Jones and A. C. Andrews, Loeb Classical Library 393 (Cambridge, MA: Harvard University Press, 1956), 155.

43. Rhian Williams, *Childlessness in the Late Republic and Early Roman Empire* (PhD thesis, University of Cardiff, Wales, 2023), 203. Credited to women: Pliny, *Natural History*, vol. VIII, books 28–32, trans. W. H. S. Jones, Loeb Classical Library 418 (Cambridge, MA: Harvard University Press, 1963), 59; the names Lais and Elephantis have been associated with sex work. Cyclamen: Pliny, *Natural History*, vol. VII, 221; Kapparis, *Abortion*, 28. Sneeze: Pliny, *Natural History*, vol. II, books 3–7, trans. H. Rackham, Loeb Classical Library 352 (Cambridge, MA: Harvard University Press, 1942), 535. Watercress: Pliny, *Natural History*, vol. VI, books 20–23, trans. W. H. S. Jones, Loeb Classical Library 392 (Cambridge, MA: Harvard University Press, 1951), 145. Pliny as pronatalist: Flemming, *Medicine*, 166–67.

44. *Juvenal and Persius*, 269.

45. Zubin Mistry, *Abortion in the Early Middle Ages, c. 500–900* (Woodbridge, England: York Medieval Press, 2015), 46–47.

Chapter 2: The Saint and the Sinner: The Middle Ages and the Rise of Christianity

1. Séan Connolly and J.-M. Picard, "Cogitosus's 'Life of St Brigid': Content and Value," *Journal of the Royal Society of Antiquaries of Ireland* 117 (1987): 5–27. I owe this story and much more to Zubin Mistry, *Abortion in the Early Middle Ages, c. 500–900* (Woodbridge, England: York Medieval Press, 2015).

2. Connolly and Picard, "Cogitosus's 'Life of St Brigid.'"

3. Lisa M. Bitel, "Monastic Identity in Early Medieval Ireland," in *The Cambridge History of Medieval Monasticism in the Latin West*, ed. Alison I. Beach and Isabelle Cochelin (Cambridge: Cambridge University Press, 2020), 297–316.

4. Robert Alter, *The Hebrew Bible: A Translation with Commentary* (New York: W. W. Norton, 2019), 30203 [Exodus 21:22–3]. I follow Alter in reading "mishap" as referring to the life of the woman.

5. Aristotle, *History of Animals*, vol. III, books 7–10, ed. and trans. D. M. Balme, Loeb Classical Library 439 (Cambridge, MA: Harvard University

Press, 1991), 435; Hippocrates, *Generation. Nature of the Child. Diseases 4. Nature of Women and Barrenness*, ed. and trans. Paul Potter, Loeb Classical Library 520 (Cambridge, MA: Harvard University Press, 2012), 51.

6. Tertullian, *On the Soul*, translation in *T. & T. Clark Reader in Theological Anthropology*, ed. Marc Cortez and Michael P. Jensen (London: Bloomsbury, 2018), 135–36; Julian Barr, *Tertullian and the Unborn Child: Christian and Pagan Attitudes in Historical Perspective* (London; New York: Routledge, 2017); Marie-Hélène Congourdeau, "Debating the Soul in Late Antiquity," in *Reproduction: Antiquity to the Present Day*, ed. Nick Hopwood, Rebecca Flemming, and Lauren Kassell (Cambridge, England: Cambridge University Press, 2018), 109–21.

7. Darrel W. Amundsen, "Visigothic Medical Legislation," *Bulletin of the History of Medicine* 45 (1971): 553–69.

8. Basil, *Letters*, vol. III, letters 186–248, trans. Roy J. Deferrari, Loeb Classical Library 243 (Cambridge, MA: Harvard University Press, 1930), 21–23; Caesarius, *Sermons*, trans. Mary Magdeleine Mueller (New York: Fathers of the Church, 1956), 221, 258–59, 26; Mistry, *Abortion*, 58–66, 51–52.

9. Mistry, *Abortion*, 40–41.

10. Kyle Harper, *From Shame to Sin: The Christian Transformation of Sexual Morality in Late Antiquity* (Cambridge: Harvard University Press, 2006).

11. Augustine, *De Bono Coniugali: De Sancta Virginitate*, ed. and trans. P. G. Walsh (Oxford, England: Clarendon, 2001), 15, 59. Harper, *From Shame to Sin*; Dyan Elliott, *The Bride of Christ Goes to Hell: Metaphor and Embodiment in the Lives of Pious Women, 200–1500* (Philadelphia: University of Pennsylvania, 2012).

12. Augustine, *De Bono Coniugali*, 23.

13. Brent D. Shaw, "The Family in Late Antiquity: The Experience of Augustine," *Past & Present* no. 115 (May 1987): 3–51, see 45–46; Augustine, *Confessions*, vol. I, books 1–8, trans. Carolyn J.-B. Hammond, Loeb Classical Library 26 (Cambridge, MA: Harvard University Press, 2014), 407, 287, 389, 293, 398.

14. Augustine, *De Nuptiis et Concupiscentia* in *The Works of Saint Augustine: A Translation for the 21st Century*, part 1, vol. 24, trans. Edmund Hill, ed. John E. Rotelle (Brooklyn, NY: New City Press, 1990–2019), 39–40.

15. Ron Barkai, *A History of Jewish Gynaecological Texts in the Middle Ages* (Leiden, Netherlands; Boston: Brill, 1998), 134, 203, 204; David M. Feldman, *Birth Control in Jewish Law: Marital Relations, Contraception, and Abortion as Set Forth in the Classic Texts of Jewish Law* (New York: New York University Press, 1968), 273, 253–57; Daniel Schiff, *Abortion in Judaism* (Cambridge, England: Cambridge University Press, 2002), 58–62.

16. Mistry, *Abortion*, 113–25, esp. 116; M. J. Elsakkers, *Reading Between the Lines: Old Germanic and Early Christian Views on Abortion* (PhD thesis,

University of Amsterdam, 2010), https://hdl.handle.net/11245/1.327030, 330–33; B. F. Musallam, *Sex and Society in Islam: Birth Control Before the Nineteenth Century* (Cambridge, England: Cambridge University Press, 1983), 57–59, 77–82; Thomas Eich, "Induced Miscarriage in Early Maliki and Hanafi Fiqh," *Islamic Law and Society* 16, nos. 3–4 (2009): 302–26.

17. Mistry, *Abortion*, 47–48.

18. Her story exists in three different versions. Connolly and Picard, "Cogitosus's 'Life of St Brigid'"; Séan Connolly, "Vita Prima Sanctae Brigidae Background and Historical Value," *Journal of the Royal Society of Antiquaries of Ireland* 119 (1989): 5–49; Lisa M. Bitel, *Landscape with Two Saints: How Genovefa of Paris and Brigid of Kildare Built Christianity in Barbarian Europe* (Oxford, England: Oxford University Press, 2009), esp. 139–45, 163–67. Connolly and Picard, "Cogitosus's 'Life of St Brigid,'" 198, lepers: 15, cattle: 18, 25; Connolly "Vita Prima," nun: 19, cattle: 18.

19. Bitel, "Monastic Identity," 297–316.

20. Connolly and Picard, "Cogitosus's 'Life of St Brigid,'" 21.

21. Zubin Mistry, "The Sexual Shame of the Chaste: 'Abortion Miracles' in Early Medieval Saints' Lives," *Gender & History* 25, no. 3 (November 2013): 607–20.

22. Robin Fleming, *The Material Fall of Roman Britain, 300–525 CE* (Philadelphia: University of Pennsylvania Press, 2021), 138–56. The data on infant mortality comes from Roman-era Egypt and Italy, but estimates suggest the numbers were similar in late antique Britain. Many thanks to Scott G. Bruce for this reference.

23. Connolly and Picard, "Cogitosus's 'Life of St Brigid,'" 16; Mistry, "Sexual Shame," 607–20; Maeve Callan, "Of Vanishing Fetuses and Maidens Made-Again: Abortion, Restored Virginity, and Similar Scenarios in Medieval Irish Hagiography and Penitentials," *Journal of the History of Sexuality* 21, no. 2 (May 2012): 82–296; Lisa Bitel, "Body of a Saint, Story of a Goddess: Origins of the Brigidine Tradition," *Textual Practice* 16 (2002): 209–28. See also the myth of Diechtine's miraculous end to a pregnancy, Lisa Bitel, *Land of Women: Tales of Sex and Gender from Early Ireland* (Ithaca, NY: Cornell University Press, 1996), 77.

24. Bitel, "Body of a Saint," 213.

25. Rob Meens, *Penance in Medieval Europe, 600–1200* (Cambridge, England: Cambridge University Press, 2014). For the "paupercula" clause, see Elsakkers, *Reading*, 449, 458.

26. Elsakkers, *Reading*, 366, 369; Mistry, "Sexual Shame," quote at 615.

27. Faith Wallis, "The Experience of the Book: Manuscripts, Texts, and the Role of Epistemology in Early Medieval Medicine," in *Knowledge and the Scholarly Medical Traditions*, ed. Donald Bates (Cambridge: Cambridge University Press, 1995), 101–26; Monica Green, "Constantinus Africanus and the Conflict Between Religion and Science," in *The Human Embryo:*

Aristotle and the Arabic and European Traditions, ed. G. R. Dunstan (Exeter, England: University of Exeter Press, 1990), 47–69.

28. Nicholas Everett, *The Alphabet of Galen: Pharmacy from Antiquity to the Middle Ages* (Toronto: University of Toronto Press, 2012), 305, 239, expelling: 269, 247, 265, antiquity: 161, 247, 319, 311, familiarity: 311, 211, 223; Anne Van Arsdall, *Medieval Herbal Remedies: The Old English Herbarium and Anglo-Saxon Medicine* (New York: Routledge, 2002), menses: 215, 216, expelling: 190–91, 177, quote at 177.

29. Musallam, *Sex and Society in Islam*, 57–59, 77–82.

30. On spignel, see, for example, *Hildegard von Bingen's Physica: The Complete English Translation of Her Classic Work on Health and Healing*, trans. Priscilla Throop (Rochester, VT: Healing Arts Press, 1998), 69, where it is known by a German name, *berwortz* ("bear plant"), as well as hog fennel.

31. *Hildegard von Bingen's Physica*, 25, 30–31, 62, 94.

32. *Hildegard von Bingen's Physica*, 58–59.

33. Monica Green, *Making Women's Medicine Masculine: The Rise of Male Authority in Pre-modern Gynaecology* (Oxford, England: Oxford University Press, 2008).

34. James A. Brundage, *Law, Sex, and Christian Society in Medieval Europe* (Chicago: University of Chicago Press, 1987).

35. Brundage, *Law, Sex, and Christian Society*; Sara McDougall, "Prosecution of Sex in Late Medieval Troyes," in *Sexuality in the Middle Ages and the Early Modern Times: New Approaches to a Fundamental Cultural-Historical and Literary-Anthropological Theme*, ed. Albrecht Classen (Berlin; New York: Walter de Gruyter, 2008), 691–714; Elizabeth Craig-Atkins, "Eavesdropping on Short Lives: Eaves-Drip Burial and the Differential Treatment of Children One Year of Age and Under in Early Christian Cemeteries," in *Medieval Childhood: Archaeological Approaches*, ed. K. A. Hemer and D. M. Hadley (Oxford, England: Oxbow, 2014), 95–113.

36. C. B. Timmins, ed., *The Register of John Chandler Dean of Salisbury, 1404–1417*, vol. 39 (Devizes, England: Wiltshire Record Society, 1984), 109–10.

37. Elsakkers, *Reading*, 423; Mistry, *Abortion*, 196, 200–3. For Regino, see Mistry, *Abortion*, 196, 200–3. For Burchard, see Elsakkers, *Reading*, 424; Danielle Jacquart and Claude Thomasset, *Sexuality and Medicine in the Middle Ages*, trans. Matthew Adamson (Cambridge, England: Polity Press,1988), 93.

38. Wolfgang P. Müller, *The Criminalization of Abortion in the West: Its Origins in Medieval Law* (Ithaca, NY: Cornell University Press, 2017), 22–25, 76–78, 83–116; G. R. Dunstan, "The Human Embryo in the Western Moral Tradition," in *The Status of the Human Embryo: Perspectives from Moral Tradition*, ed. G. R. Dunstan and Mary J. Seller (London: King Edward's Hospital for London, 1988), 39–57.

39. Fabrizio Amerini, *Aquinas on the Beginning and End of Human Life*, trans. Mark Henninger (Cambridge, MA: Harvard University Press, 2013),

58–63. On the larger context, Brundage, *Law, Sex, and Christian Society*, 229–54.

40. Henry Bracton, *De Legibus et Consuetudinibus Angliæ*, vol. 2, Latin text of George Woodbine (1876–1953), with trans. Samuel E. Thorne, 341–42, accessed November 15, 2022, https://amesfoundation.law.harvard.edu//Bracton/Unframed/English/v2/341.htm.

41. Bracton, *De Legibus et Consuetudinibus Angliæ*, 341–42. Bracton also mentions surgical abortion as an analog to the crime of castration; Bracton, *De Legibus et Consuetudinibus Angliæ*, 408, accessed November 28, 2022, https://amesfoundation.law.harvard.edu//Bracton/Unframed/English/v2/408.htm.

42. William Joseph Whittaker, ed., *Mirror of Justices*, vol. 7 (London: Selden Society, 1893), 139; Francis Morgan Nichols, ed., *Britton* (Oxford, England: Clarendon Press, 186), bk. 1, ch. 25, no. 7, 95–96. Sara M. Butler, "Alito's Leaked Draft Majority Opinion and the Medieval History of Abortion," Legal History Miscellany, May 13, 2022, accessed February 7, 2023, https://legalhistorymiscellany.com/2022/05/13/alitos-leaked-draft-majority-opinion-and-the-medieval-history-of-abortion/; Müller, *Criminalization*, 67–70, 123–49.

43. Martin Weinbaum, ed. *The London Eyre of 1276* (Leicester, England: London Record Society, 1976), 73–74; Timmins, *Register of John Chandler Dean*, vol. 39, 110. Sara M. Butler, "Abortion by Assault: Violence Against Pregnant Women in Thirteenth- and Fourteenth-Century England," *Journal of Women's History* 17, no. 4 (2005), 9–31; Sara M. Butler, "Abortion Medieval Style? Assaults on Pregnant Women in Later Medieval England," *Women's Studies* 40, no. 6 (2011): 778–99; R. H. Helmholz, "Infanticide in the Province of Canterbury During the Fifteenth Century," *History of Childhood Quarterly* 2 (1975): 379–90.

44. Margaret Archer, ed., *The Register of Philip of Repingdon, 1405–1419*, vol. 3 (Hereford, England: Hereford Times, 1963), 184–85. Thanks to Laurence Bond for translation.

45. Müller, *Criminalization*, 165–66.

46. Only 5 percent of the town's population was Jewish. "A Jewish Doctor Is Accused of Abortion and Malpractice," in *Medieval Medicine: A Reader*, ed. Faith Wallis (Toronto: University of Toronto Press, 2010), 381–83. Wallis translated from Joseph Shatzmiller, *Médecine et Justice en Provence Médiévale—Documents de Manosque, 1262–1348* (Aix-en-Provence, France: Publications de l'Université de Provence, 1989). On Jewish physicians, Joseph Shatzmiller, *Jews, Medicine, and Medieval Society* (Berkeley: University of California Press, 1994).

47. "Jewish Doctor Is Accused," 383.

48. "Jewish Doctor Is Accused," 382–83.

49. Christopher Dyer, *Standards of Living in the Later Middle Ages* (Cambridge: Cambridge University Press, 1989), 199.

50. Müller, *Criminalization*, 163–66.

51. Müller, *Criminalization*, 163–66; pardon noted in Yves Dossat, Anne-Marie Lemasson, and Philippe Wolff, *Le Languedoc et le Rouergue dans le Trésor des Chartes* (Paris: CTHS, 1983), 417.

52. Müller, *Criminalization*, 164–65; Roger Vaultier, *Le Folklore Pendant la Guerre de Cent Ans D'après les Lettres de Rémission du Trésor des Chartes* (Paris: Librairie Guénégaud, 1965), 227–29.

53. Elsakkers, *Reading*, 423; Mistry, *Abortion*, 196, 200–3.

54. "The Ghosts of Byland Abbey" in *The Penguin Book of the Undead: Fifteen Hundred Years of Supernatural Encounters*, ed. Scott G. Bruce (New York: Penguin, 2016), 213–14, quote at 214. Many thanks to Anne Lester and Scott Bruce for this story.

55. "Ghosts of Byland Abbey," 214.

56. "Ghosts of Byland Abbey," 214.

Chapter 3: The Maidservant and the Witch: Crackdowns in Early Modern Europe

1. Ernest Wickersheimer, *Dictionnaire Biographique des Medecins en France au Moyen Age*, vol. 1 (Paris: E. Droz, 1936), 9; Danielle Jacquart and Claude Thomasset, *Sexuality and Medicine in the Middle Ages*, trans. Matthew Adamson (Cambridge, England: Polity Press, 1988), 93.

2. Wickersheimer, *Dictionnaire Biographique*, vol. 1, 9; Jacquart and Thomasset, *Sexuality and Medicine*, 93.

3. Jonathan B. Durrant, *Witchcraft, Gender, and Society in Early Modern Germany* (Leiden, Netherlands; Boston: Brill, 2007), 187, 183, 184, 223. I am immensely indebted to Professor Durrant's generosity and scholarship, including a number of personal communications. Wolfgang Jöchle, "Menses-Inducing Drugs: Their Role in Antique, Medieval, and Renaissance Gynecology and Birth Control," *Contraception* 4 (1974): 425–39, citing Dioscorides as well as Renaissance authorities; Christa M. Wilmanns Wells, "A Small Herbal of Little Cost, 1762–1778: A Case Study of a Colonial Herbal as a Social and Cultural Document," PhD dissertation, University of Pennsylvania, 1980, 462.

4. Durrant, *Witchcraft, Gender, and Society*, 183, 184, 223.

5. Gregory Hanlon, *Death Control in the West 1500–1800: Sex Ratios at Baptism in Italy, France and England* (Milton, England: Taylor & Francis Group, 2022).

6. Ulinka Rublack, "The Public Body: Policing Abortion in Early Modern Germany," in *Gender Relations in German History. Power, Agency, and Experience from the Sixteenth to the Twentieth Century*, ed. Lynn Abrams and Elizabeth Harvey (London: UCL Press, 1996), 61.

7. Rublack, "Public Body," 66.

8. Larissa Leibrock-Plehn, "Friihe Neuzeit: Hebammen, Krarurermedizin und weltliche Justiz," *Geschichte der Abtreibung: von der Antike bis zur Gegenwart*, ed. Robert Jütte (Munich: C. H. Beck, 1993), 68–91; William Turner, *The First and Seconde Partes of the Herbal of William Turner*

Doctor in Phisick . . . (Cologne: Arnold Birckman, 1568), STC (2nd ed.) / 24367; see for examples, Booke 1, 14, 25, 35, 36, 38, 40, etc.

9. Elinor Hubbard, "Reading, Writing, and Initialing: Female Literacy in Early Modern London," *Journal of British Studies* 54, no. 3 (2015): 553–57; Leonard Sowerby, *The Ladies Dispensatory* . . . (London: R. Ibbiston, 1651), Thomason / E.1258[1], Wing (2nd ed.) / S4781, 146–53, 157–63, see 152, 147, 148 for quotes. Sarah Jinner, *An Almanack or Prognostication, for the Year of Our Lord 1659* (London: J. S. for the Company of Stationers, 1659), Wing / A1845, fo. B6v-B8v; quote at B7r.

10. Lyndal Roper, *Martin Luther: Renegade and Prophet* (London: Bodley Head, 2016).

11. Diarmaid MacCulloch, *The Reformation: A History* (London: Penguin, 2003); Lyndal Roper, *The Holy Household: Women and Morals in Reformation Augsburg* (Oxford, England: Clarendon Press, 1989).

12. Margaret Brannan Lewis, *Infanticide and Abortion in Early Modern Germany* (London: Routledge, 2016), 31–37, 341–47; Rublack, "Public Body," 57–80, esp. 59–60.

13. Merry Wiesner, *Working Women in Renaissance Germany* (New Brunswick, NJ: Rutgers University Press, 1986), 60–61, 71.

14. John Christopoulos, *Abortion in Early Modern Italy* (Cambridge, MA: Harvard University Press, 2021), 127–57; Wolfgang P. Müller, *The Criminalization of Abortion in the West: Its Origins in Medieval Law* (Ithaca, NY: Cornell University Press, 2017), 83–85.

15. Christopoulos, *Abortion*, 2–10, 12, 188.

16. Christopoulos, *Abortion*, 236–46.

17. Christopoulos, *Abortion*, 236–46.

18. Christopoulos, *Abortion*, 68–69, 74, 236–46.

19. Christopoulos, *Abortion*, 236–46, quote at 237.

20. Sarah Hanley, "Engendering the State: Family Formation and State Building in Early Modern France," *French Historical Studies* 16 (1989): 4–27; Peter C. Hoffer and N. E. H. Hull, *Murdering Mothers: Infanticide in England and New England, 1558–1803* (New York: New York University Press, 1981); Deborah A. Symonds, *Weep Not for Me: Women, Ballads, and Infanticide in Early Modern Scotland* (University Park: Pennsylvania State University Press, 1997).

21. Roper, *Holy Household*; Wiesner, *Working Women*.

22. Merry Wiesner-Hanks, "Having Her Own Smoke: Employment and Independence for Unmarried Women in Germany, 1400–1700," in *Singlewomen in the European Past*, ed. Judith Bennett and Amy Froide (Philadelphia: University of Pennsylvania Press, 1999), 192–216, quote at 197; Ulinka Rublack, *The Crimes of Women in Early Modern Germany* (Oxford, England: Clarendon Press,1998), 134–62.

23. Laura J. McGough, "Quarantining Beauty: The French Disease in Early Modern Venice," in *Sins of the Flesh: Responding to Sexual Disease in*

Early Modern Europe, ed. Kevin Siena (Toronto: Centre for Reformation and Renaissance Studies, 2005), 211–37.

24. Christopoulos, *Abortion*, 52–53, 120–27.

25. Lewis, *Infanticide*, 47; Rublack, "Public Body," 67; Durrant, *Witchcraft, Gender, and Society*, 171; Jan De Vries, "Population," *Handbook of European History, 1400–1600: Late Middle Ages, Renaissance, and Reformation*, vol. 1, ed. Thomas A. Brady, Heiko A. Oberman, and James D. Tracy (Leiden, Netherlands: Brill, 1994), 34.

26. Rublack, "Public Body," 63–64. On consent, Julie Hardwick, *Sex in an Old Regime City: Young People, Production, and Reproduction in France, 1660–1789* (New York: Oxford University Press, 2020).

27. Rublack, "Public Body," 65.

28. Durrant, *Witchcraft, Gender, and Society*, 169–71.

29. Durrant, *Witchcraft, Gender, and Society*, quote at 171, 169–70.

30. On the victim versus bad woman dichotomy, see Christopoulos, *Abortion*, 15. Rublack, "Public Body," 57.

31. Michael Stolberg, *Uroscopy in Early Modern Europe*, trans. Logan Kennedy and Leonhard Unglaub (Farnham, England: Ashgate, 2015), 71–104; Rublack, "Public Body," 57.

32. Christopoulos, *Abortion*, 127, 188.

33. Lewis, *Infanticide*; Roper, *The Holy Household*.

34. Laura Stokes, "Prelude: Early Witch-Hunting in Germany and Switzerland," *Magic, Ritual, and Witchcraft* 4, no. 1 (2009): 54–61; Hans Peter Broedel, *The Malleus Maleficarum and the Construction of Witchcraft: Theology and Popular Belief* (Manchester, England: Manchester University Press, 2003), 167–88; Lyndal Roper, *Oedipus and the Devil* (London: Routledge, 1994), esp. 199–225, Sigrid Brauner, *Fearless Wives and Frightened Shrews: The Construction of the Witch in Early Modern Germany*, ed. Robert H. Brown (Amherst: University of Massachusetts Press, 1995), 31–49; *The Hammer of Witches: A Complete Translation of the Malleus Maleficarum*, trans. Christopher S. Mackay (Cambridge, England: Cambridge University Press, 2009). The emphasis upon demonic sex was strongest in German-speaking and Scottish witch crazes, less so in England, France, and Italian-speaking regions.

35. *Hammer of Witches*, 190, 211, 322, 323.

36. *Hammer of Witches*, 328; Lyndal Roper, *Witch Craze: Terror and Fantasy in Baroque Germany* (New Haven, CT: Yale University Press, 2004), 139.

37. Jakob Rueff, *The Expert Midwife* . . . (London: E. Griffin, 1637), book 2, 59–60.

38. Rueff, *Midwife*, book 5, 4–5.

39. The literature on European witchcraft is vast. For examples, see Robin Briggs, *Witches & Neighbours: The Social and Cultural Context of European Witchcraft* (London: HarperCollins, 1996); Roper, *Witch Craze*; and works cited in other notes.

40. Roper, *Witch Craze*.

41. Roper, *Witch Craze*.

42. Rueff, *Midwife*, blossoms: book 2, 58; Thomas Raynalde, *The Byrth of Mankinde* (London: Thos. Ray, 1545), fo. 137v, fo 141r; Jane Sharp, *The Midwives Book* (London: Simon Miller, 1671), 363; Jacques Gelis, *L'Arbre et le Fruit: La Naissance dans l'Occident Moderne, XVIe-XIXe Siecle* (Paris: Fayard, 1984).

43. W. W., *A True and Iust Recorde* . . . (London: Thomas Dawson, 1582); Mary E. Fissell, *Vernacular Bodies: The Politics of Reproduction in Early Modern England* (Oxford, England: Oxford University Press, 2004), 78–79; Diane Purkiss, "Women's Stories of Witchcraft in Early Modern England: The House, the Body, the Child," *Gender and History* 7 (1995), 408–32; Jonathan Durrant, "A Witch-Hunting Magistrate? Brian Darcy and the St Osyth Witchcraft Cases of 1582," *English Historical Review* 135, no. 578 (February 2021): 26–54.

44. Roper, *Oedipus and the Devil*, 199–202, 209–15; Thomas Robisheaux, *The Last Witch of Langenburg: Murder in a German Village* (New York: W. W. Norton, 2009), 23–38.

45. Robin Briggs, *The Witches of Lorraine* (Oxford: Oxford University Press, 2007), 328–29; for English examples, see Lauren Kassell et al., eds., *The Casebooks of Simon Forman and Richard Napier, 1596–1634*, accessed July 27, 2023, https://casebooks.wordpress.com/selected-cases-in-full/can-beget-no-child/.

46. Roper, *Witch Craze*; Diane Purkiss, *The Witch in History: Early Modern and Twentieth-Century Representations* (London; New York: Routledge, 1996).

47. Roper, *Oedipus and the Devil*, 199–248; Durrant, *Witchcraft, Gender, and Society*, 9–15, 38, 178, 39.

48. Durrant, *Witchcraft, Gender, and Society*, 20.

49. Durrant, *Witchcraft, Gender, and Society*, 20, 27–32, 220.

50. Durrant, *Witchcraft, Gender, and Society*, 169, 255–62, 169.

51. Durrant, *Witchcraft, Gender, and Society*, 112, 111.

52. Durrant, *Witchcraft, Gender, and Society*, 170.

53. Durrant, *Witchcraft, Gender, and Society*, 183–85, quotes at 111–12.

Chapter 4: The Botanist: New Plants, New Worlds

1. Maria Sibylla Merian, *Metamorphosis Insectorum Surinamensium 1705* (Tielt, Netherlands: Lannoo, 2016), 184; Londa Schiebinger, "Agnotology and Exotic Abortifacients: The Cultural Production of Ignorance in the Eighteenth-Century Atlantic World," *Proceedings of the American Philosophical Society* 149, no. 3 (September 2005): 316–43.

2. Natalie Zemon Davis, *Women on the Margins: Three Seventeenth-Century Lives* (Cambridge, MA: Harvard University Press, 1995), 168–85.

3. Davis, *Women on the Margins*, 142–57.

4. Wendy Morris, Nothing of Importance Occurred, accessed July 2, 2023, https://www.nothingofimportanceoccurred.org/; "'Maaij' Claesje van Angola," Geni, accessed July 13, 2023, https://www.geni.com/people/Maaij-Claesje-van-Angola/6000000006245372846.

5. Morris, Nothing of Importance Occurred.

6. Bartolomé de las Casas, *An Account of the First Voyages and Discoveries Made by the Spaniards in America Containing the Most Exact Relation Hitherto Publish'd, of Their Unparallel'd Cruelties on the Indians* . . . (London: J. Darby, 1699), 127; Hans Sloane, *A Voyage to the Islands Madera, Barbadoes, Nieves, S. Christophers, and Jamaica; with the Natural History*, 2 vols. (London: B. M., 1707), vol. 1, 248, vol. 2, 50; John Stedman, *Narrative of a Five Years Expedition Against the Revolted Negroes of Surinam*, ed. Richard Price and Sally Price (Baltimore: Johns Hopkins University Press, 1988), 494. Some of these plants were not originally native to the Caribbean; the flower fence had supposedly been brought from the East Indies. Sloane, *Voyage*, vol. 2, 50.

7. Nicolas Denys, *The Description and Natural History of the Coasts of North America*, trans. and ed. William F. Ganong (Toronto: Champlain Society, 1908), 404; see also Sieur de Diereville, *Relation of the Voyage to Port Royal in Acadia or New France*, trans. Mrs. Clarence Webster, ed. John Clarence Webster (Toronto: Champlain Society, 1933), 145. Louis Armand de Lom d'Arce Lahontan, *New Voyages to North-America by the Baron de Lahontan* (Chicago: A. C. McClurg, 1905), 607–8. Many thanks to William Fissell for this reference. Alexander Mackenzie and William Combe, *Voyages from Montreal, on the River St. Laurence, Through the Continent of North America* . . . (London: T. Cadell Jr. and W. Davies, 1801), xcviii.

8. John Lawson, *A New Voyage to Carolina* . . . (London: n.p., 1709), 187; Thomas Jefferson, *Jefferson's Notes on the State of Virginia* . . . (Baltimore: W. Pechin, 1800), 65.

9. Susan E. Klepp, *Revolutionary Conceptions: Women, Fertility, and Family Limitation in America, 1760–1820* (Chapel Hill: University of North Carolina Press, 2009), 193; Joseph M. Gabriel, "Indian Secrets, Indian Cures, and the Pharmacopoeia of the United States of America," in *Drugs on the Page: Pharmacopoeias and Healing Knowledge in the Early Modern Atlantic World*, ed. Joseph M. Gabriel and Matthew James Crawford (Pittsburgh: University of Pittsburgh Press, 2019), 240–61.

10. Klepp, *Revolutionary Conceptions*, 191; *Pennsylvania Gazette*, June 12, 1740, 4.

11. Christa M. Wilmanns Wells, "A Small Herbal of Little Cost, 1762–1778: A Case Study of a Colonial Herbal as a Social and Cultural Document," PhD dissertation, University of Pennsylvania, 1980, 465.

12. Ann Marie Plane, *Colonial Intimacies: Indian Marriage in Early New England* (Ithaca, NY: Cornell University Press, 2000), 125–27.

13. Peter Smith, *The Indian Doctor's Dispensatory: Being Father Smith's Advice Respecting Diseases and Their Cure* . . . (Cincinnati: Browne and Looker, 1813), 46, 41, 31–32, 103.

14. Barbara Bush-Slimani, "Hard Labour: Women, Childbirth and Resistance in British Caribbean Slave Societies," *History Workshop Journal* 36 (1993): 91.

15. Sloane, *A Voyage to the Islands*, vol. 1, cxli–ii.

16. Edward Long, *The History of Jamaica* (London: T. Lowndes, 1774), vol. 2, 435–40, vol. 3, 820; John Williamson, *Medical and Miscellaneous Observations, Relative to the West India Islands* (Edinburgh: Smellie, 1817), 200.

17. Katherine Paugh, *The Politics of Reproduction: Race, Medicine, and Fertility in the Age of Abolition* (Oxford, England: Oxford University Press, 2017); Sasha Turner, *Contested Bodies: Pregnancy, Childrearing, and Slavery in Jamaica* (Philadelphia: University of Pennsylvania Press, 2017).

18. Rev. Henry Beame, cited in M. Craton, J. Walvin, and D. Wright, eds., *Abolition and Emancipation: Black Slaves and the British Empire: A Thematic Documentary* (Harlow, England: Longman, 1976), 141.

19. Paugh, *Politics of Reproduction*; Turner, *Contested Bodies*; Bush-Slimani, "Hard Labour"; Camilla Cowling, Maria Helena Pereira Toledo Machado, Diana Paton, and Emily West, eds., "Special Issue: Mothering Slaves: Comparative Perspectives on Motherhood, Childlessness, and the Care of Children in Atlantic Slave Societies," *Slavery and Abolition* 38, no. 2 (2017) and *Women's History Review* 27, no. 6 (2018).

20. Jennifer L. Morgan, *Reckoning with Slavery: Gender, Kinship, and Capitalism in the Early Black Atlantic* (Durham, NC: Duke University Press, 2021); Diana Paton, "Gender History, Global History, and Atlantic Slavery: On Racial Capitalism and Social Reproduction," *American Historical Review* 127, no. 2 (2022): 734; Sasha Turner, "The Nameless and the Forgotten: Maternal Grief, Sacred Protection, and the Archive of Slavery," *Slavery & Abolition* 38, no. 2 (June 2017): 232–50.

21. David Clover, "'This Horably [sic] Wicked Action': Abortion and Resistance on a Jamaican Slave Plantation," Society for Caribbean Studies Annual Conference Papers, vol. 8, 2007, ed. Sandra Courtman, http://community-languages.org.uk/SCS-Papers/Clover08.pdf, accessed April 12, 2023; Castle Wemyss Estate papers, Jamaica, https://archiveshub.jisc.ac.uk/search/archives/256a2b8a-b68f-3bbf-933f-b17e52304894, accessed June 4, 2023; Former British Colonial Dependencies, Slave Registers, 1813–1834, Simon Halliday, Jamaica, St. James, 1823, part 4, 1826, parts 1–2, National Archives, accessed via Ancestry.com.

22. Clover, "'Horably Wicked Action.'"

23. Clover, "'Horably Wicked Action.'"

24. John T. Morgan, "An Essay on the Production of Abortion Among Our Negro Population," *Nashville Journal of Medicine and Surgery* 19 (August 1860): 117–23.

25. John Travis, "A New Remedy for Amenorrhea," *Nashville Journal of Medicine and Surgery* 3, no. 3 (1852): 207–8; Thos. J. Shaw, "Remarks and Observations on Gossypium Herbaceum, or 'Cotton Plant,'" *Nashville Journal of Medicine and Surgery* 9 (July 1855): 7–9; "Gossypium Herbaceum: Cotton," *Journal of Materia Medica* 3, no. 1 (January 1, 1861): 18–22, and *Journal of Materia Medica* 3, no. 2 (February 1, 1861): 59–60; Liese M. Perrin, "Resisting Reproduction: Reconsidering Slave Contraception in the Old South," *Journal of American Studies* 35 (2001): 255–74, 260–62; Marie Jenkins Schwartz, *Birthing a Slave: Motherhood and Medicine in the Antebellum South* (Cambridge, MA: Harvard University Press, 2006), 96–99; Charles E. Buckingham, "Two Cases of Labor in the Same Patient—Persistence of the Hymen, Obstinate Vomiting, and Attempts at Producing Abortion," *Boston Medical and Surgical Journal* 53, no. 11 (October 11, 1860): 209–13.

26. Mary Gaffney, interviewed in George P. Rawick, ed., *The American Slave: Supplement Series 2, Volume 5: Texas Narratives, Part 4* (Westport, CT: Greenwood Press, 1979), 1453; Schwartz, *Birthing a Slave*, 67–106; Stephanie M. H. Camp, *Closer to Freedom: Enslaved Women and Everyday Resistance in the Plantation South* (Chapel Hill: University of North Carolina Press, 2004).

27. Lu Lee, interviewed in Rawick, *The American Slave: Supplement Series 2, Volume 6: Texas Narratives, Part 5*, 2299.

28. Dave Byrd, interviewed in Rawick, *The American Slave: Supplement Series 2, Volume 3: Texas Narratives, Part 2*, 568; William Coleman, interviewed in Rawick, *The American Slave: Supplement Series 2, Volume 3: Texas Narratives, Part 2*, 875.

29. Carla Spivack, "To 'Bring Down the Flowers': The Cultural Context of Abortion Law in Early Modern England," *William and Mary Journal of Women and the Law* 14 (2007–08): 107–51.

30. Archives of Maryland, *Judicial and Testamentary Business of the Provincial Court, 1649/50–1657*, vol. 10, 175, 177–79, https://msa.maryland.gov/megafile/msa/speccol/sc2900/sc2908/000001/000010/html/am10—186.html.

31. Archives of Maryland, *Judicial and Testamentary Business*, vol. 10, 176–79, 80.

32. Archives of Maryland, *Judicial and Testamentary Business*, vol. 10, 81, 176–77.

33. Archives of Maryland, *Judicial and Testamentary Business*, vol. 10, 173, 148–49, 181–82, 183, 174.

34. Archives of Maryland, *Judicial and Testamentary Business*, vol. 10, 149, 181, 173.

35. Archives of Maryland, *Judicial and Testamentary Business*, vol. 10, 184.

36. Archives of Maryland, *Judicial and Testamentary Business*, vol. 10, 184, 185, 174, 273.

37. Archives of Maryland, *Proceedings of the Provincial Court, 1658–1662*, vol. 41, 20, 50–51, 79–80, 85, https://msa.maryland.gov/megafile/msa/speccol/sc2900/sc2908/000001/000041/html/am41—20.html.

38. "Crimes & Misdemeanors," microfilm, series 1, file 32, Connecticut State Library and Archives, Hartford, CT. I owe this reference and much else to the kindness of Emily Jeanine Clark.

39. Archives of Maryland, *Judicial and Testamentary Business*, vol. 10, 178; Jack P. Greene, ed., *The Diary of Colonel Landon Carter of Sabine Hall, 1752–1778* (Charlottesville: University of Virginia Press, 1965), vol. 2, 859–61.

40. Greene, *Diary of Colonel Landon Carter*, vol. 2, 859–61.

41. Klepp, *Revolutionary Conceptions*, 191; John Tennent, *Every Man His Own Doctor: or, The Poor Planter's Physician* . . . , 2nd ed. (Williamsburg, VA: William Parks, 1734), 44; Molly Farrell, "Ben Franklin Put an Abortion Recipe in His Math Textbook," *Slate*, accessed June 7, 2022, https://slate.com/news-and-politics/2022/05/ben-franklin-american-instructor-textbook-abortion-recipe.html.

42. Wells, "A Small Herbal," 461–92, 476; Klepp, *Revolutionary Conceptions*, 190.

43. Klepp, *Revolutionary Conceptions*, 196; Susan H. Brandt, *Women Healers: Gender, Authority, and Medicine in Early Philadelphia* (Philadelphia: University of Pennsylvania Press, 2022), 52.

44. Klepp, *Revolutionary Conceptions*, 196; Brandt, *Women Healers*, 52.

45. Klepp, *Revolutionary Conceptions*, 196; Brandt, *Women Healers*, 52.

Chapter 5: The Seamstress and the Midwife: Sensational Stories in Victorian Britain

1. "Foreign and Colonial," *Examiner*, September 23, 1848; "The Late Extreaordinary [sic] Disclosures," *Examiner*, September 30, 1848; "Police Intelligence—Friday," *Morning Chronicle*, September 30, 1848. *Census Returns of England and Wales, 1851* (Kew, England: National Archives of the UK (TNA), Public Record Office (PRO), 1851), Class: HO107; Piece: 1575; Folio: 527; Page: 11; GSU roll: 174811; Class: HO107; Piece: 1575; Folio: 529; Page: 15; GSU roll: 174811. *Census Returns of England and Wales, 1861* (Kew, England: National Archives of the UK (TNA), Public Record Office (PRO), 1861), Class: RG 9; Piece: 367; Folio: 68; Page: 7; GSU roll: 542624.

2. "SPENCER LINDFIELD. MARY ANN DRYDEN. RICHARD ORPIN. Killing; Murder, Killing; Murder, Miscellaneous; Illegal Abortion. 23rd October 1848," Old Bailey Proceedings Online, https://www.oldbaileyonline.org/record/t18481023-2442.

3. Richard Adair, *Courtship, Illegitimacy, and Marriage in Early Modern England* (Manchester, England: Manchester University Press, 1996).

4. For example, John Money, ed., *The Chronicles of John Cannon, Excise Officer and Writing Master* (Oxford, England: Oxford University Press, 2010), 55.

5. Samantha Williams, *Unmarried Motherhood in the Metropolis, 1700–1850: Pregnancy, the Poor Law and Provision* (Basingstoke, England: Palgrave Macmillan, 2018); Alyssa Levene, T. Nutt, and S. Williams, eds., *Illegitimacy in Britain, 1700–1920* (Basingstoke, England: Palgrave Macmillan, 2005); Emma Griffin, "Sex, Illegitimacy and Social Change in Industrializing Britain," *Social History* 38, no. 2 (2013): 139–61; E. A. Wrigley, R. S. Davies, J. E. Oeppen, and R. S. Schofield, *English Population History from Family Reconstitution, 1580–1837* (Cambridge, England: Cambridge University Press,1997), 421–27.

6. Ruth K. McClure, *Coram's Children: The London Foundling Hospital in the Eighteenth Century* (New Haven, CT: Yale University Press, 1981); Lisa Forman Cody, *Birthing the Nation: Sex, Science, and the Conception of Eighteenth Century Britons* (Oxford, England: Oxford University Press, 2005).

7. Françoise Barret-Ducrocq, *Love in the Time of Victoria: Sexuality, Class, and Gender in Nineteenth-Century London* (London: Verso, 1991).

8. Cody, *Birthing the Nation*, 283–84.

9. John Killick, "Transatlantic Steerage Fares, British and Irish Migration, and Return Migration, 1815–60," *Economic History Review* 67, no. 1 (2014): 170–91.

10. Lisa Forman Cody, "The Politics of Illegitimacy in an Age of Reform: Women, Reproduction, and Political Economy in England's New Poor Law of 1834," *Journal of Women's History* 11, no. 4 (2000): 131–56; see also Thomas Nutt, "Illegitimacy, Paternal Financial Responsibility, and the 1834 Poor Law Commission Report. The Myth of the Old Poor Law and the Making of the New," *Economic History Review* 63 (2010): 335–61; "London, Thursday, Dec. 28," *Newcastle Courant*, December 29, 1843.

11. Richard Carlile, *Every Woman's Book; or, What Is Love? Containing Most Important Instructions for the Prudent Regulation of the Principle of Love, and the Number of a Family*, 4th ed. (London: R. Carlile, 1826); *Republican*, May 6, 1825—the article was made into a pamphlet and published in February 1826, with eight editions to 1828. Anna Clark, *The Struggle for the Breeches: Gender and the Making of the British Working Class* (Berkeley: University of California Press, 1995), 19; Hera Cook, *The Long Sexual Revolution: English Women, Sex, and Contraception, 1800–1975* (Oxford, England: Oxford University Press, 2004), 42–43.

12. Carlile to Holmes (RC 404), Dorchester Gaol, January 12, 1825, Carlile papers, Henry E. Huntington Library, San Marino, CA. A French instrument-maker, Ben Aimé, assisted with Francis Place's first handbill on contraception. Cook, *Long Sexual Revolution*, 55. Joseph A. Banks, *Prosperity and Parenthood: A Study of Family Planning Among the Victorian Middle Classes* (London: Routledge & Paul, 1969).

13. "SPENCER LINDFIELD," Old Bailey Proceedings Online. "*London Medical Gazette.* Trial for an Attempt to Procure Abortion with White Hellebore," *New York Journal of Medicine* 7, no. 19 (1846): 136; "News," *Reading Mercury*, April 6, 1829.

14. "Advertisements & Notices," *Morning Chronicle*, July 7, 1856; "Case of Poison Adjourned Inquest," *Newcastle Journal*, February 12, 1842; "Weekly Gossip," *Northern Liberator*, March 30, 1839.

15. Mary Wollstonecraft, *Maria: or, The Wrongs of Woman* (London: J. Johnson and G. G. and J. Robinson, 1798), 96–98.

16. T. Radford, *The Value of Embryonic and Foetal Life Legally, Socially and Obstetrically Considered* (London: n.p., 1848), 10; *The Cottage Physician, and Family Adviser; or Every Man His Own Doctor and Herbalist. On the Plain Principles of "Medicine Without Mystery* (London: Sherwood, 1825), 57, 58–59; Robert Christison, *A Treatise on Poisons* (Edinburgh: n.p., 1829), 468–70.

17. "Foreign and Colonial," *Examiner*; "Police Intelligence—Thursday," *Morning Chronicle* October 20, 1848.

18. "SPENCER LINDFIELD," Old Bailey Proceedings Online.

19. Laura Gowing, "Secret Births and Infanticide in Seventeenth-Century England," *Past & Present* 156 (1997): 87–115; Peter C. Hoffer and N. E. H. Hull, *Murdering Mothers: Infanticide in England and New England, 1558–1803* (New York: New York University Press, 1981); Mark Jackson, *New-born Child Murder: Women, Illegitimacy and the Courts in Eighteenth-Century England* (Manchester, England: Manchester University Press, 1996).

20. "Advertisements & Notices," *Newcastle Courant*, July 9, 1803; "Advertisements & Notices," *Newcastle Courant*, August 5, 1820; "Advertisements & Notices," *Newcastle Courant*, April 16, 1831; "Advertisements & Notices," *Newcastle Courant*, December 12, 1835.

21. Birth: Select Births and Christenings, 1538–1975, Provo, UT, USA, via Ancestry.com. Original data: England, Births and Christenings, 1538–1975, Salt Lake City, Utah, via FamilySearch. Marriage: London Metropolitan Archives; London, England; Reference Number: P69/BOT4/A/01/Ms 4520/8. "Police Intelligence of Saturday," *Standard*, September 25, 1848; Williams, *Unmarried Motherhood*; Ginger S. Frost, *Living in Sin: Cohabiting as Husband and Wife in Nineteenth-Century England* (Manchester, England: Manchester University Press, 2014). Anna Clark makes the point that marriage licenses, required since 1753, made weddings costly, and as long as man and wife lived together as if they were married, little would probably be said. Clark, *Struggle for the Breeches*, 49–50.

22. Clark, *Struggle for the Breeches*, 164–74.

23. "SPENCER LINDFIELD," Old Bailey Proceedings Online; Robert Woods and Chris Galley, *Mrs Stone & Dr Smellie: Eighteenth-Century Midwives and Their Patients* (Liverpool, England: Liverpool University Press, 2014); Cody, *Birthing the Nation*.

24. "Police Intelligence," *Sussex Advertiser*, October 9, 1826, 4; London Metropolitan Archives, *Register of Bastard Children, 1802–1835*, P92/MRY/357, 25.

25. "Police Intelligence of Saturday," *Standard*; "Foreign and Colonial," *Examiner*.

26. "The Inquest on Eliza Wilson," *Morning Chronicle*, September 29, 1848.

27. "Foreign and Colonial," *Examiner*.

28. The basic chronology is clearest in "Inquest on Eliza Wilson," *Morning Chronicle*.

29. "SPENCER LINDFIELD," Old Bailey Proceedings Online.

30. Irvine Loudon, *Death in Childbirth: An International Study of Maternal Care and Maternal Mortality, 1800–1950* (Oxford, England: Clarendon Press, 1992), see esp. 49–84; *39th Report of the Registrar General for 1876* (London: n.p., 1878), 242.

31. John Keown, *Abortion, Doctors and the Law: Some Aspects of the Legal Regulation of Abortion in England from 1803 to 1982* (Cambridge, England: Cambridge University Press, 2002), 3–12. For a rich account of the legal history from a contemporary, see the appendix to Evory Kennedy, *Observations on Obstetric Auscultation, with an Analysis of the Evidences of Pregnancy* (Dublin: Hodges and Smith, 1833), 261–88.

32. Keown, *Abortion, Doctors*, 12–25; Shelley A. M. Gavigan "The Criminal Sanction as It Relates to Human Reproduction: The Genesis of the Statutory Prohibition of Abortion," *Journal of Legal History* 5 (1984): 20–43.

33. Keown, *Abortion, Doctors*, 12–25; Gavigan, "The Criminal Sanction."

34. Angus McLaren, *Reproductive Rituals: The Perception of Fertility in England from the Sixteenth to the Nineteenth Century* (London: Methuen, 1984), 138–43; J. A. Le Jumeau, *Mémoire sur L'auscultation, Appliquée a L'étude de la Grossesse* (Paris: Méquiquon-Marvis, 1822).

35. Kennedy, *Observations on Obstetric Auscultation*.

36. Thomas Forbes, "A Jury of Matrons," *Medical History* 32, no. 1 (January 1988): 23–33. Kennedy, *Observations on Obstetric Auscultation*, 195, 265; this latter section was written by a barrister. On the heartbeat, see Kathleen M. Crowther, *Policing Pregnant Bodies: From Ancient Greece to Post-Roe America* (Baltimore: Johns Hopkins University Press, 2023), 11–46.

37. "Foreign and Colonial," *Examiner*.

38. "The Late Extraordinary Disclosures," *Examiner*.

39. "Police—Yesterday," *Daily News* September 30, 1848; "Police Intelligence—Friday," *Morning Chronicle*.

40. Aeron Hunt, "Calculations and Concealments: Infanticide in Mid–Nineteenth Century Britain," *Victorian Literature & Culture* 34, no. 1 (March 2006): 71–94; Josephine McDonagh, *Child Murder and British Culture, 1720–1900* (Cambridge, England: Cambridge University Press, 2003);

Newcastle Guardian, and Tyne Mercury, February 28, 1857; *Newcastle Courant*, September 6, 1861.

41. "Foreign and Colonial," *Examiner*.

42. "Foreign and Colonial," *Examiner*.

43. "Foreign and Colonial," *Examiner*; "Inquest on Eliza Wilson," *Morning Chronicle*.

44. "Foreign and Colonial," *Examiner*; "Inquest on Eliza Wilson," *Morning Chronicle*.

45. "Police Intelligence—Thursday," *Morning Chronicle*; "Inquest on Eliza Wilson," *Morning Chronicle*; Ruth Richardson, *Death, Dissection, and the Destitute* (London: Routledge & Kegan Paul, 1987); "Police Intelligence of Saturday," *Standard*.

46. "SPENCER LINDFIELD," Old Bailey Proceedings Online.

47. "SPENCER LINDFIELD," Old Bailey Proceedings Online; Doreen A. Evenden, *The Midwives of Seventeenth-Century London* (Cambridge, England: Cambridge University Press, 2000).

48. *Census Returns of England and Wales, 1851*, Class: HO107; Piece: 1567; Folio: 625; Page: 25; GSU roll: 174800-174801. For herbalist: *Post Office London Directory* (London: Frederic Kelly, 1856), 1188; Richard Orpin: London Metropolitan Archives, London, England; Board of Guardian Records, 1834–1906 / Church of England Parish Registers, 1813–1906; Reference Number: DW/T/0526; General Register Office. *England and Wales Civil Registration Indexes* (London: General Register Office), vol. 1d, 312.

49. London Metropolitan Archives; London, England; London Church of England Parish Registers; Reference Number: P85/LUK/015.

Chapter 6: The Schoolteacher: Anti-Abortion Campaigns in Nineteenth-Century America

1. Lester Frank Ward, *Young Ward's Diary, A Human and Eager Record of the Years Between 1860 and 1870* . . . (New York: G. P. Putnam's Sons, 1935), 135–51; Edward Charles Rafferty, *Apostle of Human Progress: The Life of Lester Frank Ward, 1841–1913*, PhD dissertation, Brown University, 1999. In later life, Ward became a founder of the new discipline of sociology. L. F. Ward, widow's pension application, 1913, National Archives, Washington, DC, Case Files of Approved Pension Applications, 1861–1934; Civil War and Later Pension Files; Record Group 15: Records of the Department of Veterans Affairs; pension no. Inv. 60,367, Cert. no. 66,536; W.C. 1006414, Cert. no. 763735, pension no. Inv. 60,367, Cert. no. 66,536; W.C. 1006414, Cert. no. 763735.

2. Orin Gee, pension application (Co. G, 4th Reg., Mich. Inf., Civil War), pension no. Inv. 311,077, Cert. no. 510,892; W.C. 529,076, Cert. no. 414,042, Case Files of Approved Pension Applications, 1861–1934; Civil War and Later Pension Files; Record Group 15: Records of the Department of Veterans Affairs; National Archives, Washington, DC; 1860 census: The National Archives in Washington, DC; Record Group: Records of the

Bureau of the Census; Record Group Number: 29; Series Number: M653; Residence Date: 1860; Home in 1860: Dundee, Monroe, Michigan; Roll: M653_554; Page: 322; Family History Library Film: 803554.

3. Ward, *Young Ward's Diary*, 140.

4. *Boston Daily Times*, see Portuguese Female Pills, French Periodical Pills, French Renovating Pills: all January 1, 1845; Renovating Pills: June 2, 1845; quote, French Lunar Pills: January 1, 1845. All of these were advertised repeatedly, often for years. Doctors were well aware of them: "Disgraceful Advertisements," *Boston Medical and Surgical Journal* 44, no. 15 (May 14, 1851): 265.

5. *Boston Daily Times*, Dr. Peters: June 2, 1845; Madame Vincent: December 20, 1845; Dr. Harrington: December 20, 1845; Drunette, French Lunar Pills: January 1, 1845; female physician and accoucheur at Dr. Harrington's: January 1, 1855.

6. "Advertisement," *Pittsfield Sun*, February 22, 1866; *Daily Spy*, September 7, 1850; Wright's Indian Vegetable Pills: *Boston Daily Times*, January 11, 1845.

7. *Nashville Union and American*, April 6, 1858; next three medicines: *Nashville Union and American*, March 24, 1854; *Daily Nashville Patriot*, November 10, 1861; Mrs. O: E. R. H., *Nashville Journal of Medicine and Surgery* 3, no. 6 (December 1, 1867): 254; Clarke: *Home Journal*, August 25, 1859; *Clarksville Chronicle*, October 25, 1861; *Columbia Herald*, October 22, 1869; *Bolivar Bulletin*, February 1, 1868. *Catholicon* means "panacea"—it does not refer to religion.

8. *Boston Daily Times*: French Periodical Pills: January 1, 1845; French Renovating Pills: January 1, 1845. "Criminal Abortion," *Buffalo Medical Journal and Monthly Review* 14, no. 4 (September 1858). 248.

9. *Boston Daily Times*, January 1, 1845; Thomas Richardson and Edward Stearns, "Municipal Court," *Atlas*, September 10, 1844; James C. Mohr, *Abortion in America* (Oxford, England: Oxford University Press, 1974), 52.

10. Benjamin Franklin Hallett, *Trial of Rev. Mr. Avery*, 2nd ed. (Boston: Daily Commercial Gazette, 1833).

11. "The Case of Avery," *Boston Investigator*, March 15, 1833, accessed June 9, 2023, https://gale.com/apps/doc/GT3014094177/NCNP?u=balt85423&sid=bookmark-NCNP.

12. "Weekly Record," *Boston Investigator*, May 24, 1843; "Weekly Record," *Boston Investigator*, June 7, 1843.

13. A. M. Mauriceau, *The Married Woman's Private Medical Companion* (New York: Joseph Trow, 1852), 16, accessed June 5, 2023, https://librarycompany.org/2010/01/04/new-acquisition-and-cheap-at-that-early-american-marriage-manuals/.

14. Likely the Hollick text that Ward read was Frederick Hollick, *The Marriage Guide: or, Natural History of Generation* . . . (New York: T. W. Strong, 1850), see 332–36. Ward, *Young Ward's Diary*, 41, 44, 59. April

Haynes, "The Trials of Frederick Hollick: Obscenity, Sex Education, and Medical Democracy in the Antebellum United States," *Journal of the History of Sexuality* 12, no. 4 (October 2003): 543–74; thanks to Charles Rosenberg for further information.

15. Joseph Kett, *The Formation of the American Medical Profession: The Role of Institutions, 1780–1860* (New Haven, CT: Yale University Press, 1968); John S. Haller, *Sectarian Reformers in American Medicine, 1800–1910* (New York: AMS Press, 2011); Edward C. Atwater, "The Medical Profession in a New Society, Rochester, New York (1811–60)," *Bulletin of the History of Medicine* 47, no. 3 (May–June 1973): 221–35.

16. Buell Eastman, *Practical Treatise on Diseases Peculiar to Women and Girls . . .* , 3rd ed. (Cincinnati: Cropper, 1848), 27; Thomas Hersey, *The Midwife's Practical Directory . . .* (Baltimore: H. Thomas, 1836), 320; Edwin M. Hale, *A Systematic Treatise on Abortion* (Chicago: C. S. Halsey, 1866). Hale shifted his position on abortion as regular medicine came to oppose the practice, but he continued to advocate for the importance of therapeutic abortion.

17. Edwin Fay to Sarah Fay, June 4, 1863, in *This Infernal War: The Confederate Letters of Sgt. Edwin H. Fay*, ed. Bell Irwin Wiley (Austin: University of Texas Press, 1958), 217, 196, 279–80, 311, 424; Thavolia Glymph, *Out of the House of Bondage: The Transformation of the Plantation Household* (Cambridge, England: Cambridge University Press, 2012), esp. 116; Deirdre Cooper Owens, *Medical Bondage: Race, Gender, and the Origins of American Gynecology* (Athens: University of Georgia Press, 2017), 42–72; Daina Ramey Berry, *The Price for Their Pound of Flesh: The Value of the Enslaved, from Womb to Grave, in the Building of a Nation* (Boston: Beacon Press, 2017).

18. Mohr, *Abortion in America*, 73–74.

19. Hugh L. Hodge, *On Criminal Abortion: A Lecture Introductory to the Course on Obstetrics, and Diseases of Women and Children: University of Pennsylvania: session 1854–5: by Hugh L. Hodge, M. D.* (Philadelphia: T. K. and P. G. Collins, 1854); Nora Doyle, *Maternal Bodies: Redefining Motherhood in Early America* (Chapel Hill: University of North Carolina Press, 2018), 14–51.

20. "Medical Items," *Nashville Journal of Medicine and Surgery* 8, no. 6 (June 1, 1855): 502.

21. E. M. Buckingham, "Criminal Abortion," *Cincinnati Lancet and Medical Observer* 10 (March 1867): 139–43; Kristin Luker, *Abortion and the Politics of Motherhood* (Berkeley: University of California Press, 1984), 18–27; Mohr, *Abortion in America*, 32–37.

22. Walter Channing, "Effects of Criminal Abortion," *Boston Medical and Surgical Journal* 60, no. 7 (March 17, 1859): 134–42, quotes at 135.

23. J. N. Graham, "Induction of Premature Labor," *Nashville Journal of Medicine and Surgery* 13, no. 9 (September 1, 1857): 207–10, quotes at 208;

J. P. Leonard, "Quackery and Abortion," *Boston Medical and Surgical Journal* 43, no. 24 (January 15, 1851): 477–79.

24. Edwin M. Hale, *On the Homoeopathic Treatment of Abortion* (Chicago: Halsey & King, 1860), 12–15. For "prostituted": Edwin M. Hale, *A Systematic Treatise on Abortion and Sterility* (Chicago; Buffalo: C. S. Halsey, 1868), preface to 2nd ed. For safety: Hale, *Systematic Treatise*, 29–30.

25. "The Report on Criminal Abortions," *Boston Medical and Surgical Journal* 56 (May 28, 1857): 346; "Criminal Abortions," *Boston Medical and Surgical Journal* 30 (May 15, 1844): 302–3; "Procuring Abortions," *Boston Medical and Surgical Journal* 51, no. 10 (October 4, 1854): 204–8; "Criminal Abortion; The *Boston Medical and Surgical Journal* and Its Attempts at Bullying," *New-Hampshire Journal of Medicine* 7, no. 8 (August 1857): 248–51.

26. Mohr, *Abortion in America*, 147–54.

27. Mohr, *Abortion in America*, 156–57.

28. Mohr, *Abortion in America*, 201–2.

29. Mohr, *Abortion in America*, 200–25; Eugene Quay, "Justifiable Abortion—Medical and Legal Foundations," part 2, *Georgetown Law Journal* 49, no. 3 (Spring 1961): 395–538, see digest of state laws, 447–520.

30. April R. Haynes, *Riotous Flesh: Women, Physiology, and the Solitary Vice in Nineteenth-Century America* (Chicago: University of Chicago Press, 2015), 81–106; Jean L. Silver-Isenstadt, *Shameless: The Visionary Life of Mary Gove Nichols* (Baltimore: Johns Hopkins University Press, 2002); Myra C. Glenn, *Dr. Harriot Kezia Hunt: Nineteenth-Century Physician and Woman's Rights Advocate* (Amherst; Boston: University of Massachusetts Press, 2018).

31. Regina Markell Morantz-Sanchez, *Sympathy and Science: Women Physicians in American Medicine* (New York: Oxford University Press, 1985); Ellen S. More, *Restoring the Balance: Women Physicians and the Profession of Medicine, 1850–1995* (Cambridge, MA: Harvard University Press, 1999); Glenn, *Dr. Harriot Kezia Hunt*.

32. Morantz-Sanchez, *Sympathy and Science*; More, *Restoring the Balance*.

33. Horatio Robinson Storer, *Is It I? A Book for Every Man* (Boston: Lee and Shepard, 1867), 89–90; Henry C. Wright, *The Unwelcome Child; or, The Crime of an Undesigned and Undesired Maternity* (Boston: B. Marsh, 1858), 21–22; Carroll Smith-Rosenberg, "The Abortion Movement and the AMA 1850–1880," in *Disorderly Conduct: Visions of Gender in Victorian America* (New York: Oxford University Press, 1985), 217–44.

34. H. Gibbons Sr., "On Feticide," in *Transactions of the Medical Society of the State of California During the Years 1877 and 1878* (Sacramento: H. S. Crocker, 1878), 209–25, see esp. 209, 211–12; Montrose A. Pallen, "Foeticide, or Criminal Abortion," *Medical Archives* 3, no. 195 (1869): 193–206; Helen Lefkowitz Horowitz, *Rereading Sex: Battles over Sexual Knowledge*

and *Suppression in Nineteenth-Century America* (New York: Alfred A. Knopf, 2002), 45–69.

35. Horowitz, *Rereading Sex*, 45–69; More, *Restoring the Balance*, 23–36.

36. Horowitz, *Rereading Sex*; Mary P. Ryan, *Women in Public: Between Banners and Ballots, 1825–1880* (Baltimore: Johns Hopkins University Press, 1990); Nancy A. Hewitt, *Women's Activism and Social Change: Rochester, New York, 1822–1872* (Ithaca, NY: Cornell University Press, 1984).

37. Ward, *Young Ward's Diary*, 81, 151–74.

38. Ward, *Young Ward's Diary*, 152, 140.

39. Ward, *Young Ward's Diary*, 175, 216, 246. 1880 Census: Tenth Census of the United States, 1880 (NARA microfilm publication T9, 1,454 rolls), Records of the Bureau of the Census, Record Group 29, National Archives, Washington, DC; "Martha Cook Gee," Find a Grave, https://www.findagrave.com/memorial/62622972/martha-gee.

40. Rafferty, *Apostle of Human Progress*, 20–21.

41. Horatio Storer, *Why Not? A Book for Every Woman* (Boston: Lee and Shepard, 1866), 85; Channing, "Effects of Criminal Abortion," 135.

42. Augustus K. Gardner, *Conjugal Sins Against the Laws of Life and Health, and Their Effects upon the Father, Mother and Child* (New York: G. J. Moulton, 1874), 112. On seduction narratives, Brooke Lansing Mai, "'The Helpless French Girl': Seduction Narratives in a Nineteenth-Century Abortion Trial," *Gender and History* 36, no. 2 (July 2024): 313–26.

43. S. W. Butler, "Criminal Abortion," *Medical and Surgical Reporter* 15 (1866): 262; for quote, Buckingham, "Criminal Abortion," 142; Gardner, *Conjugal Sins*, 129–30.

44. Pallen, "Foeticide," 193–206, esp. 196; Mohr, *Abortion in America*, 182–96.

45. Nicola Beisel, *Imperiled Innocents: Anthony Comstock and Family Reproduction in Victorian America* (Princeton, NJ: Princeton University Press, 1997); Horowitz, *Rereading Sex*, 358–418; Amy Werbel, *Lust on Trial: Censorship and the Rise of American Obscenity in the Age of Anthony Comstock* (New York: Columbia University Press, 2018).

46. Dr. Butts, *Dr. Butts' Pocket Marriage Guide . . .* (Saint Louis: Dr. Butts' Dispensary, 1873), 137–45; Janet Farrell Brodie, *Contraception and Abortion in Nineteenth-Century America* (Ithaca, NY: Cornell University Press, 1994), 228, 281–88.

47. Anthony Comstock, *Frauds Exposed; or, How the People Are Deceived and Robbed, and Youth Corrupted* (New York: J. H. Brown, 1880), 417–18; Nicholas Syrett, *The Trials of Madame Restell* (New York: New Press, 2023), 265–82.

48. Brodie, *Contraception and Abortion*, 225–26; Andrea Tone, *Devices and Desires: A History of Contraceptives in America* (New York: Hill and Wang, 2001), 24–45; Alicia Puglionesi, "'Your Whole Effort Has Been to

Create Desire': Reproducing Knowledge and Evading Censorship in the Nineteenth-Century Subscription Press," *Bulletin of the History of Medicine* 89, no. 3 (2015): 463–90.

49. Leslie Reagan, "Linking Midwives and Abortion in the Progressive Era," *Bulletin of the History of Medicine* 69, no. 4 (1995): 569–98; Leslie J. Reagan, *When Abortion Was a Crime: Women, Medicine, and Law in the United States, 1867–1973* (Berkeley: University of California, Press, 1997).

Chapter 7: The Housewife: Repression and Reform in Twentieth-Century America

1. Maryland State Archives, Baltimore City, Criminal Courts, Criminal Paper T495-565, case # 4420, 4421, statement, 1. 1930 US Census; Census Place: Baltimore, Blank, Maryland; Page: 1B; Enumeration District: 0441; 1940 US Census; Census Place: Baltimore, Baltimore City, Maryland; Roll: m-t0627-01520; Page: 1A; Enumeration District: 4-315. In this chapter, I use initials for the last names of every abortion-seeker who was not highly visible in the public record. From at least the turn of the century, prosecutors relied on newspapers to "name and shame" abortion recipients, who had not themselves broken the law by seeking an abortion, and I do not want to echo that practice. Leslie J. Reagan, "'About to Meet Her Maker': Women, Doctors, Dying Declarations, and the State's Investigation of Abortion, Chicago, 1867–1940," *Journal of American History* 77, no. 4 (March 1991): 1240–64.

2. Maryland State Archives, statement, 1. 1950 US Census; Census Place: Baltimore, Baltimore, Maryland; Roll: 2115; Page: 1; Enumeration District: 4-593.

3. Maryland State Archives, statement, 2–3; Richard Yates, *Revolutionary Road* (Boston: Little, Brown, 1961), 209.

4. Maryland State Archives, statement, 1–2.

5. Maryland State Archives, statement, 2–3.

6. Maryland State Archives, statement, 3–4.

7. Alan F. Guttmacher, *Babies by Choice or by Chance* (Garden City, NY: Doubleday, 1959), 219, 203.

8. "Moser Rules Out Abortion Case Against Pharmacist, Woman," *Baltimore Sun*, June 19, 1952.

9. Leslie J. Reagan, *When Abortion Was a Crime: Women, Medicine, and Law in the United States, 1867–1973* (Berkeley: University of California, Press, 1997), 132–59.

10. Kristin Luker, *Abortion and the Politics of Motherhood* (Berkeley: University of California Press, 1984), 40–54; Reagan, *When Abortion Was a Crime*, 150–62; Alan F. Guttmacher, "The Law Doctors Often Break," *Reader's Digest*, January 1960, 51–54, figure at 54.

11. Reagan, *When Abortion Was a Crime*, 6; Luker, *Abortion and the Politics of Motherhood*, 107–9; Stephanie Coontz, *Marriage: A History* (New York: Viking, 2005), 216–17.

12. Linda Gordon, *Women's Body, Women's Right: Birth Control in America* (New York: Penguin, 1977), 301–40; Reagan, *When Abortion Was a Crime*, 132–47.

13. Rose Holz, *The Birth Control Clinic in a Marketplace World* (Rochester, NY: University of Rochester Press, 2012).

14. Rickie Solinger, *Wake Up Little Susie* (New York: Routledge, 1992); Regina G. Kunzel, *Fallen Women, Problem Girls: Unmarried Mothers and the Professionalization of Benevolence, 1890–1945* (New Haven, CT: Yale University Press, 1993).

15. Ed Keemer, *Confessions of a Pro-Life Abortionist* (Detroit: Vinco Press, 1980), 24–31, 65–70.

16. Lawrence Lader, *Abortion* (Indianapolis: Bobbs-Merrill, 1966), 46–47, "Dr. Tim day": 42; Mary Steichen Calderone, *Abortion in the United States* (New York: Hoeber-Harper, 1958), 59–63.

17. "Albert Mac Crow in the 1940 Census," Ancestry.com, https://www.ancestry.com/1940-census/usa/Maryland/Albert-Mac-Crowe_573zhs; Calderone, *Abortion*, 66; Lader, *Abortion*, 43, 47; Christopher Tietze, "Report on a Series of Illegal Abortions Induced by Physicians," in *Studies in Population*, ed. George F. Mair (Princeton, NJ: Princeton University Press, 2015), 21–26. The data come from his 1949 study.

18. Tietze, "Report."

19. Jacquin Sanders, "The Shadow World of the Abortionist," *Austin Statesman*, June 7, 1970; Eleanor Cummins, "25,000 Illegal Abortions, One Doctor on the Run," *Slate*, June 15, 2022, https://slate.com/technology/2022/06/the-history-of-nathan-rappaport-new-yorks-most-notorious-illegal-abortionist.html; Keemer, *Confessions*, 140–42.

20. Patricia G. Miller, *The Worst of Times* (New York: HarperCollins, 1993), 122–39; Susan Brownmiller, "When an Abortionist Dies," *Village Voice*, January 30, 1969, https://www.villagevoice.com/when-an-abortionist-dies/; Sheila Stogsdill, "Professors Profile Grove Doctor Who Performed 5,000 Abortions," *Joplin Globe*, August 19, 2006, https://www.joplinglobe.com/news/local_news/professors-profile-grove-doctor-who-performed-5-000-abortions/article_c064a550-4ac8-5284-9b47-fe1cf39a462b.html.

21. Leslie J. Reagan, "Linking Midwives and Abortion in the Progressive Era," *Bulletin of the History of Medicine* 69, no. 4 (1995): 569–98; Mary Sherwood, "The Midwives of Baltimore," *Journal of the American Medical Association* 52, no. 25 (June 19, 1909): 2009–10. Midwives were rarely prosecuted for abortion provision in Baltimore in the 1920s and '30s. For exceptions, see "Local Matters: Almanac for Baltimore—This Day," *Baltimore Sun*, January 24, 1881; "Deacon and Midwife Held for Abortion," *Baltimore Afro-American*, March 31, 1922; "Arrested in Abortion Case: Midwife Charged with Giving White Woman Medicine," *Baltimore Afro-American*, July 9, 1920; *142nd Annual Report of the Health Department of the City of Baltimore* (1956), 161, 292.

22. "Abortionist Gets Suspended Term: Man, 64, Fined $4,000 and Is Placed on Probation," *Baltimore Sun*, March 3, 1955; Ruth Barnett, *They Weep on My Doorstep* (Beaverton, OR: Halo, 1969), 9, 27, 49; Rickie Solinger, *The Abortionist: A Woman Against the Law* (Berkeley: University of California Press, 1996).

23. Carole E. Joffe, *Doctors of Conscience: The Struggle to Provide Abortion Before and After Roe v. Wade* (Boston: Beacon Press, 1995), 110–11.

24. Alicia Gutierrez-Romine, *From Back Alley to the Border: Criminal Abortion in California, 1920–1969* (Lincoln: University of Nebraska Press, 2020), 111–34.

25. Reagan, *When Abortion Was a Crime*, 160–72.

26. Coontz, *Marriage*, 216–28; "Marriage Rates in the United States, 1900–2018," CDC, https://www.cdc.gov/nchs/data/hestat/marriage_rate_2018/marriage_rate_2018.htm.

27. Lader, *Abortion*, 120–25; "Soviet Legalizes Abortions Again: Move After Twenty Years Viewed as Part of General Easing of Restrictions," *New York Times*, December 1, 1955.

28. Lisa Riggin, *San Francisco's Queen of Vice: The Strange Career of Abortionist Inez Brown Burns* (Lincoln: University of Nebraska Press, 2017), esp. 14–15.

29. "Two Convicted in Abortion Case: Sentences Held Up Pending Probation," *Baltimore Sun*, December 30, 1950. Here I use initials because of the invasive and intimate nature of the policewomen's work. Ethel D. cases: Maryland State Archives, Baltimore City Criminal Court (Criminal Papers), State of Maryland vs. Albert MacCrowe et al., 1949, T495-T532, #5205-5216; Maryland State Archives, Baltimore City, Criminal Court (Criminal Papers) T495 565, State of Maryland vs. Beatrice J. 1951 T495-565 #4420, #4421; Maryland State Archives, Baltimore City Criminal Court (Criminal Papers), State of Maryland vs. Arza and Hilda Williams T495-546 #4036-#4038; see Miller, *Worst of Times*, 35, suggesting raids began just before a catheter was inserted.

30. Maryland State Archives, Baltimore City Criminal Court (Criminal Papers) #5873-#5881, State of MD vs. George Timanus et al., box 535 (T495-550). Hereafter cited as Timanus transcript, 242, 248, 201.

31. Reagan, *When Abortion Was a Crime*, 193–200; Lader, *Abortion*, 64–71; Laura Kaplan, *The Story of Jane: The Legendary Underground Feminist Abortion Service* (New York: Vintage, 2022), 11–14, 38–39, 55–56; Cara Delay, Cora Webb, Regina Day, and Madeleine Ware, "'No-Tell Motels': Abortion in Pre-Roe South Carolina," Nursing Clio, April 11, 2018, https://nursingclio.org/2018/04/11/no-tell-motels-abortion-in-pre-roe-south-carolina/; Miller, *Worst of Times* 122–39; Keemer, *Confessions*, 137; Miller, *Worst of Times*, 59, 63–64, 245.

32. Timanus transcript, 373–74. On the trial, see Reagan, *When Abortion Was a Crime*, 181–88.

33. Timanus transcript, 388.

34. Timanus transcript, 382, 402.

35. Maryland State Archives, Baltimore City, Criminal Courts, Criminal Paper T495-574, case # 1683; "Woman Guilty in Abortion: Man Codefendant Admits Arranging for Operation," *Baltimore Sun*, September 24, 1952.

36. "Woman Guilty in Abortion," *Baltimore Sun*. A version of this case appears in Miller, *Worst of Times*, 34–35.

37. Maryland State Archives, Baltimore City Criminal Court (Criminal Papers), State of Maryland vs. Luther Fultz et al., 1940, T495-407, #2085–#2097; "Dr. L. Fultz Faces Trial: Five Stillborn Babies Found; Wife also Held," *Baltimore Afro-American*, June 8, 1940.

38. "2 Race Groups to Hold Parley on Segregation: Whites and Negroes Will Attempt to Work Out Solution Today," *Baltimore Sun*, January 25, 1924; "Mayor Considering Negro for School Board Vacancy: Dr. B. M. Rhetta Being Backed by Two Colored Members of Council," *Baltimore Sun*, March 6, 1928; "Archbishop Curley Indorses Dr. Rhetta: Candidate for Place on School Board Termed Sane and Conservative," *Baltimore Afro-American*, April 28, 1928; Karen Kruse Thomas, *Health and Humanity: A History of the Johns Hopkins Bloomberg School of Public Health, 1935–1985* (Baltimore: Johns Hopkins University Press, 2016), 35–37; "Probation Given in Abortion Case," *Baltimore Sun*, June 18, 1955; Matthew A. Crenson, *Baltimore: A Political History* (Baltimore: Johns Hopkins University Press, 2016), 404–11, 422–24. Deepest gratitude to my colleague Graham Mooney, whose gift of clippings about the Rhetta case sparked my interest.

39. Barnett M. Rhetta, "A Plea for the Lives of the Unborn," *Journal of the National Medical Association* 7, no. 3 (1915): 200–5, quotes at 202.

40. For context see, Franklin Frazier, "The Negro and Birth Control," *Birth Control Review* 17, no. 8 (March 1933): 12–14; L. L. Burwell, "The Fertility of Women: Its Effect Physically and Morally Upon the Nation," *Journal of the National Medical Association* 5, no. 4 (October–December 1913), 226–29; Johanna Schoen, *Choice and Coercion: Birth Control, Sterilization, and Abortion in Public Health and Welfare* (Chapel Hill: University of North Carolina Press, 2005), esp. 139–96; Molly Ladd-Taylor, *Fixing the Poor: Eugenic Sterilization and Child Welfare in the Twentieth Century* (Baltimore: Johns Hopkins University Press, 2017); Wendy Kline, *Building a Better Race: Gender, Sexuality, and Eugenics from the Turn of the Century to the Baby Boom* (Berkeley: University of California Press, 2001); Keemer, *Confessions*, 24–27, 31.

41. "Opinion: Our Time Is Coming," *Baltimore Afro-American*, July 13, 1940; on white clients of Black providers, Schoen, *Choice and Coercion*, 169.

42. B. M. Phillips, "If You Ask Me: The Rhetta Case," *Baltimore Afro-American*, April 2, 1955.

43. Alan F. Guttmacher, "The Genesis of Liberalized Abortion in New York: A Personal Insight," *Case Western Reserve Law Review* 23 (1972):

756–78; Guttmacher, *Babies by Choice*, 180–81. Guttmacher told this story repeatedly; sometimes the girl's age was twelve, sometimes fourteen.

44. Barbara L. Brookes, *Abortion in England, 1900–1967* (London; New York: Croom Helm, 1988), 68–70; Lader, *Abortion*, 103–8.

45. Luker, *Abortion and the Politics of Motherhood*, 45–48; Lader, *Abortion*, 24–31; Reagan, *When Abortion Was a Crime*, 173–79, 204; Alan F. Guttmacher, "Therapeutic Abortion: The Doctor's Dilemma," *Journal of the Mount Sinai Hospital, New York* 21 (May–June 1954), 118; widely divergent indications for therapeutic abortions lingered into the 1950s, see Herbert L. Packer and Ralph J. Gampell, "Therapeutic Abortion: A Problem in Law and Medicine," *Stanford Law Review* 11, no. 3 (1959): 417–55.

46. Reagan, *When Abortion Was a Crime*, 173–81.

47. Nick Triggle, "Apology to Thalidomide Survivors," BBC News, June 14, 2010, accessed October 15, 2024, http://news.bbc.co.uk/2/hi/health/8458855.stm.

48. Leslie J. Reagan, *Dangerous Pregnancies: Mothers, Disabilities, and Abortion in America* (Berkeley: University of California Press, 2010), 57–63.

49. Lader, *Abortion*, 10–16; Joffe, *Doctors of Conscience*, 114; Reagan, *Dangerous Pregnancies*, 57–63; Luker, *Abortion and the Politics of Motherhood*, 58–62.

50. Reagan, *Dangerous Pregnancies*, 55–102; Lader, *Abortion*, 38–39; Allan C. Barnes, "Nobody Speaks for the Fetus," *Journal of the American Medical Association* 185, no. 5 (1963): 37–39.

51. Lader, *Abortion*, 52–58; Joffe, *Doctors of Conscience*, 112–14; William LaFleur, *Liquid Life: Abortion and Buddhism in Japan* (Princeton, NJ: Princeton University Press, 1992); Leslie J. Reagan, "Abortion Travels: An International History," *Journal of Modern European History* 17, no. 3 (2019): 337–52.

52. Gutierrez-Romine, *From Back Alley*, 173–75.

53. Arthur J. Mandy, "Reflections of a Gynecologist," in *Therapeutic Abortion: Medical, Psychiatric, Anthropological, and Religious Considerations*, ed. Harold Rosen (New York: Julian Press, 1954), 285, 295; *142nd Annual Report of the Health Department*, 159–60; *143rd Annual Report of the Health Department of the City of Baltimore* (1957), 178; Edwin M. Gold et al., "Therapeutic Abortion in New York City: A 20 Year Review," *American Journal of Public Health* 55 (July 1965): 964–72, esp. 965. Population figures for Hispanic/Latino people are difficult to obtain for the early 1960s; by 1970, the city's population was almost half persons of color.

54. Joffe, *Doctors of Conscience*, 119–27; Reagan, *When Abortion Was a Crime*, 173–81, 197–215; Gold et al., "Therapeutic Abortion."

55. Elizabeth M. Oliver, "Friends Chat with Dr. Rhetta in Nassau," *Baltimore Afro-American*, March 3, 1970.

56. Reagan, *When Abortion Was a Crime*, 218–22.

57. Guttmacher, "The Law," 51–54.

58. Tom Davis, *Sacred Work: Planned Parenthood and Its Clergy Alliances* (New Brunswick, NJ: Rutgers University Press, 2005), 93–103; Tiffany Brocke, "Race and Reputation: The Influence of the Johns Hopkins Hospital on Abortion Access in Baltimore, 1945– 1973," unpublished paper. I am grateful to Dr. Brocke for generously sharing her work with me. "Calendar of Women's City Clubs," *Baltimore Sun*, November 18, 1962; Helen B. Taussig, "Letter to the Editor: Doctor on Abortion," *Baltimore Afro-American*, March 2, 1968; Allan Barnes, ed. *The Social Responsibility of Gynecology and Obstetrics* (Baltimore: Johns Hopkins Press, 1965), 202; Edward G. Pickett, "Doctors, Clergymen Back Change in Abortion Laws," *Baltimore Sun*, March 9, 1967.

59. Brocke, "Race and Reputation"; *159th Annual Report of the Health Department of the City of Baltimore* (1973), 44.

60. Brittany Meija, "A California Woman's Illegal Abortion Paved the Way for Roe," *Los Angeles Times*, June 24, 2022, accessed May 25, 2024, https://www.latimes.com/california/story/2022-06-24/before-roe-vs-wade-there-was-people-vs-belous; Reagan, *When Abortion Was a Crime*, 233–34; Gutierrez-Romine, *From Back Alley*, 182–91; David Garrow, *Liberty and Sexuality: The Right to Privacy and the Making of Roe v. Wade* (New York: Macmillan, 1994), 354–79.

61. Davis, *Sacred Work*, 126–35; Edward B. Fisket, "Clergymen Offer Abortion Advice: 21 Ministers and Rabbis Form New Group Will Propose Alternatives," *New York Times*, May 2, 1967.

62. Reagan, *When Abortion Was a Crime*, 222–25; Luker, *Abortion and the Politics of Motherhood*, 96–100; Leslie J. Reagan, "Crossing the Border for Abortions: California Activists, Mexican Clinics, and the Creation of a Feminist Health Agency in the 1960s," *Feminist Studies* 26, no. 2 (2000): 323–48.

63. Garrow, *Liberty and Sexuality*, 290; Reagan, *When Abortion Was a Crime*, 222–34; Kaplan, *Story of Jane*, 139–42.

64. Reagan, *When Abortion Was a Crime*, 234–45; Joshua Prager, *The Family Roe: An American Story* (New York: W. W. Norton, 2021).

65. Reagan, *When Abortion Was a Crime*, 234–45; Garrow, *Liberty and Sexuality*, esp. 40–59.

Coda

1. Claire Cain Miller and Margot Sanger-Katz, "Despite State Bans, Legal Abortions Didn't Fall Nationwide in Year After Dobbs," *New York Times*, October 24, 2023.

INDEX

abandonment of pregnant women, 80–81, 86, 107, 116, 172, 214
abolition movement, 106–108
abortifacients. *See* herbal remedies and abortifacients
Abortion Act (1967, UK), 210
Abortion Squad (Baltimore), 191
Abulafia, Meir, 47
Adelheid, 67–69, 74
adultery, 117
 Church prosecution for abortion, 60–61
 Lutheran morality police, 72
 medieval religious abortion doctrine, 44–47
 Queen Caroline, 136
 Romans linking abortion to vanity and, 4, 30, 32–33, 35
 See also extramarital sex
agriculture
 connection with procreation and witchcraft, 89–90
 illicit sex in Victorian England, 127
alexander (abortifacient), 67–69
Algonquin nations, 101
al-Razi (physician), 54
Ambrose (Christian theologian), 37
American Law Institute (ALI), 205–208, 209–210
American Medical Association (AMA), 164
American South, 188
Black midwives' practices, 181
controlling enslaved women's reproductive lives, 110–113
enslaved Africans' botanical knowledge, 105
enslaved Black women's control of their fertility, 214
states' anti-abortion legislation, 165
See also Black women; slaves and slavery
ancient civilizations. *See* Greece, ancient; Roman Republic and Roman Empire
anesthesia, 163
antebellum America
 challenging gender roles, 166–169
 opposition to abortion, 151–153
 physicians' anti-abortion activities, 159–166
 toleration for abortion, 156
 women's freedom as threat to, 4
anti-abortion activists
 antebellum American physicians, 159–166
 culture wars motivating, 151–152
 nativism and, 171–172
 objectives of, 4–5
 postwar physicians, 175–176
anti-abortion legislation, 10
 anti-contraception, 183
 Comstock Act, 173–175
 constitutional right to abortion, 208

263

criminalization of abortion, 122–123
anti-abortion legislation *(continued)*
 Lord Ellenborough's Act, 139–141
 Maryland's liberalization, 206–207
 19th-century anti-abortion legislation, 151
 19th-century politics of abortion, 151
 Offences Against the Person Act, 211
 pronatalism in the Roman Empire, 32
 Roe v. Wade repeal, 9, 213–214
 states' anti-abortion legislation, 164–166
 therapeutic abortions, 205–206
 21st-century politics of abortion, 10
aristolochia (abortifacient), 121
Aristophanes, 24–25
arranged marriages, 16–18, 31
arsenic (abortifacient), 132
Asthure, Mary, 194–195
atheism, prosecution for, 116
attempted abortions, 114–116, 179–180, 191–192
Augustine, 6, 45–46
Avery, Ephraim, 153–154

"baby clothes defense," 77–78
baby farms, 143–144
back-alley abortions, 181, 183
Baltimore, Maryland, 213
 Abortion Squad, 191
 intersection of abortion with race, 195–198
 maternal deaths, 204
 midwives providing abortions, 187–188
 physician-clergy alliance, 206–207
 physicians providing abortions, 184–186
 prosecuting abortion providers, 179–181
baptism, 56, 65–66
Barnes, Allan, 202
Barnett, Ruth, 188, 217
Beame, Henry, 107
Belous, Leon, 207–208

birth control clinics, 183–184
birth defects, 200–202, 205
bitterwood (abortifacient), 106
Black women
 abortion as resistance, 105–108
 global expansion of herbal knowledge, 97–100
 maternal deaths from abortions, 204
 medical school admissions, 167
 midwife providers in 20th-century Baltimore, 188
 nativism and the anti-abortion movement, 171–172
 World War II labor force, 190
 See also slaves and slavery
Blackwell, Elizabeth, 167, 169
blasphemy, prosecution for, 114–117
bloodletting as abortifacient, 63–64, 76–77
Booth, Heather, 209
Boston, Massachusetts
 effects of the anti-abortion movement, 175–176
 19th-century availability of abortions, 152–154
 physicians' anti-abortion activism, 163
bougie (rubber tube), 178, 180
Bourne, Aleck, 199
Bracton, 59
Brigid of Kildare, 39–41, 48–49, 51
Britain, 1–2
 abolition of slavery, 106–108
 doctors, abortion, and the law in the 20th century, 199, 210–211
 National Health Service, 210–211
 19th-century anti-abortion legislation, 151
 Poor Laws, 129–130, 136–137
 prevalence of unwed pregnancy, 126–128
 rising use of contraception, 130–131
 Spencer Lindfield's midwifery practice and trial, 133–139, 142–148
 Thalidomide, 201

See also England
Bruinech (holy woman), 49–50
Bryant, Cheryl, 207–208
Burchard of Worms, 58, 65
Burns, Inez, 190–191, 217
Byrd, Dave, 112–113

camphor (abortifacient), 110
canon law, 57–59
cantharides (abortifacient), 104, 133
Caribbean colonies, 4, 97–101, 108–110
Carlile, Richard, 130–131
Carolina (criminal code), 73–74
Carter, Landon, 118–119
catheter abortion, 138, 178
Catholic Church
　abortion politics, 6, 58–59
　abortions by holy men and women, 51–54
　banning therapeutic abortions, 201–202
　Brigid of Kildare's miracles, 39–41
　Carolina criminal code, 73–74
　connecting abortion to illicit sex, 43–44
　crackdown on herbal remedies, 71–72
　excommunication for abortion, 73–77, 83, 173
　foundling hospitals, 128
　France's prosecution for abortion, 63
　German witch trials, 92–95
　increasing control over sexual expression, 56–60
　institutional growth and power, 55–56
　Irish religious settlements, 39–41, 48–49, 51
　Malleus Maleficarum, 85–86
　medieval abortion law and religious doctrine, 41–45
　19th-century anti-abortion campaign, 172–173
　post-2022 shifts in legislation, 213–214
　Protestant Reformation, 72–73
　regulating sexual behaviors, 47–48
　Rome's theological diversity, 37–38
　witch trials, 88–89, 94
　See also clergy; convents and monasteries; Protestant Churches and clergy
Catholic League, 92
Catholic Reformation, 69
celibacy
　Christians regulating sexual behaviors, 47–48
　holy women's penance for, 52
　increasing Church control over, 56
　Luther's reforms, 72–73
　medieval doctrine on marriage and, 44–47
　See also convents and monasteries
censorship: Comstock Act, 174
Channing, Walter, 160–162
Charles V (Holy Roman Emperor), 73–74
chastity, 16, 33, 39, 45–50, 79, 83
childbearing
　Dominican friars' misinformation about, 86
　historical importance in women's lives, 2
children
　fatherless children threatening the social order, 84
　infanticide in ancient Greece, 17–18
　medieval children's death and burials, 50–51
　Roman and medieval Christian positions on marriage, 45–46
　sex with demons producing, 87–88
choice, abortion as, 7–8, 122–123
Christianity and the Christian Church. *See* Catholic Church; clergy; Protestant Churches and clergy
Ciarán (holy person), 49–50
Cicero, 30–31
Civil War, American, 107–108, 149–150, 165
Claesje, Maaij, 99–100
clergy
　counseling for abortion access, 208

19th-century anti-abortion campaign, 172–173
paying for sex, 82
rape of incarcerated women, 79
sexual impropriety with congregants, 57, 154–156
witches collecting men's penises, 86
See also Catholic Church; Protestant Churches and clergy
Clergymen's Advisory Board, 206
climate shift: economic impact on single women, 78–80
Clough, Henry Gore, 136, 147
Coleman, William, 113
colocynth (abortifacient), 76
Colombia, 10
colonial America
 abortion as an element in social relations, 8
 German immigrants' herbal knowledge, 120–121
 inducing a lifesaving miscarriage, 121–122
 prosecuting abortions in white women, 113–114
 prosecuting for extramarital sex, 114–118
 rationales for restricting abortion, 4
 witchcraft outbreaks, 88
colonialism: global transmission of botanical knowledge and plants, 97–101
Communism–abortion link, 190
Comstock Act (1873), 173–175, 183
concealment of pregnancy, 134–135, 140
conception
 as the beginning of life, 159–161
 understanding the process, 14
 witchcraft narratives, 89–90
condoms, 183–184
confession
 Church policing of sins, 56–58
 clergymen's sexual abuse of congregants, 154–155
 religious reformations regulating sexual behavior, 69
 witch trials, 93–94
 women's prosecution for abortion, 75
confessors manuals, 52
contraception
 abortion as reproductive control, 183
 ancient Rome, 35
 birth control clinics, 183–184
 birth rate in ancient Greece, 19
 Comstock Act outlawing, 176
 emmenagogues and, 22
 free love movement, 168–169
 Islamic position on, 47
 medieval proscription, 43–44
 pomegranate peels, 25
 sex advice books providing information, 156–157
 sterilization campaign against Black people, 197
 Victorian Britain, 130–131
 See also herbal remedies and abortifacients
contrayerva (abortifacient), 109
convents and monasteries, 52–54
 abortions by holy men and women, 51–52
 Kildare, 40, 48–49
 Luther's criticism of celibacy, 72–73
 as places of incarceration, 79–80
Cornell, Sarah, 154–155
cotton root (abortifacient), 110–113, 122
crime, Victorians' fascination with, 144–145
culture wars: symbols of abortion legislation, 151
cyclamen (abortifacient), 36

D&C (dilation and curettage) procedure, 138, 185, 194, 204, 209
De Legibus et Consuetudinibus Angliae, 59
death
 from abortion gone wrong, 1–2, 5, 9–10, 204

Index

ancient abortifacients, 27
 attributing to witches, 90
 biblical definition of abortion, 41
 Indigenous Americans, 99
 infant mortality in ancient Greece, 18–19
 maternal death rates for women of color, 8
 medieval Children's death and burials, 50–51
 politics of abortion in Rome, 34
 See also herbal remedies and abortifacients; infanticide and infant death; maternal deaths
demons, sexual relations with, 85, 87, 93–94
desertion of pregnant women, 80–81, 86, 107, 116, 172, 214
Detroit, Michigan, 184
Dioscorides, 24, 28, 54
Dischler, Anna, 69–70
Diseases of Women text, 24, 26–27
dittany (abortifacient), 53
divorce ensuring legitimate children in the Roman Republic, 31
Dobbs ruling, 9, 213–214
Doe v. Bolton, 186
domestic service
 abortions in ancient Greece, 15, 26
 economic downturn forcing German women into, 78–80
 sexual abuse by masters and their sons, 78–81, 132–133
Domitian (emperor), 34
dress reform movement, 169
Dryden, Mary, 131–133, 138, 143–144, 147
Dutch colonials, 97–100

early-term abortions, 75, 159–161, 185–186
Eggenmann, Elsbetha, 5, 82–83, 88
El Salvador, 10
elecampane (abortifacient), 53
emmenagogues, 22–24, 104, 111, 152
England
 Church courts policing sins, 57–58
 infanticide laws and prosecution, 77–78
 medieval church courts, 59–61
 medieval gender politics of abortion, 65–66
 witchcraft outbreaks, 88, 90
 See also Britain
ensoulment of a fetus, 58–59
equality: women's freedom as threat to the status quo, 4
ergot (abortifacient), 178, 180
eugenics, abortion and, 172, 197
Every Man His Own Doctor (Tennent), 119–120
Every Woman's Book (Carlile), 130
excommunication, 73–77, 83, 173
executions, 8
 Carolina code, 73–74
 Catholic prosecution for abortion, 74–77
 19th-century politics of abortion, 151
 Pope Sixtus's papal bull, 75
 for witchcraft, 88, 92, 94
Exodus (biblical text), 41–43
exposure, death by, 17–18, 46–47
extramarital sex
 birth control clinics, 183
 colonial America, 114–115, 117–118
 Luther's reforms, 72–73
 Protestant Reformation penalizing, 69
 witches and demons, 85
 See also adultery; illicit sexual relations; premarital sex; sex workers

family size, limiting, 131–132, 177–178, 186
Farr, William, 139
Fay, Edwin, 158
feminists
 challenging abortion laws, 209–210
 female physicians as threat to male physicians, 166–168

Index

questioning traditional gender norms, 171–172
supporting safe abortion opportunities, 209–210
Wollstonecraft's writings, 132–133
fertility
 fertility rates of enslaved women, 107, 110
 marriage goals in ancient Greece, 16–18
 pomegranate seeds, 25–26
 witchcraft narratives, 89
fetal development, 14, 42, 46–48, 58–59, 141–142, 159–161
feticide, abortion as, 160
Finkbine, Sheri, 201–202
first-wave feminism, 166–169
Fitzpatrick, John Bernard, 172
Forte, Alan, 188
foundling hospitals, 128
fragilitas sexus (female frailty), 75
France
 15th-century abortion providers, 67–69
 foundling hospitals, 128
 "healers" as abortion providers, 67–69
 limiting family size, 131
 prosecution for abortion, 61–66
 state control of women's sexual behavior, 77
 witchcraft, 88
Franklin, Benjamin, 119–120
Franklin, Deborah, 119–120
free love movement, 168–169
Fugitive Slave Act (1850), 9
Fultz, Luther, 196–198

Gaffney, Mary, 111–112, 122
galangal (abortifacient), 67–69, 120–121
Galen, 20–21, 30
Gee, Martha, 150, 170
Gee, Orin, 170
Gellius, Aulus, 33
gender relations
 ancient Rome, 32–34
 antebellum America, 166–169
 driving anti-abortion legislation, 166
 female physicians as threat to men, 166–168
 Luther's repressive reforms, 71–72
 men's assistance with abortion in the Middle Ages, 63–66
 Protestant Reformation altering, 69
 shifts in restriction and toleration of abortion, 4
 symbols of abortion legislation, 151
 World War II shift in, 169–170, 189–190
gender: timeline for fetal development, 42
George IV, 136
Germany
 Carolina criminal code, 73–74
 control of unmarried women, 78–82
 early penalties for abortion, 8
 15th-century abortion providers, 67–69
 knowledge of herbal abortifacients, 7
 Luther's repressive reforms, 71–72
 medieval medical writings, 54–55
 witchcraft outbreaks and witch trials, 88–95
Gibbons, Henry, 168
glyster, 121–122
Gove, Mary, 166–169
Gratian (Benedictine monk), 58
Greco-Roman culture: transmission of medical knowledge to medieval Europe, 52–54
Greece, ancient, 13–14
 herbal abortifacients, 36
 Hippocratic doctors studying pregnancy and abortion, 13–16
 history of women seeking abortions, 3
 the ideal woman, 16–17
 knowledge of herbal abortifacients, 23–26
 midwives-abortion link, 20–21
 pregnancy and abortion in, 14–15
 and the rise of Rome, 28–30
 sex work–abortion link, 20
Gregory XIV (pope), 75

Griswold v. Connecticut, 183, 186
Guilhem of Rocencus, 62
Guttmacher, Alan, 180, 198, 206

Hale, Edwin, 162
Hammer of Witches, 85–87, 93
Harding, Anna, 68, 80–82, 84–85, 87, 92–95
harvest rituals, 89–90
heartbeat, fetal, 141–142
Henri II (France), 77
herbal remedies and abortifacients
　compared to abortions by holy men and women, 51–54
　ancient Greece, 14, 23–26
　antebellum America, 151–153, 159
　Britain, 130–132
　Caribbean plantation slaves, 104–106
　Church crackdown on, 71–72
　Comstock Act, 173–175
　confession manuals as sources of information, 57–58
　current study of abortifacients, 27
　enslaved women's use of, 109–113
　failure to induce abortion, 80–81
　France's prosecution for abortion, 61–66
　German immigrants in colonial America, 120–121
　global transmission of herbal knowledge, 97–102
　Greek literature detailing, 26
　hiding an incestuous pregnancy, 76–77
　Hildegard of Bingen's botanical knowledge, 54–55
　history of women's reproductive control, 6–7, 214–215
　Indigenous Americans' knowledge of, 97–101
　inducing a lifesaving miscarriage, 121–122
　Malleus Maleficarum information, 85
　men's knowledge of, 114–115, 118–119
　modern versions, 216
　pessary, 21–22, 26, 64
　Pliny on "abortives," 35–36
　printed works on, 70–71
　self-managed abortion, 5
　Spencer Lindfield's trial, 145–146
highland flag iris (abortifacient), 119–120
Hildegard of Bingen, 54–55
Hippocratic doctors, 20, 27, 42
Hodge, Hugh, 164
Hollick, Frederick, 156–157, 174
homes for unwed mothers, 184
homicide, abortion as, 41–44, 58–59
humoral theory, 6, 22–23
Hunt, Harriot, 166–167, 169
Hunter, William, 136

the ideal woman, in ancient Greece, 16–17
illegitimacy of children, 33, 80, 127–128
illicit sexual relations
　British cultural concerns over infants, 143–144
　Church courts policing, 57–58
　colonial America's abortion practices, 114–115
　France's prosecution for abortion, 61–66
　Italian Catholic shame over, 84
　medieval Christian doctrine and abortion law, 43–44, 52
　newspapers' "moral critique" of abortion, 143–144, 156
　the objectives of anti-abortion legislation, 4–5
　obscene literature leading to, 174
　Roman women, 32–33
　See also adultery; extramarital sex
immigrants
　combining Indigenous botanical knowledge, 103
　Germans in colonial America, 120–121
　nativism and the anti-abortion movement, 171–172
　prosecution of midwives, 175

impotence, herbs inducing, 68
incest, legalizing abortion for, 205
India, 10
The Indian Doctor's Dispensatory (Smith), 104
Indigenous Americans, 97–106
indigo (abortifacient), 112
infant substitution, 77
infanticide and infant death
 abortion of a formed fetus, 46–47
 accusations against enslaved women, 108
 ancient Greece, 17–19
infanticide and infant death *(continued)*
 extramarital sex in colonial America, 117
 French law under Henri II, 77
 Indigenous Americans as abortion providers, 103–104
 physicians' racist position on abortion, 172
 prosecution of enslaved women, 109–110
 prosecution of Spencer Lindfield, 143–144
 prosecution of women in Victorian Britain, 134–135
 unbaptized babies, 56
inheritance customs and laws, 30–31, 77
Invalid Corps, 149–150
Ireland
 abortion law, 10, 211
 Brigid of Kildare's miracles, 39–41, 48–49
Islam, 47, 53–54
Italy
 Catholic abortion courts, 75–76
 Catholic shame over illicit sex, 84
 foundling hospitals, 128
 incarcerating unmarried women, 79–80
 Luther's repressive reforms, 71–72
 rationales for restricting abortion, 4

Jamaica, 108–110
Jane Collective, 209–210
Japan as abortion destination, 203
Jefferson, Thomas, 101–102
Jews and Judaism, 37, 42, 47, 61–63, 206
Juvenal, 33–34, 36–37

Keemer, Ed, 184, 186
Kelsey, Frances, 200–201

labor force
 economic change and Germany's decline in marriages, 78–80
 Invalid Corps, 149–150
 Victorian baby farms, 143–144
 women in World War II, 190
 See also slaves and slavery
The Ladies Dispensatory (Sowerby), 71
Laennec, René, 141
Laistler, Anna, 80–81
late abortions, 75, 155
Le Jumeau, Alexandre, 141
legal abortions, 181
legislation. *See* anti-abortion legislation
lifesaving procedure, abortion as, 3, 35, 121–123, 162
Lindfield, Spencer, 131–139, 142–148
literacy, women's, 10
 abortion information in antebellum America, 159
 19th-century abortion information, 153–154
 printed works on abortifacients, 70–71
 Roman era, 32–33
Long, Edward, 106
Lord Ellenborough's Act (Britain; 1803), 139–141
Luther, Martin, 72
Lutheranism, 92
lying-in hospitals, 128–129, 133, 136
Lysistrata (Aristophanes), 24–25
Lysol douches, 178, 184

MacCrowe, Albert E., 185, 194, 196
Macedon, 29

MacKenzie, Leo, 194–195
madder (abortifacient), 102
Maginnis, Patricia, 208–209
Magistris, Superio de, 76–77
mail-order remedies, 154, 173–175
Malleus Maleficarum, 85–87, 93
Maria: or The Wrongs of Woman (Wollstonecraft), 132–133
Markin, Samuel, 178–179
marriage
 abortions by married women, 33, 160–161
 arranged marriages, 16–18, 31
 domestic violence provoking miscarriage, 60
 ensuring legitimate children in the Roman Republic, 31
 evolving Church doctrine, 56–57
 forced marriage of enslaved women, 111–112
 free love movement, 168–169
 the ideal woman for, 16–18
 Luther's criticism of celibacy, 72–73
 married women limiting family size, 131–132, 177–178, 186
 married women testifying about unmarried women, 83–84
 medieval abortion doctrine, 44–47
 physicians' anti-abortion position for married women, 171–172
 pregnant and abandoned brides, 80–81
 pressure on unwed mothers in Victorian England, 126–128
 Rome's moral decline, 34–35
 World War II, 190
 See also extramarital sex; unmarried women and unwed mothers
The Married Woman's Private Medical Companion, 156
maternal deaths
 Britain's Poor Law, 130
 Comstock controlling "indecent literature," 174
 the consequences of repression, 216–217
 decline following ALI laws, 207–208
 post-abortion infections, 138–139
 race and socioeconomic status, 204–205
 Spencer Lindfield's trial, 137–139, 146
 women's abortion-related deaths, 185, 187
maternity homes, 134
McCarthy era, 190
McCorvey, Norma, 186
medical condition for legal abortions, 199–202
medication, abortion by, 6–7, 9, 22. *See also* herbal remedies and abortifacients
medieval Europe
 Christian abortion law and doctrine, 41–43
 medical knowledge of abortion and abortifacients, 52–54
 providers of abortions in France and Germany, 67–69
 regulating sexual behaviors, 47–48
 See also specific countries
men
 assistance in an abortion, 63–66
 botanical knowledge, 112–113, 118
 infanticide in ancient Greece, 17–18
 witchcraft, 85, 92
menses
 abortion to regularize, 6
 herbal methods of regulation, 28, 55, 67–69, 80, 100, 111, 132, 153
 humoral theory, 22–23
 physician-performed abortions, 186
 printed information on treatment, 71, 154
Merian, Maria Sybilla, 97–99, 105
metics (guest workers in Greece), 19
Mexico as abortion destination, 203–204
midwives
 abortions in ancient Greece, 20–21
 early 20th-century providers, 187

enslaved Caribs and Arawaks, 99–101
inducing a lifesaving miscarriage, 121–122
infanticide in ancient Greece, 18
physicians linking abortion and witchcraft, 87
policing 15th-century sexual behavior, 74
prosecution for assisting in abortions, 1–2, 133–139, 142–143, 145–147
South Africa, 99–100
20th-century providers, 181
mifepristone, 216
miracles: abortions by holy men and women, 39–41, 48–49, 51–52
miscarriage
 abortion mimicking, 26
 biblical definition of abortion, 41
 fertility rates of enslaved women, 107
 as feticide, 160
 France's prosecution for abortion, 61–66
 Judeo-Christian view of accidental violent miscarriage, 47
 men's knowledge of abortifacients, 118–119
 witchcraft and pregnancy, 87–88
misoprostol, 216
Missouri: anti-abortion legislation, 165
Mitchell, William, 8, 114–121
Moody, Howard, 208
morality
 abortion in the ancient Mediterranean world, 13–15
 Church courts policing sins, 57–58
 concerns over Germany's unmarried women, 79–80
 early Christian writers on abortion, 38
 physicians' anti-abortion stance, 163–164
 shifting position of religious authorities on abortion, 6
 stories of Rome's decline, 34–37
 20th-century crackdown on abortions, 183–184

witch trials, 93–94
witchcraft narratives, 89
morality police, Lutheran, 72–74
Mormon leaders: 19th-century anti-abortion campaign, 172–173
Moser, Herman, 180–181, 195–196
movement provoking miscarriage, 13–14, 21–22, 25, 36
Muhammad (prophet), 47

nativism, 171–172
naturopaths, 188
New Harmony settlement, 168
New Poor Law (Britain; 1834), 129–130, 136–137
New York City, 153–154, 205–206
nonbinary individuals, 2–3
Northern Ireland, abortion law, 211
nostalgia, politics of, 33
nuns. *See* convents and monasteries
nurses as providers, 188

obstetrics, 175
Old English Herbarium, 53–54
On Simples, 23
On the Nature of the Child, 42
organized crime: portrayal of abortion providers, 190
Orpin, Richard, 125–126, 131–132, 138, 145, 147–148
out-of-state travel, criminalization of, 9
Owen, Robert, 168

Pacific Coast Abortion Ring (PCAR), 189, 203
Paschall, Elizabeth Coates, 121
paternal responsibility, 129–130
patient–doctor confidentiality, 175
patriarchal societies, 7–8
 European Church and state control, 72–73
 history of women's reproductive control, 214–215
 symbols of abortion legislation, 151
Peace (Aristophanes), 24–25
peacock flower (abortifacient), 97–98

Index

pennyroyal (abortifacient), 23–27, 53, 70, 102, 119–120
Persephone myth, 25–26
pessary, 21–22, 26, 64
Philip of Macedon, 29
physicians
 abortion as Black women's resistance, 105–107
 antebellum America's anti-abortion activists, 159–166
 arrest and prosecution, 192–194
 Baltimore providers, 184–186
 effect of *Roe v. Wade*, 210
 effects of the Comstock Act, 175–176
 enslaved women's frequent miscarriages, 111
 female physicians as threat to male physicians, 166–168
 hospital committee systems, 198–200
 Indigenous Americans' cross-cultural knowledge, 104
 legal authority over determining pregnancy, 141–142
 linking abortion and witchcraft, 87
 Mexico as abortion destination, 203
 19th-century anti-abortion legislation, 150, 152–153
 prosecution of Spencer Lindfield, 145–147
 race-abortion intersection, 196–197
 therapeutic abortions, 205
 20th-century American providers, 181–182, 186–187
pilgrims: temple at Epidaurus, 17
Place, Francis, 130–131
placenta, failure to be expelled, 119
Planned Parenthood, 180, 206
plantations, 104–106
plants. *See* herbal remedies and abortifacients
Plato, 20–21
Playground Athletic League, 184–185
"pleading the belly," 141–142
Pliny the Elder, 28
Pliny the Younger, 34

Poland, 10
police
 Baltimore's Abortion Squad, 191
 Lutheran morality police, 72–74
 Pacific Coast Abortion Ring, 189
 race-abortion intersection, 195–196
pomegranates (abortifacient), 25–27
Portugal, 10
postpartum illness, 118–119
premarital sex
 birth control clinics, 183
 forced marriage in Victorian Britain, 126–129
 Greek arranged marriages, 16–17
 men's attempts to provoke miscarriage, 62–63
 Protestant legislation targeting abortion, 69
 See also illicit sexual relations; unmarried women and unwed mothers
procedural abortions
 abortion in Rome, 34–35
 bougie, 178, 180
 catheter abortion, 138, 178
 transmission to medieval Europe, 52–54
 uterine sound, 162, 191
"pro-life" terminology, 5
pronatalist stance, Rome's, 34–35
property rights, 30–31, 158
prosecution
 attempted abortion in colonial America, 115–116
 British doctors, abortion, and the law in the 20th century, 199
 Catholic excommunication, 73–77, 83, 173
 enslaved women, 109–110
 France, 61–66
 German witch trials, 92–95
 immigrant midwives, 175
 Indigenous Americans, 103–104
 infanticide in Victorian Britain, 134–135

legal authority about pregnancy, 141–142
Lutheran morality police, 72–74
media coverage of abortion stories, 154–155
medieval English church courts, 59–61
medieval European "healers," 68
of midwives for assisting in abortions, 1–2, 142–143, 145–148
Pacific Coast Abortion Ring, 189
physician providers, 187, 192–194, 207–208
for political gain, 191
post-abortion maternal death, 139–141
racial politics, 196–197
16th-century increase in, 69–70
Spencer Lindfield's midwifery practice, 142–143, 145–148
prosecution (*continued*)
state and religious control of women's sexual behavior, 82–84
20th-century Baltimore, 179–181
white colonial American women, 113–114
for witchcraft, 84–95
Protestant Churches and clergy
Clergymen's Advisory Board, 206
criminalization of abortion, 69
English criminalization of abortion and miscarriage, 77–78
New York's clergy consultation service, 208
physician-clergy alliance over contraception, 206–207
prosecution for blasphemy, 114–117
recent anti-abortion position, 6
regulating morality, 72–73, 84–85
religious authorities' involvement in the abortion debate, 6
tolerance in colonial Maryland, 115–116
witchcraft and witch trials, 86–89, 92–93
See also clergy
Protestant Reformation, 69

psychiatric reasons for therapeutic abortions, 204–205
puerperal fever, 139
Puerto Rico as abortion destination, 203

quickening, fetal, 58–61, 140–141, 159–161, 164, 172–173, 216

race and racism
elite Roman women, 33
intersection of abortion and race, 195–198
nativism and the anti-abortion movement, 171–172
women's unequal access to abortion, 8
See also Black women; slaves and slavery
Rankin, Reginald, 189
rape
abortion as an element in social relations, 8
abortion following incestuous rape, 198–199
holy miracles ending unwanted pregnancies, 49–50
of incarcerated women, 79
legalizing abortion for, 205
by quartered military personnel, 81
of servants by employers, 78–81, 132–133
sexual abuse of enslaved women, 106
women instructing women on abortifacient use, 70
Rappaport, Nathan, 186
Ravenna, Italy, 53–54
red cedar (abortifacient), 120–121
Regino of Prüm, 57–58
religion. *See* Catholic Church; Protestant Churches and clergy
reproductive justice, 7–8
reproductive services clinics, 134–135
resistance, abortion as, 105–108
Restell, Madame, 154, 156, 174, 228
Revolutionary Road (Yates), 178
Rhetta, Barnett M., Jr., 205

Rhetta, Barnett M., Sr., 196–198
rights and freedoms in the Greco-Roman era, 16, 32–33
Roe v. Wade, 8–9, 186, 209–211, 213
Roman law: France's prosecution for abortion, 61–66
Roman Republic and Roman Empire
 abortion and women's freedom, 4
 Christian doctrine on marriage and celibacy, 44–47
 ensuring familial continuity, 31–32
 Irish Christianity, 40
 linking abortion to vanity and adultery, 4, 30, 33, 35
 politics of nostalgia, 33
 rise and expansion of, 28–30
 theological diversity, 37–38
Rotunda, Dublin, 141
Roundtree, Richard, 65–66
rubella outbreak, 200–202, 206
rue (abortifacient), 110
Rueff, Jacob, 87

safety of abortion procedures, 9–10, 138–139, 181–184, 191–195, 208
San Juan weekend, 203–204
Sauer, Christoph, 120–121
savin (abortifacient plant), 53, 69–70, 76, 101, 117–118, 120–121, 131, 145–146
Scotland
 infanticide laws and prosecution, 77–78
 witchcraft outbreaks, 88
 See also Britain
segregation: intersection of abortion with race, 195–198
self-managed abortion, 5, 178–179, 182, 209–211, 216
Seneca (philosopher), 33
Seneca Falls meeting, 169
Seneca snakeroot (abortifacient), 102–104
septic abortions, 139
Septuagint, 41–42
seven-boom tree (abortifacient), 101
sex advice books, 156–157

sex strikes, 24–25
sex workers
 alleviating poverty, 81–82
 ancient Greece and Rome, 19–20, 36–37, 44–45
 Hippocratic doctors studying pregnancy and abortion, 13–16
 incarceration to enforce chastity, 79
 Indigenous Americans' knowledge of abortion methods, 100–102
 priests' concubines, 56
 witch trials, 92–93
sexually transmitted disease (STD), 152
silphium (abortifacient plant), 27–28, 30
sin, abortion and, 44–47, 52, 57–59
Sixtus V (pope), 73–75, 173
slaves and slavery
 abortion as Black slaves' resistance, 105–108
 abortion as property crime, 158
 abortion in ancient Greece, 15
 British abolition, 106–108
 controlling enslaved women's reproductive lives in the American South, 110–113
 controlling women and abortion, 4–5
 death of Indigenous Americans, 99
 Dutch colonials, 97–100
 enslaved women's reproductive life, 108–110
 medieval religious doctrine and abortion law, 43
 punishment for ending a pregnancy, 122
 role of abortion in women's lives, 7–8
 Roman enslavement of Greeks, 29–30
 Roman position on sex with slaves, 45
 Saint Brigid's miracles, 49
 17th-century plantations, 104–106
 slaves as human capital, 106–107, 110
 symbols of abortion legislation, 151
 women's literacy in Rome, 32–33
Sloane, Hans, 105
Smith, Peter, 104
sneezing preventing conception, 21–22, 36

Society for Humane Abortion (SHA), 209
socioeconomic status
 abortions for mental health, 204–205
 Britain's New Poor Law, 129–130
 expense of traveling for abortions, 203–204
 framing abortion as a "choice," 121–122
 Jane Collective referrals, 209–210
 medical professionals as abortion providers, 188
 medieval religious doctrine and abortion law, 43
 19th-century Boston's abortion providers, 152
 privilege of abortion access, 213
 Romans linking abortion to vanity, 4, 30, 33, 35
 See also slaves and slavery
Socrates, 20–21
sodomy: Carolina criminal code, 73
Soranus (Greek doctor), 28, 34–35
souls
 canon law on abortion, 58–59
 Catholic concerns over fetal souls, 42–43, 173
 Church prosecution for abortion, 60–61
 death of unbaptized babies, 56
 formed and unformed fetuses, 46–47
 Jewish position on abortion, 47
South Africa, 99–100
Sowerby, Leonard, 71
Spanish fly, 104, 133
Spencer, Robert Douglas, 187
spignel (abortifacient), 54
sponges (contraceptives), 130–131
"squaw" (derogatory term for abortifacient plants), 102
state control over women's sexual expression, 9, 72–73, 77, 82–84, 94
sterilization campaigns, 197
stethoscope, invention of, 141–142
stillborn infants, 56, 74, 77–78, 106, 118–119, 143
Storer, Horatio Robinson, 162–165, 171, 175–176
stories and narratives
 enslaved women's abortion practices, 111–112
 inducing a miscarriage to save a life, 121–122
 Rome's moral decline, 33–35
 sources of, 10–11
 witchcraft accusations and trials, 89–93
 young women in ancient Greece, 17–18
Sue, Eugène, 144
Suetonius, 34
sugar plantations, 108–110
sulfa drugs, 139, 181
Supreme Court, US, 8–9, 213
surgical abortion methods. *See* procedural abortions
Surinam, 97–99

tansy (abortifacient), 55, 110, 155
thalidomide, 200–202
therapeutic abortion committees, 186, 199–202, 207, 208–209
therapeutic abortions, 162, 165, 204–206
Tietze, Christopher, 185–186
Timanus, George Loutrell, 184–186, 192–194, 196, 213
toleration for seeking an abortion, 3, 156, 159–161, 215
torture: witch trials, 93–94
trans individuals, 2–3
Turner, William, 70–71

underground referrals, 209–210
unmarried women and unwed mothers
 Algonquin nations' sexual behaviors, 101
 concerns over the morality of European women, 78–83

European laws punishing infanticide, 77–78
the importance of chastity, 16–17, 44–45
lack of access to birth control, 183
medieval European healers as abortion providers, 68
restrictions in colonial America, 4
witchcraft narratives, 89
urines, reading, 83
uterine sound, 162, 191

vanity, Romans linking abortion to, 4, 30, 33, 35
vervain (abortifacient), 109
voting rights for women, 169
Vought, Lizzie. *See* Ward, Lizzie Vought

war, 29–30
Ward, Frank, 149–150, 155, 169–171
Ward, Lizzie Vought, 149–150, 155, 169–171

Warren, Susanna, 114–121
watercress, 36
welfare system: England's New Poor Law, 129–130
Westerstetten, Christoph von, 92
wet nurses, 18
Williamson, John, 106
Wilson, Eliza, 1–2, 6, 11, 125–126, 128–129, 131, 133–134, 137–139, 145, 148
Winslow, Cora, 181–182
witchcraft, 73, 84–95
Wollstonecraft, Mary, 132–133
workhouses, 129–130
Works Progress Administration (WPA), 111–112
World War II, 189–190
Wright, Frances, 168

Xenophon, 16

Yates, Richard, 178

Mary Fissell is the inaugural J. Mario Molina Professor in the History of Medicine at Johns Hopkins University, focusing on sex, gender and reproduction. The author of *Vernacular Bodies*, among others, she has featured on the BBC, and in *Vice*, *Slate*, *The Washington Post* and *The New York Times*.

Credit: Roman N. Sherbakov